Daumier Sculpture

A Critical and Comparative Study

Daumier Sculpture

A Critical and Comparative Study

by Jeanne L. Wasserman
assisted by Joan M. Lukach and Arthur Beale

Fogg Art Museum, Harvard University May 1 - June 23, 1969

Distributed by New York Graphic Society Greenwich, Connecticut

for John Coolidge

Foreword

The idea of mounting an exhibition of Daumier's sculpture was first entertained in the Autumn of 1966. During the preceding Summer John Coolidge had acquired for the Fogg Museum, a fine cast of the bronze bas-relief "Les Emigrants." During his years as the museum's director he evinced a lively interest in sculpture, as his many acquisitions in the field demonstrate. It seemed to him and to his colleague Peter Wick, then Assistant Director of the Fogg, that it would be both natural and illuminating to make the new addition to the collection a focal point in an exhibition of Daumier's sculpture. Word of the increasing number of pieces entering the country made the idea seem entirely feasible. Jeanne Wasserman agreed to assist in assembling such an exhibition. It was only when she was well-launched on the project that the complexities and contradictions regarding Daumier's sculpture began to seem truly formidable. It became evident that not only was there little agreement among the experts, both past and present, concerning the materials and the techniques Daumier had employed. There was often a curious lack of essential documentation concerning the objects and many strange lacunae in their history. Yet more and more editions of various figures were appearing on the international art market.

The problems, while in some cases similar to those regarding the 20th century casts of Rodin and Degas sculpture, were at times more troubling. If like Daumier, Degas did not see his waxes or clays cast in his lifetime, the history of the Degas models and their casting is well-known.

Our colleagues abroad were often as baffled by the Daumier problems as we were, and were as lacking in precise answers. There seemed no easy or quick solution.

At this point, the proposal to mount an exhibition of Daumier's sculpture might well have been abandoned. Yet abandonment would have been pusillanimous, an admission of defeat. And the problems would have remained to be faced by the next enthusiasts with a similar idea. It seemed that we should not give way. The Fogg Museum is a teaching museum in a very special sense. Our staff is made up not only of scholars but also, in our Department of Conservation, of highly-skilled, competent technical experts. Our prime audience is the student-body whose eyes we wish to train, whose powers of judgment we wish to see grow. If we, with our particular qualifications for careful and objective examination of the facts before us, could not probe for solutions to troubling questions, who else would?

It was decided to go ahead.

For the past two years, Mrs. Wasserman has devoted herself to the subject, familiarizing herself with all the sculpture it was possible to see, both here and abroad. Collectors and curators on both sides of the Atlantic have been extraordinarily generous, agreeing not only to lend objects of exceptional interest but sometimes of even more exceptional fragility. They have, as well, given hours and hours of time, seeking and sharing information that was scattered, unrecorded, or overlooked. Joan M. Lukach, a Harvard graduate doctoral candidate has assisted Mrs. Wasserman, and has carried her investigations into Italy as well as France. In our laboratories, Arthur Beale has examined, measured and analysed certain key works, early made available to him.

Without the informed and fundamental work of Jean Adhémar of the Bibliothèque Nationale and that of the Italian authority Dario Durbé, without the generous assistance of Francis Gobin, the son of the late Maurice Gobin, without the sympathetic assistance of Madame Le Garrec and her grandson — to name but a few — or without the open-handed generosity of Lessing J. Rosenwald and others, the exhibition could not have become a reality. Above all we wish to acknowledge the steady, indeed inspiring understanding of Max Wasserman. He has not only made journeys possible, but he has planned and sustained them, sharing in the sometimes hazardous pilgrimages with a thorough and sensitive appreciation of their importance.

They and we are aware of the fact that in presenting the exhibition we are presenting a host of problems, many of which have never been posed before. Some may prove insoluble. We are, however, hopeful that for example by placing various editions of the same bronzes side by side, certain factors will

be clarified; that in examining the plasters and the terra cottas we may learn how the artist's hand moved; that in studying the clays we will come as close to Daumier's own ideas as it is now possible to come.

In our catalogue there are reproductions of many items that it was not possible to include in the exhibition. They are reproduced because it is hoped that they will help throw particular light on the problems.

If, with all this material, we can establish a firm basis upon which future connoisseurship can build, we will have achieved our aim.

No man was ever more honest or more direct in his dealings than Daumier. It seems that the least we can do to honor him is to know and make known, as far as possible, exactly what came from his skilled hands working as the expressive interpreters of that often caustic but always humane intelligence.

AGNES MONGAN
Spring 1969

Acknowledgments

We are deeply indebted to the lenders to this exhibition for their extraordinary generosity. We are especially grateful to those who have allowed us to borrow objects of great fragility as well as those who have parted with their possessions more than once or for an extended period in order to assist us in our research and in preparation of the catalogue.

Our research has been aided by many people in this country and abroad who have generously shared their knowledge with us. Special thanks are due Jacques de Caso, Frederick B. Deknatel, Dario Durbé, Albert E. Elsen, Oliver Larkin, K. E. Maison, John Rewald, Heinrich Schwarz. The many museum curators who have been generous with their assistance include Jean Adhémar of the Bibliothèque Nationale, Paris; Fred Cain of the Alverthorpe Gallery, Jenkintown, Pa.; Sinclair H. Hitchings and Paul B. Swensen of the Boston Public Library; Emilia Lange of the Goldfarb Library, Brandeis University; Marielle Latour of the Musée Cantini, Marseilles; Abram Lerner of the Joseph H. Hirshhorn Collection, New York; Haavard Rostrup of the Ny Carlsberg Glyptotek, Copenhagen; Eleanor A. Sayre of the Museum of Fine Arts, Boston. We are indebted also to our colleagues at the Massachusetts Institute of Technology, especially Heather Lechtman for superb x-rays, and Cyril S. Smith for his helpful suggestions on casting techniques. Technical advice was generously given by Daniel Cushing, Consulting Metallurgist; William Young, Head of the Research Laboratory, Boston Museum of Fine Arts; and Lloyd Lillie, Associate Professor of Art, Boston University.

We are grateful for information supplied by Aage Fersing, Francis Gobin, Marcelle Minet and Jean Osouf of Paris. Dealers who have been specially helpful include M. Roy Fisher of Wildenstein & Co., Inc., New York; Mira Jacob of Le Bateau Lavoir, Paris; Marcel Lecomte, Paris; Pierre Matisse, New York; Frank Perls, Los Angeles; Henri M. Petiet, Paris; J. C. Romand of Sagot-Le Garrec & Cie., Paris; as well as Monsieur Tamburro of the Valsuani Foundry. In addition, we are enormously indebted to Jacqueline Hyde for handling with great sensitivity the delicate task of photographing the fragile clay busts and terra-cotta figurines in Paris.

We have been assisted in the preparation of the catalogue and the exhibition by countless members of the Fogg Museum staff. We give special thanks to Henry Berg, Assistant Director, for his tireless help in almost every phase of this project. We are also deeply grateful to Elizabeth H. Jones, Chief Conservator; Ruth S. Magurn, Curator of Prints; Wolfgang Freitag, Librarian; Elena Drake, Acting Registrar; Mildred K. Frost, Secretary of the Fogg; and Joanne J. Turnbull. We have been greatly assisted by James Ufford, Michael A. Nedzweski, Bonnie Solomon and Catherine Coté of the Photography Department, as well as by Laurence Doherty, Superintendent, and his staff.

Several graduate students in the Fine Arts have made significant contributions. We are indebted to Cynthia R. Field for research on the Daumier lithographs, and for helping to locate and select those illustrated in the catalogue and included in the exhibition. We are grateful to James Rubin for assistance in our research on the bust of Louis XIV and in particular for information on 17th century French portraiture. Alice I. Davies' previous research on the Fogg drawing, "Fugitives," provided a starting point for our work on "Le Fardeau." We are grateful to Suzannah F. Doeringer, Dorothy W. Gillerman, Joan R. Mertens, and Eunice Williams for their advice and for sharing with us their own previous exhibition experience.

For help in the preparation of the catalogue we are greatly indebted to Mardges E. Bacon, Joan A. Scida, Bernice Jones, Louisa Sprague, Leonoor Ingraham, Pamela Williams, Linn Orear, Julia Mansfield, and also Norma G. Wasserman.

Finally, this project could never have been realized without the help and guidance of Agnes Mongan, Acting Director, and Curator of Drawings at the Fogg Museum, who, in spite of the unremitting demands of her schedule, gave cheerfully and unsparingly of her knowledge and experience.

Contents

List of Lenders

Anonymous

Mr. and Mrs. Lester Francis Avnet, New York, New York

Madame Berthe Le Garrec, Paris

Mr. D. Geoffroy-Dechaume, Paris

Mr. and Mrs. Thomas H. Lee, Boston, Massachusetts

Mr. and Mrs. Harry Remis, Boston, Massachusetts

Mr. Claude Roger-Marx, Paris

Mr. Lessing J. Rosenwald, Jenkintown, Pennsylvania

Mr. and Mrs. Benjamin A. Trustman, Boston, Massachusetts

Mr. and Mrs. Arthur E. Vershbow, Newton, Massachusetts

Dr. Howard P. Vincent, Kent, Ohio

Baltimore, Maryland, The Walters Art Gallery

Boston, Massachusetts, Boston Public Library

Boston, Massachusetts, Museum of Fine Arts

Buffalo, New York, Albright-Knox Art Gallery

Cambridge, Massachusetts, Fogg Art Museum, Harvard University

Melbourne, Australia, National Gallery of Victoria

Paris, Galerie Sagot-Le Garrec

Waltham, Massachusetts, Brandeis University, Benjamin A. and Julia M. Trustman Collection

Washington, D.C., National Gallery of Art, Lessing J. Rosenwald Collection

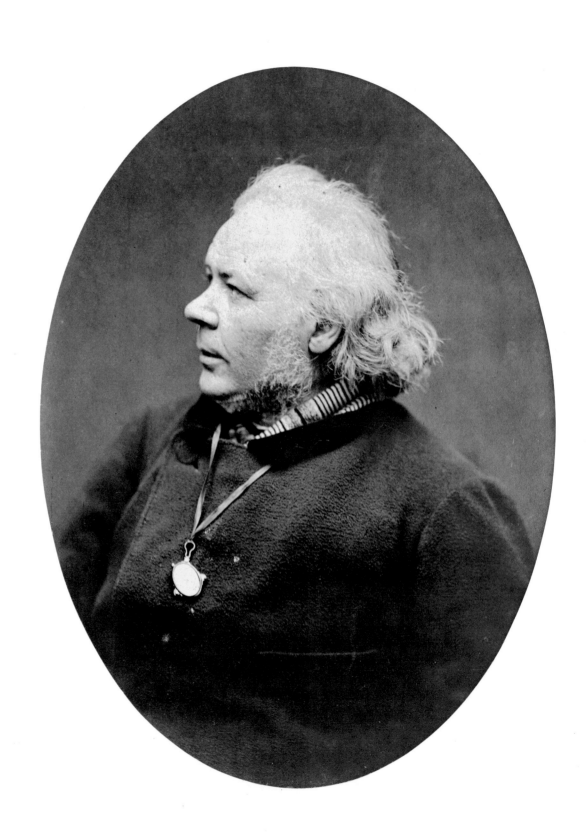

Honoré Daumier
1808-1879

Honoré Daumier was born in Marseilles on February 26, 1808. His father, an artisan, had literary aspirations, and moved to Paris in 1814 in the hope of gaining recognition for his poetry. Young Honoré was apprenticed for a time to a bailiff, but turned early to a career in art, first with the assistance of the archeologist Lenoir. By 1828 he had become a regular visitor at the studio of the academic artist Boudin, where he met the sculptor Préault and painters Diaz, Jeanron, and Huet. His friend Ramelet taught him the new technique of lithography. This he soon put to use, making prints during the Revolution of 1830 to uphold Republican sentiments. He was soon hired by Charles Philipon, founder-editor of two satiric newspapers, *La Caricature* (1830-35) and *Charivari* (1832-36). Thus began Daumier's lifelong career as a journalist-illustrator, a career which produced over four thousand lithographs, both political and social. He made a series of caricature busts in clay for Philipon, satirizing Louis Philippe's lawmen. From these he drew the series *Célébrités de la Caricature* and *Chambre non prostituée*. When Louis Philippe censored the free press in 1835, *La Caricature* ceased publication, and Daumier concentrated upon the foibles of everyday life in Paris. This is the period of *Robert Macaire*, *Les Moeurs conjugales*, *Les Bons Bourgeois*, *Histoire ancienne*, *Les Bas Bleu*, etc.

In 1846 Daumier married Alexandrine Dassy. They had no children. (She died in 1895.) At the same time, Daumier moved to 9 Quai d'Anjou, where he lived in close companionship with painters Corot, Daubigny, Dupré, caricaturist Trimolet, sculptors Pascal, Steinheil, Barye, Geoffroy-Dechaume, and Carrier-Belleuse, and authors Baudelaire, Gautier and Champfleury. In 1848 Louis Philippe was deposed, and for a brief period, Daumier's dream of a Republic came to power. But Louis Napoleon Bonaparte began his campaign to seize control, and by 1850 Daumier was again involved in political offensives, creating "Ratapoil" in both lithographs and sculpture to attack the new enemy. When Louis Napoleon took power, December 1851, Daumier again was forced to cease his political activities. In the 1860's he concentrated upon painting. About 1870 his sight began to fail, until by 1877 he was almost totally blind. His friends organized a retrospective exhibition for him at Durand-Ruel in 1878. He died at his country home in Valmondois, February 11, 1879.

42c. Photograph of Daumier by Etienne Carjat, 1861
Signed by Daumier lower left: h. Daumier
Fogg Art Museum, Harvard University

Introduction

"Ce Daumier, quel sculpteur!" exclaimed Rodin as he held and admired a bronze cast of the "Ratapoil." Raymond Escholier thus discusses a scene which took place in his office in Victor Hugo's house, during the spring of 1914. This praise from Rodin is appropriate indeed, for the sculpture of Daumier has been increasingly appreciated in this century. Like Rodin's own late studies, Daumier's small sculptures — spontaneous, bold, lively — appeal strongly to the 20th century eye.

Yet Daumier never intended his sculpture for public exhibition. The lithographer and aspiring painter modelled in clay for his own satisfaction and to know and study the subjects he treated in other media. Although a few contemporaries have left brief and rather puzzling eye witness accounts of sculpture that they saw in Daumier's studio, this phase of his art was ignored by such contemporary critics as Baudelaire.

In 1879, shortly before Daumier's death, his friends organized an exhibition of his work at Durand-Ruel. It is significant that the catalogue mentions only a few pieces of sculpture — "heads in colored clay" and two "studies in plaster" called "Fugitifs." For some reason, the statuette known as "Ratapoil" was not included in that exhibition, although its creation by Daumier is well documented.

No sculpture by Daumier was cast in bronze during his lifetime. The earliest bronze editions are those of the "Ratapoil" and "Les Emigrants" ("Fugitifs") made by the Siot-Decauville foundry sometime in the 1890's. The caricature busts, those brilliant lampoons of Louis Philippe's politicians, which are perhaps the best known and best loved of Daumier's sculpture, were not reproduced in bronze until 1929-30 when some editions began to appear. All known editions of these and other sculptures attributed to Daumier were made in the 20th century. Some are still being made today.

Daumier the sculptor was first discussed by Geffroy in an article for L'Art et Les Artistes, published in 1905. Nineteenth century biographers, such as Champfleury and Alexandre, already had made catalogues of his works. They listed only the busts, "Ratapoil," and "Les Emigrants." In fact, these are the only sculptures mentioned in the Daumier literature until 1927. Growing appreciation of this aspect of Daumier's work led several critics to express the hope that more examples would be found. For instance, Duncan Phillips in 1922 described the sculpture as rapidly and boldly modelled and added that its quality "makes you wish there were more. . . ." Fuchs, actively searching for more, presented two hitherto unknown terra cottas in his book published in 1927. On the occasion of the Daumier exhibition held at "L'Orangerie" in 1934, Claude Roger-Marx wrote in the catalogue's preface of "recent discoveries which will, perhaps, enrich this sculptured work." Presumably he referred to the group of nineteen terra-cotta figurines discovered by Maurice Gobin, which were published for the first time in 1952 in the latter's catalogue raisonné of Daumier's sculpture. Since the appearance of Gobin's book, other sculptures in unbaked clay and terra cotta have been discovered, attributed to Daumier, and cast in bronze editions. Although the histories of these editions are scrupulously noted, the origin of the clays and the terra cottas from which the bronzes were cast remains a mystery.

When, in 1966, the Fogg Museum acquired a cast of the splendid "first" version of "Les Emigrants," the idea for a full-scale Daumier sculpture exhibition was first conceived. In the process of seeking out the examples of clays, terra cottas and bronzes in museums and private collections in the United States and Europe, many problems and inconsistencies began to emerge. Research in the enormous body of Daumier literature only served to reveal further confusions and misunderstandings. In order to study these problems in depth, it was decided not to limit the exhibition to those few sculptures documented during Daumier's lifetime, but rather to gather together for study and comparison as many as possible of the works that have been attributed to him over the years. Discovering that more than one edition exists of many of the sculptures — for instance, two in bronze and one in terra cotta of the busts, and three in bronze of the "Ratapoil" — it was decided to show an example of each edition and to include reproductions and even two surmoulages

(bronze cast from a bronze). It was hoped that such side by side comparison would reveal not only the comparative merits of the editions, which might be compared to the states of a print, but that it also would reveal how each edition reflects the artist's original concept.

The sculpture of Daumier has been included in many previous exhibitions both in the United States and abroad. It was treated with unusual thoroughness in the exhibition at the Galerie Sagot-Le Garrec in Paris in 1957, when two of the original clay busts, six terra-cotta figurines and three plasters were shown, and in the exhibition at the Château de Blois in 1968, when one example of each of the bronzes was shown. This is, however, the first exhibition in the United States to include clay and plaster originals, and more than one bronze edition of particular subjects.

We are indebted to Madame Berthe Le Garrec for allowing her grandson, Monsieur J. C. Romand, to bring to the Fogg four of Daumier's original hand-painted clay busts — the first time that they have crossed the ocean. These fragile objects of unbaked clay are the only sculptures in our exhibition known to have come from Daumier's hand. Of necessity, repaired several times, they nevertheless remain so alive that they seem to breathe. I am pleased that the excitement I experienced in June 1967, when I saw the thirty-six original clay busts in Madame Le Garrec's house outside Paris, can, in part, be recreated at the Fogg Museum. The presence of these unbaked clays which we know were modelled by Daumier gives us a rare opportunity; for we can make a detailed comparison between them and the bronze casts and terra-cotta reproductions which derive from them.

We are indebted to the Albright-Knox Art Gallery not only for allowing us to borrow their plaster of the "Ratapoil" but for making it available to us for study long before the opening of the exhibition. Arthur Beale, Assistant Conservator of the Fogg, has found physical evidence that this plaster could be the original one. Laboratory examination indicates that the plaster was made by means of a waste mold from Daumier's clay, which, as Gobin has surmised, was destroyed in the process. In his technical discussion in this catalogue, Mr. Beale describes how other plasters were made from the original one and how they, in turn, were used in the various bronze editions. Examples of three bronze editions and a reproduction, all in the exhibition, can be compared to this plaster which is most faithful to the original lost clay.

In our search for sculpture attributed to Daumier, we have seen thirteen of the terra-cotta figurines in Paris, and the terra-cotta "Pitre Aboyeur" in the Magnin Collection in Dijon. None of these could be borrowed, so we are grateful indeed to the Walters Art Gallery for lending their terra cotta, "Le Fardeau." Never cast in bronze, "Le Fardeau" has been exhibited only once before outside the Walters Gallery. We hope that its inclusion in the present exhibition will shed some light on Daumier's use of terra cotta.

We have also seen the clay bust of Louis XIV at Wildenstein & Co., Inc. in New York, the plaster of the "Portrait of Daumier" in a private collection in Milan, and the unbaked clay originals of the "Two Little Busts" in the Ny Carlsberg Glyptotek in Copenhagen. Since none of these could travel to the Fogg Museum, we could not make all of the studies necessary to help solve the problems connected with them. We have no other recourse, therefore, than to set down all we know of their appearance and history, in the hope that such information, incomplete as it is, will serve as a guide for future research.

We are especially grateful to Lessing J. Rosenwald for making his entire collection of Daumier bronzes available to us. His willingness to send several works in advance of the exhibition has contributed greatly to our technical studies of the bronze casts.

Although the greater Boston area is unusually rich in large collections of Daumier's graphic work, both public and private, we have limited our selection to those lithographs and wood engravings which appear to have close relationship to the sculpture. Only the most pertinent prints are illustrated in the catalogue; additional ones are included in the exhibition. We also have included two drawings that are

closely connected with sculptures for which we could find no lithographic counterpart. Although we mention and illustrate several related paintings in the catalogue, it was decided not to include them in the exhibition, mainly because we desire to focus attention on the central issue of our concern — the sculpture itself.

The task of selecting and locating the objects for this exhibition was greatly eased by several very helpful and monumental reference works — Delteil's ten volume catalogue of almost 4000 Daumier lithographs published in 1925-30, Bouvy's catalogue of nearly 1000 engravings published in 1933, and K. E. Maison's Catalogue Raisonné of the Paintings, Watercolors and Drawings, published in 1968. Above all, we are indebted to Maurice Gobin's book Daumier Sculpteur, the catalogue raisonné of the sculpture, for setting us on the road to discovery which led to this exhibition. We have retraced Monsieur Gobin's footsteps and found almost every sculpture he described, except for the small clay "Masque de Louis-Philippe" (Gobin no. 37) of which we could find no trace. If we do not always agree with his theories and conclusions, we nevertheless admire his diligence and share his enthusiasm for Daumier the sculptor. Although our catalogue does not follow Gobin's order in presenting the sculpture, his numbers are given for identification. Except for the busts, Gobin's names for the sculptures are given in quotation marks. For the busts, we have used the names of the persons they represent, given in alphabetical order.

Since we have found the various attempts to date the sculptures unconvincing, we have presented them in groups, according to type, starting with the most fully documented — the busts, "Ratapoil," and "Les Emigrants." In the Appendix will be found several sculptures, not in Gobin, which have been brought to our attention, but which, with one exception, we have not seen or studied. We feel they should be included in the catalogue, particularly since bronze editions have been made in two instances.

We hope that, by bringing together as many of the sculptures attributed to Daumier as it was possible to assemble in the time at our disposal, we will provide an opportunity for intensive visual comparisons. Only through such first-hand study will it be possible to establish criteria for sound judgements concerning the attributions, and thus to come closer to a true understanding of Daumier the sculptor.

JEANNE L. WASSERMAN

Materials and Techniques

A Technical Examination of the Sculpture of Honoré Daumier

While time may give us greater insight into and appreciation of the work of a given artist, it often confuses our understanding of the techniques mastered and employed by that artist to achieve his unique statement. Since earliest times, opportunists have been in good supply and ready to capitalize on the success of an artist who enjoys a measure of growing acceptance. Our poor understanding of technique helps to make us easy prey for copyists and forgers. The influx of questionable works into the main stream of an artist's creative output compounds the difficulties produced by the erosion of time and further clouds our awareness of technique.

Almost ninety years have passed since the death of Honoré Daumier. Certainly we now stand far enough away from his presence to delight in the universal appeal of his work. Unfortunately, with Daumier sculpture, this passage of time has also produced an inordinate amount of confusion which tarnishes some of the prestige these works deserve.

The following technical study will attempt to deal with the problems associated with a basic understanding of the techniques employed in the production of Daumier sculpture. Confronted with the fact that this sculpture is best known by bronze casts made only after Daumier's death, I have expanded the study to cover the various casting techniques used to translate his work into metal and other reproductive materials. To avoid the pitfall of drawing conclusions from observations made from works of questionable attribution, I shall confine my discussion to a few of the best documented pieces: the caricature busts, the "first" version of "Les Emigrants," and the figure of "Ratapoil." Since I had the privilege of examining in the laboratory and performing major treatment to preserve the original plaster cast of "Ratapoil" (lent by the Albright-Knox Art Gallery), I shall center my discussion on this particular sculpture, seeking to make, whenever possible, critical comparisons of technique with other works by Daumier.

Modelling in Clay

The material with which Daumier probably made all of his sculpture was a water-softened modelling clay. The unbaked clay that has survived in the caricature busts appears in photographs to be somewhat coarse in texture, containing particles of various sizes. These particles are most likely grog, heat-treated earth clay that has been mixed with finer natural clay to reduce warpage and cracking in drying (see fig. 1). Although the original model of "Ratapoil" was destroyed in the casting process, I feel very sure it too was modelled in wet clay. On the surface of the original plaster cast, made by the sculptor Geoffroy-Dechaume for Daumier during his lifetime (Gobin, p. 294), one can see a definite textile pattern cast through from the original image. I theorize that Daumier used wet rags to keep the clay of the "Ratapoil" damp while he worked on it over a period of days, weeks, or even months. The cloth left an impression that was picked up by the mold and in turn cast into the plaster image.

Figure 1. Detail of broken area showing unbaked clay of original Daumier caricature bust, Guizot (cat. no. 17a)

The handling in "Les Emigrants," as can be seen in the original plaster cast in the Louvre, is so similar to that of "Ratapoil" with its nervous, liquid surface that I can only conclude that they were modelled with the same material.

The tools Daumier used for modelling left characteristic marks that can be found consistently on the busts, "Ratapoil," and the "first" version of "Les Emigrants." Favorites among his tools were the combs. These had fine or coarse teeth. He freely used the coarser-toothed comb to give texture to the hair and coats of the busts. On "Ratapoil" and "Les Emigrants," he used a finer-toothed comb to model and texture flesh areas, clothing and background (see fig. 2).

Daumier, of course, was not primarily a sculptor, but he did possess an extraordinary sculptural sense. Although it is not entirely clear why he produced these three-dimensional images, it is clear from his technique that he was not conceiving them as bronzes. A good percentage of the fine details of modelling and textural tool-work that can be seen on the original plaster casts and the unbaked clays is lost in the transition to bronze. Furthermore, when modelling the clay, he delighted in making deep undercuts and spacial pockets that are difficult to reproduce even in a flexible gelatine mold. Were

Figure 2. EXAMPLES OF COMB TOOLING FOUND ON DAUMIER SCULPTURE

a. Unbaked clay original caricature bust, Gallois (cat. no. 14a)

b. Detail: back of head of plaster original, "Ratapoil" (cat. no. 37a)

c. Detail: section of bronze cast, "first" version, "Les Emigrants" (cat. no. 38b)

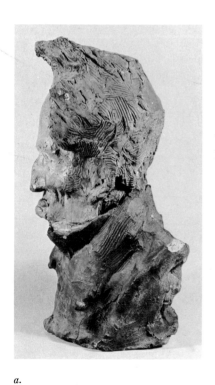

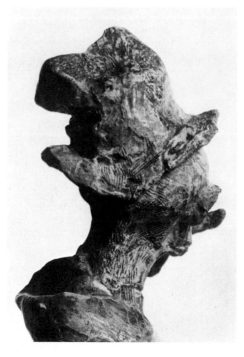

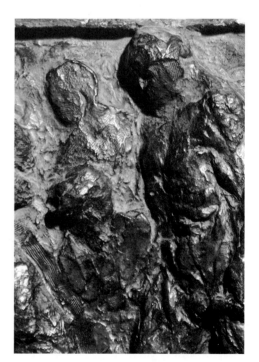

a.

b.

c.

these sculptures, then, conceived as terra cottas (baked clays)? It is very unlikely. The clay in the busts is loosely packed as is demonstrated by the way in which they have cracked and crumbled over the years. If baked, the air pockets in them would surely have caused many to explode. In addition, Daumier finished his busts by painting them; a step which would have prevented them from ever being subjected to high temperatures. The "Ratapoil" with its thin legs, arms and cane would have to have been been modelled over an armature, again preventing the piece from being baked. "Les Emigrants" could perhaps have been fired, but clay shrinks considerably in firing and, with a piece of this scale, the distortion would have been quite disturbing.

"Ratapoil" and "Les Emigrants" are both rather ambitious works. Daumier, perhaps aware that his larger sculptures would quickly fall apart as the clay dried, probably allowed his sculptor friend Victor Geoffroy-Dechaume to make plaster casts of the works (Gobin, pp. 294, 308). Plaster, though still a fragile material, was much more permanent than the drying clay and, under a skilled hand, even the complex "Ratapoil" could be cast without a significant loss in detail.

Plaster Molds and Casts

Around 1850, faced with the difficult task of translating the clay sculpture of "Ratapoil" into plaster, Victor Geoffroy-Dechaume evidently initiated the first of what was to be a long history of the reproduction of Daumier sculpture. I believe the technique he selected was that of waste mold casting. Although in this process the original clay and plaster molds are both destroyed, the resultant plaster positive can be extremely faithful in detail, able to reproduce even the most complicated of undercuts. A careful study of the original plaster reveals the presence of just such small undercut pockets, especially in the areas of the head and coat.

The first step in plaster waste mold casting is to divide the surface of the clay image into several large sections. In soft clay, these divisions are often made with thin metal "fences" pressed in a line, each one slightly overlapping the next, along the high points of a form. In the case of "Ratapoil," at least three sections would have to have been so divided to create three separate mold pieces, which could in turn be separated from the figure without catching on the armature. Despite these major divisions, many small undercut areas, such as those found in the head and folds of the coat, would catch

in the mold during the removal and cause the soft clay to pull away from the armature. To aid in the removal of the mold from the clay original, the divider fences are often pulled out to allow water to be poured between the mold surface and the clay surface. This water further softens the clay, allowing it to loosen its grip on the mold. From this brief description, it should be evident why the original clay image is necessarily destroyed in the mold-making process.

The next step in waste mold casting is that of cleaning the mold. When the caster locates his fences on the clay model, he has this cleaning process in mind. He designs mold sections from which he will be able to wash and brush away fine bits of trapped clay without excessive probing that may damage the mold. Wherever clay is left in the mold, it will, of course, cause a corresponding loss in detail in the plaster cast. Geoffroy-Dechaume's mold picked up not only Daumier's fine tool working but even his finger prints and the delicate textile pattern I have mentioned before.

The clean mold sections are painted with a separator, reassembled, and the positive plaster cast is poured. In the case of the "Ratapoil," Geoffroy-Dechaume must have painted a thin layer of plaster on the inside surfaces of the mold sections before he assembled them. This step allowed him to place reinforcing armature wires inside the mold before closing and filling it. When the plaster has hardened, the mold is broken away from the newly poured cast, hence the name "waste mold." A blunt chisel-like tool is a favorite of sculptors for chipping off this type of mold. After long examination of the surface of the original "Ratapoil" plaster cast, I believe I have found several similar marks on the work that could indeed be left by such a tool.

The strongest evidence for this sculpture having been cast from a waste mold is revealed by a study of the seam lines left on the positive from the joints of the mold sections. The marks indicate that fences divided the clay original roughly into at least three mold sections. The largest section took in the entire back of the figure. The joints ran through the cane, across the base, through the left leg, and over the figure along the left side of the coat. Next, they traveled up the left arm through the head and down the right arm back to the cane. The spaces between the legs and those between the arms and torso would have been closed in with fences. The division which would have created the other two major mold sections ran from the right front corner of the base up the right leg to the head.

To prevent a mold joint from leaving a negative

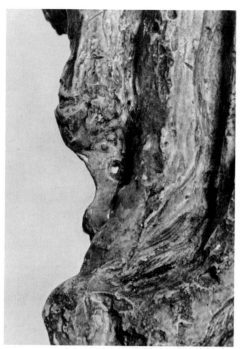

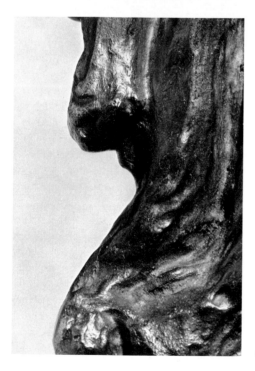

a.

b.

Figure 3. COMPARATIVE DETAILS OF AREA OF MOLD LINE
REMNANT
a. Plaster original, "Ratapoil" (cat. no. 37a)
b. Bronze cast, Rudier edition, "Ratapoil" (cat. no. 37c)

line in a cast, a caster bevels the edges of his mold sections so that they will cast a positive ridge. This burr can then be cut off to surface level in the finishing process. In the hat and many other areas of "Ratapoil," one can see where Geoffroy-Dechaume used a fine rasp to trim off the mold lines. This tool has left characteristic fine scratches that are easily distinguished from the coarser marks left by Daumier's comb modelling tool (see fig. 2b). In one particular area on the left side of "Ratapoil's" coat can be seen a large plaster fin which creates a web between two drapery forms. I believe this thin section is a remnant of the raised mold line that ran along the high points of the form from base to hat. I would theorize that in the mold-making process, two fences spread apart creating a negative space in the mold joint. This space was filled with plaster in the casting process and thus became a new positive form in the drapery. It is interesting to note that this fin-like form has been lost in the 1925 Rudier translation of the plaster into bronze. Comparative study reveals that the design and continuity of the forms associated with the lower part of the coat read quite differently with this small alteration. In the plaster, the sweep of the tail of "Ratapoil's" coat is interrupted by the vertical imposition of the fin. In the bronze, the omission of the piece creates a fluid profile that intensifies the flamboyant attitude of the figure (see fig. 3).

"Les Emigrants," which Daumier is said to have executed in clay, was also cast in plaster by the sculptor Victor Geoffroy-Dechaume (Gobin, p. 308). Assuming the clay was wet, the process for casting would have been the same as that used for the "Ratapoil." The basic relief form of "Les Emigrants" is a much simpler shape to cast. If a waste mold was used, Geoffroy-Dechaume probably would not have had to divide up the original clay with fences for mold sections. There would be no rigid armature to inhibit the removal of the mold. Undercut clay pieces which would be pulled off and remain in the mold could be easily washed out from the open side.

Although we possess Daumier's caricature busts in the original material in which he created them, we may well be closer to the artist and an understanding of his technique in the plaster casts of "Ratapoil" and "Les Emigrants." The unbaked clay busts have undergone steady deterioration from the time they were made early in Daumier's career. Environmental changes in temperature and relative humidity have caused the hydroscopic clay to expand and contract countless times. The unbaked clays, lacking the cohesion and hardness of terra cotta, have cracked and broken up as a result of

these structural movements. Numerous restorations have further altered forms and obscured original detail. Despite all of the criticism that can be justly leveled at reproductive techniques, it should be noted that the familiar bronze casts of the busts have already made a valuable contribution by the very nature of their permanence. A comparative study of the unbaked clays in their present condition, to early photographs of the same works and to the bronze reproductions, suggests the special caution that must be exercised in any critical evaluation of the techniques found in these works. For example, let us look at the caricature bust called Pataille. A photograph taken in 1968 of the unbaked clay original shows the bow-tie of the figure running in a straight diagonal line. All of the bronzes I have seen of the edition begun in the 1930's have the left half of the tie curving down. Both positions are possible, but each one gives Pataille a distinctly different attitude. Which is Daumier's conception?

Gelatine Molds

Sometime between 1927-29, the sculptor Fix-Masseau repaired the busts and made the molds necessary for the bronze casts (Gobin, p. 163). Fix-Masseau was given a very difficult job. The clay busts were dry and cracking, and had large losses, and chipped paint. His problem was to make accurate molds with a minimum of disturbance to the original material. Although the actual techniques he employed are, for me, conjectural, there seem to be such strong probabilities that I find them worth mentioning. Foremost among these is the gelatine mold technique.

If we assume Fix-Masseau's initial task was to restore each bust, we may then conclude that he at least should not have had deep cracks or large losses to contend with in the mold-making process. Although it is impossible to say without first-hand analysis, it is likely that he coated the surfaces of the busts with a shellac-like substance as a kind of initial consolidator and mold separator. If the gelatine mold technique were used, the first step would be to make a plaster retainer mold to hold the liquid gelatine. This could be accomplished by first putting a filler material over the entire surface of the original unbaked clay. The material occupies the space where the gelatine will eventually be poured. A plaster retainer mold is next constructed over the filler. In the case of the caricature busts, this mold would probably be made in two pieces. The retainer mold is separated, the filler material removed, and the

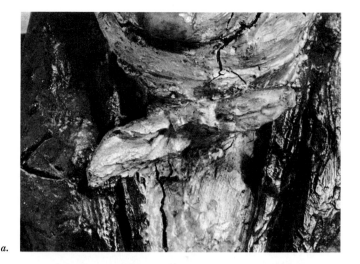

a.

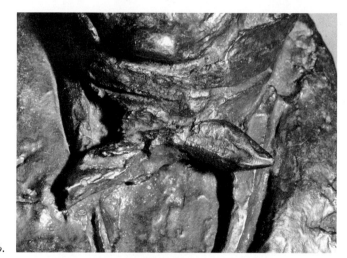

b.

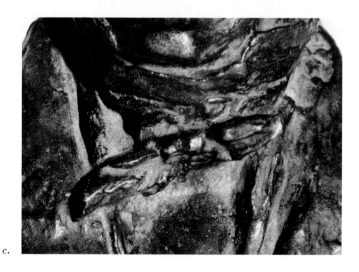

c.

Figure 4. COMPARATIVE VIEWS SHOWING CHANGES OF FORM IN BOW TIE OF CARICATURE BUST
a. *Unbaked clay original, Pataille (cat. no. 25a)*
b. *Bronze cast, Barbedienne edition, Pataille (cat. no. 25b)*
c. *Bronze surmoulage, Pataille (cat. no. 25c)*

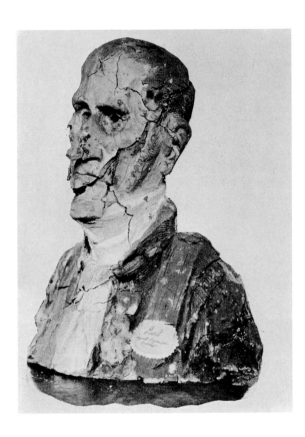

Figure 5. Early photograph showing condition of unbaked clay original caricature bust, Persil (cat. no. 26b)

retainer mold is reassembled over the original bust. The liquid gelatine is poured into the space formerly occupied by the filler. When the gelatine cools and solidifies, the retainer mold is removed. The solid but flexible gelatine negative is cut and gently pulled free of the original. The detail picked up by this type of mold is usually quite complete. Deep undercuts in the original may retain some small bits of the gelatine mold. This minor damage would cause small losses in a positive cast. The new gelatine mold is put back into its retainer mold for support during the casting process. In the case of Fix-Masseau's work, the positive would be one or more plaster casts made directly in the gelatine mold. The cast as well as the retainer mold would then have been given to the foundry for the next reproductive stage. A gelatine mold is fragile and will dry out and shrink in a matter of hours and for this reason it would be discarded.

The only other probable technique which Fix-Masseau might have employed to make plaster positives of the fragile clay busts would have been that of plaster piece mold construction. This type of mold would, however, have two distinct disadvantages as opposed to the use of the gelatine mold. The mold material, plaster, would be stronger than the unbaked clay and would, with its inflexibility, cause damage to the original where it might catch in undercuts during removal. To avoid the risk of this damage, a sculptor could, to some extent, increase the number of pieces in his plaster mold. This, of course, would compound the second disadvantage of this technique, namely, mold lines in the positive plaster cast. The trimming required to remove these lines could significantly alter the surface character of the cast.

The Bronze Casts

Since 1890, there have been some fifty-five bronze casts made of "Ratapoil," at least ten bronzes made of the "first" version of "Les Emigrants," and a total of one thousand fifty-eight bronze casts made of the caricature busts. These figures do not include, of course, the unnumbered trial proofs and "surmoulages" (bronzes made from other bronzes) which also exist. Before one can accurately appraise the merit of these numerous casts, one should be fully aware of the limitations of technique that alter an artist's conception in the reproductive process. Looking first at the broadest implications of translating a modelled sculpture into bronze, I would like to digress for a moment and compare Direct Casting

to Indirect Casting. In essence, the differences between them strongly reflect the extremes of probability for the clear presence of the hand of the artist in a given metallic creation.

Indirect Casting is a method of approach that can employ either the techniques of "sand casting" or those of "lost-wax." Direct Casting usually only includes the lost-wax process. It has been well documented in the literature that the authorized editions of the caricature busts were lost-wax cast. After inspecting a number of bronzes of the busts from both the Barbedienne and Valsuani editions, I found no evidence to indicate that the literature was incorrect. I was also fortunate in having had the opportunity to study in the laboratory one or more bronzes of "Ratapoil" from each of the three authorized editions. Two of these casts were x-rayed at Massachusetts Institute of Technology as part of my study. All of the bronzes examined appeared to be lost-wax cast. Finally, I extended my investigation with a brief analysis of a bronze cast of the "first" version of "Les Emigrants." This work, in the collection of the Fogg Art Museum, was also lost-wax cast. Although one cannot be completely sure that conclusions based on the study of a single bronze of a large edition will hold true for the entire edition, the probability is significant. For this reason I have decided to center the discussion of Direct and Indirect Casting around the lost-wax technique.

Direct Casting

A purist would argue that Direct Casting is the only technique by which an artist can have maximum control in creating a sculpture in cast metal. All of the decisions and craft affecting the final conception are made and performed by the artist himself. Those artists who have employed this technique to its logical extreme have become founders as well as sculptors. Once the artist has worked out a design, perhaps with sketches made in clay or wax, he begins his final model in a material consisting in part of a plaster base mixture. Exact formulas vary greatly but they often include earth clay and fine sand as well as plaster. This part of the model is actually a core to be used later in the bronze casting process. When he has worked up to the equivalent of the inside surface of a hollow bronze cast, he stops and changes to a wax modelling material. The thickness of this wax layer will determine the eventual thickness of the bronze. All of the surface detail essential to the work is given life in the wax. To help the sculptor visualize what this surface will look like in bronze, he may even go so far as to dust the wax with bronze powder.

In preparation for the casting process, the sculptor will attach to the wax image rod-like forms called "vents" and "gates." These attachments will eventually become the openings for pouring in the bronze and allowing air and gases to escape from the mold. Locating the vents and gates can involve rather crucial decisions. When the bronze is cast, these wax forms become a bronze network that must be cut free of the image. In short, they must be placed in such a way so as not only to be functional but also to be removable with a minimum of alteration to surface detail. Equally important, and for the same reasons, are the decisions that will locate the metal pins, "chaplets," that will hold the inside core in position relative to the outer negative mold when the wax is melted out. These chaplets will be left sticking through the bronze cast when the outer mold and core are finally broken away. As with the gates and vents, chasing them off will involve cutting and finishing on the surface of the sculpture.

The final stages of Direct Casting see the wax and its attached network of wax gates and vents covered with a negative mold "investment" material. This investment is similar in composition to the core material with which the sculptor began modelling his final conception. The whole unit, core, wax image, and outer investment mold, are put in an oven and baked until the wax is melted and runs off, hence the name "lost-wax." This baking further dries the core and outer investment mold, preparing them to receive the molten metal. The bronze is poured in the space formerly occupied by the wax and allowed to cool. Next, the investment and core are broken away and the gates and vents (now in bronze) along with the chaplets are cut off. The bronze image is "chased" by the sculptor as he files and polishes off the positive flaws left where the gates, vents, and chaplets have been removed. At this point, he may even work directly in the bronze with a steel chisel or other tools to strengthen detail and make other subtle changes on the surface. Adding the final touch, the sculptor may chemically patinate the surface of his metallic creation to achieve the color and accent that will give the most satisfactory definition to the work.

What I have just described is the creative process by which an artist can produce a unique sculpture in bronze. All of the bronze editions of Daumier's sculpture, however, have been produced by the basic reproductive process called Indirect Casting.

Indirect Casting

The greatest differences between Direct and Indirect Casting are found in the making of the waxes. As we have seen in the Direct method, the wax is essentially the image modelled by the artist. In the case of Indirect Casting, the wax is itself a reproduction made from a mold. The model, from which the negative molds for the waxes are made, can be created in a variety of materials. More permanent materials, such as plaster, allow for more than one mold, wax model, and hence bronze to be produced. In the case of Daumier sculpture, the founders were commissioned to make many copies and therefore needed plaster models. As Gobin has suggested, Victor Geoffroy-Dechaume and Fix-Masseau produced the plasters necessary for the founders to make large bronze editions of the caricature busts, "Ratapoil" and "Les Emigrants." The next problem is to determine the techniques used by the founders to make from these plaster models the over two thousand waxes necessary for the production of the various bronze editions of the sculpture dealt with in this paper. In the process of sifting out the evidence for the probable use of one technique as opposed to another, I became increasingly aware of both the complexity of the problem and the limitations imposed by the unavailability of technical information. For the sake of clarity, I shall deal with one sculpture or sculptural group at a time.

The Waxes

The Caricature Busts

According to an official French document, on March 2, 1965, in the presence of witnesses, the plaster molds and models used for the making of the bronze editions of the thirty-six caricature busts were destroyed. This certified destruction took place at the Valsuani foundry where a second limited edition (three bronzes of each bust) had just been completed. Because I was interested in what types of molds had actually been destroyed, I requested clarification from one of the witnesses present at the event. His answer sheds light on the question of the technique used by the Barbedienne and Valsuani foundries to make the waxes for the bronze casts of the busts. In essence, he said that they destroyed the plaster models (positives) and hollow molds (retainers) used to make gelatine impressions (negatives). As I have previously mentioned, if the sculptor Fix-Masseau used the gelatine mold tech-

nique to make plaster models of the caricature busts from the original unbaked clays, he might have provided the Barbedienne foundry with the plaster retainer molds as well as the plaster models. The founder's job would then have been to assemble a retainer mold over a plaster model and pour a new gelatine negative. When the gelatine had solidified, the retainer would have been removed and the gelatine carefully cut and separated from the plaster model. Finally, the new gelatine mold would have been put back into its plaster retainer for support, while the first wax positive was made.

The greatest problem with a gelatine mold when it is used to make waxes is its short life. Fragile gelatine molds can only be used a few times to make wax models. The hot wax disturbs the gelatine, causing it to dry out and lose its shape. The caricature busts were hollow cast with a fairly even thickness of bronze. This would mean that the wax positives were built up to the desired thickness with painted layers. Because of the small size of the busts, an alternative technique for applying the wax, could have been used. In this technique, the gelatine mold would be inverted and a quantity of liquid wax poured into the head area. The mold would then be rolled back and forth, allowing all inside surfaces of the mold to be evenly coated as the wax cooled and solidified. Continuing with a general description of the making of wax positives, when the wax has cooled to room temperature, the molds are removed. First, the plaster retainer mold is separated from the gelatine negative and then the gelatine is pulled free of the new positive. At this point, the wax can be reworked to repair any damage caused by the removal of the gelatine mold or to disguise any lines left by the mold joints. If the artist, whose work is being cast, performs the reworking in the wax himself, there is a good chance that the finished product will have uniform handling. Daumier died long before any of his sculpture was cast in bronze. All of the reworking of the waxes made for the bronze editions of Daumier's sculpture has been performed by other artists or by foundry technicians. This fact, second only to the considerable changes effected on the works by numerous restorations, should indicate the problem of making any serious analysis of Daumier's handling by looking only at the bronze casts. Again, the caricature bust of Pataille well illustrates this point. A mold line, probably left in the wax by a gelatine negative, has been cast into at least two bronzes of a numbered edition. What is interesting is that one or more foundry technicians have reworked the waxes in different ways. In one cast of Pataille, the mold line is

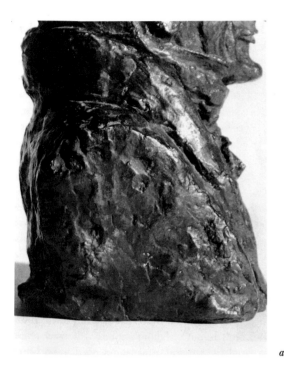

a.

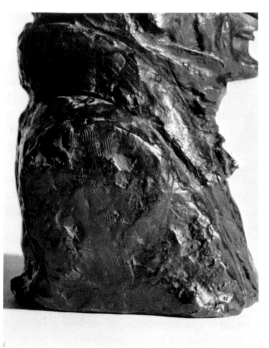

b.

Figure 6. COMPARATIVE VIEWS SHOWING VARIATION OF SURFACE DETAIL IN TWO CASTS FROM THE SAME EDITION
a. Bronze cast, Barbedienne edition, Pataille (cat. no. 25b)
b. Bronze cast, Barbedienne edition, Pataille (not in catalogue)

disguised with smooth cutting strokes and in the other a comb tool has been used to rake over the joint area (see fig. 6).

"Ratapoil"

Unlike the plaster models for the busts, the plaster casts of "Ratapoil" and "Les Emigrants" were probably not originally conceived as founder's models. They seem to have been made many years before Siot-Decauville began casting bronze editions. In any case, it is highly unlikely that a founder would use an original plaster cast as a working model. He would be more apt to use one or more plaster foundry models made from a carefully executed gelatine mold of the original. These copy plasters would, in turn, be used to make gelatines for wax positives.

The whole question of founder's models is complicated by the appearance of a second plaster cast of "Ratapoil" during the 20th century. This second plaster (now in Milan, Italy) was apparently cast from a piece mold made from the original plaster, belonging to the Albright-Knox Art Gallery. Numerous piece mold lines crisscross the surface of the second plaster. Although materials such as wax or gelatine could have been used to construct this piece mold, there is evidence on the surface of the original cast that indicates the material used was plaster. On top of the shellacked surface in small undercut areas of the original plaster, I have found a white material which has been chemically identified as calcium sulfate (gypsum plaster). Although I will admit that some of this plaster could have been lodged in these undercuts during past repairs or remounting, the general distribution of these plaster bits would rather suggest mold fragments. The reason for the making of this second plaster is somewhat a mystery. What is definitely known is that this second plaster was used by the Valsuani foundry in 1959 to make a third bronze edition of "Ratapoil."

Through a comparative analysis of certain detailed areas in the figure, as can be seen in each of the two plasters and several of the bronzes of each of the three editions, I have reached some conclusions about the date of the casting of the second plaster. First, in the 1890 bronze cast, there is a finger-like form on the center of the glove which "Ratapoil" has hanging from the middle right side of his jacket. This finger-like form is now broken off in the original plaster and was apparently broken off before the casting of the 1925 Rudier bronze edition. Although the corner of the hanging glove is

divisions for a gelatine negative of "Ratapoil" would undoubtedly fall at the same places where Geoffroy-Dechaume divided up Daumier's clay for the waste mold. The color variance, in reality the degree of shellac disturbance in a given section, could be indicative of the length of time a damp gelatine mold section remained against the surface of the plaster. The front face of the figure shows the thinnest concentration of shellac. Because of the delicacy of the front forms, especially in the head area, it would not be surprising that this were the last section to be removed.

Although I have explained how plaster retainer molds and gelatine molds are made for simple forms like the caricature busts, it will take a more detailed review to clarify the techniques used to produce these molds for "Ratapoil."

Only through the consistent high quality of the molds can a founder produce accurate wax positives for bronze casting. It should be remembered that distortions or poor registration in a mold will mean that reworking will be necessary in a wax positive. In order to produce a gelatine mold of a consistent thickness where no one area will dry out and shrink more rapidly than another, some care has to be taken in constructing the plaster retainer mold. First, the filler material that will occupy the space where the gelatine will eventually be poured, must be plastic enough to be applied evenly over the plaster model. Soft clay is often used as this filler. Once the plaster model has been covered with the clay filler, metal or clay fences can be used to divide off retainer mold sections. "Keys" of corresponding negative and positive shapes are constructed in the fences where one section joins another. These keys give the edges of the plaster retainer mold pieces interlocking shapes that register the pieces with one another for reassembling. The same principle can be used to see that the flexible gelatine negative registers within its plaster retainer. In the case of the figure of "Ratapoil," the plaster retainer, like its original plaster waste mold, would have been made in at least three pieces. With all of the pieces constructed, the retainer mold is separated from the clay filler material. The filler, in turn, is now removed from the model and any deposits of clay left in undercuts of the plaster are cleaned away. The retainer is reassembled over the model and the gelatine is poured.

The making of a wax of "Ratapoil" in a gelatine mold would be complicated by the need for a core inside the wax positive. This core would prevent warpage and fracture resulting from shrinkage in the bronze as it cooled. To help explore the techniques for making this complex inclusion in the wax, I had an x-ray taken of one of the bronzes of "Ratapoil" from the Siot-Decauville edition. The x-ray allowed us to estimate the thickness of the bronze, to see the extent of the core, and to ascertain the shape, number, and location of internal metal supports. Further tests with a magnet on the surface of the bronze confirmed a suspicion that the internal supports were made of iron and located their intersection with the surface of the bronze.

The metal supports inside this cast take two forms: thin tubes and wires. Generally, these forms appear to have functioned both as core armatures and as chaplets. In addition, the tubes may have served as core vents. Before being cut off in the chasing process, the irons suspended the core inside the investment mold. One tube ran through the top of "Ratapoil's" head, down through his body, inside his left leg, and out into the investment of the hollow base. Another tube started in the center of the core at his waist, traveled down inside his right leg and out through the base. A wire rod ran perpendicular to the tubes across the widest part of the tail of his coat. One final wire rod ran from the center of the core at his chest, up to his left shoulder and down inside his left arm, emerging at the wrist where it tied into the investment mold. If it were not for the fact that these iron supports were carefully bent to the contours of the figure, one might suppose that they were pressed through the hollow wax image after it was cast. The care taken in their placement suggests that they were located while the mold was still open. Furthermore, the core occupies a much larger area than one might expect. Not only is it found in the head and torso of the figure, but also in the legs and left arm. Suggestions for possible techniques for the making of this complex core will be covered in the next section of this paper. Let us assume, for the moment, that this core has been separately made to fit inside a gelatine mold. The iron supports seen in the x-ray stick out of the core and register the unit in the mold in such a way that there is a uniform space between the two. This is the space where the wax is poured to make the positive. Finally, the gelatine mold sections are removed from the cored wax image and any mold lines or damages are tooled out.

Although further study of a bronze cast from the 1925 Rudier edition of "Ratapoil" has indicated that some reworking was performed on the waxes for this group, several areas that could have been reworked have been left untouched. First, mold lines (suggesting the broad sections of a gelatine mold) are present on the inside surfaces of the arms and

legs. Second, and more significant as surface alteration, is a change of form in the area where "Ratapoil's" cane is attached to the base of the sculpture. In the early Siot-Decauville edition, the connection is that of a simple rod form intersecting a plane. In the Rudier edition, the rod flares out at the point of intersection, as a tree trunk might where it meets the ground. The original plaster shows signs of an old break at the base of the cane. I would theorize that this break occurred after Siot-Decauville began the edition in 1890. Thirty-five years later, the founders at Rudier had to repair it or at least deal with a repaired break. The solution appears to have been that the area was reinforced with plaster or wax. The added material changed the profile of the joint. The gelatine molds picked up the alteration and caused it to be cast into the waxes. A correction was not made in the wax positives and thus the bronzes possess this inaccuracy (see fig. 9).

"Les Emigrants"

Only one bronze edition of the "first" version of "Les Emigrants" has been mentioned in the literature on Daumier sculpture. This edition, numbering about ten bronzes, was produced by the Rudier foundry about 1960. The making of the waxes for this group of bronzes should not have been a complicated procedure, at least in comparison to those of "Ratapoil." The greatest problem would be the undercuts created by the high relief of the figures. It seems likely that this problem was solved by the use of a flexible gelatine or latex rubber mold. The retainer for these molds would be a simple one-piece box-like form. The wax positives would be made in the flexible molds by painting hot liquid wax in layers to a final depth of approximately ⅛ of an inch. As there would have been no mold lines to chase off, reworking in the waxes would be minimal.

The Cores

Once the wax positives have been made, the next stages in the Indirect Casting process are quite similar to those of Direct Casting. In fact, the only major difference concerns the construction of the core. We have seen that in the Direct method the core was made first and the wax was modelled over it. Although with the Indirect method a core may be made first and a wax positive cast over it, usually the wax comes first and the core is added later.

I have described how the wax positives of the

a.

b.

Figure 9. COMPARATIVE VIEWS SHOWING PROFILE CHANGE OF CANE IN TWO BRONZE EDITIONS OF "RATAPOIL"
a. Bronze cast, Siot-Decauville edition (cat. no. 37b)
b. Bronze cast, Rudier edition (cat. no. 37c)

21

busts would be hollow because the hot liquid wax was painted or rolled in the molds. Any necessary chaplets could be placed in these positives by simply sticking the metal pins through the soft wax and allowing the ends to protrude. A core would then be made by filling the hollow cavity of the wax with core material. In the same manner, a core-like structure could be made in the hollow base of "Ratapoil" and in the inside of the "first" version of "Les Emigrants" by filling these areas with investment material. The making of a core for the figure section of "Ratapoil" is another problem. As I suggested before, it was probably constructed before the wax was cast. This conclusion was based on examination of the x-ray of the Siot-Decauville bronze. In order to see if a Rudier bronze of "Ratapoil" was similarly constructed, I had x-rays made of a cast from this later edition. The core areas of the two bronzes proved to be strikingly similar. The only significant differences were that the Rudier bronze had a few more iron tubes and wires and a slightly more complete core. How then were these cores made? Although the following suggestions will again be conjectural, they are intended to give the reader further understanding of the technical complexity of bronze casting.

A precise core of the type needed to make a consistently thin cast of "Ratapoil" could itself have had a model. It should be remembered that twenty or more cores would be needed for each of these first two editions. This model could begin as a plaster positive made from a gelatine mold. The mold would, in turn, be produced in the same manner as later gelatine molds for the wax positives. The plaster model would then be carved and shaped to the dimensions of the eventual core. Areas like the cane, mustache, and coat tail, which would be solid cast in the bronze, would be cut off of the model. In fact, the entire base would be removed since it is cored separately. The carver would thin arms, legs, torso and head by the exact dimension of the desired thickness of the eventual bronze. A separator would be painted on the core model and a simple two or three piece plaster mold would be constructed over its surface. Once the mold was made, the core model would no longer be needed. Notches would be cut in the new piece mold for registering the reinforcing tubes and wires that must pass through the center areas of the core form. Finally, with irons in place, the core material would be poured and packed into the mold. With all of the cores uniformly manufactured in this way for a given edition, the founder could then bake them before starting to cast the wax positives over these core inclusions.

Finishing

The final stages of the Indirect Casting process are identical to those of Direct. Wax gates and vents are attached to the wax positive and the whole unit is covered with an investment mold. Baking melts out the wax and dries the core and investment. The bronze is poured in the space formerly occupied by the wax.

The bronze cast that emerges, as the investment is broken away, looks very little like the image to which we are accustomed. The color of the cast is a bright metallic yellow. The network of gates and vents formerly in wax is now in bronze. These must be cut away, as well as any iron or bronze chaplets left protruding from the surface of the bronze. It is now up to the founder to plug, file, and chase out any flaws left on the cast. If it is felt necessary, he can strengthen detail on the bronze by filing, incising, and chiselling with steel tools. An example of this sort of metal re-working can be seen in the Rudier cast of "Ratapoil" (see fig. 8c). The mustache and beard of the bronze have been incised with lines to suggest hairs. Chatter marks within these lines indicate the characteristic resistance pattern of one metal cutting another. Finally, the founder must chemically patinate the bright metal to change its color to a tone that will best define Daumier's modelling. The arbitrariness of this final technique, often a treasured foundry secret, is well illustrated by a brief comparison of a bronze from each of the three editions of "Ratapoil." The Siot-Decauville example has a heavy patina of a dark greenish-brown color. The Rudier bronze has a light patina of a warm brown color, and last, the Valsuani casts are black.

Other Techniques

In order that the reader may have a broader understanding of the techniques employed to cast in various materials both the sculptures discussed in this paper and other work attributed to Daumier, I shall attempt to clarify areas of frequent misunderstanding.

Sand Casting

At least one bronze edition of the "second" version of "Les Emigrants" appears to be sand cast. In the course of my examination of various bronzes of the caricature busts, I had the opportunity to see an

apparent surmoulage of Pataille. This bronze, which would have used one of the Barbedienne bronzes as a model, also exhibited some of the characteristics of a sand cast.

Briefly, in the sand casting technique, the mold made from the model is the same mold into which the bronze is cast. No wax need be involved. A model, often plaster, serves as a positive from which a founder makes a piece mold composed mainly of a fine grained sand. The moist sand mixture is pressed against the model. Large composite mold sections are layered and enclosed by iron frames called "flasks." When the piece mold is complete, it is disassembled, the model removed, and the mold reassembled. If the bronze is to be hollow, a sand core is fashioned by hand and suspended with wires or chaplets inside the mold. The space between the inner surface of the mold and the outer surface of the core determines the eventual thickness of the bronze. Gates and vents are made by cutting channels in the sand mold at layer joints. Like the investment of a lost-wax cast, the assembled mold of a sand cast is baked before the molten bronze is poured.

Sand casting has two distinct disadvantages as compared to lost-wax casting. First, the piece mold lines of a sand cast appear on the surface of the bronze. Second, oddly shaped sculptures with numerous undercuts cannot be successfully cast by the sand process without considerable loss of detail. In fact, the detail reproduced in a sand cast is generally inferior to that of a lost-wax cast.

Surmoulage

Gobin mentions (p. 164) the existence of surmoulages (bronzes that use other bronzes as models) of some of the caricature busts. The Pataille is among these. He describes the marking on these unauthorized casts as an "H D." A cast of Pataille which I studied in the laboratory had this marking (see fig. 10). A comparative analysis of this work with two bronzes of Pataille of the Barbedienne edition gave even more conclusive proof. Detail was diminished in the surmoulage. While heavier in weight by some 294 grams, the surmoulage was generally .2 cm. smaller than one of the authorized bronzes. The small size was to be expected since molds shrink in baking and bronze shrinks considerably in cooling. If the molds for the two bronzes had been made from the same model, the bronzes would have been the same size. Explaining the increase in weight of the surmoulage was a little more difficult. Obviously it meant that the bronze was

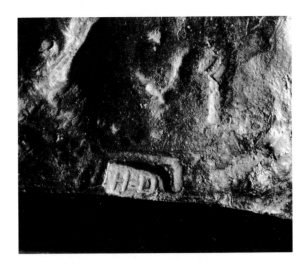

Figure 10. Marking on bronze surmoulage of caricature bust, Pataille (cat. no. 25c)

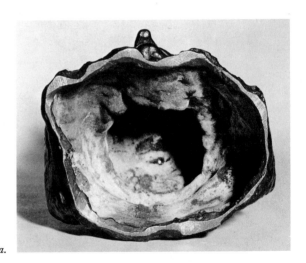

a.

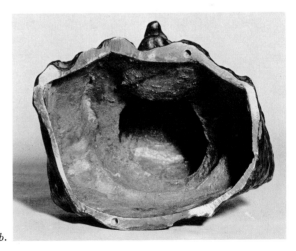

b.

Figure 11. COMPARATIVE VIEWS OF THE INTERIORS OF TWO BRONZE CASTS SHOWING DIFFERENT CORE IMPRESSIONS
a. Barbedienne edition, Pataille (not in catalogue)
b. Surmoulage, Pataille (cat. no. 25c)

thicker, but the question became: what casting technique made it thicker? A comparison of the appearance of the hollow interiors of the three bronzes suggested an answer. The core for the surmoulage left an impression that indicated it was shaped in a rough geometric fashion. The core impression of the Barbedienne bronzes exhibited a consistent fluid quality. This smoothness would be a reflection more of the inner surface of the wax positives used to make these bronzes than of the outer surface of the cores which were added later. If we remember that in a sand cast the core is fashioned by hand to fit inside the sand mold, then we also have a possible explanation for the geometric shape of the core of the surmoulage (see fig. 11).

Earlier in this paper, under the heading Plaster Molds and Casts, I posed the question as to what form and direction Daumier modelled the bow tie on the bust called Pataille. The design of this tie area as seen in the surmoulage of the bust adds a new dimension to the whole question of reproduction accuracy (see fig. 4c). Contrary to what one would expect, the tie in the surmoulage is more like the tie in the restored original unbaked clay than it is like the ties of its Barbedienne counterparts. While there are no good explanations for the similarities in the ties between the surmoulage and the clay, there are a number of possible explanations for the differences between the Pataille of the Barbedienne edition and the surmoulage. First, there is a chance that the exact Barbedienne bronze used as the model was a miscast with the tie bent or missing in part. It should be remembered that the complete edition of Pataille included thirty bronze casts. With an edition of this size, there would be produced a certain number of trial proofs and miscasts. Second, the undercuts associated with the tie area are the most difficult to reproduce in a sand cast. Assuming a sand mold was used to make the surmoulage, it would not be improbable that mold damage would occur in this fragile area.

Although we have defined the term surmoulage as it applies to the making of bronze casts from a bronze model, a broader definition can be inferred from the processes involved. The issue is often confused by the factors of authorization and intent. A case in point grew out of an investigation of a plaster cast of "Ratapoil" belonging to the Musée des Beaux Arts in Marseilles. Photographs revealed the presence of the Siot-Decauville foundry stamp on the plaster. Detail in the plaster cast proved to be equal to or poorer than that found in the bronzes of the Siot-Decauville edition. These facts strongly suggested that a bronze of the Siot-Decauville edition was used as a model to make this plaster. The only other possibility, a wax foundry positive as a model, can be dismissed when it is realized that the Siot-Decauville foundry stamp is a metallic disc added to the bronzes after casting (see fig. 14b).

For all intents and purposes then, the Marseilles plaster "Ratapoil" would appear to be a surmoulage.

Terra Cotta

A group of sculptural works attributed to Daumier and included elsewhere in this catalogue are fashioned in terra cotta. The term "terra cotta" simply means baked earth or clay. In theory then, the unbaked clay material of the caricature busts and a few other attributed works is the same basic substance found in the terra cottas. In fact, an edition of reproduction caricature busts has been produced in terra cotta (see cat. no. 1d). The models and molds used for this edition are said to be the same ones that were used for the Barbedienne and Valsuani bronze editions. A size comparison between the original unbaked clay busts and the baked clay reproductions shows the latter to be considerably smaller. The reason is that clay shrinks when baked. In addition, it should be noted that even if not baked, these clay reproductions would be smaller than the originals since clay initially shrinks when it is air dried at room temperature.

Synthetic Materials

Two commercial companies are marketing reproductions of a few works attributed to Daumier. The editions associated with these reproductions are limited in number only by the principle of supply and demand. The most recent reproductions to appear are of "Le Monsieur Qui Ricane" (cat. no. 55). These are made by Sculpture Collectors Limited and are advertised as being "hand cast" in a material referred to as "Foundry-Stone." The other commercial reproductions are made by Alva Museum Replicas, Inc. These casts reproduce "Ratapoil" and four of the caricature busts. Both companies have used bronze casts as their models. The numbered bronze cast of "Ratapoil" (cat. no. 37b) used for the Alva series was one of the casts which I studied in the laboratory. Comparative measurements of size made between an Alva replica of "Ratapoil" and its bronze model revealed that the replica was slightly larger.

Almost all of the molding and casting materials which I have discussed thus far shrink as they dry

or cool. Reproductionists today have available versatile new materials for making molds and casts. These synthetics use catalysts to initiate the change from a liquid to a solid state. For example, molds of silicon rubber translate the minutest detail without shrinkage. These molds are strong yet flexible and remain stable for indefinite periods of time. With such modern materials available, it is not surprising that the Alva "Ratapoil," made of a plaster-like synthetic, is close in dimension to its bronze model. The increase in size in the replica can be explained by the fact that the synthetic cast has been heavily coated with bronze-like paint as an imitation of the patina of its bronze model.

Markings

One of the greatest areas of confusion in regard to Daumier sculpture concerns signatures and foundry stamps. Markings, that can be seen on both attributed original works and reproduction casts, have been made in a variety of ways and in a number of materials. In an attempt to clarify the various techniques employed in making signatures and stamps on sculpture, I shall outline the possibilities for each of the materials in which we find Daumier sculpture.

Clay

A signature is usually made in a clay sculpture while the clay is still wet and soft. The pointed end of a modelling tool or a pencil-like implement is used to make an impression. Although none of the caricature busts have signatures, other attributed clay works, both baked or unbaked, have either "h D" or the name "DAUMIER" inscribed on them. It should be noted that it is possible to add a signature to an unbaked clay sculpture after it has dried. This can be done in two ways. First, a signature can be incised in dry clay with a sharp tool. Second, dry clay can be carefully resoftened with moisture in the area where a signature is desired and then an impression made in the normal fashion. Once clay has been baked, it is much more difficult to make a mark or signature on it. In fact, it can only be done by incising or scratching with a hardened steel tool. The appearance of marks made in this way are necessarily very different from those made in wet clay before it is fired (see fig. 12).

Plaster

A signature can be made in a "direct plaster" (a sculpture modelled directly in wet plaster) while the material is still soft. The soft wet surface of a plaster cast, however, is inaccessible as the cast dries and hardens inside a mold. Incising with a sharp tool is the usual way of marking a dried plaster. There are no markings apparent on the original plaster casts of "Ratapoil" and the "first" version of "Les Emigrants."

Wax

Most of the bronze casts of Daumier sculpture have some kind of marking. In many cases these stamps and signatures are obviously cast rather than incised in the metal. Where it is unlikely that plaster founder's models possessed these markings, it would be safe to assume that the impressions were made on the wax positives used to cast the bronzes. Wax is a material in which it is easy to make a clear impression. As examples, I have chosen the markings found on a Valsuani bronze cast of the caricature bust, Podenas. The Valsuani foundry stamp, which includes the words *"Cire Perdue"* (lost-wax), has been pressed into the wax positive used for this cast. The words, "Mme H," to the right of the stamp has been written with a pointed tool leaving an impression in the wax (see fig. 13a). Also on this cast is the

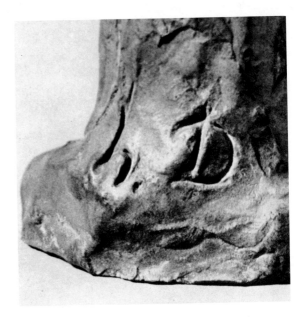

Figure 12. Detail showing signature "h D" impressed in clay before baking, terra-cotta figurine "Le Bourgeois Qui Flâne" (cat. no. 50a)

a.

b.

Figure 13. Details showing various impressions made in wax positive and cast in bronze caricature bust, Podenas, Valsuani edition (cat. no. 27d)

M L G stamp (Maurice Le Garrec) which designates the authorization of the owner of the original unbaked clays for both bronze editions. This stamp has been impressed on a lump of wax which, in turn, was first pressed against the surface of the wax positive. I believe this lump in the Valsuani edition, although not found in the Barbedienne edition, was intended to suggest that the stamp was not part of Daumier's original clay (see fig. 13b).

The bronzes of the Rudier editions of "Ratapoil" and the "first" version of "Les Emigrants" are signed "H. Daumier." Although I do not exclude the possibility that these signatures were incised by the founder in plaster foundry models, it seems more likely that the waxes were marked each time before being invested.

Bronzes

Incising of signatures on bronzes can be performed as part of the chasing process. Determining which marks have been incised and which have been cast is complicated by the possibility that poorly cast signatures can be reinforced by incising. The signature, "DAUMIER," written on the base of the bronzes of the Siot-Decauville edition of "Ratapoil" is such a case. Without further comparative study and metallographic analysis, it is difficult to determine how this signature was added. What is clear, however, is that the founder's stamp on this edition was added after the bronzes were cast. This circular seal is an insert much like a coin. It appears that each bronze cast was machined to receive this precast or stamped seal, which was then hammered into place.

Most of the bronze editions of Daumier's sculpture have been numbered. Each bronze of a particular edition was given a number to designate its position relative to the order of manufacture. On the Siot-Decauville edition of "Ratapoil" these numbers are stamped into the bronze with a metal punch. The numbers for the bronzes of the Barbedienne editions of the caricature busts appear inside the casts. Two numbers, separated by an incised slash, are found inside an incised circle. The bottom number designates the total number of bronzes in the edition and the top one designates when the particular bronze was made relative to the other casts of the edition. Again, the numbers were made by punching with a hard metal tool (see fig. 14b). The exact number of bronzes, even in a numbered edition, is often greatly confused by the appearance of unnumbered trial proofs. When these trial proofs are

marked, they are usually punched with the initials "E.E." (*Epreuve Essai*) (see fig. 14c). Casts marked "0" may also be founder's trial proofs. The initials "H.C." (*Hors Commerce*) on a bronze mean it was not intended for sale.

Conclusions

What significant information concerning Daumier the sculptor has been learned to date from our comparative studies both inside and outside the laboratory? The first and most important observation that can be drawn from comparative examinations is that the works that bring us closest to the hand of Daumier are those that were cast or conceived in stable materials during the lifetime of the artist. Foremost among these are the original plaster casts of "Ratapoil" and the "first" version of "Les Emigrants." Next, we have become aware of the special problem in seeking detailed stylistic evidence from the heavily restored caricature busts. Finally, we have begun to develop criteria for critical evaluation of the bronze reproductions, now numbering in the thousands, which have been produced since the death of Daumier. Above all, we have learned that we must constantly bear in mind the overshadowing fact that reproductive techniques lead to inevitable alterations of the artist's original conception.

ARTHUR BEALE

FURTHER READING

Hoffman, Malvina, *Sculpture Inside and Out*, New York: W. W. Norton and Company, 1939

Le Garrec, Berthe, "Les Bronzes des Parliamentaires," Daumier issue, *Arts et Livres de Provence*, No. 8, 1948, 101-102

Rich, Jack C., *The Materials and Methods of Sculpture*, New York: Oxford University Press, 1947

a.

b.

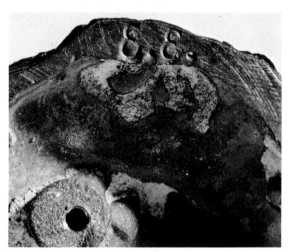

c.

Figure 14. DETAILS SHOWING VARIOUS MARKINGS ON BRONZE CASTS
a. Inset founder's stamp in Siot-Decauville edition of "Ratapoil" (cat. no. 37b)
b. Numbering inside caricature bust of Podenas (not in catalogue)
c. Trial proof marks on bottom of figurine "Le Lecteur" (not in catalogue)

Introduction to the Busts

If no sculpture by Daumier had survived but the busts of the parliamentarians, Daumier would still have to be considered a major sculptor. Fortunately more than thirty do survive, in a French private collection. They remain as one group, having changed hands only twice. In the 1830's, Daumier left them with his editor Charles Philipon. The Philipon family kept them in two glass cases until 1927 when they were sold to Maurice Le Garrec. Madame Berthe Le Garrec, the widow of Maurice, still owns them. These busts are the only clays in existence today in the form in which Daumier modelled them. A limited edition of bronze casts was made from them about one hundred years after they were created. A group of terra-cotta reproductions is now in progress.

Unlike most of Daumier's sculpture, the busts have a long history. It begins with Philipon's announcement of them made in *La Caricature* in 1832. The busts were discussed during Daumier's lifetime. Some were then exhibited, and most, if not all, were photographed. We do not know the exact number of original busts but there may have been as many as forty-five. Today there are thirty-six. These little heads, made of unbaked potter's clay, were probably not expected to survive. As early as 1865 their fragile condition had disturbed their owner. It was too hazardous for the Fogg to borrow all thirty-six busts for this exhibition. We consider that we are extremely fortunate to have four clays, thanks to the generosity of Madame Le Garrec.

The busts, the standing figure "Ratapoil" and the bas-relief "Refugees" are the only sculptures incontrovertibly by Daumier. They were discussed in his lifetime. Of the three categories the busts have the most reliable history, yet even their history is not as clear as might be supposed. The exact number of busts surviving to this century, for example, is not precisely recorded. In this Introduction we will discuss the busts as a group. The chronological history of the group follows this introduction. Information relevant to each individual bust will be found under the catalogue entry for that bust.

Genesis of the Busts

The genesis of the busts was sparked by the political situation of the time. Daumier was an active young Republican living under a monarchy recently returned to power, the so-called July Monarchy of Louis Philippe. Anti-government literature pilloried Louis and his cabinet. Among the most vociferous voices were *La Caricature* and *Charivari*, the politically-slanted satirical newspapers created and edited by Charles Philipon (1800-1862). Philipon considered the Monarchy an unjust and illegal government inflicted upon the Republicans. He regarded Louis as a man of bourgeois mentality who surrounded himself with businessmen and idlers lacking in ability to govern wisely. Philipon wrote most of the text of his two papers himself, but although it was he who invented the device of the Pear to symbolize Louis Philippe, he generally hired as illustrators artists with Republican sentiments similar to his own. These included Grandville, Monnier, Devéria, Johannot, Charlet, Raffet, etc. The new, inexpensive process of lithography made such illustrations possible. Philipon's attention was caught by several satirical lithographs made by Daumier. The young artist was soon put on the staff of *La Caricature*. His first lithograph to appear there, in March, 1832, was "Masks of 1831" (see cat. no. A). Soon after, on April 26, 1832, Philipon announced his intention of presenting a series of portraits of the eminent men surrounding Louis, the *Celebrity* series. Honoré Daumier was to be the artist. The full text which appeared with the first portrait, Lameth, reads as follows:

> *La Caricature*. . . . promised a gallery of portraits of the celebrities of the Juste-Milieu, whose likenesses, conscientiously studied, would possess that energetic character, that burlesque trait, known as a *charge*. Being used to finding all possible means of success for its publications, *La Caricature* deferred the realization of this project for some time so that it could have each personage modelled *en maquette*. These drawings were exe-

cuted after these modellings of clay . . .

Though opinion varies, it is generally concluded that it was Philipon who suggested to Daumier that he make first a group of sculpted busts of his intended victims.

The process of having the lithographer make a series of sculptures was unusual. If indeed the sculpture was Philipon's idea, it is possible that he was hoping to find another Dantan (1800-1869), for that artist's small humorous figurines and busts of contemporary celebrities had been enormously popular in Paris since 1829. It is possible, however, that Daumier thought of making the satirical sculptures himself. He was at the time a close friend of the sculptors Antoine-Augustin Préault (1810-1879) and Michel Pascal (1810-1882), friends who may have influenced him. Young Daumier was still learning. He might well have been curious to try modelling clay as his friends were doing.

Dating

Precisely when Daumier made these busts is uncertain, though most agree it was sometime between 1830 and 1835. The starting date of 1830 has not been put forth too convincingly. Champfleury (1821-1889), a political satirist himself and later well acquainted with Daumier, whose witness to the existence of the busts is valuable, wrote that "from 1832-35 Daumier unceasingly redid the same political personalities." This statement, however, includes the lithographs (see *Histoire Caricature*, 1865, p. 47). Klossowski mentions the date 1832, but he also discusses both clays and lithographs (1923, p. 36). The next author to attempt to date the busts was Fuchs who in 1927 mentioned 1830-34 although he gave no reasons (p. 24), and even changed the suggested date to 1832 under the illustrations (p. 52). Barr tentatively suggested 1830-32 (MOMA, 1930, p. 17). The Albertina Daumier catalogue stayed with 1832 (1936, p. 16). The first author to discuss the personages of the thirty-six busts, Charles Mourre, in 1948, decided all were done just after Daumier was released from six months in prison, which he thought was January of 1833 (in *Arts et Livres*, p. 97). His reasoning is not illogical. Daumier was sent to prison as a political troublemaker after making a rather crude lithograph of King Louis Philippe. Mourre's conclusion implies that Daumier (and Philipon) were inspired to make the busts and lithographs in revenge. (The date of Daumier's release was corrected to early February, 1833, by Adhémar in 1954, pp. 18-19.) Gobin chose 1830-32 as the dates for the busts (1952, pp. 11, 25, 163).

Gobin's thesis was that Daumier had made sculpture since childhood, but dated his "true beginning as a painter and sculptor" from about 1828, saying that he then began dropping in at the Académie Boudin where he met the sculptor Préault. If Daumier began the clay busts in 1830 and did not meet Philipon until 1831, as Gobin says (p. 12), this would then imply that Daumier conceived and began the busts of his own accord. Given their political nature, and Philipon's announcement, this hardly seems likely. In 1952 Konrad Kaiser wrote an exhibition catalogue for the Deutsche Akademie der Künste in Berlin in which he identified and described the thirty-six bronze busts that the Academy had acquired in 1951. He felt that the clay originals were begun in March-April 1832, just before Philipon's announcement (Deutsche Akademie, Berlin, p. 10). Adhémar, whose study of Daumier tends to be more reasoned than Gobin's perhaps over-enthusiastic work, decided that the busts were done between January and April, 1832, at Philipon's request (Bibliothèque Nationale, 1958, p. xxii). Finally, the most thorough and entertaining study of the busts to date was that made by Dario Durbé in 1961. Durbé's work included not only a stylistic analysis of the busts, but also a detailed study of the historical personage each represents, including his role in the July Monarchy and his appearance in the press as an object of news and of satire. Durbé placed the busts in two groups, one just before Philipon's announcement (mostly the smaller ones), the other in 1833, after Daumier's release from prison. He dates one bust, Montlosier, about 1835 (Museo Poldi Pezzoli, pp. xv-xx). Durbé's dates, as well as some of the historical material he found for each bust will be noted in the individual entries. This catalogue will not attempt to date the busts exactly, but will agree with Kaiser, Adhémar and Durbé that the bulk of them were certainly made with *La Caricature* in mind, beginning not before 1832.

Medium

To date, no published laboratory analysis of the busts exists. The announcement in *La Caricature* had stated that each personage had been modelled "en maquette" (that is, small, rough models), and referred to "ces moules de terre" (clay modellings, or casts). Champfleury, who gives us both useful and erroneous information, is apparently the earliest source to say that the busts were "colored by the master" (*Histoire Caricature*, pp. 33-34), a statement which Duranty, a well-known critic, reiterated

in an 1878 article on Daumier (*Gazette des Beaux-Arts*, II, p. 532). In his catalogue of Daumier's work, also 1878, Champfleury caused confusion by misquoting the announcement in *La Caricature*, changing "moules de terre" to "terre cuites," or terra cotta (p. 18). But Arsène Alexandre (1859-1937), Daumier's first biographer, talked to Daumier's widow and friends, and sorted through available material. He carefully corrected Champfleury's remark that Daumier modelled the busts right in the Chamber of Deputies, and also emphasized that the busts unfortunately were not terra cotta but "terre glaise" (that is, not fired clay, but simply plain clay), painted. He appears to have seen them, for he despaired of their condition, which was fragile and falling apart (pp. 61-62; see also pp. 336, 359, 379). Gustave Geffroy, who saw and photographed the busts, was the first to describe the polychromy in any detail: "these clays were colored by Daumier, and the colors that he used served to express sanguine, apoplectic or bilious temperaments, the pallors and blotches of middle and old age (*Art et Artistes*, 1905, p. 104). Geffroy's 1905 photographs also indicate this polychromy (for example, see cat. nos. 7b, 12b, 28b, 34b). Durbé suggests Daumier's inspiration might have arisen from the usage of the time of hand-coloring prints (p. 3). Humorous polychromed figurines were not unknown before Daumier's busts. While other descriptions range as far afield as Walter Pach's "modelled in wax" (1924, p. 105), to Raymond Escholier's probably careless use of both "terre cuite" and "terre glaise" to describe the busts, it seems safe enough to state that the busts were and are simply clay. In 1948 Madame Le Garrec noted that the clay contained grains of plaster (*Arts et Livres*, p. 101). Gobin said they were "grains of limestone which would render baking difficult" (p. 30). This is not precisely correct (see the technical section "Materials and Techniques").

Photographic Evidence

Champfleury was Daumier's contemporary, an innovative thinker, who had shared many of Daumier's political ideals and hopes. He, who had himself used caricature as a means of political dissension, was one of the very first to recognize Daumier's lithographs and sculpture as art. The auction in 1891 of his own collection, two years after his death, included an intriguing item: "six sheets, photographs of 34 busts *en terre*, with a note by Champfleury that read 'most of these busts were modelled by Daumier

in the Chamber of Peers . . . they were never baked . . . they remained the property of Philipon. In 1865 his [Philipon's] adopted son had the idea of conserving them by making photographs of them, in an edition of 12 photographs'" (Champfleury sale, 1891, no. 72). This item allows us to date a photograph in the Museum of Fine Arts of six of the busts (see cat. no. F). It must be one of the six sheets of photographs of the busts taken by Philipon's family. Champfleury's statement clarifies another reference that is generally overlooked: Item 242 of the 1878 Daumier exhibition at Durand-Ruel's reads "6 photographic sheets of 34 colored clays and 2 lithographic portraits. Collection Geoffroy-Dechaume" (Item 236 refers to "Heads in Colored Clay"). This too must have been one of the twelve sets of photographs taken by Philipon's stepson in 1865. The only current authors to mention the existence of these six sheets of photographs seem slightly confused, for one said the photos "proved there were 36 busts" (Palais Galliera, 1966, n.p.), and the other said Marcel Lecomte (author of the latter catalogue) cited the existence of "an album of photographs executed about 1890 by Philipon's adopted son which represented thirty-six busts on six sheets of six photos" (Château de Blois, 1968, p. 202). Until copies of all six sheets can be located, the number of clay busts represented cannot be stated surely. It seems wisest at present to rely on the two early references which stated that thirty-four busts were reproduced in photographs taken in 1865.

In 1897 another of Daumier's younger contemporaries and champions published a book on the period of Louis Philippe based on illustrative materials of the time. In that book, *Journées Révolutionnaires*, Armand Dayot, 1856-1934 (also publisher-editor of the art magazine *L'Art et les Artistes*) was at pains to include eleven photographs of Daumier's clay busts which he had either taken himself or had had taken ("with some concern, and not without difficulty we succeeded in photographing some, thanks to their owner Paul Philipon;" part II, p. 35). Dayot emphasized the poor condition of the busts, made in plain clay, which had been kept in two vitrines where they "wear and crumble, leaving little hope that they could figure in the museum of satirical art which we hope to see founded. For, with the action of time these surprising images, executed in a material which was never fired, are falling into powder, and hardly two or three, like Dupin, one of the best preserved, could today support the perilous trial of being cast" (part I, p. 3). Several of Dayot's illustrations have been reproduced in this catalogue (cat. nos. 1b, 4b, 8b, 9b, 11b, 22b, 36b) for pur-

poses of comparison with the busts as they exist today.

In 1905 Geffroy wrote the first article on Daumier the sculptor. He illustrated seventeen of the clay busts, with photographs different from Dayot's (in *Art et Artistes*, pp. 101-107). Either the busts had been photographed for the third time, or Geffroy used Philipon's 1865 photographs. Geffroy studied the busts very carefully in Philipon's two glass cases and attempted to identify them (see Persons Portrayed below). Geffroy's photographs reproduced in this catalogue are nos. 7b, 12b, 13b, 14b, 19b, 20b, 26b, 27b, 28b, 32b, 34b, 35b.

No new photographs of the busts were made, apparently, for another twenty-five years. Bertels (1908), Phillips (1922), Klossowski (1923), Pach (1924) and Fuchs (1927) all published photographs identical to those in Geffroy's article. None of these authors illustrated all of the clay busts, however, nor did Bouvy, whose *Trente-six Bustes de H. Daumier* of 1932 illustrates thirty-six busts, eleven of which are bronze rather than clay. Clays which are illustrated for the first time in Bouvy are: Baillot, Cunin, Etienne, Ganneron, Gaudry, Guizot, Harle, Lecomte, Odier, Pataille, Royer-Collard, Sébastiani, Vatout, and "Girod." Gobin in 1952 was the first to provide photographs of all the thirty-six clay busts which exist today, providing the first photographs of Barthe and Delessert since 1865. And, finally, the first series of color photographs of the thirty-six clay busts was taken for this catalogue. Madame Le Garrec allowed four views of each bust to be photographed in black and white, as well as one view of each in color. It was a delicate undertaking. Although only six are reproduced in color here (nos. 1a, 5a, 13a, 17a, 25a, 29a), all the photographs will remain in the Fogg Museum Library study collection.

Condition and Ownership

The photographs provide graphic evidence of the deterioration of the clay busts. A glance at Persil (cat. nos. 26a and 26b) or Fruchard (cat. nos. 12a and 12b) shows grave losses. Others such as d'Argout (cat. nos. 1a and 1b) have remained in fairly good condition. It is also apparent that the busts have been restored, of necessity. Contrary to Gobin's conclusion that the busts were damaged and broken because they were carelessly moved around in the 19th century (p. 29), it seems instead that they were hardly moved at all. They could not have suffered because of Daumier's many changes of home, for they did not in fact belong to Daumier,

but to Philipon. The latter seems to have put them in glass cases, perhaps as early as 1832. Only ten were surely exhibited in the 1878 exhibition at Durand-Ruel (Vincent, 1968, p. 45). The catalogue entry reads simply "clay busts, collection of the Widow Philipon." But perhaps the inclusion in the exhibition of photographs of thirty-four clay busts is the best indication that only a few of the actual clays were exhibited. Nor is it necessary to think that they were tossed in a cart and trundled over the cobblestones to Durand-Ruel, as Gobin wrote (1952, p. 29; quoting Armand Dayot). This sounds simply like colorful 19th century writing. In fact, it is not necessary to look to outside causes for the deterioration of the clays, for they are basically impermanent.

After Charles Philipon's death in 1862, his widow, followed by his stepson Eugène and grandson Paul, apparently kept the busts in the same glass cases. Geffroy wrote in 1905 that the owner (Paul Philipon) had attempted to repair them, succeeding with some but finding that pieces were missing from others (Geffroy, p. 104).

In 1927 the busts, as a group, changed hands for only the second time in their existence, when Maurice Le Garrec purchased them from the Philipon family. Since his death, about 1945, the clay busts have belonged to his widow, Berthe Le Garrec. Madame Le Garrec in 1948 (*Arts et Livres*, pp. 101-102) explained that when Le Garrec acquired the busts he had Fix-Masseau, a sculptor, restore them and prepare the molds for making castings (also Gobin, p. 163). This explains why none of the bronze busts lacks ears or noses, or displays huge cracks, even though these are visible in the early photographs of the clays. We can add that as noses and ears continued to fall, no matter how carefully the busts are treated, restoration must continue on these fragile little objects, whose very survival for 130 years is quite remarkable. The polychromy is also being restored. This restoration will be completed by March 1969. The photographs for this catalogue were taken in the early part of 1968; therefore there is some variation between the appearance of the clay busts today and the photographs in this catalogue.

Number of Clay Busts

A tantalizing problem presented by the earlier documents is that of the number of busts. Many would agree that Daumier must originally have made forty or more heads. The question appears to be: how

many of them survived? The first mention of any number relating to the busts is in the 1878 Durand-Ruel catalogue. Although Item 236 says simply "Clay heads, colored. Collection of the Widow Philipon," Item 242 refers to photographs of thirty-four busts plus two lithographic portraits, belonging to Geoffroy-Dechaume (as has been stated above).

Alexandre also refers several times to thirty-four busts (pp. 336, 359, 379), remarking that "the collection, or at least part of these colored clays, belongs to the Philipon family" (pp. 61-62), implying that he thought there had been others. He might have meant that some had already crumbled away. He also might have heard that two were said to have been given away, one to Champfleury and one to Nadar, the photographer (see below; no trace of either of these has been located). Though Dayot saw the busts in 1897, he did not mention how many he had seen. But Geffroy, who also saw the group, in 1905, wrote: "There exist by Daumier the sculptor: 36 clay busts, which belong to Philipon, grandson of the founder of *La Caricature*. . . . There were originally 38 clay busts. Mr. Philipon told me that one was given to Champfleury and one to Nadar. All represented persons around the court of Louis-Philippe" (p. 102). Further on, he wrote, "The 36 busts, which Philipon has in two glass cases, have not all been identified" (p. 104). Now, if there were thirty-six, why were only thirty-four photographed in 1865? And if it was because two had already been given away (perfectly likely), then when did two others enter Philipon's collection? Champfleury died in 1889; Nadar in 1910; did their busts somehow return to Philipon? It remains a puzzle.

Bertels, no strong authority, wrote that of the busts, thirty-four are preserved (1908, p. 14). But Fuchs, who looked long and hard for possible Daumier sculptures and added "Le Fardeau" (cat. no. 40) and "Le Pitre Aboyeur" (cat. no. 41) to the list, wrote of only thirty-four small colored clay busts (p. 24). The Museum of Modern Art catalogue of 1930 wrote of "34 busts in terra cotta" (p. 41). Bouvy, working for Maurice Le Garrec, published thirty-six; by then some had been cast in bronze, so he apparently illustrated the new bronzes (his order and numbering are the same as Gobin's; in fact, the source of Gobin's inexplicable ordering seems to have been Bouvy's book). Mourre wrote about thirty-six busts in 1948; by this time all had been cast in bronze. Other articles of 1948 on the new collection at Marseilles refer to thirty-eight busts, but this seems to be a simple typographic error.

In 1952 Gobin illustrated the thirty-six Philipon-Le Garrec clay busts. But he included this startling note: "Mr. Delatre, who was the expert in charge of the Malherbe sale in 1912, told me that when the sale took place [apparently lithographs from the Philipon collection], those busts then in ruin were tossed in the trash before his eyes" (p. 29). What can this mean? Adhémar, who studied the historical subjects of the busts carefully, was convinced that Daumier originally made up to forty-five clays (1954, p. 15), which seems perfectly possible. He cites other personages of the lithographs for whom the existence of a clay bust seems imperative such as Thiers, because he was a favorite enemy of Daumier and appears even more often than Dupin (p. 20). He then mentions rather confusingly, the present existence of thirty-seven clays (p. 15). The 1958 catalogue of the extensive Daumier exhibition at Paris' Bibliothèque Nationale, based on Adhémar's book, stated "before the end of April, 1832, Daumier made a certain number of busts of celebrities. These busts, of terra cotta, numbering about 39-45, *37* of which alone remain, were exhibited in the windows of *Caricature*, passage Véro-Dodat. From the heirs of Philipon they passed to Maurice Le Garrec. . . ." (p. xxii). Why thirty-seven remaining? The similar statement in the Boston Museum of Fine Arts catalogue of the same year was based upon Adhémar (n.p. The statement that Gobin had acquired the busts from Le Garrec was an error). Durbé, who listed only thirty-six busts, agreed with Adhémar that there were once other busts, such as Thiers or Lobau, but suggested they were subsequently lost (Poldi Pezzoli, p. xxvi).

To add to the confusion about existing clay busts, Escholier wrote in 1965 that Le Garrec had saved the clays modelled by Daumier by having them cast in bronze, but unfortunately, he added, "certain originals, already very worn, perished at the time of the casting; but like Armand Dayot, I had the good fortune to see them at Paul Philipon's" (p. 191. This statement does not appear in the earlier versions of Escholier's book on Daumier). No further explanation could be elicited from Escholier about this remark. Finally, the Blois exhibition catalogue truly confuses matters. There one may read that "in the first Daumier exhibition in 1878, there were 39 of them [the busts] in the catalogue," and of "The existence of an album of photographs executed about 1890 by the adopted son of Philipon which represents only 36 busts on six sheets of six photos of the same busts. It is true that between 1878 and 1890, three busts could have been destroyed or lost" (Château de Blois, p. 202). As far as can be determined, however, the 1878 Durand-

Ruel catalogue noted only an unspecified number of clay busts, and the photographs taken of the busts by Philipon's adopted son were of thirty-four busts (and two lithographs); these were taken in 1865. Armand Dayot did have photographs taken about 1897, but he wrote he could only photograph *some* of them, and he illustrated only eleven.

To sum up this section: from 1865 on, the Philipon group is numbered at thirty-four busts. Two busts were presumably given away, one to Nadar and the other to Champfleury. In 1905 Dayot mentioned thirty-six busts at Philipon's, of an original thirty-eight. But other writers continued to mention thirty-four, until Bouvy published *Trente-six Bustes*. . . . Gobin in 1952 illustrated thirty-six clay busts, but he quoted a reference to "those in ruins" being tossed in the trash in 1912. Adhémar wrote of thirty-seven busts (in 1954), and Escholier stated in 1965 that some of the clays had been destroyed when cast in bronze. As the clay busts have been restored several times, and yet must continue to crumble away, perhaps not even laboratory tests would be able to settle this question.

Persons Portrayed and Style of the Busts

Who do these thirty-six clay busts represent? What was Daumier's purpose in making them? If we may rely on Philipon's announcement in 1832, they were made as studies for the "gallery of portraits of celebrities of the Juste-Milieu." Every word of *La Caricature* was heavily satiric so that Philipon's remark that they were intended as *portraits charges* (weighted, or figuratively, jesting) may be accepted. Charged or loaded portraits, or caricatures, were half the meat of Philipon's paper. Lithographs reproduced in the paper would have reached as many people as possible with Philipon's anti-government tirades. Sculptured caricature was not then unknown. Dantan *Jeune* had been having an enormous success since 1829 with his jesting figurines of many well-known persons of the day (the best-known is perhaps Balzac). Dantan's figures, both full-length and busts, were well-publicized by means of prints which were sold to an eager audience. Perhaps Philipon had something similar in mind for Daumier. But Dantan's figurines were infinitely more able to be cast than Daumier's deeply-worked busts, and with their more "finished" surface and their extraneous clues to the subject's identity, such as Balzac's giant pen, they were more likely to appeal to a popular audience of the 1830's.

Daumier's portraits are all busts, that is, heads resting on shoulders. The men are dressed in two or three basic garment styles (judges' robes or a high-rolled-collar coat and bow tie). The differentiation from one to the next is in the features and shape of the heads. Durbé pointed out the relationship between Daumier's busts and the current interest in physiognomy and phrenology, two of the many "sciences" that fascinated the late 18th and early 19th centuries. Physiognomy contained the idea that a man's character could be read in the shape of his head and features. Durbé noted that this was to be found in Lavater's *Phisiognomische Fragmente*, the French translation of which was reprinted at least fifteen times between 1781-1845 (p. xix). Before Lavater, a strange Austrian, Franz Xavier Messerschmidt (1737-1783), had made a series of odd busts of himself in a great variety of expressions and grimaces. To these excellent, if startling, sculptures he gave such titles as "A Hypochondriac," to explain the expression. In Daumier's own era, charts of facial expressions were available, such as Boilly's *Grimaces* (see Adhémar, opp. p. 23) on which were noted the correspondence of each facial type illustrated to a temperament (saintly, bilious, etc.). Durbé wrote that the influence of the *Grimaces*, which appeared between 1820-1827, on Daumier is documented (p. xxi). Daumier's lithograph of the "Masks of 1831" (cat. no. A) showing caricatured faces bearing names of political leaders seems a parody on the physiognomy charts. In fact, physiognomy had reached such a popular level in Daumier's day that, Adhémar tells us, there was a backstreet entertainer whose specialty was making faces for the audience (pp. 20-21).

Daumier's busts of Louis Philippe's supporters seem clearly to follow just after the "Masks of 1831." The characteristics of the sculptures are not particularly like the heads in that print, but are in general nearly identical to the individual portraits in the *Celebrity* series. In the clays Daumier seems to combine a satirical attack on specific men, his political enemies, with an interest in exploring the great number of variations possible on the shape of the human head, an approach related to physiognomy. Within the group of thirty-six busts known today there seem to exist smaller groups. Discussing these groups might give an idea of how Daumier worked. In Lameth (cat. no. 20a), there is a certain overworking of the surface without much sense of the structure beneath; in d'Argout (cat. no. 1a) and the unknown no. 34a one finds an exaggeration of features like noses and eyelids to the point of grotesqueness, with tiny heads, and still not much

sense of structure, especially in the necks and shoulders. In the next group, Daumier seems to seek to put more life into the heads by means of exaggerated expressions, as in Dupin saying "ou" (cat. no. 9a), Kératry with a wide egregious grin and enormous teeth (cat. no. 19a), "Toothless Laughter" with a bigger laugh still (cat. no. 35a), then Royer-Collard (cat. no. 29a) where the expression changes from grin to grimace — like Messerschmidt Daumier found that a twisted mouth caused interesting lines in the face. In this group Daumier also began to work with a great variety of hair styles, and began to concentrate more on the eyes as well as mouths. Puffing Harle *père* also squints (cat. no. 18a); the whole face of a bald unknown (cat. no. 36a) is contorted and the head even twisted upon the neck (this may not actually represent anyone, but rather be an expression that came out well yet lacked sufficient individualization for Daumier to use it in his drawings); Prunelle with his shaggy mane and thin lips forming a twisted mouth (cat. no. 28a); the last unknown (cat. no. 33a) wearing another grimace of mouth and eyes, with very curly hair — again this may not refer to anyone in the drawings; and finally Fruchard (cat. no. 12a), a truly ugly face and grimace, far from the simple grinning Kératry. After this, Daumier seems to relax and turn away from very distorted expressions to more subtle ones, still concentrating on the mouth drawn down, as in Odier (cat. no. 24a). Cunin (cat. no. 5a), like Odier, wears his hair in tufts, but like Sébastiani (cat. no. 30a) bears more delicate, refined features. The latter is, in fact, the height of aristocratic disdain, stuck stiffly up in his collar. Then Etienne (cat. no. 10a), whose mouth is merely a pursed line and whose only expression is in his closed but squinted eyes.

The following sculptures may be grouped because they are greater in size and breadth; they exhibit very little expression, but show instead a great variety of bone structure. With these Daumier shows less interest in the wrinkles and changes in the surface of the skin than in the whole structure of the head. First, Barthe (cat. no. 3a), which while larger in scale seems, with his mouth drawn down and restrained sneer, to be closer to Sébastiani or Etienne. Guizot (cat. no. 17a), one of Daumier's masterpieces, hardly seems to be caricatured except for the almost skeletal deep sockets under the cheekbones and the cranial bumps. From him Daumier seemed to turn, in a spoof on phrenology, to men with extraordinary skulls and crania such as Delessert (cat. no. 6a), who may actually have had such a long upper lip, tiny nose, and deep-set eyes;

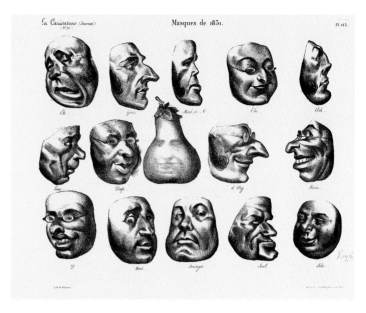

A. MASQUES DE 1931 (Masks of 1831) L.D. 42
Lithograph; 212 x 290 mm.
La Caricature, March 8, 1832
Fogg Art Museum, Harvard University
Left to right, from top: Etienne, Guizot, Madier de Montjau, Thiers, Athalin; Lameth, Dupin, Louis Philippe (Pear), d'Argout, Kératry; D., Barthe, Seringot, Soult, Schoenen

Fulchiron (cat. no. 13a) with long upper lip, hollow cheeks and bumpy skull; Vatout (cat. no. 31a), long upper lip, tiny nose; Viennet (cat. no. 32a) adds a great protruding forehead as does Ganneron (cat. no. 15a). Persil (cat. no. 26a) still bears the large potato chin, big skull and deep-set eyes, but is rather bland except for his long pointed nose. Lefebvre (cat. no. 22a) is also bland in expression, with all attention concentrated on his incredible Cyrano-like nose. The skill of modelling of this whole head is greatly advanced from that of tiny d'Argout. The next three are relatively large (up to 9¼"). Delort (cat. no. 7a) wears a ruffle of hair framing his head as did Lefebvre; his face has some expression about the eyes as if he were going to speak. Gallois (cat. no. 14a) has a similar hair ruffle and seems to speak; his head is extended upwards.

In the remaining busts Daumier seems to combine irregular bone structure and unusual facial features with a delicate working of the surface caused by a variety of expressions, which however never reach exaggeration. The busts in this group are all quite large, for Daumier. Falloux's (cat. no. 11a) extended head is drawn downward to a scraggly beard; he seems to speak. Then Daumier

seems to form the faces into geometrical forms: Pataille (cat. no. 25a), a sprightly, chatting face, is balanced on his pointed chin; Podenas (cat. no. 27a), massive and grim, reverses Pataille, with his pinhead resting heavily on a broad bottom — here the man is almost forced into a geometric form. Dubois (cat. no. 8a) is also massive and grim, with a tiny pinched face. These two busts have the most elegant contours along the bottom edges. Baillot (cat. no. 2a) has a square head; Lecomte's (cat. no. 21a) is even squarer, with an emphasis on horizontals and verticals. Gaudry (cat. no. 16a) has an even blockier base, but the shape is changed by dropping the head forward. Montlosier's (cat. no. 23a) round head juts forward even more, as Daumier now works with clearly separate parts, unlike the solid d'Argout. Chevandier (cat. no. 4a) is a further variant, less geometric.

As for the identifications of the busts just listed above, we are following several very able earlier researchers. When Geffroy saw the busts in 1905 he identified some, but said he doubted if all would ever be identified. Since then all but four (cat. nos. 33, 34, 35, 36) have been at least tentatively identified, mostly by patient comparison with the lithographs. Some, such as Dupin and d'Argout, based on very well known and quite distinguishable men, seem never to have lost their identities. Geffroy, who wrote of and identified or illustrated twenty-seven, said he was basing his identifications on the "labels made by Champfleury" (1905, p. 105). These paper labels are visible and some are even legible in the early photographs (see cat. no. 26b, for example). When and why Champfleury put these labels on some of the busts is not clear. But it is on this basis that we have retained the identification of Gallois (cat. no. 14), who would otherwise remain a mystery. In 1932 Bouvy named all but the four noted above which are still without identity. Names have been attached to them, on the basis of supposed resemblances to lithographs, but these are so remote it does not seem logical to continue to use the names. In 1948 Mourre wrote a short, light-hearted biographical paragraph on each historical personage. Gobin regrettably gave each bust a nickname of his own invention, regrettable because these names often represent nothing more than his personal reaction and could be interchangeable ("The Important Personage," "The Disdainful"), while Daumier and Philipon had already provided epithets for many of them ("M. Pot-de-Naz," for example). "Toothless Laughter" was a happy choice however. Gobin's nicknames will be noted under each entry, for identification purposes. Kaiser in 1952 in the Berlin Daumier exhibition catalogue provided more factual material for many of the subjects. The Paris Bibliothèque Nationale catalogue in 1958, for which Adhémar was responsible, provided similar biographies, often with material that differed from Kaiser's. Durbé did Daumier scholars a great service in the Poldi Pezzoli museum catalogue of 1961 with his thorough study of each bust and personage represented. Not only did he illustrate the related lithographs from *La Caricature* or *Charivari* in full, so that the parody coats-of-arms could be seen, he also quoted Philipon's very funny texts relating to these men. On Fruchard, for example:

> What is that unformed mass on the opposite page? Is it a goatskin? an old stump? a lump? a pumpkin? You won't guess. It is your representative! That object whose nature is unclear to you is your deputy, charged with your interests. His name is Fruchard . . . Who has ever heard Mr. Fruchard speak? His name is so unknown that the most active researches have not uncovered which city Mr. Fruchard is delegate of. All we know is that he is a Deputy, because Daumier assured us that he discovered him reclining on a bench *improstitué*. Our gay caricaturist was so struck by this remarkable visage that he believed he ought to share his discovery with all Europe (Poldi Pezzoli, p. 93, from *Charivari*, October 12, 1833).

Durbé combed the newspapers and other literature of the era, in order to suggest why these particular men had been singled out as objects of satire by Daumier and Philipon. He showed that while some figures such as Persil, Viennet, and Guizot were subjects of lively discussion and controversy in their day, others, such as Fruchard, still defy research, and owe whatever posterity they have gained to the fact that Daumier found their appearance interesting enough to caricature.

Relation to Lithographs

Daumier is supposed to have made the clay busts to use as models for his lithographs, particularly the series of *Celebrities* in *La Caricature*, April 1832 to April 1833. Many of the lithographic portraits in this series seem clearly drawn directly from the clay busts, for example Lameth (cat. nos. 20a and 20e), Dupin (cat. nos. 9a and 9f), d'Argout (cat. nos. 1a and 1e), and Persil (cat. nos. 26a and 26e). In these Daumier remained faithful to the expression on the clay, the clothing, and the modulations of surface which are carefully brought out in the lithographs by means of strong lights and darks. In some, how-

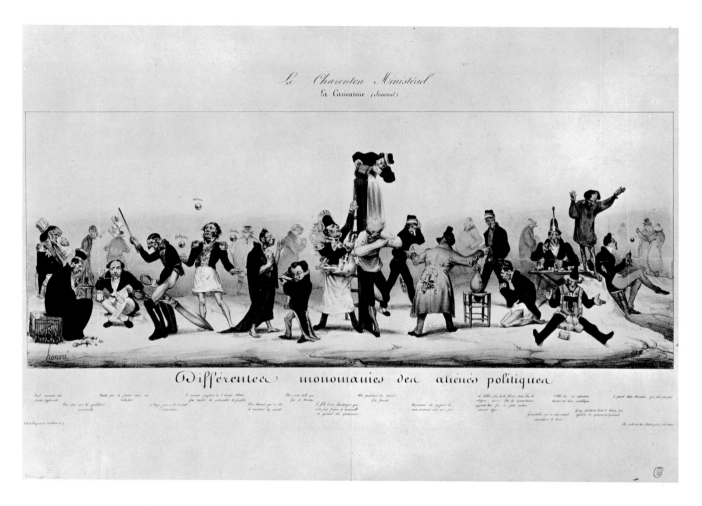

Le Charenton Ministériel.
La Caricature (Journal)

Différentes monomanies des aliénés politiques

B. LE CHARENTON MINISTERIEL (The Ministerial Madhouse)
L.D. 44
Lithograph, second state, hand colored; 195 x 509 mm.
La Caricature, May 31, 1832
Benjamin A. and Julia M. Trustman Collection, Brandeis
University
Left to right: Soult, Persil, Barthe, d'Argout, Sébastiani (juggling),
Dupin, Thiers, Lobau, ? , ? , ? , Louis Philippe (back turned),
Lameth, l'Abbé Louis (kneeling), Girod de l'Ain, ? , Guizot
(standing on mound), Montalivet

ever, such as Dubois (cat. nos. 8a and 8d), the litho-
graph lacks the vivacious detail of the clay, which
is modelled into a much more subtle expression than
the lithograph. This might also be said of Chevan-
dier (cat. nos. 4a and 4d), Pataille (cat. nos. 25a
and 25d), or of both lithographs of Odier (cat. nos.
24a, 24c, and 24d). In the majority of the litho-
graphs related to the clays, however, Daumier was
too much of an artist to copy directly, repeating
verbatim something he had already done. While
retaining the type of exaggerations he had devised
for his caricature in clay, such as an elongated nose
or a fringe of hair, he nevertheless varied the ex-
pression and various details. For example, in the
clay of Podenas, Daumier gave him a pinhead on a
broad jaw, a veritable pyramid. But in both litho-
graphs he modified the narrow pointed head while
emphasizing the piercing gaze and the horizontal
lines of the clothing (cat. nos. 27a, 27f and 27g).

When Daumier included many of these person-
ages in group lithographs, such as the vignettes used
as leaders in *Charivari* (cat. no. D), the "Charenton
Ministériel" (cat. no. B), or the "Ventre législatif"

(cat. no. C), it is possible to recognize certain fig-
ures, such as d'Argout or Dupin, from a resemblance
to the clay. But the drawn caricatures vary in ex-
pression, in modelling, even in contour from the
clays, which therefore can hardly be said to have
served as models for any of the groups. A good ex-
ample is the "Ventre législatif," for which the clays
are thought to have posed. Yet there is no agreement
in the identification of the personages seated on the
benches. Had Daumier drawn them as carefully
from his clay busts as he did the individual Lameth

37

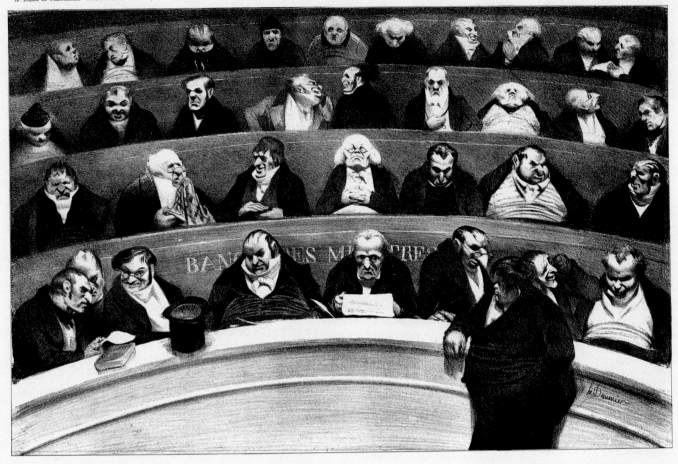

LE VENTRE LÉGISLATIF.

Aspect des bancs ministériels de la chambre improstituée de 1834.

C. LE VENTRE LEGISLATIF (The Legislative Belly) L.D. 131
Lithograph; 280 x 431 mm.
L'Association Mensuelle, January, 1834
Fogg Art Museum, Harvard University
Suggested identities, left to right, first row: Guizot, Persil, Thiers,
Barthe, Soult?, d'Argout, Prunelle (standing), ? , de Rigny;
second row: Podenas, Harle *père*, Royer-Collard, Odier, ? ,
Fruchard, Delessert; third row: ? , ? , Vatout, Kératry, Jollivet,
? , ? , Lefebvre, ? ; top row: ? , ? , Viennet, ? , ? , ? , Pataille,
Etienne, ? , ?

or Dupin, there would be little doubt who each was, excluding those for whom no clays exist. Thus it is possible to say that Daumier's lithographs are sculptor's drawings, not because they are copied from sculptures (a weak argument), but because they demonstrate a knowledge of and an ability to represent three-dimensional structure by means of planes, an ability Daumier demonstrated the rest of his life in his drawings, and for which the premise of previously-sculpted figurines serving as models (suggested by Gobin) is totally superfluous, if not ridiculous for an artist of Daumier's calibre.

Castings and Reproductions

Although Daumier's clay busts existed for 130 years as unique objects, since 1929 they have been cast in several different media, so that now there is a minimum of thirty reproductions of each bust. After Le Garrec purchased the busts in 1927, he had Fix-Masseau repair them and prepare a plaster mold of each. The clay busts have not since been subjected to any phase of the casting process. From these molds Le Garrec had the Barbedienne foundry cast bronze editions of each bust by means of the lost-wax method. For a fuller discussion of the casting process, see the "Materials and Techniques" section. According to Madame Le Garrec, thirty consecutively-numbered bronzes were made of d'Argout, Fulchiron, Guizot, Harle, Lameth, Odier, Pataille, Prunelle, Viennet, and "Girod," while twenty-five consecutively-numbered bronzes were made from the rest. They were originally sold on a subscription basis. The first twelve busts to appear in bronze, in 1929-1930 were: Barthe, Delessert, Dupin, Fruchard, Fulchiron, Ganneron, Kératry, Podenas, Prunelle, Royer-Collard, Viennet, and "Toothless Laughter." Some bronzes of all thirty-six had been completed by 1948 when the Marseilles museum acquired a complete set. According to J. C. Romand, the last of the Barbedienne bronzes were made in 1952 (letter to Fogg Museum, December 27, 1968). Each of the Barbedienne bronzes is stamped MLG (for Maurice Le Garrec) on the back or shoulder, and bears an edition number in the form of a fraction, on the inside.

When the Barbedienne foundry went out of business in 1953 the molds were returned to Madame Le Garrec. Beginning in 1953, she had the Valsuani foundry make a final edition of three bronzes of each of the thirty-six busts, for herself and her two daughters. These Valsuani bronzes are stamped MLG and either LG, Mme H, or C. Two bronzes, of Mont-

D. LE MAGASIN CHARIVARIQUE Bouvy 22a (variant)
Title page, *Charivari*, 1834
Wood engraving; 255 x 171 mm.
Museum of Fine Arts, Boston

losier and Podenas (cat. nos. 23e and 27d), in this catalogue are from this Valsuani edition. In March, 1965, upon completion of this casting, the thirty-six plaster molds of the busts were destroyed at the Valsuani foundry, in the presence of Madame Le Garrec and an official of the government. An affidavit exists attesting to this.

Few collections are known to possess all thirty-six bronzes. Lessing J. Rosenwald, whose collection now belongs to the National Gallery in Washington, began buying his bronzes on the subscription basis in the 1930's. His collection of thirty-six has been generously lent for this exhibition. Other complete collections included: Musée des Beaux-Arts, Marseilles (all numbered 20); Lyons museum; Deutsche Akademie der Künste, Berlin; the late Billy Rose (now apparently broken up); the late Count Aldo Borletti di Arosio (all numbered 19); and Madame Berthe Le Garrec.

Since the 1930's the Le Garrec family have been preparing an edition of terra-cotta busts cast from the Fix-Masseau molds, comprising seven of each subject. These are being hand-painted to resemble the original clays. This edition has not been completed, and has never been placed on the market. However, six have been sent by J.C. Romand for inclusion in this exhibition (see cat. nos. 1d, 9e, 13d, 17d, 22e, and 27e). Four of them, of Cunin, Harlé, Lameth, and Sébastiani, were included in the Daumier exhibition at the Bibliothèque Nationale in 1934, as Item No. 393, according to Madame Le Garrec (in *Arts et Livres*, 1948, p. 102). These terra-cotta busts are considerably smaller than the originals due to shrinkage which occurs during the firing process.

A rather vague reference by Madame Philippe Garcin in 1959 suggested that "reproductions of Daumier's busts were made around 1850, generally rather poor copies" (in *Aesculape*, p. 24). She mentioned that one was in the collection of Paul Prouté. Prouté wrote that he had owned a bust of Podenas, different from the series of the men of the July Monarchy. He considered it a fake and destroyed it (letter to Fogg Museum, December 27, 1968). The puzzling Item 493 in the 1901 Ecole des Beaux-Arts Daumier catalogue (under *Supplement-Divers*), "Reproductions of colored clays, after Daumier, Coll. Armand Dayot," may refer to these 1850 copies. It has not been possible to investigate this fascinating hint, but if indeed sculptured (terra cotta?) copies of Daumier's busts were made one hundred years ago it is certainly possible that some of these now aging copies could be mistaken for originals.

In 1957, the firm of Alva Museum Replicas, Inc. began making reproductions of four of the busts, intended for the mass market. These reproductions are made of a synthetic material which resembles bronze surprisingly well. They were cast from four of the bronzes which appear in this exhibition, of Lameth, Lefebvre, Montlosier, and Persil (cat. nos. 20d, 22d, 23f, and 26d). They are produced in unlimited editions, and each bust is clearly marked: ALVA MUSEUM REPLICAS INC.

Finally, there also exist bronzes which were taken from some of the Barbedienne bronzes. These "surmoulages" were made at an unknown time and by unknown persons, and must be considered spurious. Madame Le Garrec has identified surmoulages of Pataille (see cat. no. 25c), Viennet, and "Toothless Laughter." A detailed discussion may be found in the section "Materials and Techniques."

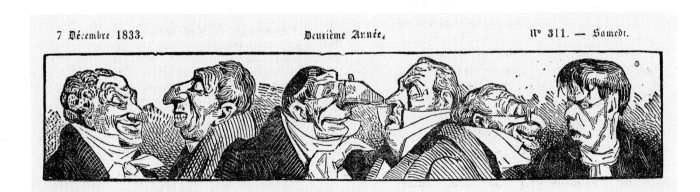

E. MASTHEAD WITH PATAILLE, FULCHIRON?, D'ARGOUT, SEBASTIANI, KERATRY, AND PLOUGOULM Bouvy 7
Wood engraving; 35 x 170 mm.
Charivari, December 7, 1833
Museum of Fine Arts, Boston

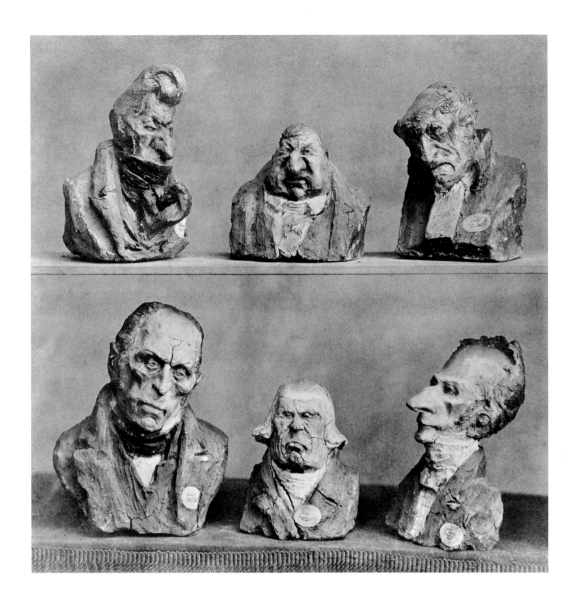

F. Album page with mounted photograph of busts of Chevandier de
Valdrome, Fruchard, Gaudry, Guizot, Odier, and Lefebvre (from
top, left to right)
Probably taken by Eugène Philipon, 1865
285 x 262 mm. (includes mount)
Museum of Fine Arts, Boston

The clay busts are the only sculpted objects exist-
ing today which surely came from Daumier's hand.
Even "Ratapoil" and the "Refugees" which are also
mentioned in his lifetime (no other sculpture is)
exist now as plaster casts probably made from lost
clay originals. As all students of Daumier's sculpture
(as well as his paintings and drawings) are forced
in the end to make judgments based on style, all
attributions of sculpture to Daumier must begin
with a thorough study of the busts.

J.M.L.

*　　*　　*

The thirty-six busts are arranged in alphabetical order with
the four unidentified heads at the end.
Captions include: the subject's last name; then his other
names and titles; his lifespan; and Gobin's number for this
subject. Height of all sculptures is given in inches and milli-
meters. Few of these objects could be measured by the Fogg
staff before the exhibition; generally measurements were
given by the owners.
Information under the bronzes includes markings made on
the bronzes such as the MLG stamp, the edition number
(3/25, etc.), and other unexplained but consistent markings
such as a four- or five-digit number, or the word BRONZE.
Under lithographs, L.D. refers to Loys Delteil, *Le Peintre-
Graveur Illustré*, the standard reference for Daumier litho-
graphs. Each lithograph (where possible) is given its L.D.
number; the title is from the lithograph itself. Date and
place of appearance are from Delteil. Measurements of the
lithographs are also from Delteil and are in millimeters.
State, type of paper, etc., refers to the actual lithograph
used for this exhibition.

CHRONOLOGICAL HISTORY OF REFERENCES TO THE
BUSTS AS A GROUP

(No doubt many books and exhibitions in the 1950's and 1960's have included one or several of Daumier's busts. We have tried to note only those which concentrated upon Daumier and contained new researches, new concepts, or new photographic material.)

1832 *La Caricature*, April 26 — under Lameth, whose lithograph opened the series of *Celebrities*

1865 Champfleury, *Histoire de la Caricature*, 33-34; 47 (see text)

1878 Galeries Durand-Ruel, Paris, No. 236: "Têtes en terre coloriée. Appart. à Mme. veuve Philippon." No. 242: "Un passe-partout contenant six feuilles photographiques de 34 terres coloriées et deux portraits lithographiés."
Champfleury, *Catalogue de l'Oeuvre*, 18 (see text). He noted that Philippon's daughter-in-law owned the busts, some of which could be seen in the Daumier exhibition
Duranty, II, 532 (discussing style in lithos, etc.) "A ce propos, l'on remarquera que lorsque Daumier a voulu réaliser quelques-uns de ses types les plus accentués, les plus vigoureux, comme ceux des *Députés en 1835*, comme la *Poire*, comme le *Ratapoil*, il commença par les modeler en terre. Mme. Philippon possédé encore ces statuettes ou ces bustes, violemment pétris (dont quelques-uns coloriés), énergiques comme de la roche frappé à coups de masse."

1882 Claretie, 320-21 [The exhibition at Durand-Ruel] ". . . réunir là tout ce qui était tombé du crayon de Daumier. Certain maquettes en terre pétries par le pouce vigoureux de l'artiste et représentant des *charges* de M. Dupin ou de M. d'Argout, qu'il exécuta plus tard en lithographies, . . ."; 324 ". . . tout ces *charges*, pour lesquelles justement Daumier avait pétrie en terre ces maquettes qu'on pouvait voir rue Lafitte . . ."

1888 Alexandre, 61-62; 336; 359; 379 (see text)

1891 Champfleury sale, January 26, No. 72 "Bustes en terre, reproductions par la photographie. Six planches contenant trente-quatre portraits: Kératry . . . etc. . . . in-4, cart. En tête, note manuscrite de Champfleury: 'La plupart de ces petits bustes furent modelés par Daumier à la Chambre des Pairs. . . . Ces terres, qui ne furent jamais cuites, resterent le propriété de Philippon; en 1865, son fils adoptif eût l'idée, pour les conserver, de les faire photographier à douze exemplaires.' "

1897 Dayot, I, 2-3; II, 35 (see text)

1901 Palais de l'Ecole des Beaux-Arts, Paris, No. 493 (under Supplement-Divers) "Reproduction de terres crues coloriées d'après Daumier. Coll. Armand Dayot."

1905 Geffroy, 101-108 (see text)

1908 Bertels, 14-15

1922 Phillips, 19; 57

1923 Escholier, 156: Daumier's portraits in *La Caricature* were executed after clay models which today, unfortunately mutilated, are in the collection of Mr. Paul Philippon
Ivins, 89; 94
Klossowski, 36

1924 Pach, 105

1927 Fuchs, 23-24; 52

1928 Luc-Benoist, 143

1929 Focillon, 96

1930 V. N., "Exhibitions," *International Studio*, 74: twelve of the twenty-odd bronzes which have been cast from Daumier's clay studies . . . may now be seen at Weyhe Gallery; 76
MOMA, New York, 17; 41
Escholier, 107-08; 128

1932 Bouvy (see text)

1934 Escholier, 163-64
Bibliothèque Nationale, Paris

1936 Albertina, Vienna

1939 Buchholz Gallery, New York, Nos. 1-6

1947 Musée Cantini, Marseilles

1948 Guillet, 8: town of Marseilles has just acquired a collection of 38 [*sic*] bronze busts cast after clays made by Daumier
Blin, 8
C.V., *Emporium*, 184
Daumier issue of *Arts et Livres de Provence:* including articles by Mourre (on 36 personages of the busts), by Mme. Le Garrec, etc.
Marceau-Rosen, 82: erroneously reports that the 36 clay busts were found in Daumier's studio at his death

1952 Gobin (see text)
Deutsche Akademie der Künste, Berlin, catalogue by Konrad Kaiser (see text)

1954 Adhémar, 14-17 (see text)

1957 Galerie Sagot-Le Garrec, Paris (see text); exhibition included some of the original clays

1958 Bibliothèque Nationale, Paris: exhibition to show in chronological order Daumier's lithographs, drawings, sculptures, and paintings, based on Adhémar's book
Museum of Fine Arts, Boston
Los Angeles County Museum
Museo de Bellas Artes, Buenos Aires
le Foyer

1959 Garcin, Mme. Philippe, 21-30

1961 Museo Poldi Pezzoli, catalogue by Dario Durbé (see text)
Musée Cognacq-Jay, Paris

1962 Museum für Kunst und Gewerbe, Hamburg

1965 Escholier, 147-48; 180; 191; 192; 196 (see text)

1966 Larkin, 20; 23; 72
Palais Galliera, Paris

1968 Château de Blois (see text)

The Busts

1. D'Argout

Antoine-Maurice-Apollinaire, Comte
1782-1858

Gobin No. 31

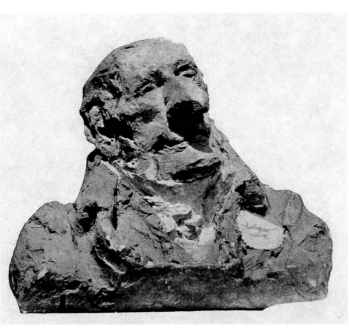

1b.

1a. D'ARGOUT
Unbaked clay, painted; h. 5-5/16″ (135 mm.)
Bronze edition of 30 begun by 1934
Collection Madame Berthe Le Garrec, Paris

1b. Early photograph of unbaked clay no. 1a from Dayot,
1897, II, p. 41

Count d'Argout was one of the best-known and most lampooned men of his time. A conscientious bureaucrat, he had entered government service at twenty and had risen quickly through the ranks to become Councilor of State and Peer of France by 1818. Under Louis Philippe he was Censor for the July Monarchy and served as Ministers of Commerce, Public Works, Fine Arts, and the Interior. Guizot praised him highly for his dedication. D'Argout was also broadly known for his total ignorance of anything beyond his own office. During his Ministry of Fine Arts, his Secretary, Mérimée, wrote to Stendhal that d'Argout had asked him who Rembrandt was. Most of all, d'Argout was celebrated for his nose. Almost daily, jests appeared in the newspapers, such as one report that "the nose of Minister d'Argout was seen leaving his office one minute and forty-three seconds before the rest of his person appeared." Daumier, Philipon, Grandville, Traviés, and other caricaturists included his profile in countless cartoons. Daumier's contribution included a drawing of d'Argout's wife and children sheltered under his nose in a rainstorm (cat. no. 1f), and another of the Count and Countess gazing at an infant whose nose is larger than the rest of the baby (cat. no. 1g). The title of the latter, "Un Nouveau-nez," is a French pun meaning "A new-born" or "A new nose." Unlike many of his fellow victims, however, d'Argout was treated with a roguish rather than a malicious humor, for he was almost equally well-known for his simple innocence, accepting his role as a target with resigned good nature. Gobin's epithet for him, "Spirituel et malin" (Intellectual and Malign), is particularly appropriate.

This clay bust of d'Argout has a long and fairly reliable history. It was mentioned shortly after Daumier's death by Claretie, in his book *Peintres et Sculpteurs Contemporains*, 1882, who said that several clay sculptures had been on view in the Daumier exhibition of 1878, including caricature busts of d'Argout and Dupin, from which Daumier later made lithographs (pp. 320-21). The auction of Champfleury's collection in 1891 included a set of photographs taken in 1865 of thirty-four of Daumier's clay busts. The bust of d'Argout is listed (Champ-

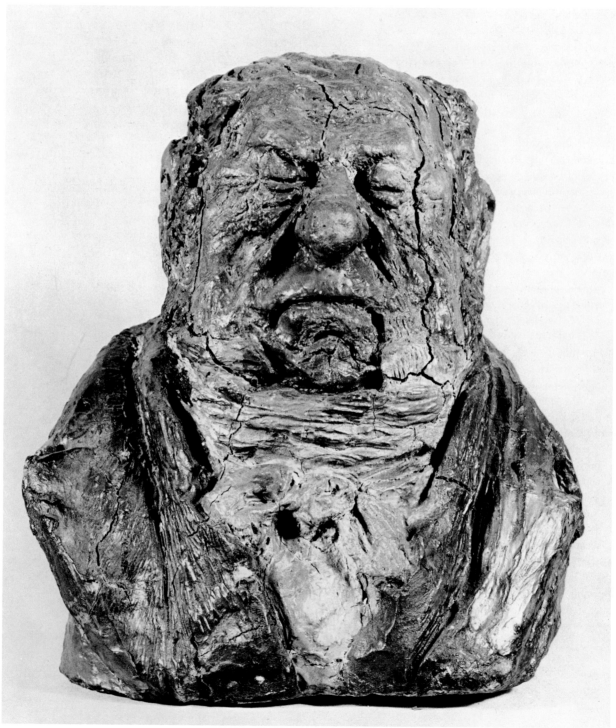

2a.

fleury sale, 1891, no. 72). In 1897 this bust was one of the few that Dayot could name, in his book, *Journées Révolutionnaires*, on the era of Louis Philippe. Dayot was the first to publish a photograph of the clay (II, 41). It seems to have been in excellent condition at that time (see cat. no. 1b), and wears a label that reads: "D'Argout Ministre," supposedly supplied by Champfleury. Geffroy published a different photograph of the bust in 1905 also taken at Paul Philipon's (p. 103). Phillips repeated this photograph in 1922 (n.p.). The first bronze to be published was in the catalogue of the Bibliothèque Nationale Daumier exhibition in 1934 (no. 376).

Considering the prominence given d'Argout by the caricaturists and the fact that a humorous type had already been created to represent him, it would seem natural that Daumier would include d'Argout among his first caricature sculptures. Daumier's d'Argout has a face like Punch. The nose was made as a separate piece and fitted abruptly to the face. With this joint still visible, it looks almost like a false nose. Added to that is the long pointed chin curving up to meet the nose, as on the face of many a wooden puppet. Still, with tiny, near-sighted eyes and an amiable smile, this sculpture retains a remarkable humanity.

D'Argout appeared in many of Daumier's lithographs, including the "Masks of 1831" (cat. no. A), "Charenton Ministériel" (cat. no. B), and the "Ventre législatif" (cat. no. C). In all of them he is easily recognized by his nose. However, the print that resembles the sculpture most closely is the portrait Daumier made as one of the first of the series *Célébrités de la Caricature* (see cat. no. 1e). Daumier carefully copied every detail of the sculpture, including the tubular ear and the line where the nose joins the face. In the text accompanying this print Philipon wrote facetiously that this was an exact portrait without any exaggeration. In Daumier's other portrait of d'Argout, which appeared a year later, the head does not greatly resemble the sculpture, for it is set at a different angle and wears a more solemn expression (see Appendix, cat. no. Ib). Nor does the head of d'Argout that appears in the wood engraving used as a masthead in *Charivari* bear any particular resemblance to the bust, beyond the device of the enormous nose (see cat. no. E). In general, Daumier seems to have used his clay heads as models only for his bust-length lithograph portraits, for once the type was created for each subject, he varied it greatly from drawing to drawing.

D'Argout appeared in the following: L.D. 49, 50, 62, 91, 92, 101, 179, 194, 210, 218.

HISTORY

1882 Claretie, 320-21 (clay)
1891 Champfleury sale, No. 72 (refers to clay)
1897, Dayot, I, 2-3; II, 35, 41 (clay, ILLUSTRATED)
1905 Geffroy, 105, 103 (clay, ILLUSTRATED)
1922 Phillips, n.p. (clay, ILLUSTRATED)
1932 Bouvy, No. 31 (clay, ILLUSTRATED)
1934 Bibliothèque Nationale, Paris, No. 376 (bronze)
1939 Buchholz Gallery, New York, No. 5 (bronze)
1947 Musée Cantini, Marseilles, No. 22 (bronze)
1948 Mourre, 100
1952 Gobin, No. 31 (clay, ILLUSTRATED)
 Deutsche Akademie der Künste, Berlin, 13; No. 31 (bronze, ILLUSTRATED)
1957 Galerie Sagot-Le Garrec, Paris, No. 31 (bronze)
1958 Los Angeles County Museum, No. 237 (bronze)
 Bibliothèque Nationale, Paris, No. 9 (bronze)
 Museum of Fine Arts, Boston, No. 10 (bronze, ILLUSTRATED)
1961 Museo Poldi Pezzoli, Milan, No. 8 (bronze, ILLUSTRATED)
 Musée Cognacq-Jay, Paris, No. 326 (bronze, ILLUSTRATED)
1966 Larkin, 23
1968 Château de Blois, No. 470 (bronze)

1. D'Argout

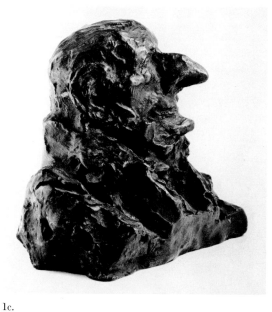

1c.

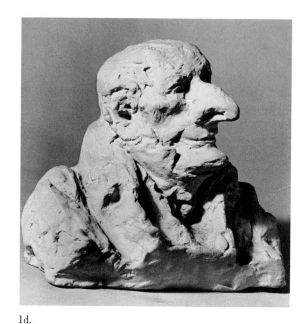

1d.

1c. D'ARGOUT
 Cast bronze; h. 5-1/16″ (128.5 mm.)
 Markings: lower left rear: MLG; inside: 23/30
 National Gallery of Art, Lessing J. Rosenwald Collection

1d. D'ARGOUT
 Terra-cotta reproduction; h. 4-31/32″ (126 mm.)
 Galerie Sagot-Le Garrec, Paris

1e. D'ARG. . . . L.D. 48
 Lithograph; 292 x 154 mm.
 La Caricature, August 9, 1832
 Fogg Art Museum, Harvard University

1f. LA FAMILLE D'ARGOUT PENDANT L'ORAGE
 (The d'Argout family during the storm) L.D. 165
 Lithograph, second state, white paper; 265 x 200 mm.
 Charivari, September 29, 1833
 Museum of Fine Arts, Boston
 (not illustrated)

1g. UN NOUVEAU-NEZ (A new nose) L.D. 172
 Lithograph, white paper; 268 x 205 mm.
 Charivari, November 7, 1833
 Benjamin A. and Julia M. Trustman Collection,
 Brandeis University
 (not illustrated)

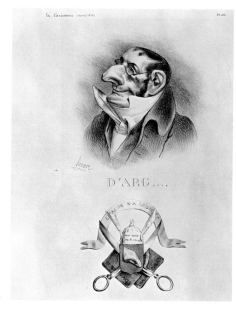

1e.

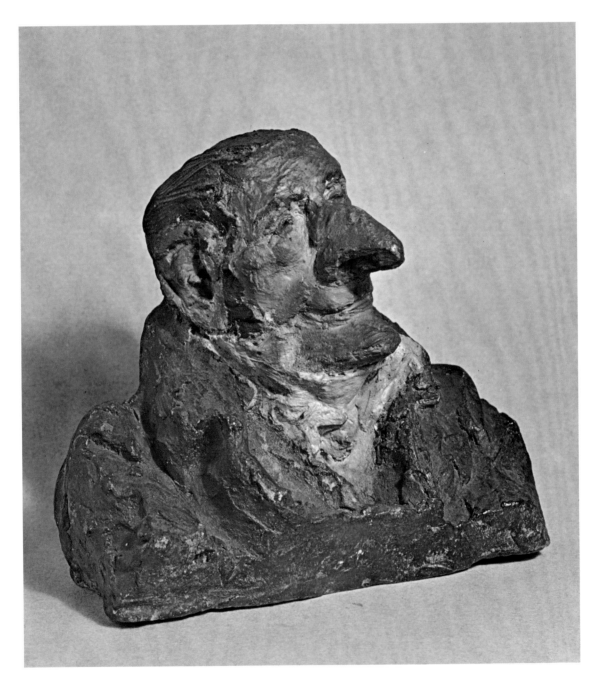

1a.

2. Baillot

Claude 1771- ?

Gobin No. 22

The fame of Baillot, or Bailliot, rests on the fact that he was caricatured in clay by Daumier. The clay was first identified in 1932 by Bouvy in his book *Trente-six bustes de H. Daumier* (no. 22). He must have patiently matched the bust to the single lithograph Daumier made of Baillot. Mourre wrote that Baillot was an exchange agent (1948, p. 99). Kaiser, in the 1952 Berlin exhibition catalogue, added that he was made a Peer of France after his son was killed in an insurrection in 1834 (Deutsche Akademie, no. 22). Durbé noted that Baillot's name had appeared three or four times in *Charivari* in March and June of 1833. For this reason he dated the bust that year and considered it one of the last that Daumier made (Poldi Pezzoli, 1961, no. 33).

The bust is a large one, and seems to fit in with Dubois (cat. no. 8a) and Lecomte (cat. no. 21a). As in the latter, Daumier placed a blocky head upon square shoulders. The expression is one Daumier repeated several times, with the eyes squinted shut causing lines to radiate out from their inner corners.

Daumier's only lithograph of Baillot is a full-length portrait included in the series *Chambre non prostituée* in *La Caricature* (September 12, 1833). The lithograph does not seem to be more than generally derived from the bust, for in the print the eyes are open, the eyebrows arch higher, and the mouth is clenched and pursed, an expression which caused a sharp vertical line to extend from the corner of the mouth to the chin. In the lithograph Baillot has, on the whole, a more alert and cantankerous expression. It would appear that Daumier made the clay in 1832 when he was working on the *Celebrity* series, but did not draw Baillot's portrait until 1833. While retaining the features of his bust — puffy eyes, bulbous nose, hollow cheek, and cleft chin — Daumier chose to portray the man in a different mood (see cat. no. 2c).

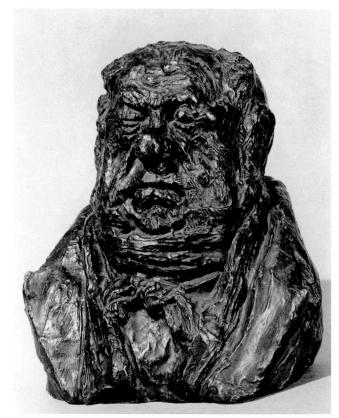

2b.

2a. BAILLOT
 Unbaked clay, painted; h. 7-3/16″ (183 mm.)
 Bronze edition of 25
 Collection Madame Berthe Le Garrec, Paris
 (not in exhibition)

2b. BAILLOT
 Cast bronze; h. 6⅞″ (175 mm.)
 Markings: lower right side: MLG; bottom rim: 2200-1;
 inside: 3/25
 National Gallery of Art, Lessing J. Rosenwald Collection

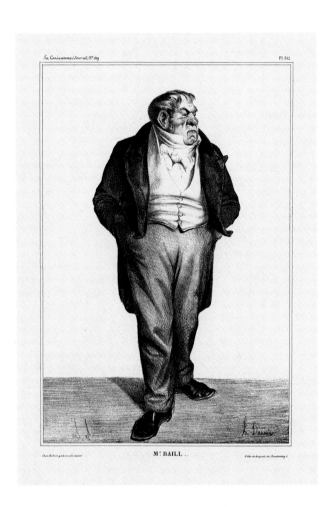

2c. MR. BAILL. . . . L.D. 69
 Lithograph; 280 x 190 mm.
 La Caricature, September 12, 1833
 Private Collection, Boston

HISTORY

1932 Bouvy, No. 22 (clay, ILLUSTRATED)
1948 Mourre, 99
1952 Gobin, No. 22 (clay, ILLUSTRATED)
 Deutsche Akademie der Künste, Berlin, No.
 22 (bronze, ILLUSTRATED)
1957 Galerie Sagot-Le Garrec, Paris, No. 22
 (bronze)
1958 Bibliothèque Nationale, Paris, No. 10 (bronze)
 Los Angeles County Museum, No. 234
 (bronze)
1961 Museo Poldi-Pezzoli, Milan, No. 33 (bronze,
 ILLUSTRATED)
1966 Larkin, 23
 Palais Galliera, Paris, No. 23 (bronze, ILLUS-
 TRATED)
1968 Hôtel Drouot, Paris, No. 3 (bronze, ILLUS-
 TRATED)
 Château de Blois, No. 461 (bronze)

3. Barthe

Félix 1795-1863

Gobin No. 5

Although Geffroy identified the bust of Barthe in 1905, he did not illustrate it. He wrote that Barthe was "Keeper of the Seals, Minister of Justice, moon-faced, tallow-like" (p. 105). Gobin called him "L'Important Personnage" (The Important Personage) and, in 1952, was the first to illustrate the clay (no. 5). Our photograph (see cat. no. 3a) apparently illustrates this clay for only the second time.

A large repair at the base of the bust on its left is visible in both photographs (this detail carries over into the bronze). Since the 1952 photograph the cracks at the top of the head have widened and the left nostril has deteriorated. According to Romand, the bust has now been completely restored.

Barthe was one of the twelve bronzes cast in 1929-30. A bronze was illustrated in the Museum of Modern Art *Corot-Daumier* catalogue (1930, no. 136). Bouvy also chose to illustrate a bronze (1932, no. 5).

Barthe was a fairly well-known figure. Mourre wrote that he had been a revolutionary in 1830, and served as a defender of the four sergeants of La Rochelle. Later as a Minister and Peer, he became more conservative (1948, p. 99). The Paris Bibliothèque Nationale Daumier catalogue explained that Barthe, a lawyer, though liberal at first, "began curbing the misdemeanors of the press, and presented the law of censure of political associations." This catalogue added that "the little magazines pretended his cross-eyes allowed him to watch both Carlists and Republicans at the same time" (Bibliothèque Nationale, 1958, no. 11). Durbé, seeking the reason that Barthe was chosen for caricature, explained that in the 1820's Barthe was one of the *carbonari* (revolutionaries), and received acclaim in 1822 for his defense of his fellows, the four sergeants. But he was ambitious; he joined the July Revolution, becoming Deputy and Minister, and growing conservative. Thus, wrote Durbé, he became an object of attack by the papers, who explained his about-face by his cross-eyes. Daumier included Barthe in "Masks of 1831" (cat. no. A), "Charenton" (cat. no. B), the "Cour du Roi Petaud," and the "Ventre législatif" (cat. no. C). Attacks on him in Philipon's papers were especially strong in 1831 and 1832. From this Durbé concluded the bust was one of Daumier's first (Museo Poldi Pezzoli, 1961, no. 9).

We feel, on the contrary, that the bust of Barthe should be grouped with Sébastiani and Etienne, since it shares their haughty expressions and straight-lipped mouths. The working of the eyes, however, is closer to that of Guizot, Delessert, and other, larger, busts. Like these, in Barthe, Daumier turned his attention away from facial expressions (surface detail) to the cranial structure underneath the skin. Barthe's head is flattened on one side, and the two eye sockets are different, reflecting his cross-eyes. This detail is exaggerated even more greatly in Delessert (see cat. no. 6a).

Daumier's lithographed portrait of Barthe is a full-length figure from the *Chambre non prostituée* series of 1833 (see cat. no. 3c). As in the clay, the head is smoothly rounded, with a minimum of surface detail, the major modulation being the deep shadows of the eye sockets. Daumier did not reverse the features in the lithograph, probably to be faithful to the fact that it was the man's left eye that squinted.

HISTORY

1905 Geffroy, 105 (referring to clay)
1930 MOMA, New York, No. 136 (bronze, ILLUSTRATED)
1932 Bouvy, No. 5 (bronze, ILLUSTRATED)
1934 Bibliothèque Nationale, Paris, No. 377 (bronze)
1948 Mourre, 99
1952 Gobin, No. 5 (clay, ILLUSTRATED)
 Deutsche Akademie der Künste, Berlin, No. 5 (bronze, ILLUSTRATED)
1957 Galerie Sagot-Le Garrec, Paris, No. 5 (bronze)
1958 Bibliothèque Nationale, Paris, No. 11 (bronze)
 Los Angeles County Museum, No. 226 (bronze)
1961 Museo Poldi Pezzoli, Milan, No. 9 (bronze, ILLUSTRATED)
1968 Château de Blois, No. 444 (bronze)

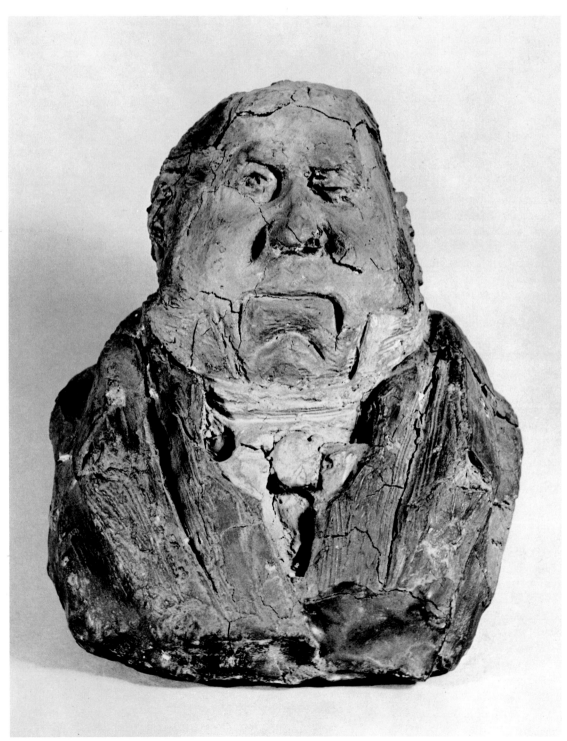

3a.

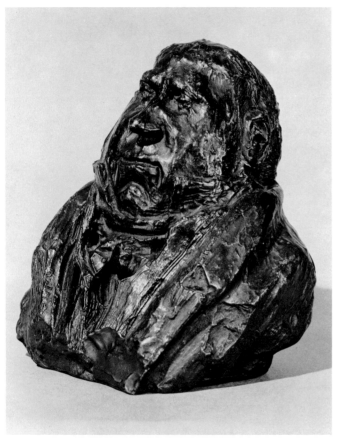

3b.

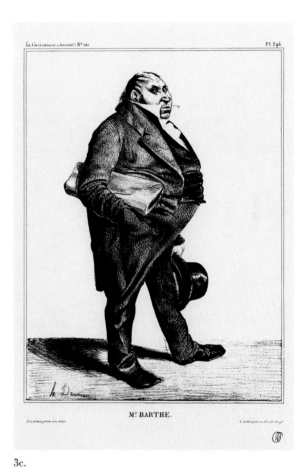

3c.

3a. BARTHE
 Unbaked clay, painted; h. 6-11/16″ (170 mm.)
 Bronze edition of 25 made beginning 1929
 Collection Madame Berthe Le Garrec, Paris
 (not in exhibition)

3b. BARTHE
 Cast bronze; h. 6⅜″ (162 mm.)
 Markings: left center rear: MLG; bottom rim: 3/25;
 inside: 3/25
 National Gallery of Art, Lessing J. Rosenwald Collection

3c. MR. BARTHE L.D. 63
 Lithograph; 268 x 204 mm.
 La Caricature, July 18, 1833
 Benjamin A. and Julia M. Trustman Collection,
 Brandeis University

53

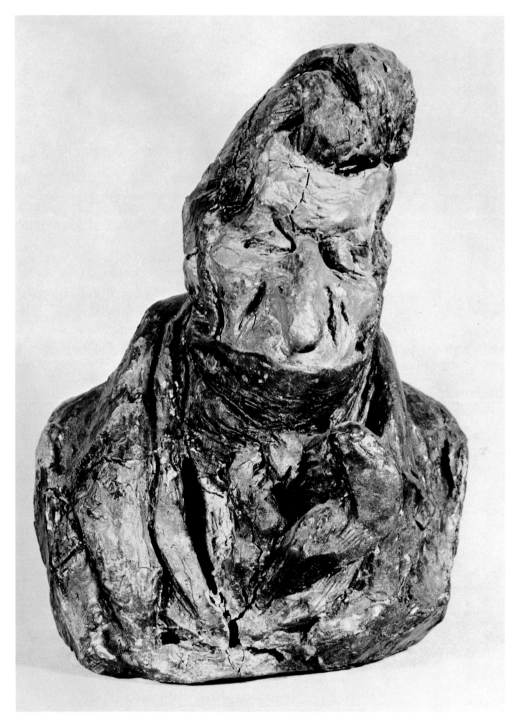

4a.

4. Chevandier de Valdrome

Jean-Auguste 1781-1878

Gobin No. 14

Gustave Geffroy is responsible for bringing the name of this minor personage back into the light. He illustrated the bust in 1905 and noted that he had relied on labels made by Champfleury to identify many of the busts. A paper label attached to the clay with "Chevandier Député" on it is clearly visible in his photograph. Geffroy described Chevandier as a Deputy "with the double unrolling of his forelock and his trumpet-like nose" (p. 105). Before Geffroy, Dayot had illustrated the bust, unidentified, although the label shows in his photograph as well (see cat. no. 4b). Why did he not read it? Perhaps the name meant nothing to him. Phillips and Fuchs reproduced photographs identical to Geffroy's, but in Fuchs' the label has been erased from the photograph. In 1948 Mourre still found Chevandier "dead without a trace" (p. 99). It was Adhémar in 1958, in the Bibliothèque Nationale catalogue, who added that he was also the Director of the manufacture of mirrors of Cirey (no. 12).

This bust of Chevandier, sunk down into his collar asleep, is one of the most amusing of the series. A lugubrious undulating motion rolls down from his heavy, rounded pompadour, to his big nose, to his plump, protruding Windsor tie. Repairs are already visible in the 1905 photograph, where the left shoulder seems to have been broken and mended. There is no record of a bronze of Chevandier before the Berlin exhibition in 1952 (Deutsche Akademie, no. 14). However, at least one must have been cast by 1948 when a complete set of thirty-six bronzes entered the Marseilles Museum.

Chevandier appears only once in the lithographs, in *Charivari*, June 20, 1833 (see cat. no. 4d). In the print Daumier adhered fairly closely to the bust, emphasizing the sleeping eyes but flattening down the tie and pompadour. The head in the lithograph tips to the opposite side from the angle of the bust, and the angle of the tie is reversed, which suggests that Daumier drew from the bust directly onto the stone.

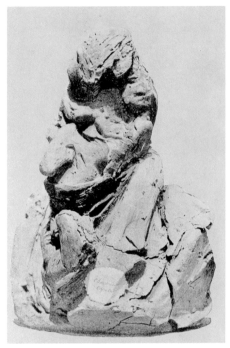

4b.

4a. CHEVANDIER DE VALDROME
Unbaked clay, painted; h. 7½″ (190 mm.)
Bronze edition of 25
Collection Madame Berthe Le Garrec, Paris
(not in exhibition)

4b. Early photograph of unbaked clay no. 4a from Dayot, 1897, II, p. 35

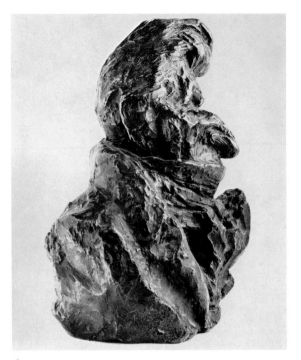

4c.

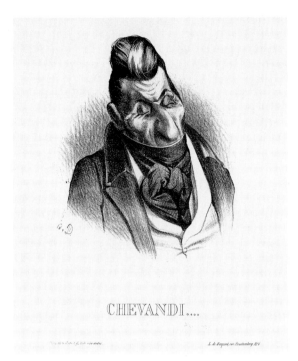

4d.

Durbé found no other mention of Chevandier in *Charivari*, and none in *La Caricature*. He dated the bust in 1833, among the later ones (Poldi Pezzoli, 1961, no. 27). The bulbosity of the forms of this bust makes it similar to Montlosier (see cat. no. 23a), with the head dropped forward in a similar manner. Unique among the busts, Chevandier is certainly asleep.

4c. CHEVANDIER DE VALDROME
Cast bronze; h. 7-3/16″ (183 mm.)
Markings: lower left rear: MLG; bottom rim: 2183; inside: 3/25
National Gallery of Art, Lessing J. Rosenwald Collection

4d. CHEVANDI. . . . L.D. 153
Lithograph; 156 x 132 mm.
Charivari, June 20, 1833
Museum of Fine Arts, Boston

HISTORY

1897 Dayot, II, 35 (clay, ILLUSTRATED)
1905 Geffroy, 105, 103 (clay, ILLUSTRATED)
1922 Phillips, n.p. (clay, ILLUSTRATED)
1927 Fuchs, No. 169c: "terra cotta" (actually clay, ILLUSTRATED)
1932 Bouvy, No. 14 (clay, ILLUSTRATED)
1948 Mourre, 99
1952 Gobin, No. 14 (clay, ILLUSTRATED)
Deutsche Akademie der Künste, Berlin, No. 14 (bronze, ILLUSTRATED)
1958 Bibliothèque Nationale, Paris, No. 12: 1810-1878 (bronze)
1961 Museo Poldi Pezzoli, Milan, No. 27: b. 1781 (bronze, ILLUSTRATED)
1968 Château de Blois, No. 453 (bronze)

5. Cunin (also called Cunin-Gridaine)

Laurent 1778-1859

Gobin No. 34

Mourre summed up Cunin as "a simple worker, great patron, minister — made a fine career and was satisfied" (1948, p. 100). Laurent Cunin was an industrialist who rose to political power. He married the daughter of his associate Gridaine, took his name, and succeeded him in business. He took part in the July Revolution. After 1830 he acquired great political importance and filled posts in all the cabinets. In 1830 and 1832 he served as Secretary and Vice President of the Chamber. Durbé wrote that he was generally attacked in the papers at that time for his lack of action (Museo Poldi Pezzoli, 1961, no. 15; also Deutsche Akademie, Berlin, 1952, no. 34; and Bibliothèque Nationale, Paris, 1958, no. 18).

The sculpture of Cunin is first mentioned in Bouvy, who identified him and illustrated the clay (1932, no. 34). A bronze was included in the 1936 Daumier exhibition at the Albertina museum in Vienna (no. 80). Gobin (1952, no. 34) called him "Le Mauvais" (The Bad One). The bust of Cunin was one of four to be represented by terra-cotta reproductions in the 1934 Daumier exhibition in Paris (Bibliothèque Nationale, no. 393). The others were Harle, Lameth, and Sébastiani. They were lent by Maurice Le Garrec. In 1948 Madame Le Garrec explained that these were four of the terra cottas that her husband had had cast by Fix-Masseau from the plaster molds from which the bronzes were also cast (*Arts et Livres*, p. 102). To date these have not been put on the market.

This clay bust, like that of Sébastiani, is one of the small, delicate sculptures in which Daumier took great care to define the texture of hair and its style as well as the wrinkles of the skin caused by the disapproving expression. His expression lies between the grimaces of one of the unknown clays (see cat. no. 33a), and the expressionless face of larger busts like Barthe. Daumier worked the hair into large curls, then indicated the texture with a comb tool. The beady eyes, which look slightly crossed, were made by poking a sharp instrument into the clay to indicate pupils. As in most of the busts, Daumier textured the coat and shirt front with the comb. The clay is in apparently good condition (see color plate, cat. no. 5a).

On July 18, 1833, the lithograph of Cunin appeared in the same issue of *La Caricature* with that of Barthe (see cat. no. 5c). This is the only print Daumier made of Cunin. There are many changes from the clay to the lithograph, besides the addition of spectacles. In the lithograph Daumier did not attempt to repeat the active, wrinkled surface of the clay, but smoothed out the brow and cheeks. Where the face of the clay seems quite flat, the face of the lithograph is rounded, almost puffy (note the lines of the cheek). The cleft of the chin was eliminated. The tie, with one end pointed downward, is not reversed in the lithograph. There is a good case to be made for the theory that Daumier made all the busts in 1832, when the first lithographs appeared (Lameth, Dupin), for the lithographs of 1833 are generally quite changed from the clays, as if Daumier were no longer bothering to copy them carefully (for example Etienne, Harle, Royer-Collard, or Sébastiani).

HISTORY

1932 Bouvy, No. 34 (clay, ILLUSTRATED)
1934 Bibliothèque Nationale, Paris, No. 393 (terracotta reproduction)
1936 Albertina, Vienna, No. 80 (bronze)
1948 Mourre, 100
 Le Garrec, Berthe, *Arts et Livres*, 102 (terracotta reproduction)
1952 Gobin, No. 34 (clay, ILLUSTRATED)
 Deutsche Akademie der Künste, Berlin, No. 34 (bronze, ILLUSTRATED)
1957 Galerie Sagot-Le Garrec, Paris, No. 34 (bronze)
1958 Bibliothèque Nationale, Paris, No. 18 (bronze)
 Los Angeles County Museum, No. 238 (bronze, ILLUSTRATED)
1961 Museo Poldi Pezzoli, Milan, No. 15 (bronze, ILLUSTRATED)
1966 Hôtel Drouot, No. 13 (bronze, ILLUSTRATED)
1968 Château de Blois, No. 473 (bronze)

5. Cunin (also called Cunin-Gridaine)

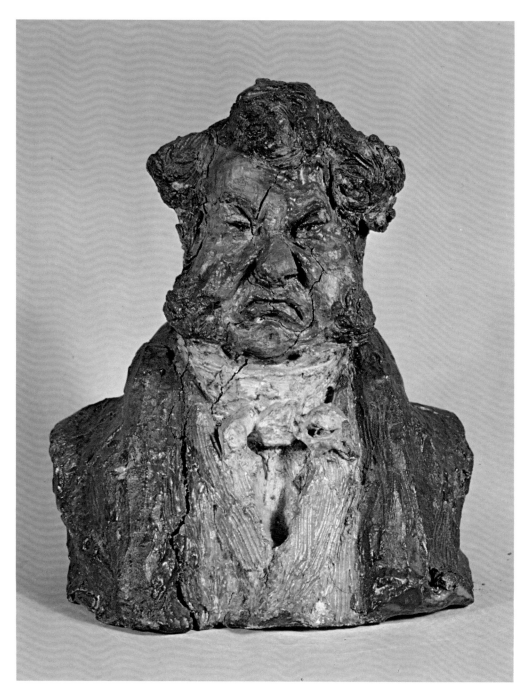

5a.

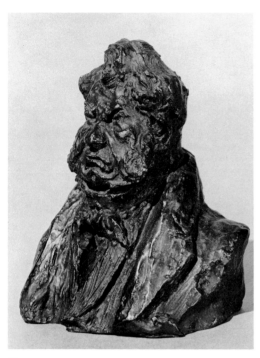

5b.

5a. CUNIN
Unbaked clay, painted; h. 5-31/32″ (152 mm.)
Bronze edition of 25 begun by 1936
Collection Madame Berthe Le Garrec, Paris
(not in exhibition)

5b. CUNIN
Cast bronze; h. 5¾″ (146 mm.)
Markings: lower center rear: MLG; inside: 23/25
National Gallery of Art, Lessing J. Rosenwald Collection

5c. MR. CUNIN GRID. . . . L.D. 64
Lithograph; 285 x 185 mm.
La Caricature, July 18, 1833
Private Collection, Boston

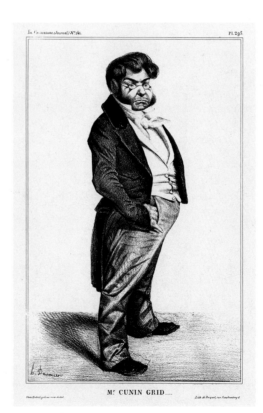

5c.

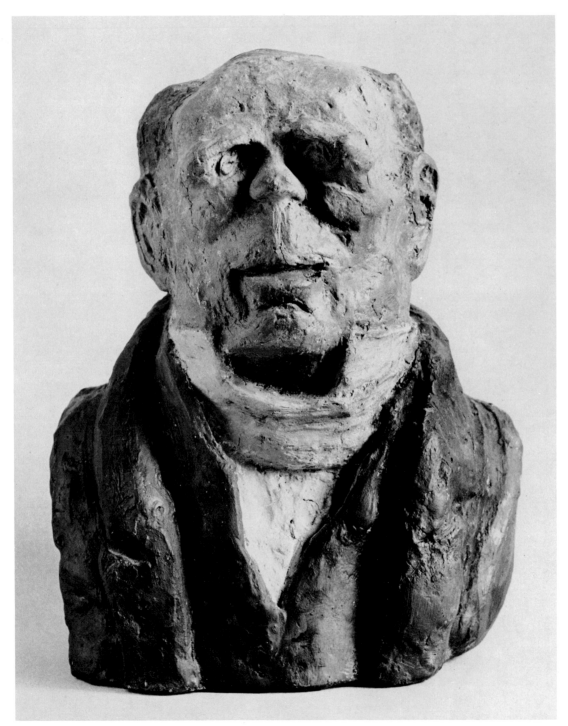

6a.

6. Delessert

Benjamin 1773-1847

Gobin No. 2

In the case of Delessert, the bronze appears in photographs well before the clay, for the bronze, one of the first cast (1929-30) was illustrated in Bouvy in 1932 (no. 2). The earliest photograph of the clay yet located is in Gobin (1952, no. 2). However, in discussing the clays he had identified at Philipon's in 1905, Geffroy mentioned Delessert, "the prefect with his soupçon of a nose and baboon's mouth . . ." (p. 105).

Though Gobin called the bust "Le Têtu borné" (Stubborn and Narrow-minded), Delessert was actually an active member of the Philanthropical Society, and was one of the first modern industrialists. His spirit of initiative led him into several fields. Mourre wrote that in 1806 he was the first to obtain crystalized beet sugar (1948, p. 98). Kaiser said Delessert established the first cotton-spinning mill in Passy in 1801 (Deutsche Akademie, 1952, no. 2). He was made a member of the Academy of Science in 1816 and left them a magnificent botanical and shell collection. He served as a Deputy for twenty-five years. He was also a banker. Durbé found that his name was mentioned in the papers along with other bankers during the confrontations of the June insurrection, which he felt confirmed an 1833 dating for the clay (Museo Poldi Pezzoli, no. 25).

The clay, which has been restored, appears to be in good condition. It is close in handling to Guizot, Fulchiron, and Vatout, whose balding heads allowed Daumier to concentrate upon unusual crania. Both Delessert and Guizot (see cat. no. 17) have close-set eyes in deep sockets over sharp, protruding cheekbones, and straight lips over turned-up chins. Delessert's features seem almost to have developed out of Guizot's, pushed into greater irregularity by Daumier's witty thumb. His eye sockets are deeper and more irregular than Guizot's, his pupils are transformed into flat buttons, and his rudimentary nose sits above an even more elongated upper lip.

Daumier made two lithograph portraits of Delessert, in June and October of 1833, and if anything, made Delessert even more grotesque in crayon than in clay (see cat. nos. 6c and 6d). Though the pose and features are similar, there are differences between the two media. For example, Daumier used

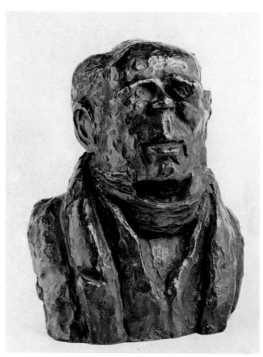

6b.

6a. DELESSERT
Unbaked clay, painted; h. 7-5/32″ (182 mm.)
Bronze edition of 25 made beginning 1929
Collection Madame Berthe Le Garrec, Paris
(not in exhibition)

6b. DELESSERT
Cast bronze; h. 6⅞″ (175 mm.)
Markings: lower left side: MLG; bottom rim: 3/25 A²; inside: 3/25
National Gallery of Art, Lessing J. Rosenwald Collection

6. Delessert

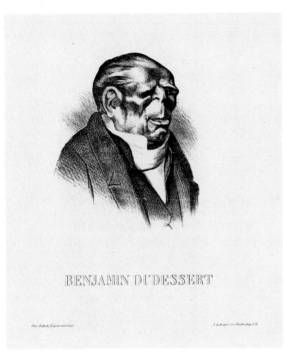

6c.

6c. BENJAMIN DUDESSERT L.D. 170
Lithograph, second state; 180 x 120 mm.
Charivari, October 26, 1833
Boston Public Library

6d. MR. BENJAMIN DUDESSERT L.D. 59
Lithograph; 275 x 185 mm.
La Caricature, June 27, 1833
Private Collection, Boston
(not illustrated)

cross-hatching for texture and shading in both litho-graphs (see coat, hollow of cheek, and background), but there are no visible traces of his typical use of the rake for similar purposes on the clay. Such detailing may have been lost in restoration. In the drawings the head is round, while the clay head seems square. And further, the nose changes from a blob in the clay to a short, bony beak in both lithographs.

Delessert was included in the "Ventre législatif" of 1834 (cat. no. C). Otherwise, Daumier had no further incentive for attacking this well-known man even if he did have extraordinary features.

HISTORY

1905 Geffroy, 105 (referring to clay)
1930 MOMA, New York, No. 146 (bronze)
1932 Bouvy, No. 2 (bronze, ILLUSTRATED)
1934 Bibliothèque Nationale, Paris, No. 378 (bronze)
1936 Albertina, Vienna, No. 76 (bronze)
1939 Buchholz Gallery, New York, No. 6 (bronze)
1948 Mourre, 98
1952 Gobin, No. 2 (clay, ILLUSTRATED)
 Deutsche Akademie der Künste, Berlin, No. 2 (bronze, ILLUSTRATED)
1957 Galerie Sagot-Le Garrec, Paris, No. 2 (bronze)
1958 Bibliothèque Nationale, Paris, No. 14: gives his dates as 1773-1857 (bronze)
1961 Museo Poldi Pezzoli, Milan, No. 25 (bronze, ILLUSTRATED)
 Musée Cognacq-Jay, Paris, No. 318 (bronze, ILLUSTRATED)
1966 Palais Galliera, Paris, No. 18 (bronze, ILLUSTRATED)
1968 Hôtel Drouot, No. 1 (bronze, ILLUSTRATED)
 Château de Blois, No. 441 (bronze)

62

7. Delort

Jacques-Antoine-Adrian, Baron 1773-1846

Gobin No. 29

This clay was illustrated by Geffroy in 1905 and identified as Delort, "General and Deputy" (pp. 104 and 106). The early photograph is reproduced here (cat. no. 7b). Fuchs, in 1927, reproduced the same photograph (no. 169a). Durbé described Delort as a "Baron, an ex-Napoleonic general, and aide-de-camp for Louis Philippe." His name appeared in *Charivari* May-October, 1833 (Poldi Pezzoli, 1961, no. 29). At 9¼" it is the largest of Daumier's clay busts.

Daumier's major quarrel with Delort was probably that he was "prostituting himself" (Philipon called him *"doublement improstitué,"* in *Charivari*, June 29, 1833), one of Napoleon's valiant generals, by serving as aide-de-camp to Louis Philippe. Daumier seems to have drawn only the one lithograph of him (cat. no. 7d), in which he chose to reproduce the most flattering angle of the bust.

Although the bust in front view, like the lithograph, makes Delort look quite distinguished (see cat. no. 7b), in profile Daumier made him look remarkably stupid (see cat. no. 7a). With his tufts of hair and a beard framing his face and squaring it off, his frontal aspect is handsome enough. But Daumier was not one to see an object unilaterally, and any other angle shows the general's long, scrawny neck, his elongated, bent, and bumpy skull, and ape-like mouth. The vertical lines or fine wrinkles along the upper lip, visible in the 1905 photograph, have now been smoothed away, eliminating some of the intended simian effect, though restoration has not destroyed the fine lines with which Daumier drew the hair. The early photograph also suggests that the original polychromy made the face quite dark, almost florid, especially across the cheeks and nose. This clay shares similarities with Lefebvre, Gallois, Falloux, and Pataille. Like the first two, a ruffle of hair frames the balding head, and like Pataille, there are alarming bumps, like cropped horns, on the forehead. Gobin called him "Le Moqueur" (The Mocker). A better epithet might be "The Mocked."

HISTORY

1905 Geffroy, 106; 104 (clay, ILLUSTRATED)
1927 Fuchs, No. 169a (clay, ILLUSTRATED)
1932 Bouvy, No. 29 (clay, ILLUSTRATED)
1934 Bibliothèque Nationale, Paris, No. 379 (bronze)
1936 Albertina, Vienna, No. 79 (bronze)
1948 Mourre, 100
1952 Gobin, No. 29 (clay, ILLUSTRATED)
 Deutsche Akademie der Künste, Berlin, No. 29: "General under Napoleon I; Deputy in 1830; Peer in 1837" (bronze, ILLUSTRATED)
1957 Galerie Sagot-Le Garrec, Paris, No. 29 (bronze)
1958 Bibliothèque Nationale, Paris, No. 15 (bronze)
1961 Musée Cognacq-Jay, Paris, No. 324 (bronze, ILLUSTRATED)
 Museo Poldi Pezzoli, Milan, No. 29 (bronze, ILLUSTRATED)
1966 Palais Galliera, Paris, No. 24 (bronze, ILLUSTRATED)
1968 Château de Blois, No. 468 (bronze)

7. Delort

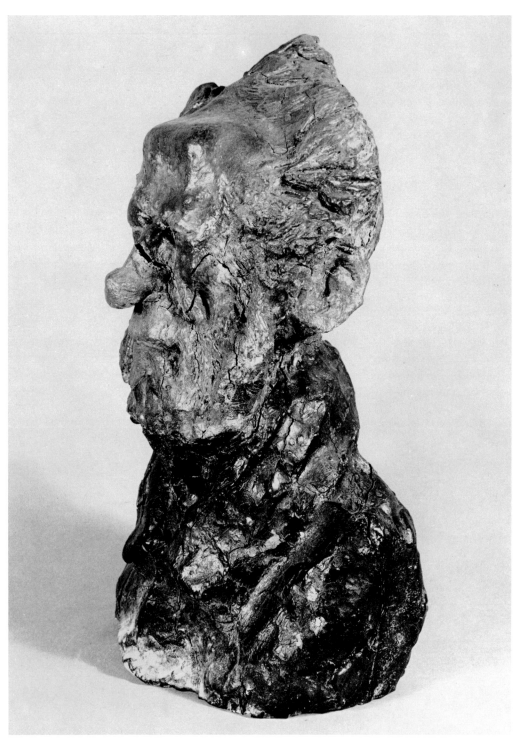

7a.

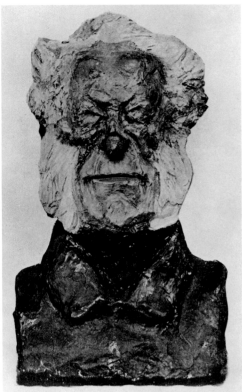

7b.

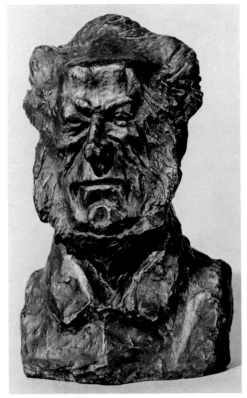

7c.

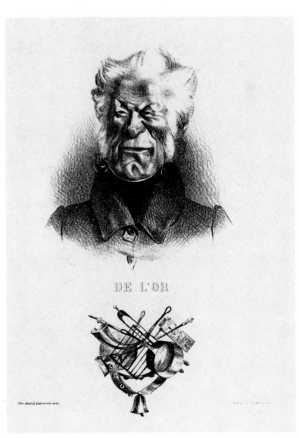

7a. DELORT
 Unbaked clay, painted; h. 9¼″ (235 mm.)
 Bronze edition of 25 begun by 1934
 Collection Madame Berthe Le Garrec, Paris
 (not in exhibition)

7b. Early photograph of unbaked clay no. 7a from Geffroy,
 1905, p. 104

7c. DELORT
 Cast bronze; h.. 9-5/16″ (236.5 mm.)
 Markings: lower right rear: MLG; inside: 23/25
 National Gallery of Art, Lessing J. Rosenwald Collection

7d. DE L'OR L.D. 154
 Lithograph, second state; 290 x 160 mm.
 Charivari, June 29, 1833
 Boston Public Library

7d.

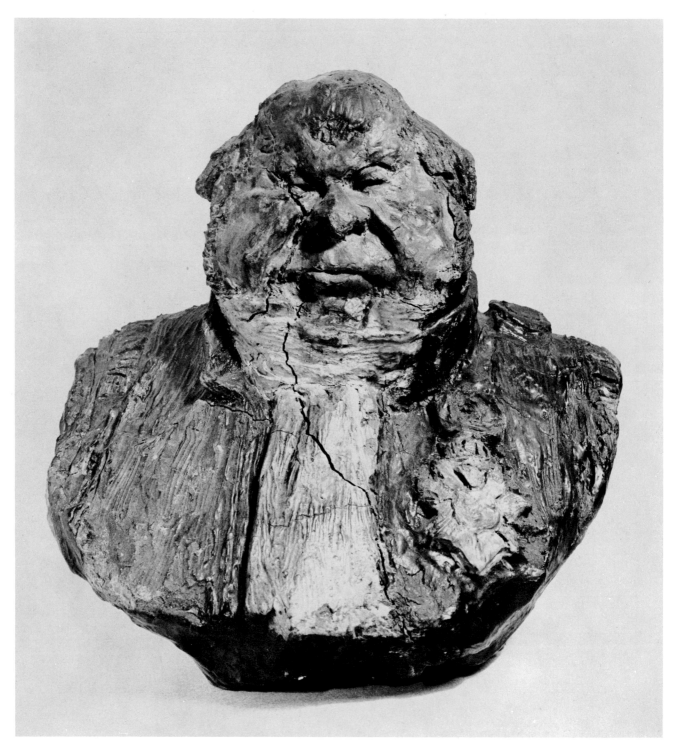

8a.

8. Dubois

Hippolyte-Abraham 1794-1863

Gobin No. 27

This large bust was one of the eleven illustrated in 1897 by Dayot (II, p. 3), who called him a "corpulent type from the July Government." In Dayot's photograph, reproduced here (see cat. no. 8b), there is clearly visible a paper label attached to the bust, at the bottom below the medallion, and the label appears to say "Dubois." It seems odd that Dayot did not read it. Geffroy wrote in 1905 that these labels were attached by Champfleury. The tag is also visible in Geffroy's photograph of the bust, which he identified as "Dubois d'Angers, Deputy and President of the court of assizes, with his fat, heavy-set appearance, his chubby-cheeked face" (Geffroy, p. 105). Fuchs repeated Geffroy's photograph (1927, no. 170b). Durbé in 1961 is the first to elaborate upon Dubois' biography, explaining that from March 1833 he was the magistrate who presided over the trial of the assassin who attacked Louis Philippe. Dubois was also a Deputy, and became a judge as a result of his political career. In March and April, 1833, *Charivari* dedicated an article to him daily. Durbé felt that the bust was made at the same time as Podenas in 1833 (Poldi Pezzoli, 1961, no. 19). Gobin's nickname for him, "Le Gros, Gras et . . . Satisfait" (Big, Fat and . . . Satisfied), was borrowed from the title of an 1833 lithograph of Louis Philippe (L.D. 176).

No bronzes of Dubois were published before 1952 (Deutsche Akademie, no. 27); however, some casts must have existed by 1948 when the Marseilles museum received a complete set.

The bust is similar in height (nearly 8″) and breadth to Podenas (cat. no. 27a). Both men have small, narrow eyes, heavy jowls, and a cold, unbending air. Both seem massive and grim. Also, these two busts have the most fluid contour from shoulder to shoulder along the base. While the rest of the clays are cut straight across from shoulder to shoulder, these two have a curving contour there and rest on narrow, undercut, pedestal-like bases in the more traditional manner for busts.

Though over-exposed, the early photograph of the clay shows detail somewhat different from the present restored state. The hair seems originally to have been made of small, irregularly-placed pellets

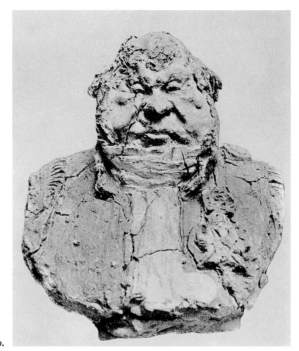

8b.

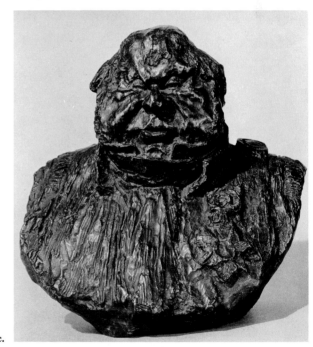

8c.

8a. DUBOIS
 Unbaked clay, painted; h. 7-29/32″ (201 mm.)
 Bronze edition of 25
 Collection Madame Berthe Le Garrec, Paris
 (not in exhibition)

8b. Early photograph of unbaked clay no. 8a from Dayot,
 1897, II, p. 3

8c. DUBOIS
 Cast bronze; h. 7-9/16″ (192 mm.)
 Markings: lower right rear: MLG; inside: 23/25
 National Gallery of Art, Lessing J. Rosenwald Collection

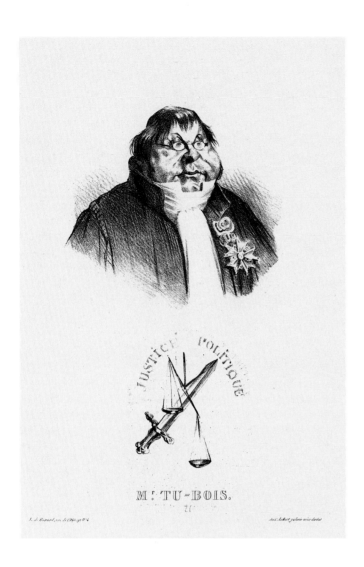

JUSTICE POLITIQUE

M. TU-BOIS.

8d. MR. TU-BOIS L.D. 144
Lithograph, first state; 215 x 140 mm.
Charivari, March 25, 1833
Boston Public Library

of clay, similar in handling to the unknown, cat. no. 33a. Today this rough texture is greatly smoothed out. Gone also are the warts between the eyes, over the right eye, and out on the left cheek. Daumier dressed Dubois in his judge's robe worn over a white collar and flowing stock. Even in the pale early photograph one may distinguish fine vertical and horizontal lines drawn lightly into the surface of the robe to indicate folds. Here Daumier showed a draftsman's rather than a sculptor's approach. The differentiation between stock and robe is greatly lost in the monochrome bronze, a problem Daumier could have avoided had he intended the clay for casting.

Daumier made only one lithograph of Dubois, which was published in March 1833 (see cat. no. 8d). In it he emphasized the narrow skull resting on wide, sagging jowls shored up by the collar. The straggly wisps of hair suggest what Daumier was striving for in the clay. The face of the lithograph lacks the warts of the clay. With his eyes hidden by spectacles, Dubois no longer looks grim, but quite as stupid as Philipon could have wished.

HISTORY

1897 Dayot, II, 3: Unidentified (clay, ILLUSTRATED)
1905 Geffroy, 105, 107: "Dubois d'Angers" (clay, ILLUSTRATED)
1927 Fuchs, No. 170b: "colored terra-cotta" (actually clay, ILLUSTRATED)
1932 Bouvy, No. 27 (clay, ILLUSTRATED)
1948 Mourre, 100, opp. 97: "colored terra cotta" (actually clay, ILLUSTRATED)
1952 Gobin, No. 27 (clay, ILLUSTRATED)
Deutsche Akademie der Künste, Berlin, No. 27 (bronze, ILLUSTRATED)
1957 Galerie Sagot-Le Garrec, Paris, No. 27 (bronze)
1958 Bibliothèque Nationale, Paris, No. 16 (bronze)
Museo Nacional de Bellas Artes, Buenos Aires, No. 272 (bronze, ILLUSTRATED)
1961 Museo Poldi Pezzoli, Milan, No. 19 (bronze, ILLUSTRATED)
1966 Larkin, 23
1968 Hôtel Drouot, Paris, No. 6 (bronze, ILLUSTRATED)
Château de Blois, No. 466: "President of Court in famous trial of Bergeron and Benoit" (bronze)

9. Dupin (called Dupin aîné)

André-Marie-Jean-Jacques 1783-1865

Gobin No. 10

Along with Guizot, Thiers, Persil, and d'Argout, Dupin was one of the most influential men of his day, and along with the bust of d'Argout (cat. no. 1a) this clay has the oldest recorded history of the thirty-six existing busts. Mourre summed up Dupin well: "Lawyer, Attorney-General, Senator under the Empire, defender of high personalities like Ney, had many enemies, which did not prevent him from shining in all political constellations. This suppleness must have displeased Daumier" (1948, p. 98). Gobin's name "L'Orateur" (The Orator) was a natural one for Dupin (1952, no. 10). From 1831 to 1835 Dupin's name was one of the most frequently mentioned in *La Caricature* and *Charivari*. He was caricatured by Grandville, Forest, and Traviés, as well as by Daumier (Museo Poldi Pezzoli, 1961, no. 7).

Daumier's clay bust of Dupin is mentioned in Claretie in 1882 (see Introduction to the Busts). Champfleury's estate sale of 1891 included a set of photographs of thirty-four busts by Daumier, taken in 1865 by Philipon's adopted son. One of these, Champfleury had written, was a bust of Dupin (Champfleury sale, no. 72). Dayot illustrated the bust in 1897 (see cat. no. 9b), and identified it as "Dupin aîné, President of the order of French lawyers in Paris, 1829" (I, p. 2). Geffroy also illustrated the clay of Dupin, and described it thus: "all enormous mouth, fleshy, wide-open, a mean, heavy face surmounted by huge ears" (1905, p. 105). In both photographs Champfleury's paper label is visible at the bottom of the bust next to the stock. Bertels, Escholier in 1923, and Fuchs all repeated the Geffroy photograph, with the difference that the paper label was somehow erased from the photograph. In Gobin's illustration the clay is clearly broken at exactly the point where this label once was. This damage might have occurred when the label was removed from the clay in preparation for casting. Dupin was one of the first busts to be cast in bronze, in 1929-30 (see cat. no. 9d). A bronze was illustrated in the 1930 Museum of Modern Art Daumier catalogue (no. 137).

This clay surely was one of Daumier's first, along with d'Argout, the unknown bullet-headed man (cat. no. 34a), and Lameth. Like these, Dupin is small

and compact (5-13/16″ high). The joining of head and neck is clearer than in d'Argout, but the sense of the structure beneath the skin is less sophisticated than, for example, in Guizot or Delessert. As with Kératry and "Toothless Laughter" (cat. no. 35a), Daumier brought the sculpture to life by means of an exaggerated expression: his open, extra-thick lips indicate his speech-making. Only eight years earlier, David d'Angers had seen Dupin very differently, in fact, handsome and dashing with a long, straight nose and fine, thin lips (see cat. no. 9c). Doubtless, David d'Angers idealized Dupin, perhaps refining his features to make them more Grecian, but doubtless too, Daumier burlesqued him, coarsening his features to suggest the clownish mentality he wished to attribute to Dupin.

To make his Dupin, Daumier used various tools: a pointed stick for the open mouth, for the ears, the larger folds (on the sleeves), and perhaps to draw the hairline; and a comb or rake for the smaller folds, and to give texture to the collar. But his big thumb is strongly felt in the thick ears, the hollows of the cheeks, and the blunt end of the nose.

Daumier seems to have carefully translated his bust into the lithograph of June 14, 1832 (see cat. no. 9f). The long diagonal sideburns, now lost in the repaint of the restored clay, are faintly visible in the early photograph of the clay, and have also carried over into the bronze (see cat. no. 9d). The pointed head, large fleshy ears, blunt nose, large lower jaw, and thick lips are very similar in clay and print. The resemblance between the cross-hatching on the clay (see collars) and in the lithograph (see background and robe) is particularly striking here. In 1832 Dupin also appeared in several group lithographs. His features in "La Cour du Roi Petaud" of August 23 (L.D. 49), just to the left of the spear, are closest to the clay and to the individual lithograph (the features are reversed in the latter). But in others, such as the "Masks of 1831" (cat. no. A), or "Charenton" (cat. no. B), there is only a general relationship, notably in the thick lips. After utilizing the bust to draw Dupin's portrait for the *Celebrity* series, Daumier seems not to have returned to it.

When the molds were made for the bronzes, the Le Garrec family also began to make an edition of terra-cotta reproductions (see Introduction to the Busts). One of the terra-cotta Dupins has now been painted and is illustrated here (see cat. no. 9e). The terra cotta seems to reproduce form and surface detail as well as the bronzes, and the polychromy

9. Dupin (called Dupin aîné)

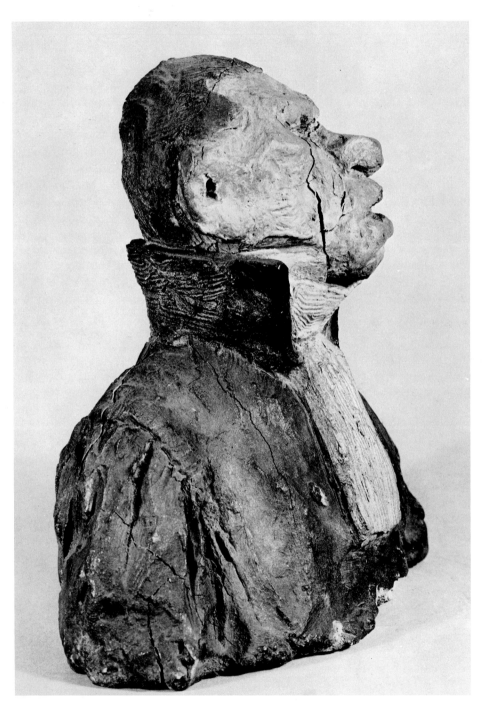

9a.

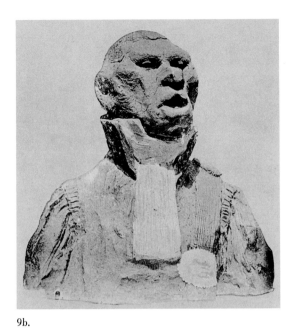

9b.

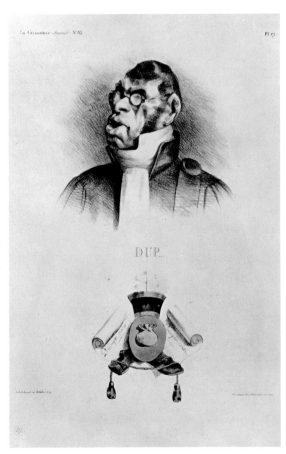

9d.

9a. DUPIN
 Unbaked clay, painted; h. 5-13/16″ (148 mm.)
 Bronze edition of 25 made beginning 1929
 Collection Madame Berthe Le Garrec, Paris

9b. Early photograph of unbaked clay no. 9a from Dayot,
 1897, I, p. 2

9d. DUPIN
 Cast bronze; h. 5⅝″ (143 mm.)
 Markings: lower left rear: MLG; inside: 3/25
 National Gallery of Art, Lessing J. Rosenwald Collection

9f. DUP. . . . L.D. 45
 Lithograph; 280 x 154 mm.
 La Caricature, June 14, 1832
 Benjamin A. and Julia M. Trustman Collection,
 Brandeis University

9f.

makes it possible to set off the stock from the robe as in the original clay. However, it seems an impossible task to recapture Daumier's coloring of the face in the terra cottas, especially since even the original clays no longer retain Daumier's coloring intact. Another, different bust of Dupin is discussed in the appendix (see cat. no. IIIa).

Dupin also appears in L.D. 9, 10, 11, 40, 44, 45, 49, 50, 98, 99, 101, 199, 201, 217, 219, 239, 1815, 1819, 1908, 1948, 1955, 1965, 1966, 1967, 1969, 1973, 2003, 2009, 2026, 2051, 2055, 2083, 2094, 2170, and wood engraving Bouvy 10.

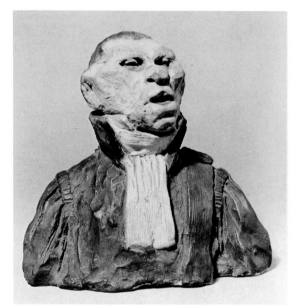

9e.

HISTORY

1882 Claretie, 320-21 (clay)
1891 Champfleury sale, No. 72 (refers to clay)
1897 Dayot, I, 2 (clay, ILLUSTRATED)
1905 Geffroy, 105 (clay, ILLUSTRATED)
1908 Bertels, No. 6: "terra cotta" (actually clay, ILLUSTRATED)
1923 Escholier, 154 (clay, ILLUSTRATED)
1927 Fuchs, No. 167c: "terra cotta" (actually clay, ILLUSTRATED)
1930 MOMA, New York, No. 137 (bronze, ILLUSTRATED)
1932 Bouvy, No. 10 (bronze, ILLUSTRATED)
1934 Bibliothèque Nationale, Paris, No. 380 (bronze, ILLUSTRATED)
1947 Musée Cantini, Marseilles, No. 23 (bronze)
1948 Mourre, 98
1952 Gobin, No. 10 (clay, ILLUSTRATED)
 Deutsche Akademie der Künste, Berlin, No. 10: "1783-1865. Lawyer, 1800, Louis Philippe's councilor . . ." (bronze, ILLUSTRATED)
1957 Galerie Sagot-Le Garrec, Paris, No. 10 (bronze, ILLUSTRATED)
1958 Bibliothèque Nationale, Paris, No. 17: "1764-1860. During the Restoration he defended liberals and the press. Under Louis Philippe named Attorney-General at the Court of Appeals, then President of the Chamber of Deputies. He demanded suppression of political associations in 1834" (bronze)
 Museum of Fine Arts, Boston, No. 14 (bronze)
 Le Foyer, 74-77 (bronze, ILLUSTRATED)
1961 Museo Poldi Pezzoli, Milan, No. 7 (bronze, ILLUSTRATED)
1963 Brandeis University, Waltham, Mass., No. 120 (bronze)
1966 Larkin, 23
1967 Licht, Pl. 81 (bronze, ILLUSTRATED)
1968 Château de Blois, No. 449 (bronze)

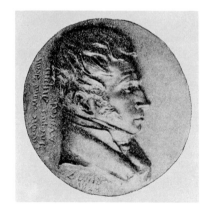

9c.

9e. DUPIN
 Terra-cotta reproduction, painted to resemble original clay; h. 5-9/16" (141 mm.)
 Galerie Sagot-Le Garrec, Paris

9c. Early photograph of medallion portrait of Dupin by David d'Angers from Dayot, 1897, I, p. 64

10. Etienne

Charles-Guillaume 1778-1845

Gobin No. 26

The bust of Etienne seems to have gone unrecorded until 1932 when Bouvy identified him and illustrated the clay (no. 26). Gobin also illustrated the clay, and nicknamed it "Le Vaniteaux" (The Vain) in 1952, (no. 26). No bronzes were published until 1952 (Deutsche Akademie der Künste, Berlin, no. 26). However, at least one must have existed by 1948 when the Marseilles museum received a complete set of bronzes.

Etienne was one of the group of literati around the July Monarchy. He was the author of brilliant, delicate comedies and melodramas, and of a history of the French theater after the Revolution, 1802. Etienne was especially known as director of the *Constitutionnel*, which was underground during the Restoration, then became the semi-official paper for the July Monarchy (Museo Poldi Pezzoli, 1961, no. 10). He was also a Deputy.

Daumier especially enjoyed attacking the editor of a rival underground journal which had become so respectable that it served as the mouthpiece for Louis Philippe's government. He drew Etienne's portrait twice, both full-length (cat. no. 10d) and in bust (cat. no. 10c), and included him in the "Masks of 1831" (cat. no. A), the "Ventre législatif" (cat. no. C), and in numerous other lithographs where he often personified his paper. Daumier's Etienne might best be described as a stuffed shirt, and indeed, Philipon wrote for the portrait that appeared in *Charivari:* "One reads in a biography of this honorable gentleman, 'There is something high and elevated about his face.' The biographer no doubt was speaking of his shirt collar." (In Museo Poldi Pezzoli catalogue, 1961, p. 114.)

Although the bust-length lithograph did not appear until September, 1833 (cat. no. 10c), the composition is very like the portraits of the *Celebrity* series, a head and shoulders set against an oval cross-hatched shadow, with the face carefully worked out in broad areas of light and shadow (see lithographs of d'Argout, Dupin, Kératry, etc.). But some similarities are noticeable between clay and lithograph, especially the shape of the nose, the long upper lip, and the pursed mouth between the wings of the collar. In the clay the eye was drawn with a pointed tool, one broad line for the closed lid and several short jabs for squint-lines beside the eye. Daumier carefully drew these same details in the lithographs. But the shape of the top and sides of the head are fuller and more rounded in the prints. The full-length lithograph bears only a general resemblance to either the clay or bust-length print, and the profile is notably more draftsmanly than sculptural. It seems probable that Daumier made the clay and the bust-length lithograph at the same time in 1832, then drew the full-length lithograph in 1833.

The clay of Etienne seems to have suffered over the years, and has been greatly restored. Reconstruction of the top and sides of the head of this bust would explain why the clay differs so from either of the portrait lithographs, for the greatest changes are in the shape of the head and hair, and the necktie. The head today seems too narrow and flattened, while one end of the tie was surely tucked under the coat originally, as in both lithographs. However, Daumier's hand is clearly visible in the face and shirt front. First his thumb pushed the nose upward and urged the cheeks into two flaps of skin, then he finished off the portrait in his draftsmanly fashion, texturing the shirt with his rake and drawing the lines around the eyes with a pointed tool.

The bust seems to fit into a group that includes Cunin, Sébastiani, and Barthe. Like the former two, Etienne wears a disdainful expression, and shows emphasized wrinkles and hollows of the skin rather than the structure beneath.

Etienne also appears in L.D. 78, 89, 99, 102, 111, 169, 176, 177, 188, 202, 203, 258, 1267, 1268.

10. Etienne

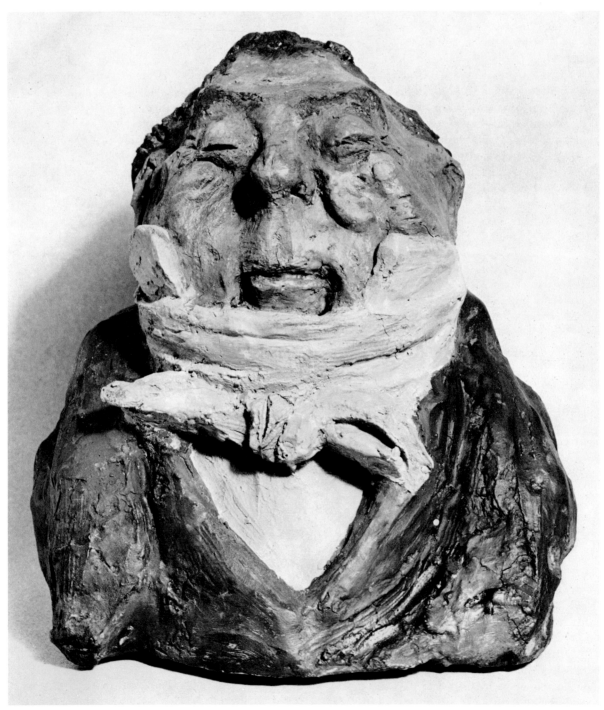

10a.

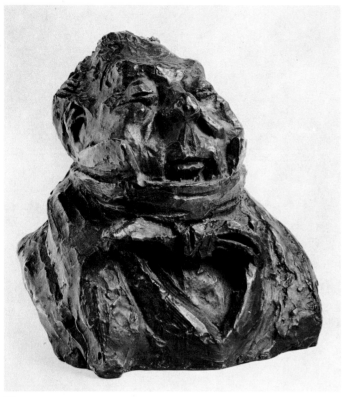

10b.

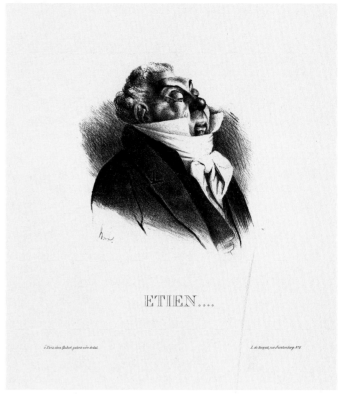

10c.

HISTORY

1932 Bouvy, No. 26 (clay, ILLUSTRATED)
1948 Mourre, 99: "Journalist, author, actor, deputy, academician. Had envied place in Paris merry-go-round"
1952 Gobin, No. 26 (clay, ILLUSTRATED)
 Deutsche Akademie der Künste, No. 26: "Author, general censor of newspapers for police, 1810; member of French Academy, 1811; revoked under Restoration; Deputy 1829; Peer 1839" (bronze, ILLUSTRATED)
1957 Galerie Sagot-Le Garrec, Paris, No. 26 (bronze)
1958 Bibliothèque Nationale, Paris, No. 18: "Dramatist, member of French Academy under Napoleon, revoked 1815. Liberal, sat to Left in 1820's. Deputy" (bronze)
1961 Museo Poldi Pezzoli, Milan, No. 10 (bronze, ILLUSTRATED)
1968 Hôtel Drouot, No. 5 (bronze, ILLUSTRATED)
 Château de Blois, No. 465 (bronze)

10a. ETIENNE
Unbaked clay, painted; h. 6-9/16″ (167 mm.)
Bronze edition of 25
Collection Madame Berthe Le Garrec, Paris
(not in exhibition)

10b. ETIENNE
Cast bronze; h. 6⅜″ (162 mm.)
Markings: lower center rear: MLG, BRONZE; inside: 23/25
National Gallery of Art, Lessing J. Rosenwald Collection

10c. ETIEN. . . . L.D. 164
Lithograph, second state; 128 x 122 mm.
Charivari, September 20, 1833
Museum of Fine Arts, Boston

10d. MR. ETIEN. . . . L.D. 57
Lithograph; 276 x 193 mm.
La Caricature, June 13, 1833
Benjamin A. and Julia M. Trustman Collection, Brandeis University
(not illustrated)

11. Falloux

A. Fred. Pierre, Comte de 1811-1866?

Gobin No. 23

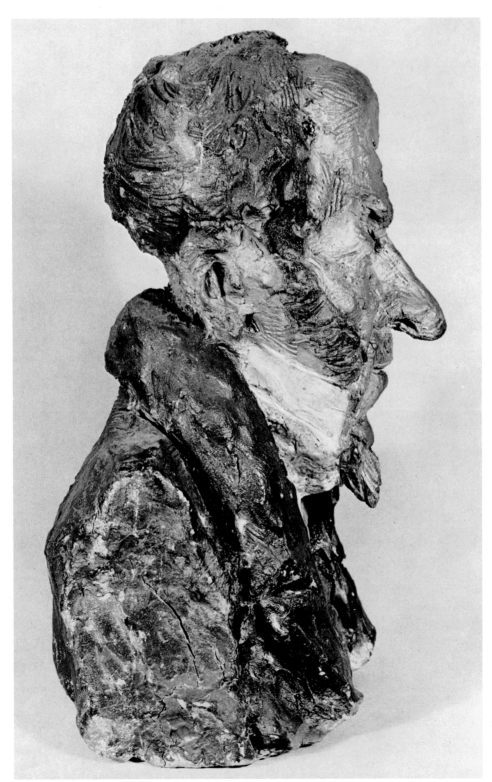

11a.

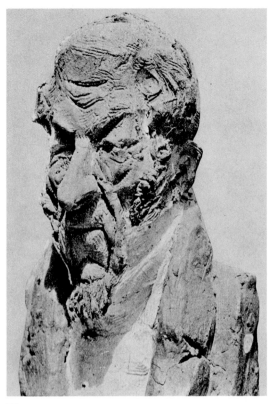

11b.

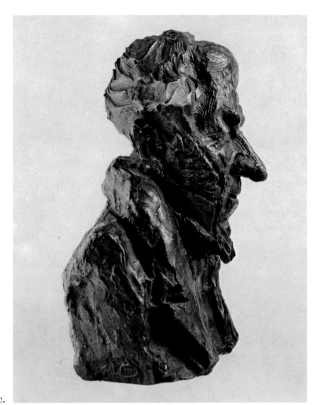

11c.

11a. FALLOUX
Unbaked clay, painted; h. 9-7/32″ (234 mm.)
Bronze edition of 25 begun by 1939
Collection Madame Berthe Le Garrec, Paris
(not in exhibition)

11b. Early photograph of unbaked clay no. 11a from Dayot,
1897, II, p. 41

11c. FALLOUX
Cast bronze; h. 8-15/16″ (227 mm.)
Markings: lower right rear: MLG; bottom rim: 2202-2;
inside: 3/25
National Gallery of Art, Lessing J. Rosenwald
Collection

11d. FALLOUX L.D. 1848
Lithograph, second state, white paper; 262 x 198 mm.
Charivari, 1849; also *Les Représentans Représentés*
Benjamin A. and Julia M. Trustman Collection,
Brandeis University

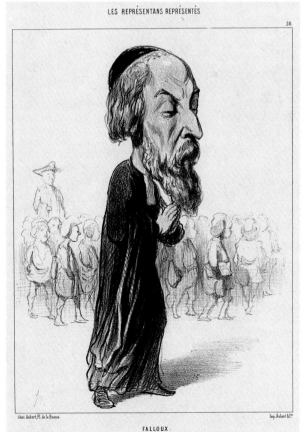

LES REPRÉSENTANS REPRÉSENTÉS

30.

FALLOUX.
Choisi, sous la république, pour être ministre de l'instruction publique, en sa qualité de frère ignorantin.

11d.

11. Falloux

There is a lively argument over the identity of this bust. Bouvy was the first to call him Falloux (1932, no. 23), probably on the basis of the lithograph included in this exhibition, which was also mentioned by Mourre (1948, p. 98). But Gobin did not agree with this identification, saying it was hard to accept, if it was the Falloux born in 1811 (which would make him about twenty-one in 1832). He called him simply "Un Malin" (A Sly One). Durbé said it could not be Alfred-Pierre, Count of Falloux, 1811-1866, famous for a law on public instruction published in 1850 (Poldi Pezzoli, 1961, no. 35).

However, there is an undeniable resemblance between the clay and the lithograph of Falloux published in 1849 (see cat. no. 11d). By 1849 Alfred-Pierre would have been thirty-eight, but this would suggest that Daumier made the clay, which is indeed of a middle-aged man, in the 1840's. Another possibility is that the clay does not represent Alfred-Pierre, but his father. Delteil called the Falloux in the lithograph "A. Fréd. Pierre" (Delteil, L.D. 1848), a similar but not identical name. If A. Fréd. Pierre had a son born in 1811 (Alfred-Pierre), he the father would have reached his forties, at least, by 1832-33, and his sixties by the time of the lithograph, ages which are certainly applicable to the clay and the lithograph. For this reason the identification of the clay as Falloux has been retained.

The clay illustrated in Dayot in 1897 was apparently in excellent condition (see cat. no. 11b). The paper label on his shoulder bears a number but no name, and Dayot did not identify him. Rümann's photograph in 1920 is identical to Dayot's. The condition of the bust today is still quite good. This large bust is only a few millimeters smaller than Delort, and their mouths and eyes are very similar. As with Delort, Gallois, Gaudry, and others, in Falloux, Daumier combined irregular bone structure with an intricate working of the skin caused by the intensity of the expression. These countenances, however, are no longer as exaggerated as Royer-Collard's or Odier's, but seem to be speaking naturally. Falloux, with his wide, round skull tapering down to a long, pointed chin and scraggly beard seems to reverse Gallois, whose features rise from a non-existent chin to a long, narrow forehead topped by a wave of hair. In Falloux, Daumier used the man's features to accentuate this downward pull, the lines of the brow sagging to the nose, and the pendulous nose hanging out over the little beard.

The fine detail of this head with its quizzical look has been quite successfully captured in the bronze (see cat. no. 11c).

HISTORY

1897 Dayot, II, 41: "Unknown" (clay, ILLUSTRATED)
1920 Rümann, opp. p. 21: "Head of a Deputy" (clay, ILLUSTRATED)
1932 Bouvy, No. 23: "Falloux" (clay, ILLUSTRATED)
1939 Buchholz Gallery, New York, No. 3: "Comte de Falloux" (bronze)
1948 Mourre, 98: "Became famous later for his teaching. Was only 22 when bust was modelled but Daumier gave him the air of an old man"
1952 Gobin, No. 23: "Unknown" (bronze and clay, ILLUSTRATED)
Deutsche Akademie der Künste, Berlin, No. 23: "Unknown — not Falloux" (bronze, ILLUSTRATED)
1957 Galerie Sagot-Le Garrec, Paris, No. 45: "Unknown. Like Gallois, this bust does not seem a caricature. The sitter may perhaps be found among the liberals" (bronze)
1958 Museum of Fine Arts, Boston, No. 9: "Fréderic Falloux (?)" (bronze)
1961 Museo Poldi Pezzoli, Milan, No. 35: "Unknown" (bronze, ILLUSTRATED)
1968 Château de Blois, No. 462: "Unknown" (bronze)

12. Fruchard

Jean-Marie 1786- ?

Gobin No. 11

Fruchard, a totally obscure man, has been immortalized forever, skewered by the pen of Philipon and the thumb and crayon of Daumier. In fact, his very obscurity was what caught Philipon's interest (see Introduction to Busts). Even now, it is unknown when he died, and his given name is debatable, as Adhémar called him Félix Fruchard (Bibliothèque Nationale, 1958, no. 19) while Durbé wrote Jean-Marie (Poldi Pezzoli, 1961, no. 18). Gobin nicknamed him "Le Dégoût personnifié" (Disgust Personified).

The clay is one of the six that appear in the Boston Museum of Fine Arts photograph presumably taken in 1865 (see cat. no. F). Fruchard also appeared in Geffroy (see cat. no. 12b). Oddly, Geffroy described Fruchard as a Deputy, "Massive, bloated, a huge nose falling over his mouth, lots of cheeks, no skull," though he did not notice that his description fit the clay which he labelled "unknown" (1905, pp. 103 and 105). Phillips and Fuchs repeat Geffroy's photograph.

The bronze, one of the first cast, was mentioned in 1930 in the Museum of Modern Art's catalogue (no. 143), and one was illustrated in Bouvy (1932, no. 11).

Although the clay appears in good condition in the 1865 photograph, it too has suffered since. Geffroy's photograph shows a shiny glue repair holding a piece of his right coat front in place. Lately, two pieces have cracked from the left front of the clay, only the largest of which was replaced. Fortunately the bronze was cast before this loss occurred. A bump on the right temple, visible in the Geffroy photograph, seems to have disappeared before 1929 however, and the center of the tie appears restored.

Though he·seems larger, Fruchard is only 5⅛" high, and wears one of the more evil grimaces made by Daumier, following Royer-Collard, Harle, "Soult," Prunelle, and "Girod," as the young sculptor entertained himself seeing just how horrible a face he could make. By scratching the nose with his rake Daumier made it wrinkle up along with the eyes and cheeks.

The lithograph (cat. no. 12d) does nothing to lessen the brutal ugliness of the clay. In fact, there

Daumier enlarged the cheeks, twisted the nose and ears, and contorted the forehead even more. Fruchard appeared only once again, unbeautiful as ever, in the "Ventre législatif," (cat. no. C). This hardly seems to be a portrait of a person. Instead, poor ignominious Fruchard, transformed into a goatskin, is left to embody Daumier's opinion of Louis Philippe's deputies.

HISTORY

1905 Geffroy, 103; 105: "Unknown" (clay, ILLUSTRATED)

1922 Phillips, n.p.: "Unknown" (clay, ILLUSTRATED)

1927 Fuchs, No. 170c: "Fruchard, colored terra cotta" (actually clay, ILLUSTRATED)

1930 MOMA, New York, No. 143 (bronze)

1932 Bouvy, No. 11 (bronze, ILLUSTRATED)

1934 Bibliothèque Nationale, Paris, No. 382 (bronze)

1948 Mourre, 99: "Dead without a trace"

1952 Gobin, No. 11 (clay, ILLUSTRATED)
Deutsche Akademie der Künste, Berlin, No. 11 (bronze, ILLUSTRATED)

1957 Galerie Sagot-Le Garrec, Paris, No. 11 (bronze)

1958 Bibliothèque Nationale, Paris, No. 19 (bronze)
Los Angeles County Museum, No. 229 (bronze)

1961 Museo Poldi Pezzoli, Milan, No. 18 (bronze, ILLUSTRATED)

1964 Rostrup, No. 615d (bronze)

1968 Château de Blois, No. 450 (bronze)

12. Fruchard

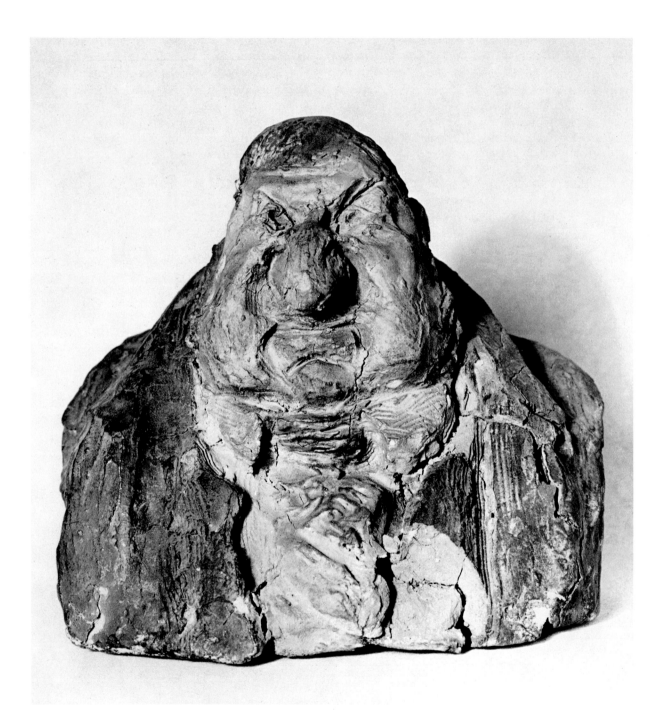

12a.

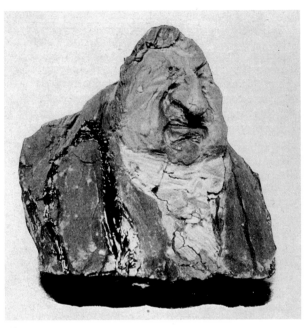

12b.

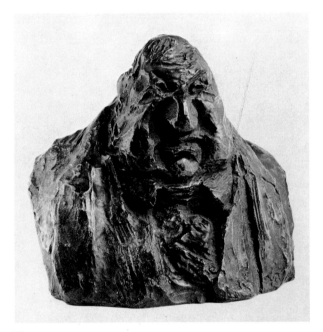

12c.

12a. FRUCHARD
 Unbaked clay, painted; h. 5⅛″ (130 mm.)
 Bronze edition of 25 made beginning 1929
 Collection Madame Berthe Le Garrec, Paris
 (not in exhibition)

12b. Early photograph of unbaked clay no. 12a from
 Geffroy, 1905, p. 103

12c. FRUCHARD
 Cast bronze; h. 5″ (127 mm.)
 Markings: lower left rear: MLG; bottom rim: 3/25 F¹;
 inside: 3/25
 National Gallery of Art, Lessing J. Rosenwald
 Collection

12d. MR. FRUCH. . . . L.D. 168
 Lithograph, second state, white paper; 140 x 140 mm.
 Charivari, October 12, 1833
 Museum of Fine Arts, Boston

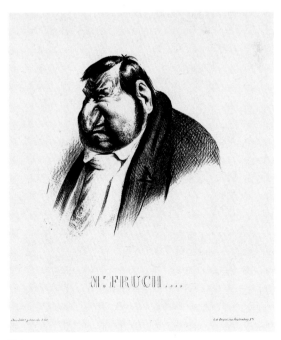

12d.

13. Fulchiron

Jean-Claude 1774-1859

Gobin No. 3

One of the most distinctive of Daumier's caricatures, Fulchiron was actually a nonentity, or as Mourre put it, he did not go far on the road to glory (1948, p. 99). He was a minor poet and a Deputy from Lyons, Philipon's hometown. He was attacked several times in *Charivari* in 1833, for his provincialism and his wish to stifle the voice of the people (Poldi Pezzoli, 1961, no. 23). Durbé dated the clay in 1833.

Except for the inevitable cracking the clay seems to have survived quite well. The crack opening on the cheek in our photograph (cat. no. 13a) is recent and is being repaired. This conservation is most fortunate, for Fulchiron is a masterpiece. Daumier's mocking thumb made every part of the man's face seem to twitch and quiver with poetic sensibility. Lips phrasing a mellifluous sound, eyebrows raised in eager delight, left ear reaching out to catch his own beautiful phrases, while the hair at the back of his head tips up delicately to match the pointed nose, he is his own best audience. The bust makes Molière spring to mind, and Gobin called him "Le Tartufe" [*sic*]. He might also be the *Bourgeois Gentilhomme* happily discovering that he can speak in prose as well as poetry.

The bust's appeal is indicated by its popularity. Even though unknown, he was illustrated in Dayot, Geffroy (see cat. no. 13b), Klossowski, Pach, and Fuchs. The latter four photographs are identical. Fuchs, who identified him as Ganneron (1927, no. 168d), must have matched the clay to a lithograph unpublished by Daumier and illustrated in Delteil under the title "Ganneron" (L.D. 183). Like the bust-length lithographs of others in the *Celebrity* series, Fulchiron's features are strongly modelled in contrasting areas of light and shade, and, in this case, are very similar to those of the clay (including the flip of the hair). The coat and the oval shadow behind are hastily cross-hatched. Compared to the wonderfully sensitive modelling of the clay, the lithograph seems harsh. Daumier probably made the bust-length lithograph for the *Celebrity* series, then Philipon decided not to use it.

Escholier in 1930 finally identified the bust correctly, though he illustrated a bronze and called it clay (1930, pl. 100). Fulchiron was one of the first bronzes to be cast, in 1929-30.

Daumier's only other lithograph of Fulchiron is illustrated here (cat. no. 13e), a full-length portrait in *La Caricature*, May, 1833. There is a general resemblance to the clay in the raised eyes and open mouth, but as with the full-length portrait of Etienne, Daumier does not seem to have relied upon the sculpture for his second drawing. Fulchiron appears much younger in this print than in the bust (he was only fifty). Instead of a quivering surface as in the clay, the lithograph portrait is conceived more as a series of linear patterns. For example, the jagged line of the cheek runs into the groove on the nose, and the wisps of hair reach forward as the wrinkles of the brow ripple back.

Fulchiron has also been reproduced in a terracotta edition, made from the mold made originally for the bronzes. One of these hand-painted terra cottas has been included in the exhibition (cat. no. 13d).

Fulchiron also appears in L.D. 233

13a. FULCHIRON
Unbaked clay, painted; h. 6-11/16″ (170 mm.)
Bronze edition of 30 made beginning 1929
Collection Madame Berthe Le Garrec, Paris
(not in exhibition)

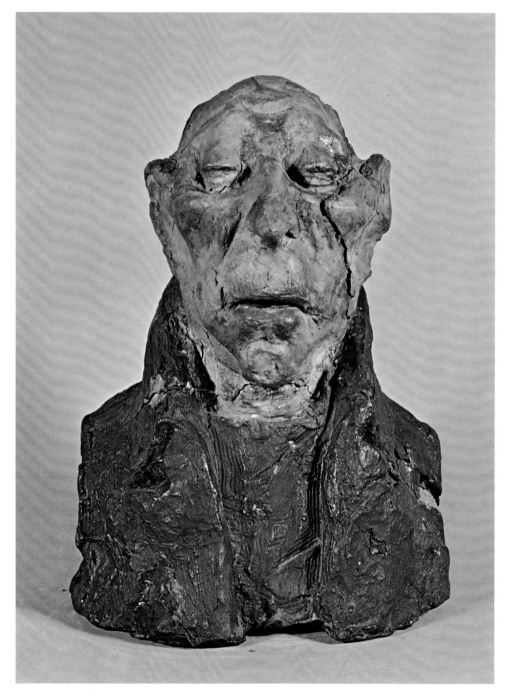

13a.

13. Fulchiron

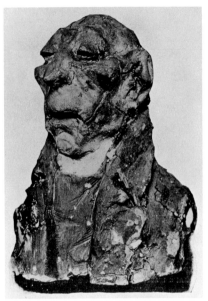

13b.

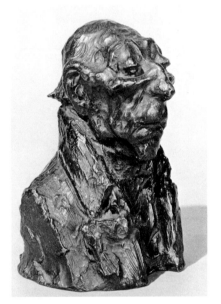

13c.

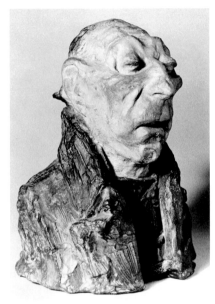

13d.

13b. Early photograph of unbaked clay no. 13a from Geffroy,
 1905, p. 107

13c. FULCHIRON
 Cast bronze; h. 6⅜" (162 mm.)
 Markings: lower left side: MLG; bottom rim: 3/30 B¹;
 inside: 3/30
 National Gallery of Art, Lessing J. Rosenwald
 Collection

13d. FULCHIRON
 Terra-cotta reproduction, painted to resemble original
 clay; h. 6-3/16" (157 mm.)
 Galerie Sagot-Le Garrec, Paris

13e. MR. FULCHIR. . . . L.D. 53
 Lithograph, second state; 258 x 171 mm.
 La Caricature, May 16, 1833
 Private Collection, Boston

1897 Dayot, II, 35: "Unknown" (clay, ILLUS-
TRATED)

1905 Geffroy, 107: "Unknown" (clay, ILLUSTRATED)

1923 Klossowski, No. 458, Pl. 9: "Deputy" (clay,
ILLUSTRATED)

1924 Pach, n.p.: "Sculptural model of head, done
in wax" (actually clay, ILLUSTRATED)

1927 Fuchs, No. 168d: "Ganneron, colored terra
cotta" (actually clay, ILLUSTRATED)

1930 Escholier, Pl. 100: "Fulchiron — clay" (ac-
tually bronze, ILLUSTRATED)
MOMA, New York, No. 138: "Guizot"
bronze, ILLUSTRATED)

1932 Bouvy, No. 3: "Fulchiron" (bronze, ILLUS-
TRATED)

1945 Cochet, No. 44: "clay sculpture" (actually
bronze, ILLUSTRATED)

1947 Musée Cantini, Marseilles, No. 24 (bronze)

1948 *Emporium*, 185 (clay, ILLUSTRATED)
Mourre, 99

1952 Gobin, No. 3 (clay, ILLUSTRATED)
Deutsche Akademie der Künste, Berlin, No. 3
(bronze, ILLUSTRATED)

1954 Adhémar, Pl. I (bronze, ILLUSTRATED)

1957 Galerie Sagot-Le Garrec, Paris, No. 3a (clay,
ILLUSTRATED); No. 3b (bronze)

1958 Bibliothèque Nationale, Paris, No. 20: said
Fulchiron died 1851 (bronze)
Museum of Fine Arts, Boston, No. 12 (bronze,
ILLUSTRATED)
Los Angeles County Museum, No. 224
(bronze)

1959 Rey, Pl. 3: "terra cotta" (actually bronze,
ILLUSTRATED)

1961 Museo Poldi Pezzoli, Milan, No. 23 (bronze,
ILLUSTRATED)
Musée Cognacq-Jay, Paris, No. 319 (bronze,
ILLUSTRATED)

1968 Château de Blois, No. 442 (bronze)

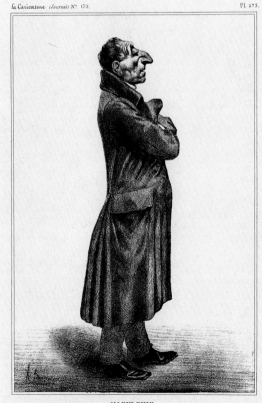

13e.

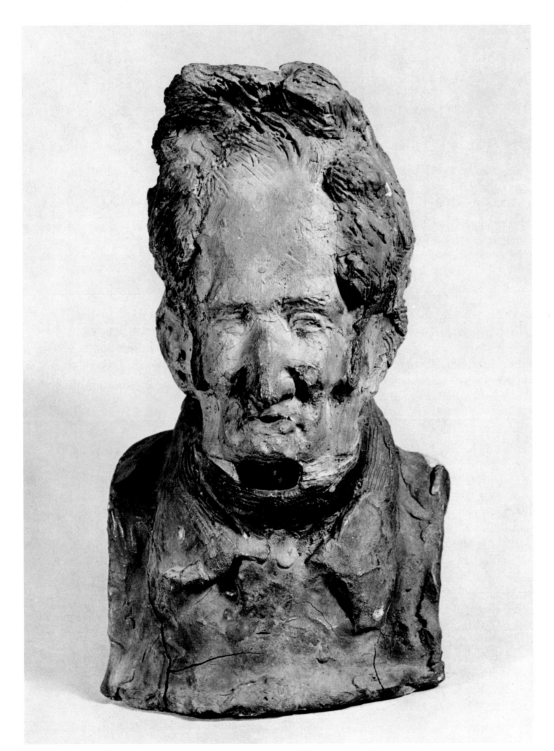

14a.

14. Gallois

Charles-Léonard 1789-1851

Gobin No. 21

Like Falloux, Gallois' identity has been disputed. In his case, however, no one has been able to discover a single lithograph of a man with these features which might justify his identification. Bouvy, Mourre, Gobin, and Adhémar do retain the name Gallois. It has been retained in this catalogue on the basis of Champfleury's paper label visible in Geffroy's 1905 photograph (see cat. no. 14b). This one clearly reads "Gallois Homme des lettres et journaliste." Geffroy called him "Gallois, journalist, with his hydrocephalus, the extraordinary contrast between the tiny chin and great forehead" (1905, pp. 105-06). Mourre added that he was a publicist and historian who had served three months in prison in 1822 for an anti-legitimist pamphlet (1948, p. 99). Adhémar added that he was a liberal and an author of works on the French Revolution, whose son Leonard was a friend of Daumier's (1958, Bibliothèque Nationale, no. 44). Possibly Champfleury also knew Leonard Gallois and recognized the bust of his father.

The clay apparently has survived in good condition. Casting of the bronzes had begun by 1937 when one was exhibited in the Daumier exhibition at the Pennsylvania Museum (no. 2). The lines of the rake, with which Daumier drew the hair and sideburns, carry over well in the bronze (cat. no. 14c). Gobin called him "L'Ironiste" (The Ironist).

The bust is one of the large ones (8½″) and seems to continue the type which Daumier began with Lefebvre and Delort, with a high forehead framed by a ruffle of hair, to its ultimate extreme, with the hair pulled up to a point above the extraordinary brow. Daumier then seems to have reversed this upward pull in Falloux (cat. no. 11) whose flattish head draws down to a big chin and trailing beard. Daumier was a fast worker, full of ideas, who was known later to work on six lithographs at once, running from stone to stone. If he worked this same way on the clay busts, making a series of four or five related facial types at a time that developed one from the other, with individual characteristics based on persons he knew who fitted that type as they popped into his head, rather than going back and forth to the law courts thirty-six times to do each

bust separately from the model, that might explain the presence of Gallois, a man with an interesting head whom Daumier knew, but whom Philipon had no reason to attack and therefore did not request a lithograph.

HISTORY

1905 Geffroy, 105, 106: "Gallois" (clay, ILLUSTRATED)
1927 Fuchs, No. 168c: "Unknown, colored terra cotta" (actually clay, ILLUSTRATED)
1932 Bouvy, No. 21: "Gallois" (clay, ILLUSTRATED)
1937 Pennsylvania Museum of Art, Philadelphia, No. 2 (bronze)
1939 Buchholz Gallery, New York, No. 4: "Gallois" (bronze)
1948 *Emporium*, 85 (clay, ILLUSTRATED)
 Mourre, 99: "Gallois"
1952 Gobin, No. 21: "Gallois?" (clay and bronze, ILLUSTRATED)
 Deutsche Akademie der Künste, Berlin, No. 21: "Unknown" (bronze, ILLUSTRATED)
1957 Galerie Sagot-Le Garrec, Paris, No. 21: "Gallois?" (bronze)
1958 Bibliothèque Nationale, Paris, No. 44: "Gallois" (bronze)
 Los Angeles County Museum, No. 233 (bronze, ILLUSTRATED)
1961 Museo Poldi Pezzoli, Milan, No. 28: "Unknown, Sometimes called 'Gallois'" (bronze, ILLUSTRATED)
1968 Château de Blois, No. 460: "Gallois?" (bronze)

14a. GALLOIS
Unbaked clay, painted; h. 8½″ (216 mm.)
Bronze edition of 25 begun by 1939
Collection Madame Berthe Le Garrec, Paris
(not in exhibition)

14. Gallois

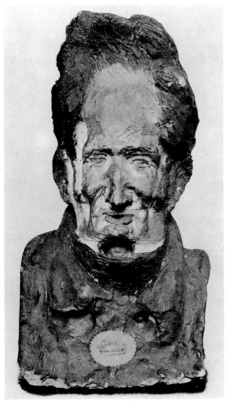 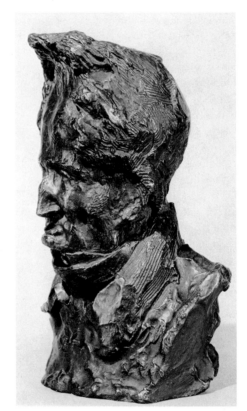

14b. 14c.

14b. Early photograph of unbaked clay no. 14a from Geffroy,
 1905, p. 106

14c. GALLOIS
 Cast bronze; h. 8-7/16″ (214 mm.)
 Markings: lower right side: MLG; bottom rim: 2199-1;
 inside: 3/25
 National Gallery of Art, Lessing J. Rosenwald
 Collection

88

15. Ganneron

Auguste-Hippolyte 1792-1847

Gobin No. 7

Deputy Ganneron, like Guizot, Delessert, Fulchiron, Vatout, and Viennet, had an unusual head which caught Daumier's eye. Unlike the smaller busts, in which Daumier worked out a series of lively grins and grimaces, these larger busts are relatively expressionless. The surface of their skin is smooth and instead of concerning himself with wrinkles, Daumier concentrated on warping the structure of the head itself. Ganneron, with his huge lumpy brow hiding his tiny eyes, his crooked potato nose, and big broad chin, is with Delessert one of Daumier's most extraordinary conceptions.

He appeared in only one lithograph, in *Charivari*, September, 1833 (cat. no. 15c), a portrait in bust. The translation of the bust with its large, smooth, irregular areas into broad areas of lights and darks is especially successful in this lithograph. The bronze, one of the first cast, also reproduces these largely-modelled areas particularly well (see cat. no. 15b).

Ganneron was a wealthy manufacturer of candles, which somehow seems a source of hilarity in itself. Mourre punned that this was the only light that still shines on him (1948, p. 99). Gobin called him "Le Timide" (Timid) in *Daumier Sculpteur* (1952, no. 7), which seems an unlikely description of an "industrialist, banker, president of the Chamber of Commerce, Deputy, and Colonel in the National Guard" (from Deutsche Akademie, 1952, no. 7). Durbé added that as a businessman like Delessert, Odier, Baillot, and Cunin, he was the solid support of the July Monarchy. He had once been a magistrate. His name was used as one for whom the legal became illegal. It appeared in *La Caricature* after April, 1832, and in *Charivari* more often in 1833 (Poldi Pezzoli, 1961, no. 32).

The clay has suffered some losses, especially around the mouth. Perhaps this is why Geffroy did not illustrate it even though he was able to recognize the bust as Ganneron (1905, p. 106). Since our photograph was taken (cat. no. 15a) the clay has been completely restored.

HISTORY

1905 Geffroy, 106: "Ganneron, deputy and candle merchant" (refers to clay)

1930 MOMA, New York, No. 144: "Aug. H. P. Gannerton" (bronze)
Escholier, Pl. 100: "Gameron, clay" (actually bronze, ILLUSTRATED)

1932 Bouvy, No. 7: "Ganneron" (clay, ILLUSTRATED)

1934 Bibliothèque Nationale, Paris, No. 383: "Ganneron" (bronze)

1936 Albertina, Vienna, No. 78: "A. H. Garmeron" (bronze)

1945 Cochet, No. 45: "Gameron, clay" (actually bronze, ILLUSTRATED)

1948 Mourre, 99

1952 Gobin, No. 7: "Ganneron" (clay, ILLUSTRATED)
Deutsche Akademie der Künste, Berlin, No. 7: "Ganneron" (bronze, ILLUSTRATED)

1954 Adhémar, Pl. I (bronze, ILLUSTRATED)

1957 Galerie Sagot-Le Garrec, Paris, No. 7 (bronze)

1958 Bibliothèque Nationale, Paris, No. 21 (bronze)

1959 Rey, Pl. 3: "terra cotta" (actually bronze, ILLUSTRATED)

1961 Musée Cognacq-Jay, Paris, No. 320 (bronze, ILLUSTRATED)
Museo Poldi Pezzoli, Milan, No. 32 (bronze, ILLUSTRATED)

1966 Palais Galliera, Paris, No. 19 (bronze, ILLUSTRATED)

1968 Hôtel Drouot, Paris, No. 2 (bronze, ILLUSTRATED)
Château de Blois, No. 446 (bronze)

15. Ganneron

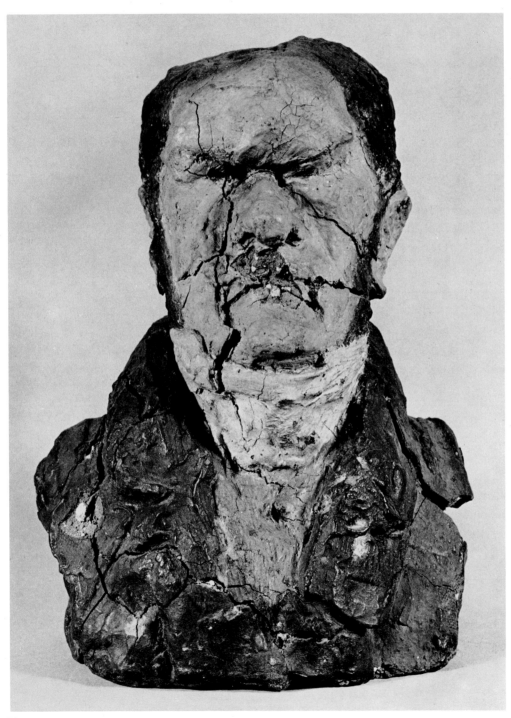

15a.

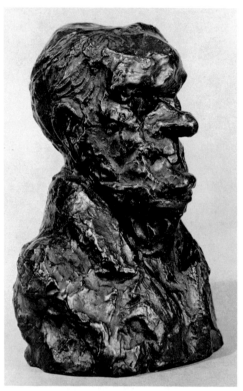

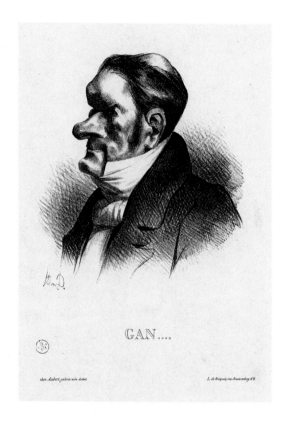

15b.

15a. GANNERON
 Unbaked clay, painted; h. 7-5/16″ (186 mm.)
 Bronze edition of 25 made beginning 1929
 Collection Madame Berthe Le Garrec, Paris
 (not in exhibition)

15b. GANNERON
 Cast bronze; h. 7-1/16″ (179 mm.)
 Markings: lower left side: MLG; bottom rim: 3/25 D^1;
 inside: 3/25
 National Gallery of Art, Lessing J. Rosenwald
 Collection

15c. GAN. . . . L.D. 162
 Lithograph, white paper; 142 x 132 mm.
 Charivari, September 6, 1833
 Boston Public Library

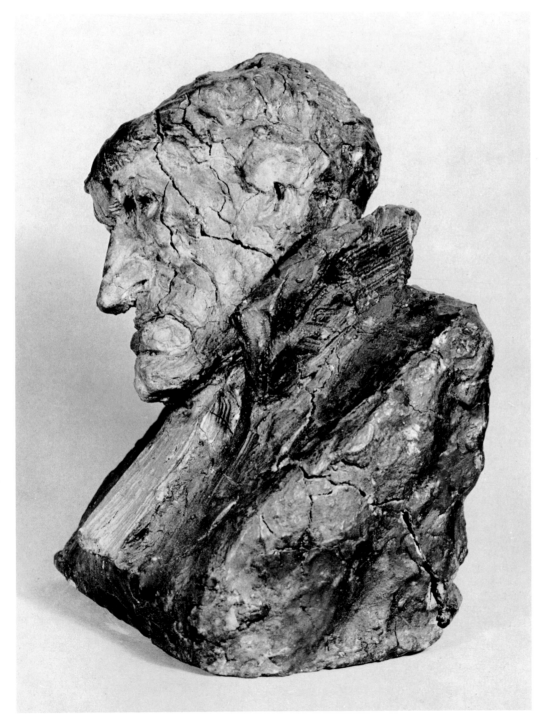

16a.

16. Gaudry

Joachim-Antoine-Joseph 1790-1875

Gobin No. 35

Although Gobin called him "Gandry," Mourre, Kaiser, Adhémar, and Durbé, who researched the historical personalities of the busts, all refer to him as "Gaudry," giving his full name and dates. In *Charivari* he was called "Mr. Ga.," and given the pseudonym Gâchis. Geffroy referred to him as "Gady." He was probably relying on Champfleury's paper label which is visible in the 1865 group photograph and seems to read "Gady Juge à Versaille" (see cat. no. F). We will accept the recent evidence that his name was Gaudry.

The Boston Museum of Fine Arts' photograph, published here for the first time, is the earliest known picture of Gaudry. The clay was not photographed again until Bouvy in 1932 (no. 35). No bronzes were published until the Deutsche Akademie der Künste exhibition in Berlin in 1952 (no. 35), but some casts must have been made by 1948 when the Marseilles museum received a complete set of bronzes.

As may be seen in the Boston Museum photograph, the clay had begun to crack by 1865. Fortunately it was cast before the damage occurred to the left eye (see cat. no. 16a). The other cracks do not detract from the work's artistic merit. The clay seems to follow Baillot and Lecomte. In all three sculptures, Daumier was working with the head and shoulders as separate parts, a small square set upon a larger one. The first two are upright, then in Gaudry he let the head drop forward. Montlosier continues this series. In the latter two, Daumier returned to the grimace, as in the small busts, with wrinkled skin and fine detail, but combined now with a firm sense of the bone structure of the head. Compare Gaudry to Dupin, Kératry, or especially to Lameth with his hesitant surface ripples and unclear structure. In the shoulder and coat of Lameth (cat. no. 20a), though Daumier carefully worked over the whole surface, he managed to produce only meaningless rumples. By the time he did Gaudry he was masterful enough to chop off a block of clay peremptorily on four sides and draw some lines down the front for the stock, adding a small horseshoe of clay for the collar, and yet make this simple structure completely readable.

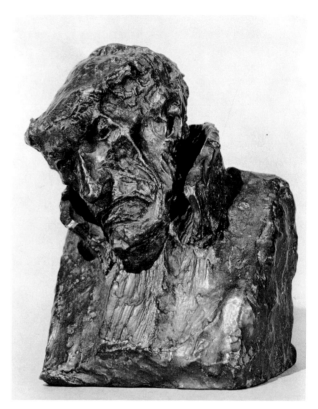

16b.

16a. GAUDRY
Unbaked clay, painted; h. 6-11/16″ (170 mm.)
Bronze edition of 25
Collection Madame Berthe Le Garrec, Paris
(not in exhibition)

16b. GAUDRY
Cast bronze; h. 6-5/16″ (160 mm.)
Markings: lower left rear: MLG, BR; inside: 23/25
National Gallery of Art, Lessing J. Rosenwald
 Collection

16. Gaudry

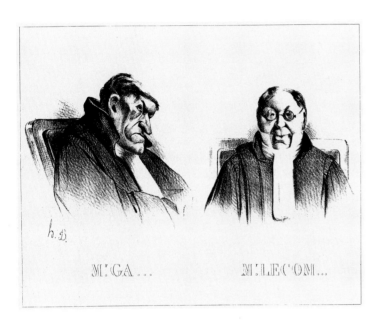

16c. MR. GA. . . . MR. LECOM. . . . L.D. 160
Lithograph; 204 x 259 mm.
Charivari, August 29, 1833
Boston Public Library

(see cat. no. 21c)

Gaudry appears in lithographs only once, in a double portrait with Lecomte that appeared in August, 1833 (see cat. no. 16c). In the lithograph Daumier carefully followed the pose of his sculpture, drawing directly on the stone so that the print came out in reverse. He combined his technique of broad areas of lights and darks (as in the *Celebrity* series) with a series of lines around eyes and mouth which create a lively pattern and at the same time emphasize the mouth drawn down in boredom.

Gaudry and Lecomte were judges for the processes against the *National*, the paper founded by Thiers in 1830, which had shifted its viewpoint from constitutional-monarchic to moderate Republican. Daumier and Philipon used the two men to portray their idea of the bored judge. Philipon wrote in *Charivari* that they were the "judges reposing at the trial . . ." He said Daumier had sketched them "at the moment where they recline in the *National* affair, Gâchis [Gaudry] soporific of resemblance . . ." (in Poldi Pezzoli, 1961, p. 134). Gobin somewhat sentimentally called Gaudry "Triste jusqu'à la Mort" (Sorrowful Unto Death). "Bored to Death" would be more to Daumier's point.

HISTORY

1905 Geffroy, 106: "and Gady, judge at Versailles" (referring to clay)
1932 Bouvy, No. 35: "Gaudry" (clay, ILLUSTRATED)
1948 Mourre, 100: "Gaudry, called Gachis." . . .
1952 Gobin, No. 35: "Gandry" (clay, ILLUSTRATED) Deutsche Akademie der Künste, Berlin, No. 35: "Gaudry" (bronze, ILLUSTRATED)
1957 Galerie Sagot-Le Garrec, Paris, No. 35: "Gaudry" (bronze, ILLUSTRATED)
1958 Bibliothèque Nationale, Paris, No. 42: "Gaudry" (bronze)
1961 Museo Poldi Pezzoli, Milan, No. 30: "Gaudry" (bronze, ILLUSTRATED)
1968 Château de Blois, No. 474: "Gaudry" (bronze)

17. Guizot

François-Pierre-Guillaume 1787-1874

Gobin No. 25

Guizot is by far the best-remembered of the persons Daumier portrayed in these thirty-six busts. His role as a major statesman in French politics lasted from the 1820's to 1848, when he voluntarily went into exile with Louis Philippe. After that he wrote his *Mémoires* (1858-67). He also wrote a history of the revolution in England (1826-56), and an uncompleted general history of civilization in modern Europe (1829-32). A Protestant, Guizot had been educated in Geneva. He became Professor of modern history at the University of Paris. Sympathetic to the modern Royalists, he took part in the July Revolution of 1830, and became one of the leading intellectual exponents of the July Monarchy. He served as Minister of the Interior in 1830, as Minister of Public Instruction, 1832-37, and, as Kaiser said, he was the omnipotent councilor of state for the July Monarchy (Deutsche Akademie, 1952, no. 25). Durbé enlarged upon Guizot's intellectual role, explaining that he "believed in the definitive victory of moral force. Among political men of his day, Guizot was one who believed most tenaciously that the current regime finally realized the dream of the *philosophes*, and passed beyond 'politics of mere reason of state. . . .' Perhaps his intuition of conflict between a moral imperative and brutal reality gave Daumier the grandiose inspiration for his Guizot...." (Poldi Pezzoli, 1961, no. 24).

Daumier's clay head of Guizot was not published until 1932 when it appeared in Bouvy (no. 25). It had been mentioned by Geffroy in 1905: "Guizot, minister, with a pensive face of illness and sorrow" (p. 105). Earlier still, it was one of the clay busts that Champfleury mentioned by name as having been photographed in 1865 by Philipon's adopted son (Champfleury sale, 1891, no. 72). This 1865 photograph is illustrated here for the first time (see cat. no. F). There sits Guizot, almost twice the size of Odier next to him, wearing Champfleury's label: "Guizot, Ministre et Député." The bust was cast in bronze in time to be included in the 1934 Daumier exhibition in Paris (Bibliothèque Nationale, no. 384).

The present exhibition includes the clay itself, lent by Madame Le Garrec, a bronze cast made from it, lent by Lessing J. Rosenwald (see cat. no. 17c), and a terra-cotta reproduction also made from the clay, lent by the Galerie Sagot-Le Garrec. The terra cotta has not yet been painted (cat. no. 17d).

Many consider this clay to be Daumier's masterpiece among the busts. Champfleury noted that even in caricature Guizot passed as a noble figure (quoted in Bibliothèque Nationale catalogue, 1958, no. 23). Mourre said he was hardly caricatured at all — Daumier seemed to have respected him. "His celebrated motto, 'Enrich yourselves,' might have caused the plebeian sculptor to bristle, but he was probably aware of a certain moral honesty of the minister" (Mourre, 1948, p. 98). Gobin, on the other hand, called this bust "The Bore" or "L'Ennuyeux" (1952, no. 25). Most would agree with Durbé, however, who called Guizot a key work in the entire artistic development of Daumier (Poldi Pezzoli, 1961, no. 24).

In this clay Daumier manipulated the cranium and emphasized the bony structure, slightly exaggerating the high, sharp cheekbones, an approach similar to his treatment of Delessert, Fulchiron, Vatout, or Ganneron. Like those busts, Guizot is relatively expressionless, yet something of the personality of the man seems to come through. Perhaps the downward tilt of the head, and eyes cast down, are what give the bust a feeling of pensiveness.

An official portrait of Guizot painted by Delaroche not long after Daumier's bust (about 1837) and copied in a lithograph by Emile Lassalle (see cat. no. 17b) reinforces the idea that Daumier's Guizot is hardly caricatured. Delaroche smoothed away any defects, just as Daumier preferred to emphasize them. Still, both artists gave Guizot a broad, high forehead, a somewhat pointed chin, a thin, firmly-set mouth, and knitted brow. Delaroche hinted at the high cheekbones. Most interesting are the eyes, for though Delaroche showed Guizot staring straight ahead, his treatment of the brow line and pupil is almost identical to Daumier's.

Not surprisingly, Guizot appeared many times in Daumier's graphic work. In 1832 he was included only in the "Masks of 1831" (cat. no. A) and "Charenton" (cat. no. B). In neither of these does he

17. Guizot

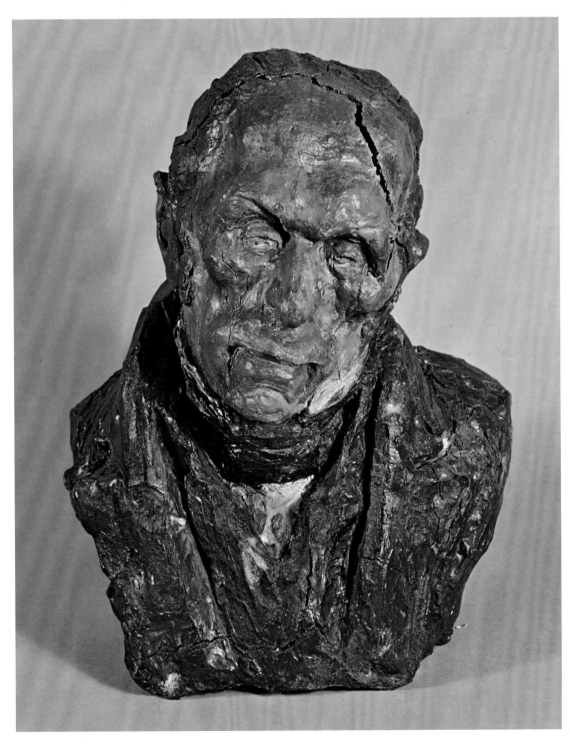

17a.

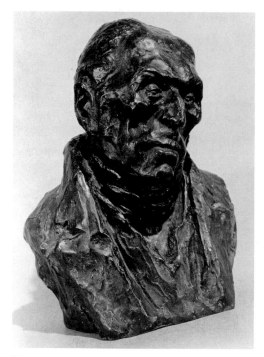

17c.

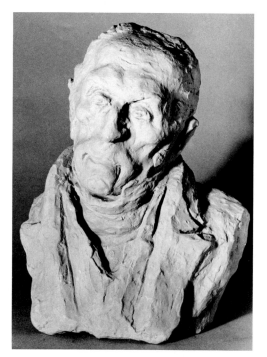

17d.

17a. GUIZOT
 Unbaked clay, painted; h. 8-29/32″ (226 mm.)
 Bronze edition of 30 made beginning 1934
 Collection Madame Berthe Le Garrec, Paris

17c. GUIZOT
 Cast bronze; h. 8-11/16″ (221 mm.)
 Markings: lower left rear: MLG, BRONZE; inside: 23/30
 National Gallery of Art, Lessing J. Rosenwald
 Collection

17d. GUIZOT
 Terra-cotta reproduction; h. 8-5/32″ (207 mm.)
 Galerie Sagot-Le Garrec, Paris

17f. MR. GUIZ. . . . L.D. 74
 Lithograph; 268 x 201 mm.
 La Caricature, December 13, 1833
 Fogg Art Museum, Harvard University

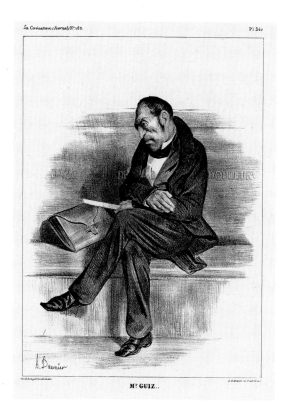

17f.

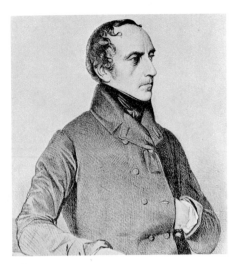

17b.

resemble the clay. Durbé is probably correct when he says they were done before the clay (Poldi Pezzoli, no. 24). The two individual portraits (cat. nos. 17e and 17f), both from 1833, are closest to the clay. In both, the angle of the head is reversed as if Daumier drew from the clay directly onto the stone. The bust-length portrait, called "Guiz. . . . ," has the careful attention to broad areas reflecting light that Daumier showed in most of the bust-length portraits. The full-length lithograph shows Guizot seated, on what Daumier and Philipon called the "Bench of Sorrow." Daumier often drew Guizot seated in later lithographs, including the "Ventre législatif" (cat. no. C) or "Le Carcan" (cat. no. 17g). The expression is often more animated, and the head tilts to his left as if Daumier then drew from the full-length lithograph instead of from the clay which had, of course, remained at Philipon's.

Guizot also appears in L.D. 75, 95, 133, 200, 216, 218, 239.

17b. Lithograph by Emile Lasalle after a portrait of Guizot by Delaroche from Dayot, 1897, II, p. 21

17e. GUIZ. . . . L.D. 148
Lithograph, second state; 143 x 130 mm.
Charivari, May 31, 1833
Museum of Fine Arts, Boston
(not illustrated)

17g. LE CARCAN (The pillory) L.D. 105
Lithograph; 229 x 275 mm.
La Caricature, January 15, 1835
Private Collection, Boston
(not illustrated)

17h. CONFUSION DE LA FUSION! (Confusion of the fusion) L.D. 2129
Lithograph, white paper; 210 x 264 mm.
Charivari, July 29, 1851
Boston Public Library
(not illustrated)

HISTORY

1891 Champfleury sale, No. 72 (refers to clay)
1905 Geffroy, 105 (refers to clay)
1932 Bouvy, No. 25 (clay, ILLUSTRATED)
1934 Bibliothèque Nationale, Paris, No. 384 (bronze)
1947 Musée Cantini, Marseilles, No. 25 (bronze)
1948 Mourre, 98
 Guillet, 8 (bronze, ILLUSTRATED)
1952 Gobin, No. 25 (clay, ILLUSTRATED)
 Deutsche Akademie der Künste, Berlin, No. 25 (bronze, ILLUSTRATED)
1957 Galerie Sagot-Le Garrec, Paris, No. 25 (bronze, ILLUSTRATED)
1958 Bibliothèque Nationale, Paris, No. 23 (bronze)
 Los Angeles County Museum, No. 235 (bronze, ILLUSTRATED)
1961 Musée Cognacq-Jay, Paris, No. 323 (bronze, ILLUSTRATED)
 Museo Poldi Pezzoli, Milan, No. 24 (bronze, ILLUSTRATED)
 Museum für Kunst und Gewerbe, Hamburg, No. 106 (bronze)
1965 Escholier, 158 (bronze, ILLUSTRATED)
1966 Palais Galliera, Paris, No. 22 (bronze, ILLUSTRATED)
1968 Château de Blois, No. 464 (bronze)

18. Harle

Jean-Marie, Père 1765-1838

Gobin No. 32

"Old Harle," as Philipon and Daumier called him, was nearly seventy when the bust was made. He had served as a Deputy from Calais since 1816. He might even have been a well-beloved figure there, for the city of Arras raised funds to have his bust made by Antoine Moine. It is now in the Musée d'Arras (from 1958 Bibliothèque Nationale catalogue, no. 24). For Daumier and Philipon, however, Harle was "one of the most remarkable fossils of the center" in Louis Philippe's government, remarkable for interrupting sessions in the Chamber of Deputies by loudly blowing his nose (*Charivari*, November 5, 1833; quoted in Poldi Pezzoli, 1961, p. 106). In the bust-length lithograph (cat. no. 18c), Daumier simply showed the old man in profile, but in his full-length portrait (cat. no. 18d) and the "Ventre législatif" (cat. no. C) Daumier added an enormous handkerchief and a running nose to go along with the jest. These are the only lithographs in which Harle appears.

The clay bust was located and identified by Bouvy in 1932 (no. 32). Bouvy called him "Harle *père*" rather than "Harlé" as do some others. A bronze is first mentioned in the 1952 Berlin Daumier exhibition catalogue (Deutsche Akademie, no. 32). However, a terra-cotta reproduction of the clay had been made by Maurice Le Garrec by 1934, when one was exhibited in the Bibliothèque Nationale exhibition (no. 393). This was also discussed in Berthe Le Garrec's 1948 article in *Arts et Livres de Provence* (p. 102). The clay was probably not an easy one to cast, for it has been much restored, notably from the ears along both temples and including the bridge of the nose. Daumier's intention for the nose will never be known, for the part lost in the sculpture is covered by the spectacles in the lithographs.

The original bust of Harle, or Harlé, appears to have been one of Daumier's physiognomy studies. The skin is contorted as in Royer-Collard, Cunin, or Fruchard, not so much because of an exaggerated expression here, but because of the excessive, loose fat of the subject's face, which hangs forward and nearly buries his mouth. Daumier did not go to quite such an extreme in the lithograph. Gobin called the bust "Le Gâteux" (Old Fool).

HISTORY

1932 Bouvy, No. 32: "Harle [*sic*] *père*" (clay, ILLUSTRATED)

1934 Bibliothèque Nationale, Paris, No. 393 (terracotta reproduction)

1948 Mourre, 100
Le Garrec, Berthe, *Arts et Livres*, 102 (terracotta reproduction)

1952 Gobin, No. 32 (clay, ILLUSTRATED)
Deutsche Akademie der Künste, Berlin, No. 32 (bronze, ILLUSTRATED)

1957 Galerie Sagot-Le Garrec, Paris, No. 32 (bronze)

1958 Bibliothèque Nationale, Paris, No. 24: "Harle *père* (bronze)

1960 Galerie Charpentier, Paris, No. 87 (bronze, ILLUSTRATED)

1961 Musée Cognacq-Jay, Paris, No. 327 (bronze, ILLUSTRATED)
Museo Poldi Pezzoli, Milan, No. 17 (bronze, ILLUSTRATED)

1966 Palais Galliera, Paris, No. 26 (bronze, ILLUSTRATED)

1968 Château de Blois, No. 471 (bronze)

18. Harle

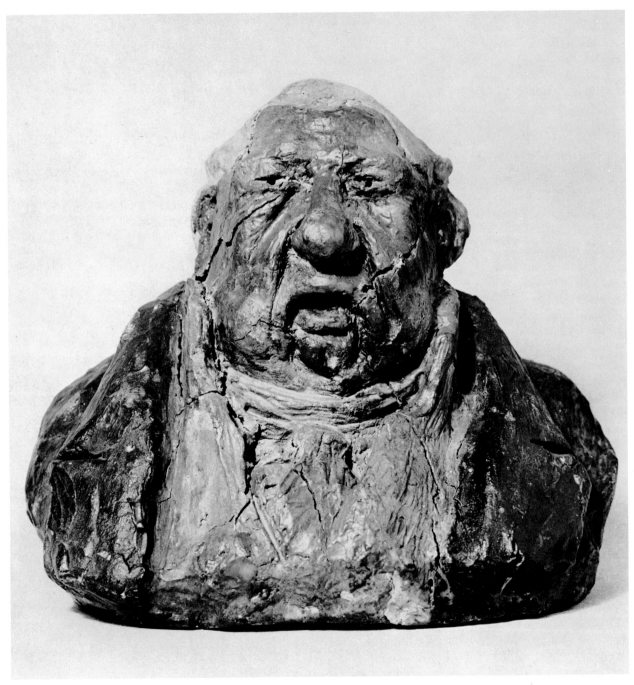

18a.

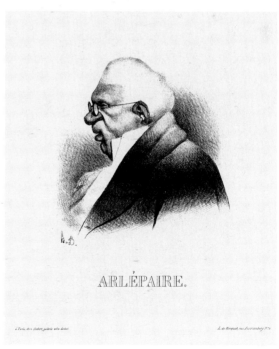

18b.

18a. HARLE
 Unbaked clay, painted; h. 4-31/32″ (126 mm.)
 Bronze edition of 30
 Collection Madame Berthe Le Garrec, Paris
 (not in exhibition)

18b. HARLE
 Cast bronze; h. 4-11/16″ (119 mm.)
 Markings: lower right rear: MLG, BRONZE; inside: 23/30
 National Gallery of Art, Lessing J. Rosenwald
 Collection

18c. ARLEPAIRE L.D. 171
 Lithograph, second state; 120 x 120 mm.
 Charivari, November 5, 1833
 Benjamin A. and Julia M. Trustman Collection,
 Brandeis University

18d. MR. ARLEPAIRE L.D. 55
 Lithograph; 265 x 179 mm.
 La Caricature, June 5, 1833
 Fogg Art Museum, Harvard University
 (not illustrated)

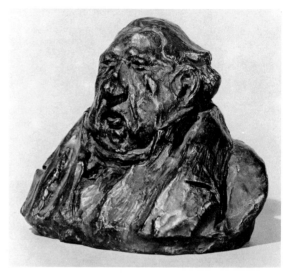

ARLÉPAIRE.

18c.

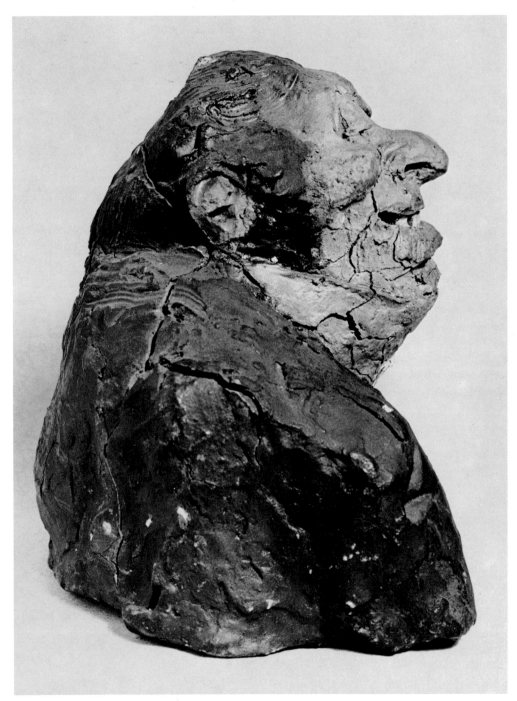

19a.

19. Kératry

Auguste-Hilarion, Comte de 1769-1859

Gobin No. 4

Count Kératry was clearly a character. His true looks aside, Daumier could hardly have resisted making fun of him, for the man was an art critic. Durbé said he was another typical intellectual of the liberal opposition during the Restoration, who became an obsequious courtier in the July Monarchy. He was first made Deputy in 1818; under Louis Philippe he became a Peer. He was also an author of works with a moral or philosophical content, including a tract on Kant (1822), a discussion of the Salon of 1819, and a tract on the Beautiful in Art (*Du Beau dans les Arts d'Imitation*, 1822). Durbé wrote that the caricaturists attacked Kératry for his ape-like features and his affected grace, not overlooking his marital woes (Poldi Pezzoli, 1961, no. 12).

The clay of Kératry is one that has been known for many years. Champfleury's sale in 1891 listed the bust of Kératry by name as one of those in Philipon's 1865 photographs (Champfleury sale, no. 72). Geffroy illustrated the clay, though he could not identify it (1905, p. 107). Bertels and Fuchs reproduced the same photograph (see cat. no. 19b). In the latter's photograph, which was not cropped, a small stick may be seen bracing the left front section of the bust which would otherwise have fallen off. This piece survived so that the bust could be restored and cast intact, however. The subject of the bust was first identified (with his name slightly misspelled) in the Museum of Modern Art exhibition catalogue in 1930 (no. 142). A bronze was exhibited. Since the casting, the clay of this amusing fellow has cracked gravely, but the bronze reproduces faithfully many details which will eventually be lost (see cat. no. 19c).

Unlike most of the larger busts, in which Daumier's caricaturing is more subtle, humor is treated broadly in Kératry, with his flat head and the over-wide grin exposing big teeth incised in the clay. Comparing Kératry with Daumier's other esthetician, the poet Fulchiron (cat. no. 13a) is like comparing burlesque humor with gentle farce. Nevertheless Kératry is a fascinating object, instructive of Daumier's development as a sculptor. The bust seems to be one of Daumier's first, along with d'Argout, Lameth, and Dupin. As with those, the

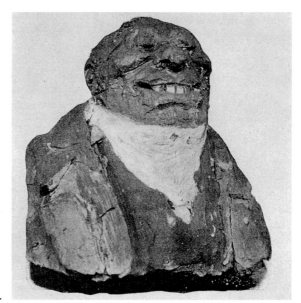

19b.

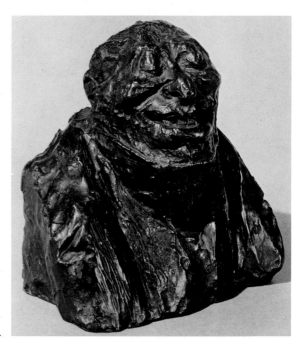

19c.

19a. KERATRY
Unbaked clay, painted; h. 5-3/32″ (129 mm.)
Bronze edition of 25 made beginning 1929
Collection Madame Berthe Le Garrec, Paris
(not in exhibition)

19b. Early photograph of unbaked clay no. 19a from Geffroy, 1905, p. 107

19c. KERATRY
Cast bronze; h. 4-3/16″ (122 mm.)
Markings: lower left rear: MLG; bottom rim: 3/25 B²; inside: 3/25
National Gallery of Art, Lessing J. Rosenwald Collection

forms of Kératry are very simple, and the joining of head and neck to body, especially in the back, is not handled as skillfully as in Daumier's later works such as Lefebvre, Gaudry, or Guizot. The profile view, like that of d'Argout, shows that Daumier treated the head and shoulders as a single block, carving the head from the chest in such a way that leaves no room for a neck. In his drawing (the lithograph) he corrected this deficiency by setting the head back farther in the coat collar. The rest of the busts testify that Daumier soon learned how to model anatomy believably. And even in Kératry, his budding skill as a modeller allowed him to fashion the wonderful hooked nose, which lifts away from the flattened head with something like an energy of its own. Daumier's inventiveness when it comes to personable noses is truly remarkable. Another wonderful piece of whimsy is Kératry's bald pate with its wispy circle of hair. With his silly grin, Kératry is one of the busts most closely related to Boilly's *Grimaces* and other studies of physiognomy.

The face of Kératry that appears on Daumier's first lithograph for Philipon, the "Masks of 1831" (cat. no. A) is quite noticeably like the clay bust, unlike any of the other faces appearing there. The nose, grin, and big teeth are all very similar. It is conceivable that Daumier modelled this clay after this lithograph, which would certainly place the clay among the first to be modelled. In the portrait lithograph of Kératry, of 1833 (cat. no. 19d), Daumier retained the profile he had invented, but raised the skull somewhat to reduce the simian appearance. Filled with affected grace, and in his ballet shoes resembling a character from the *Commedia dell' Arte*, Kératry is one of the most animated of these early portrait prints by Daumier.

HISTORY

1891 Champfleury sale, No. 72 (refers to clay)
1905 Geffroy, 107: "Unknown" (clay, ILLUSTRATED)
1908 Bertels, No. 3: "A representative, terra cotta" (actually clay, ILLUSTRATED)
1927 Fuchs, No. 170a: "Unknown, colored terra cotta" (actually clay, ILLUSTRATED)
1930 MOMA, New York, No. 142: "Compte de Keatry" (bronze)
1932 Bouvy, No. 4: "Kératry" (bronze, ILLUSTRATED)
1934 Bibliothèque Nationale, Paris, No. 385 (bronze)
1947 Musée Cantini, Marseilles, No. 26 (bronze)
1948 Mourre, 99: "thin, pitiful, deputy, peer, 'Charles XII in ideology, Alexandre in metaphysics' "
1952 Gobin, No. 4 (clay and bronze, ILLUSTRATED) Deutsche Akademie der Künste, Berlin, No. 4 (bronze, ILLUSTRATED)
1957 Galerie Sagot-Le Garrec, Paris, No. 4 (bronze)
1958 Bibliothèque Nationale, Paris, No. 25 (bronze) Los Angeles County Museum, No. 225 (bronze)
1961 Museo Poldi Pezzoli, Milan, No. 12 (bronze, ILLUSTRATED)
1968 Château de Blois, No. 443 (bronze)

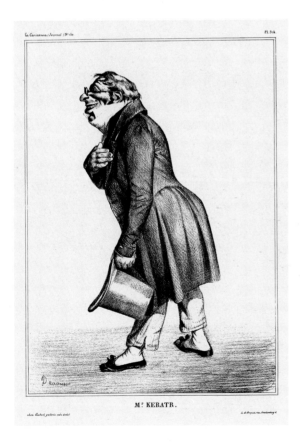

19d. MR. KERATR. . . . L.D. 70
 Lithograph, second state; 278 x 204 mm.
 La Caricature, September 19, 1833
 Fogg Art Museum, Harvard University

20. Lameth

Charles-Malo-François, Comte de
1752-1832

Gobin No. 18

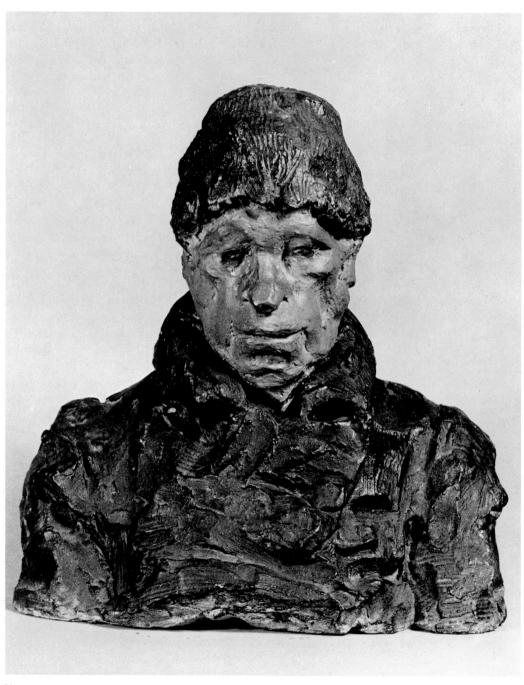

20a.

Daumier's lithograph of Lameth was the first to appear in the *Célébrités de la Caricature* series. With the lithograph appeared Philipon's announcement that Daumier had made a group of clay busts of the persons to be represented, and had drawn the lithographs from these clays (see Introduction to the Busts).

Lameth was an aristocrat whose sympathies were with the bourgeoisie. He took part in the American Revolution and was wounded twice at Yorktown. During the French Revolution, in 1789, he voted for the abolition of the aristocracy and for freedom of the press. Thus forced to emigrate, in 1792, he founded a business in Hamburg. In 1801 Napoleon made him Governor of Würzburg. During the Restoration he became a Deputy of the liberal opposition, finally growing conservative under Louis Philippe (Deutsche Akademie, 1952, no. 18; Bibliothèque Nationale, 1958, no. 26; and Poldi Pezzoli, 1961, no. 6). Durbé noted that Lameth was eighty when Daumier made this bust, and represented to the young Republicans the symbol of an epoch, "a living example of moral compromise."

The clay bust of Lameth was mentioned by name in the Champfleury sale as one of those included in Philipon's photograph of 1865 (Champfleury sale, 1891, no. 72). Geffroy illustrated the bust in 1905 (see cat. no. 20b), saying that Lameth had a displeased, peevish face, with his narrow skull covered with a black church warden's skullcap (pp. 101, 105). Champfleury's identification label appears on the bust. Bertels, Klossowski, Pach, and Fuchs all repeated the same photograph, except that in the latter illustration the label was blocked out.

In 1934 a terra-cotta reproduction made from the Le Garrec clay was exhibited at the Bibliothèque Nationale in Paris (no. 393). The first mention of a bronze was published in the catalogue of the Daumier exhibition in Marseilles (Musée Cantini, 1947, no. 27). In 1967 the firm of Alva Museum Replicas, Inc. began to issue a series of reproductions made from the bronze now in the collection of the National Gallery of Art in Washington. For purposes of comparison, both the bronze (cat. no. 20c) and the reproduction (cat. no. 20d) are included in this exhibition.

Technically, the clay bust of Lameth seems to be the least satisfactory of the thirty-six. The nose is an unpleasant affair, a tube of clay flattened slightly, then grafted onto the face rather obviously. The eyes have either been damaged or were never well-defined. The surface of the skin is busily worked, but the structure of the skull below is not made sensible. In fact, the ears and jawbone seem unfinished. The top of the head is shaped with some wit into a caplike device, but the nature of this "cap" is unclear. Geffroy called it a skullcap. Mourre said Lameth was "rigged out in a phrygian bonnet" (1948, p. 98). But the surface of this cap was stroked with the comb tool, a method Daumier generally used to represent hair. Differing from the other busts, the surface of Lameth's jacket is worked up into meaningless rumples. It is possible that these weaknesses are the result of heavy restoration of this bust. However, the clay seems to be in good condition, and does not appear to have changed much since the 1905 illustration. Also, the lithograph of Lameth, which Philipon said was made after the clay, is quite like it. The shape of the cap is nearly identical and has fine lines drawn on it. The lights and darks of the cheeks could have been based directly on the clay. And Daumier put into heavy shade those areas that are least clear in the clay: the ear, jawline, and eyes. Like d'Argout, this clay must come from Daumier's novice period, one which lasted a remarkably short time.

Lameth was included in the "Masks of 1831" (cat. no. A), and like Kératry's, his profile is drawn with a firm hand there, and bears a reasonable resemblance to the bust. As with Kératry, it would not be a surprise to learn that Daumier modelled his bust with this drawing in mind. Daumier included Lameth in only one other lithograph, the "Charenton Ministérial" (cat. no. B). Lameth died soon after, in December, 1832. Obviously the bust must have been made before that date. Gobin called the bust "L'Indécis" (The Irresolute).

HISTORY

1832 *La Caricature,* April 26 (clay)
1891 Champfleury sale, No. 72 (refers to clay)
1905 Geffroy, 105; 101 (clay, ILLUSTRATED)
1908 Bertels, No. 4: "Deputy Lameth, terra cotta" (actually clay, ILLUSTRATED)
1923 Klossowski, Pl. 8, No. 458 (clay, ILLUSTRATED)
1924 Pach, Pl. 5: "unidentified head, wax" (actually clay, ILLUSTRATED)
1927 Fuchs, No. 170d: "terra cotta" (actually clay, ILLUSTRATED)
1932 Bouvy, No. 18 (clay, ILLUSTRATED)
1934 Bibliothèque Nationale, Paris, No. 393 (terracotta reproduction)
1947 Musée Cantini, Marseilles, No. 27 (bronze)
1948 Mourre, 98: "mediocre deputy, well-known. . . . with the pear, cross, and fleur-de-lys on a shield with the device, 'To Emigrate Is Not To Desert' "
 Le Garrec, Berthe, *Arts et Livres,* 102 (terracotta reproduction)
1952 Gobin, No. 18 (clay, ILLUSTRATED)
 Deutsche Akademie der Künste, Berlin, No. 18 (bronze, ILLUSTRATED)
1957 Galerie Sagot-Le Garrec, Paris, No. 18 (bronze)
1958 Bibliothèque Nationale, Paris, No. 26 (bronze)
 Museum of Fine Arts, Boston, No. 13 (bronze, ILLUSTRATED)
 Los Angeles County Museum, No. 230 (bronze)
1961 Musée Cognacq-Jay, Paris, No. 322 (bronze, ILLUSTRATED)
 Museo Poldi Pezzoli, Milan, No. 6 (bronze, ILLUSTRATED)
1966 Palais Galliera, Paris, No. 21 (bronze, ILLUSTRATED)
1968 Château de Blois, No. 457 (bronze)

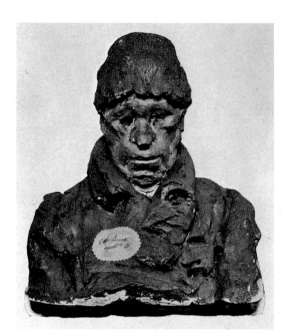

20b.

20a. LAMETH
 Unbaked clay, painted; h. 5-15/16″ (151 mm.)
 Bronze edition of 30
 Collection Madame Berthe Le Garrec, Paris
 (not in exhibition)

20b. Early photograph of unbaked clay no. 20a from Geffroy, 1905, p. 101

20. Lameth

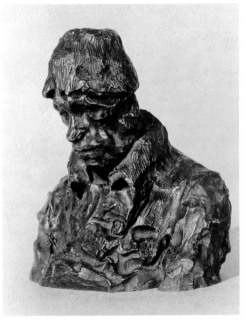

20c.

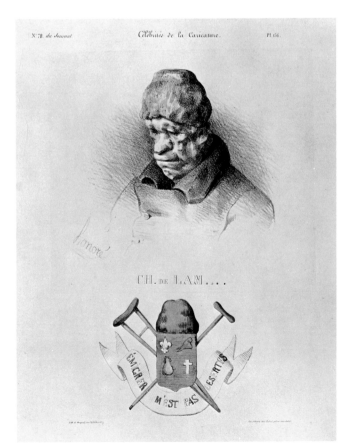

20e.

20c. LAMETH
Cast bronze; h. 5¾″ (146 mm.)
Markings: lower left rear: MLG; bottom rim: 2198-1;
 inside: 3/30
National Gallery of Art, Lessing J. Rosenwald
 Collection

20d. LAMETH
Alva reproduction made from Rosenwald bronze no. 20c
Synthetic material; h. 5-13/16″ (148 mm.)
Markings: bottom rear: © 1967 ALVA MUSEUM
 REPLICAS INC., MLG
Fogg Art Museum, Harvard University
(not illustrated)

20e. CH. DE LAM. . . . L.D. 43
Lithograph, hand colored; 270 x 170 mm.
La Caricature, April 26, 1832
Fogg Art Museum, Harvard University

21. Lecomte

Gobin No. 16

Nothing is known about Lecomte beyond the fact that he was the judge with Gaudry at the trial at Versailles against the newspaper *Le National*. Even his first name has defied research. The clay was mentioned as early as 1905 by Geffroy (p. 106), who may have known the name "Lecomte" from a label attached to the bust. The first author to illustrate the clay was Bouvy, in *Trente-six bustes de H. Daumier*, 1932 (no. 16).

Lecomte and Gaudry appeared together in a lithograph of 1833 (see cat. no. 21c). The two busts are quite similar. In both Daumier, working with two blocks, placed a square head on a square torso. In Lecomte, this sense of geometry is enhanced by the regular horizontal and vertical lines of the collar and stock, and by the recession of the smallish features of the face which emphasizes the blocky head. In Gaudry, Daumier relaxed this effect by dropping the head forward (see cat. no. 16a).

The lively expression of the face of Lecomte counteracts any excessive geometry in this bust. Two sharp eyes peep out, punched into the clay by a sharp tool. The mouth lifts at one corner, forming a slight smile. A certain virtuosity is noticeable in the modelling here, even to the placement of the head upon the shoulders, and the forming of the judges' collar from a thin half-circle of clay set around the shoulders. Very little is lost in the translation of this bust from clay to bronze. Gobin called it "Le Subtil" (Subtle, or Crafty) in 1952 (no. 16). Subtle applies to the handling of the clay as well.

Oddly enough, the figure of Lecomte does not seem particularly sculptural in the only lithograph by Daumier in which he appears (see cat. no. 21c). For example, his robe there is almost two-dimensional in appearance. The head does seem rounded, as it is shaded on one side. But on the face, as on that of Gaudry, Daumier emphasized linear patterns, by drawing two identical lines from the eyebrow down the nose and mouth to the collar, in the form of an hourglass. The lithograph is dated August, 1833. The differences between the two media suggest once again that Daumier made the clays in early 1832, and did not use them as models for lithographs after the *Celebrity* series which ended in April, 1833.

HISTORY

1905 Geffroy, 106: ". . . and Lecomte" (referring to clay)
1932 Bouvy, No. 16 (clay, ILLUSTRATED)
1948 Mourre, 99
1952 Gobin, No. 16 (clay, ILLUSTRATED)
 Deutsche Akademie der Künste, Berlin, No. 16 (bronze, ILLUSTRATED)
1957 Galerie Sagot-Le Garrec, Paris, No. 16a (clay, ILLUSTRATED); 16b (bronze)
1958 Bibliothèque Nationale, Paris, No. 41 (bronze)
1961 Museo Poldi Pezzoli, Milan, No. 31 (bronze, ILLUSTRATED)
1968 Château de Blois, No. 455 (bronze)

21. Lecomte

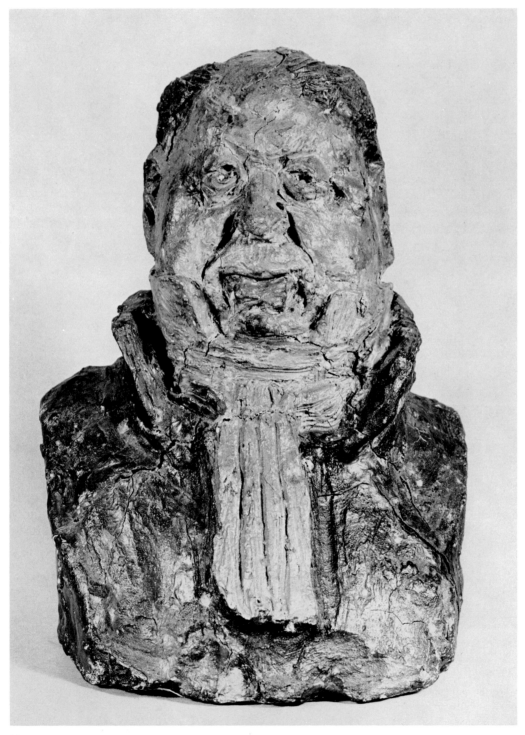

21a.

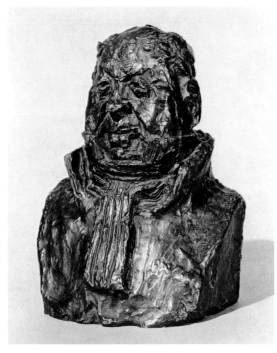

21b.

21a. LECOMTE
Unbaked clay, painted; h. 6-15/16″ (176 mm.)
Bronze edition of 25
Collection Madame Berthe Le Garrec, Paris
(not in exhibition)

21b. LECOMTE
Cast bronze; h. 6-9/16″ (167 mm.)
Markings: left side: MLG; bottom rim: 2195-1;
 inside: 3/25
National Gallery of Art, Lessing J. Rosenwald
 Collection

21c. MR. GA. . . . MR. LECOM. . . . L.D. 160
(See also No. 16c)

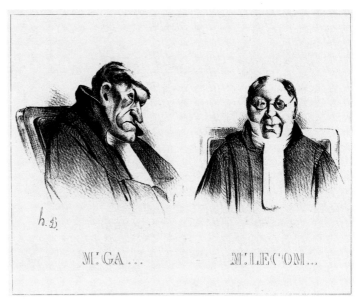

21c.

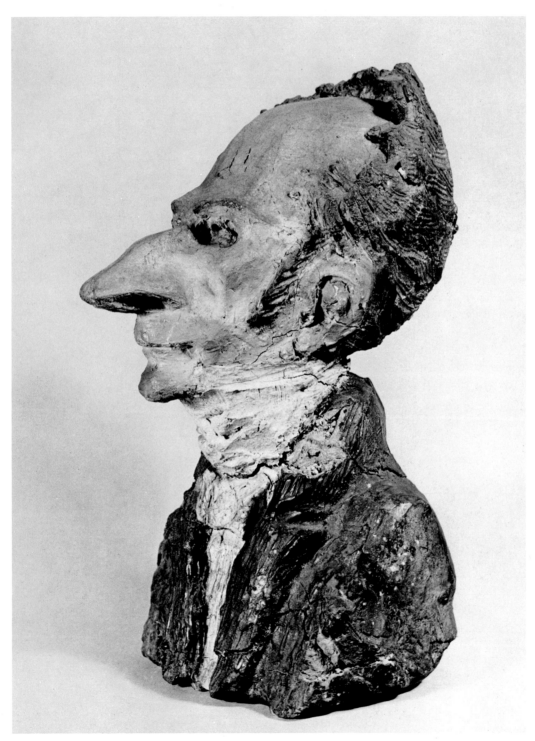

22a.

22. Lefebvre

Jacques 1773-1856

Gobin No. 28

The bust of Lefebvre has been mistaken for Persil. Lefebvre was a banker and not a lawyer like Persil. Mourre said he was President of the Chamber of Commerce (1948, p. 100); Durbé said he was influential in economic areas (Poldi Pezzoli, 1961, no. 34); and Adhémar wrote that Lefebvre became a Deputy in 1827, and after 1830 grew ultra-conservative and reactionary (Bibliothèque Nationale, 1958, no. 27). Gobin called the bust "L'Esprit fin et tranchant" (The Fine, Trenchant Spirit).

This bust is one of the best-documented in photographs. The clay was illustrated by Dayot in 1897 (see cat. no. 22b), and appeared to be in good condition except for cracking across the jacket front. Dayot called it "Persil." There is a paper identification label on the left front of the bust which cannot be read in the photograph. Geffroy illustrated a different photograph of the bust in 1905 (p. 103), calling it "Jacques Lefèvre." The bust also appears in the group photograph in the Museum of Fine Arts, probably taken in 1865 (cat. no. F). Phillips, Fuchs, and Luc-Benoist repeated Geffroy's photograph. A bronze was first published (but not illus-

22a. LEFEBVRE
Unbaked clay, painted; h. 7-15/16″ (202 mm.)
Bronze edition of 25 begun by 1934
Collection Madame Berthe Le Garrec, Paris
(not in exhibition)

22b. Early photograph of unbaked clay no. 22a from Dayot, 1897, II, p. 35

22c. LEFEBVRE
Cast bronze; h. 7¾″ (197 mm.)
Markings: center rear: MLG, BRONZE; inside: 23/25
National Gallery of Art, Lessing J. Rosenwald Collection

22d. LEFEBVRE
Alva reproduction made from Rosenwald bronze no. 22c
Synthetic material; h. 7¾″ (197 mm.)
Markings: bottom rear: © 1957 ALVA MUSEUM REPLICAS INC., MLG
Fogg Art Museum, Harvard University
(not illustrated)

22e. LEFEBVRE
Terra-cotta reproduction, painted to resemble original clay; h. 7-9/16″ (192 mm.)
Galerie Sagot-Le Garrec, Paris

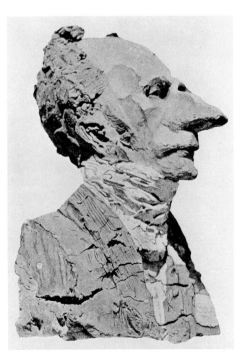

22b.

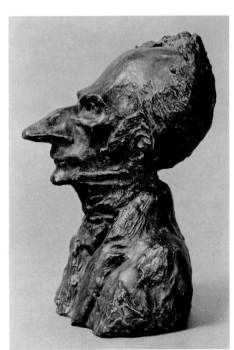

22c.

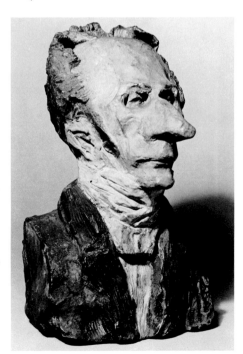

22e.

trated) in the Bibliothèque Nationale catalogue in 1934 (no. 386).

Since then, two further reproductions have been made of Daumier's original clay. An edition of eight terra cottas is in preparation, cast from molds taken from the clay. These will be hand painted in an effort to simulate Daumier's polychromy. A reproduction of one is included in this exhibition (see cat. no. 22e). In 1957 Alva Museum Replicas began to produce reproductions made of a synthetic material that resembles bronze, although it does not have the sheen of the metal (cat. no. 22d). These replicas were based on the Rosenwald bronze also included in this exhibition (cat. no. 22c). The Alva replicas are clearly stamped with their copyright.

In Lefebvre, Daumier attained a peak in his satirical modelling. All the anatomical parts seem plausible though Daumier obviously extended them beyond reality. The skull looks round and brittle as an ostrich egg with skin pulled taut over it. This is particularly effective in the bronze. The thin, bony face is set in front of, and almost detached from, the skull, pulled forward by an incredible Cyrano-de-Bergerac nose. The nose, like Cyrano's, has a personality of its own. It moves forward, then down, spreading at the sides, as if a short piece of cartilage supported a large umbrella of flesh. Beneath is the tiny, delicate chin and scrawny neck. The bust obviously pleased Daumier, for he repeated it carefully in the lithograph (see cat. no. 22f), exaggerating even more the large round skull set well behind the face and balancing the forward reach of the umbrella-like nose. Lefebvre also appears in the "Ventre légis-latif" (cat. no. C) though quite changed from these two portraits.

Lefebvre appeared in Philipon's papers only in 1833 (Poldi Pezzoli, 1961, no. 34). This led Durbé to date the clay from that year as well. However, the bust-length print illustrated here, published in November, 1833, closely resembles similar prints of the *Celebrity* series, which ran from April 1832 to April 1833. It does not seem impossible that Daumier made busts and prints as a group in 1832, even though Philipon did not publish Lefebvre until 1833.

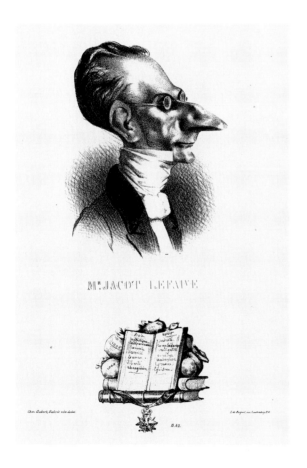

22f. MR. JACOT-LEFAIVE L.D. 173
 Lithograph, second state; 280 x 128 mm.
 Charivari, November 9, 1833
 Boston Public Library

HISTORY

1897 Dayot, II, 35: "Persil" (clay, ILLUSTRATED)
1905 Geffroy, 105: "Lefèvre, the banker, with his sharp knife-life face"; 103 (clay, ILLUSTRATED)
1922 Phillips, n.p. (clay, ILLUSTRATED)
1927 Fuchs, No. 169d (clay, ILLUSTRATED)
1928 Luc-Benoist, opp. 132 (clay, ILLUSTRATED)
1932 Bouvy, No. 28: "Lefebvre" (clay, ILLUSTRATED)
1934 Bibliothèque Nationale, Paris, No. 386 (bronze)
1937 Pennsylvania Museum of Art, Philadelphia, No. 4 (bronze)
1939 Buchholz Gallery, New York, No. 2 (bronze)
1948 Mourre, 100
1952 Gobin, No. 28 (clay, ILLUSTRATED)
 Deutsche Akademie der Künste, Berlin, No. 28 (bronze, ILLUSTRATED)
1957 Galerie Sagot-Le Garrec, Paris, No. 28 (bronze)
1958 Bibliothèque Nationale, Paris, No. 27 (bronze)
 Museum of Fine Arts, Boston, No. 7 (bronze)
 Los Angeles County Museum, No. 236 (bronze)
1961 Museo Poldi Pezzoli, Milan, No. 34 (bronze, ILLUSTRATED)
1968 Château de Blois, No. 467 (bronze)

23. Montlosier

François-Dominique-Reynaud, Comte de
1755-1838

Gobin No. 36

This clay was first given the name of "Montlosier" by Bouvy in 1932 (no. 36). The identification has continued in use, for the bust closely resembles a drawing of Montlosier from a triple lithograph Daumier did in 1835 (see cat. no. 23g). Gobin's awkward nickname, "Le Fourbe et Rusé" (The Knave and Sly, or Knavish and Sly) does not seem particularly apt for this bust (Gobin, 1952, no. 36).

Count Montlosier would certainly have been a suitable target for Daumier. According to Durbé he was an "ardent supporter of aristocratic privilege" who wrote a book on monarchy during the Restoration, a "panegyric on feudal institutions" (Poldi Pezzoli, 1961, no. 37). He had been an *émigré* in 1791, then was a Napoleonist. He was made a Peer of France by Louis Philippe. In 1833 he caused a scandal by demanding that the clergy be prevented from instructing children (Bibliothèque Nationale, 1958, no. 28). However, this colorful character did not appear in Philipon's newspapers until 1835 when he sat with the other Peers as the high court of justice in the trial of the Accused of April in 1835, the event to which the lithograph here illustrated refers.

The clay was first illustrated, though not identified, by Fuchs in 1927 (no. 169d). The heavy black paint of the sideburns and eyebrows is quite startling in his photograph (see cat. no. 23b). This polychromy seems to have faded today. As all the other photographs used by Fuchs are identical to Geffroy's of 1905, it is conceivable that this photograph of Montlosier dates back to 1905 as well.

Durbé felt that the clay and lithograph show a similar inspiration, different from those of 1832-33, and he dated the clay about 1835. However, the clay does not seem so very different from Gaudry or Chevandier (cat. nos. 16 and 4). The former has a square head dropped forward on a square base; Montlosier has a big round head hanging forward on a squarish base. Chevandier is very similar in form to Montlosier, with his fat, rounded pompadour, nose, and tie. His nose and Montlosier's are almost identical, and it is not a great step from Montlosier's squinted eyes to Chevandier's shut in sleep. In all three busts Daumier drew a crease along the nose extending down into the cheek. Though greatly abraded, the clay of Montlosier still bears clear traces of the rake with which Daumier drew lines on the coat. Thus, there seems no reason to separate this bust from the others. The lithograph portrait is certainly quite different from the bust, but not more so than full-length lithographs Daumier made of his subjects in 1833 (for example, Cunin or Etienne). After drawing the bust-length-portraits, especially those for the *Celebrity* series, Daumier does not seem to have copied the clays carefully. Therefore, the changes that occurred in this drawing, which was not made until 1835, are quite consistent.

An engraved portrait of Montlosier by another hand, made when he was somewhat younger, depicts a nattier man. The heavy features are not dissimilar to those sculpted by Daumier, however, except for the eyes, for the engraver also gave him a round bald head, high eyebrows knitted over a long, bulbous nose, and rather thick lips (cat. no. 23c).

There are two bronzes of Montlosier in this exhibition. One, from the Rosenwald collection (cat. no. 23d), is a Barbedienne bronze from the edition begun by 1934. The other, from a Boston collection (cat. no. 23e) was made by the Valsuani foundry between 1953-65, from the same mold, now broken. The initial "C" stamped on this bronze refers to one of Maurice Le Garrec's daughters, for whom one complete set of thirty-six was made (see Introduction to the Busts). Finally, in 1967, Alva Museum Replicas began an edition of copies of the Rosenwald bronze, made of a synthetic material resembling bronze. One of these is also included in this exhibition (cat. no. 23f).

HISTORY

1927 Fuchs, No. 169b: "Unknown" (clay, ILLUSTRATED)

1932 Bouvy, No. 36: "Montlosier" (clay, ILLUSTRATED)

1934 Bibliothèque Nationale, Paris, No. 387 (bronze)

1936 Albertina, Vienna, No. 81 (bronze)

1948 Mourre, 100

1952 Gobin, No. 36 (clay, ILLUSTRATED)
Deutsche Akademie der Künste, Berlin, No. 36 (bronze, ILLUSTRATED)

1957 Galerie Sagot-Le Garrec, Paris, No. 36 (bronze)

1958 Bibliothèque Nationale, Paris, No. 28 (bronze)

1961 Museo Poldi Pezzoli, Milan, No. 37 (bronze, ILLUSTRATED)

1968 Château de Blois, No. 475 (bronze)

23. Montlosier

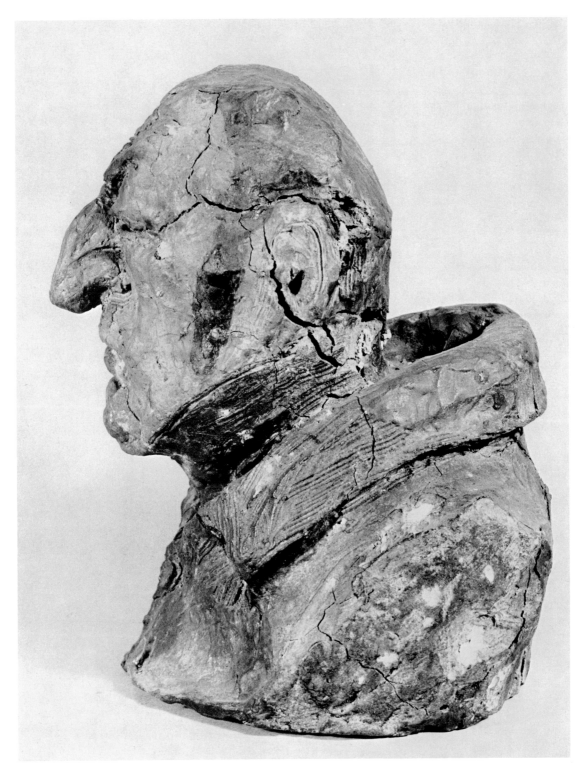

23a.

23a. MONTLOSIER
 Unbaked clay, painted; h. 7-23/32″ (196 mm.)
 Bronze edition of 25 begun by 1934
 Collection Madame Berthe Le Garrec, Paris
 (not in exhibition)

23b. Early photograph of unbaked clay no. 23a from Fuchs,
 1927, pl. 169b

23g. COMTE PORTALIS — DUC DE BASSANO —
 COMTE DE MONTLOSIER L.D. 121
 Lithograph; 228 x 500 mm.
 La Caricature, July 3, 1835
 Museum of Fine Arts, Boston

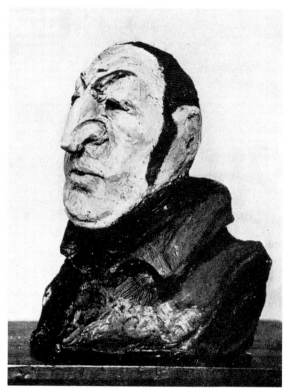

23b.

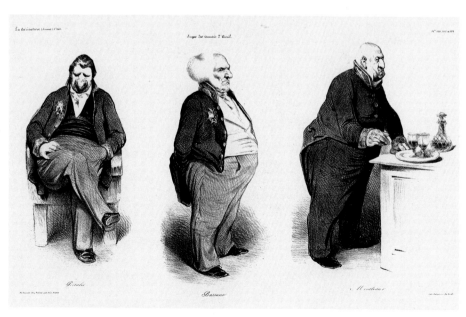

23g.

23. Montlosier

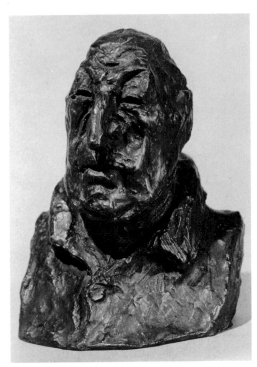

23d.

23c. **UNKNOWN ARTIST**

FOIS. DQUE. REYNAUD, COMTE DE MONTLOSIER
Engraving; 182 x 152 mm.
Collection Lessing J. Rosenwald, Jenkintown,
Pennsylvania

23d. **MONTLOSIER**
Cast bronze; h. 7½″ (190 mm.)
Markings: lower right rear: MLG, BRONZE;
inside: 23/30
National Gallery of Art, Lessing J. Rosenwald
Collection

23e. **MONTLOSIER**
Cast bronze; h. 7½″ (190 mm.)
Markings: lower rear: Valsuani stamp, MLG, followed
by letter C in a circle
Private Collection, Boston
(not illustrated)

23f. **MONTLOSIER**
Alva reproduction made from Rosenwald bronze no. 23d
Synthetic material; h. 7-9/16″ (192 mm.)
Markings: bottom rear: © 1967 ALVA MUSEUM
REPLICAS INC., MLG
Fogg Art Museum, Harvard University
(not illustrated)

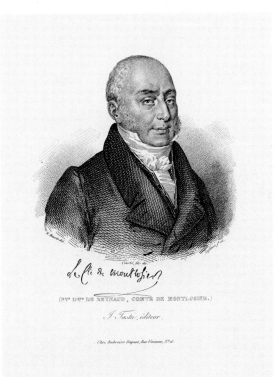

le Cte de montlosier

(F.ᵗᵉ Dᵘᵉ DE REYNAUD, COMTE DE MONTLOSIER.)

J. Tastu, éditeur.

Chez Ambroise Dupont, Rue Vivienne, N.º 16.

23c.

24. Odier

Antoine 1766-1853

Gobin No. 17

Until now, the oldest known photograph of the bust of Odier was in Bouvy (1932, no. 17). Geffroy had described the bust in 1905: "Odier, banker and deputy, old, an expression of concentration, long white hair falling to his collar" (p. 105). Happily, Odier is also one of the six busts that appear in the photograph belonging to the Museum of Fine Arts, probably taken in 1865, which is illustrated here (see cat. no. F). The label visible in the photograph reads: "Odier banquier et député."

Odier himself was a little-known deputy, who was seated with the opposition under the Restoration, and "seemed allied to Louis without much conviction" (Bibliothèque Nationale, 1958, no. 29). This Paris catalogue called him Antoine Odier-Boué. Durbé noted he was one of the bankers and industrialists who supported the July Monarchy (Poldi Pezzoli, 1961, no. 16). Gobin called him "Le Méprisant" (The Scornful).

As may be seen in the Museum of Fine Arts photograph, the bust is one of the smaller ones. It had begun to crack by that time, especially around the chin, the right eye, and along the right side of the base. Restorations in these areas are visible today. However, Daumier's basic concept has not been lost, and is well preserved in the bronzes (cat. no. 24b). Odier seems to be one of the group of studies of physiognomy combined with unusual hair styles that Daumier made with his smaller clays. With his broad jaw and the wrinkles around the nose, the bust of Odier seems to follow Fruchard, and to lead Cunin, Sébastiani, and Etienne away from the exaggerated grimaces of Fruchard or Prunelle. The profile of this bust is especially telling. The pugnacious chin is thrust well forward, nose raised above it like a canopy, brow sloping down toward the jaw, with all the wrinkles of the cheeks and waves of the hair rippling backward in opposition to the jaw's forward thrust.

The lithograph of Odier (cat. no. 24c) is mild compared to the vigor of the clay, for though Daumier copied the features and the basic expression, he changed the drawing from a true grimace to something resembling a portrait. He drew Odier twice more, once still looking pugnacious, in a full-length portrait called, rather unnecessarily, "Mr. Odieux" (Mr. Odious), an excellent lithograph indirectly derived from the bust (cat. no. 24d). Odier also appeared in the "Ventre législatif." He is seen from the front in that print, though the nose and features are still related to the clay bust.

HISTORY

1905 Geffroy, 105 (referring to clay)
1932 Bouvy, No. 17 (clay, ILLUSTRATED)
1948 Mourre, 99: "Deputy and peer"
Guillet, 8 (bronze, ILLUSTRATED)
1952 Gobin, No. 17 (clay, ILLUSTRATED)
Deutsche Akademie der Künste, Berlin, No. 17 (bronze, ILLUSTRATED)
1957 Galerie Sagot-Le Garrec, Paris, No. 17 (bronze)
1958 Bibliothèque Nationale, Paris, No. 29 (bronze)
1961 Museo Poldi Pezzoli, Milan, No. 16 (bronze, ILLUSTRATED)
1966 Larkin, 23
1968 Château de Blois, No. 456 (bronze)

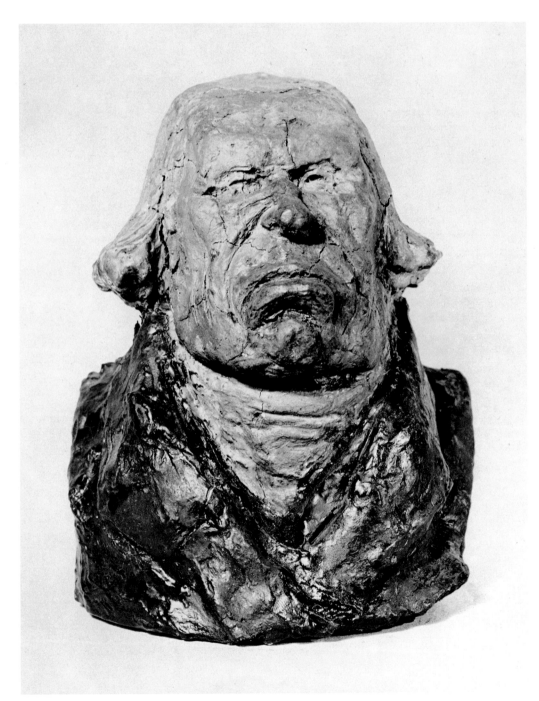

24a.

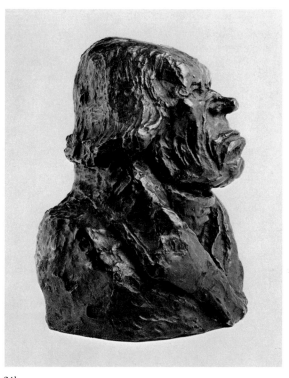

24b.

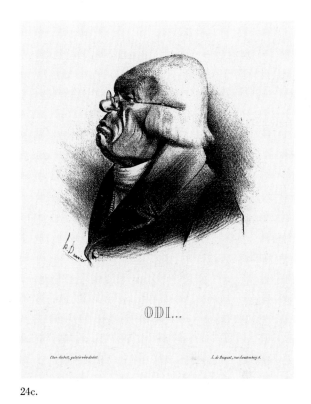

24c.

24a. ODIER
 Unbaked clay, painted; h. 5⅞″ (149 mm.)
 Bronze edition of 30
 Collection Madame Berthe Le Garrec, Paris
 (not in exhibition)

24b. ODIER
 Cast bronze; h. 5½″ (140 mm.)
 Markings: lower right side: MLG; bottom rim: 2197-1;
 inside: 3/30
 National Gallery of Art, Lessing J. Rosenwald
 Collection

24c. ODI. . . . L.D. 147
 Lithograph; 128 x 130 mm.
 Charivari, May 22, 1833
 Boston Public Library

24d. MR. ODIEUX L.D. 58
 Lithograph; 272 x 189 mm.
 La Caricature, June 20, 1833
 Benjamin A. and Julia M. Trustman Collection,
 Brandeis University
 (not illustrated)

25. Pataille

Alexandre-Simon 1781-1857

Gobin No. 33

Though caricatured in profile view by the bump on his forehead, this sprightly fellow is nevertheless one of Daumier's most winning portraits. Pataille was a provincial, the first President of the Court of Aix and Deputy from Bouches-du-Rhône (Mourre, 1948, p. 100), and a magistrate who "created a sensation by his 'vigorous eloquence, his tight dialectic, his irresistible argument' " (Bibliothèque Nationale, 1958, no. 30). The latter catalogue called him "Alexis Simone Pataille." Daumier must have been inspired by phrenologists' charts when he exaggerated the large bump on Pataille's forehead. Gobin, for reasons of his own, called the bust "Le Gourmet" (The Epicure), in his 1952 catalogue (no. 33).

Geffroy mentioned the bust in 1905 (p. 105) but did not illustrate it, and it has clearly suffered damage. However, traces of Daumier's pointed instrument are visible around the eyes, and the fine lines of his comb tool appear here and there on the jacket. The illustration (cat. no. 25a) indicates the variety of color in the polychromy, although it is difficult to know how much of this paint is Daumier's and how much is due to restoration. The bust is near to Falloux or Delort in the refinement of handling, and has a nose and cranial bumps like the latter. Pataille's delicate, triangular face comes to a point at the chin. This unstable balance on a point adds to the liveliness of the conception. Heavy pyramidal Podenas is almost his antithesis.

Two bronzes of Pataille are included in this exhibition. One is a Barbedienne bronze, number twenty-three of an edition begun by 1934 by Maurice Le Garrec (see cat. no. 25b). The other is an unauthorized bronze, cast by an unknown hand from one of the Barbedienne bronzes (see cat. no. 25c). Berthe Le Garrec first warned of the existence of these pirated casts in 1948: "In 1943 there appeared gross falsifications, surmoulages of three of the busts including Pataille. . . . These fakes are easily recognizable, lacking finesse in casting (supression of numerous details), are slightly smaller in size, and lack numbering. They are stamped falsely 'H.D.,' while the original bronzes are stamped 'M.L.G.,' and bear a series number in the form of a fraction" (*Arts et Livres*, p. 102). The owners of these two bronzes kindly allowed the Fogg to make detailed laboratory comparisons of the two. The results of this study may be found in "Materials and Techniques."

Pataille appeared in only two lithographs, a portrait in bust (cat. no. 25d) and the "Ventre législatif." Like most of the bust portraits, this one adheres fairly closely to the clay, with bright lights and strong darks emphasized. Though a faithful adaptation, the print does not capture the sense of spontaneity of the clay, which seems about to speak.

HISTORY

1905 Geffroy, 105: "Pataille, deputy, so acute" (referring to clay)
1932 Bouvy, No. 33 (clay, ILLUSTRATED)
1934 Bibliothèque Nationale, Paris, No. 388 (bronze)
1947 Musée Cantini, Marseilles, No. 28 (bronze)
1948 Le Garrec, Berthe, *Arts et Livres*, 102 (bronze, surmoulage)
Mourre, 100
1952 Gobin, No. 33 (clay, ILLUSTRATED)
Deutsche Akademie der Künste, Berlin, No. 33 (bronze, ILLUSTRATED)
1957 Galerie Sagot-Le Garrec, Paris, No. 33 (bronze)
1958 Bibliothèque Nationale, Paris, No. 30 (bronze)
1961 Museo Poldi Pezzoli, Milan, No. 26 (bronze, ILLUSTRATED)
1966 Larkin, 23
1968 Château de Blois, No. 472 (bronze)

25a. PATAILLE
Unbaked clay, painted; h. 6-27/32" (174 mm.)
Bronze edition of 30 made beginning 1934
Collection Madame Berthe Le Garrec, Paris
(not in exhibition)

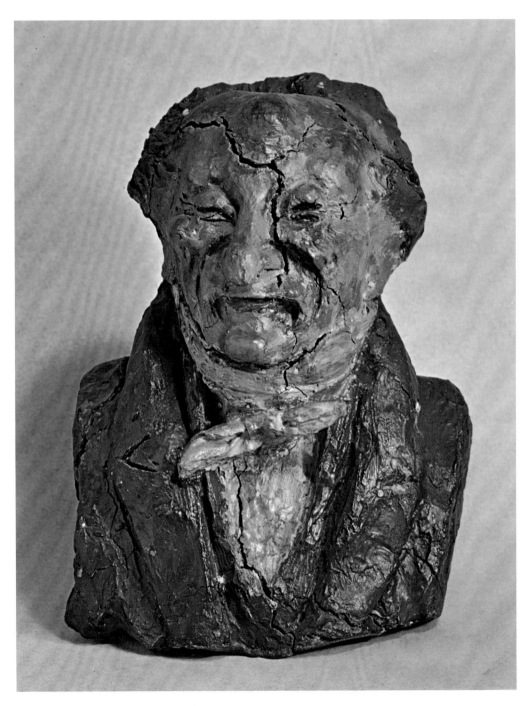

25a.

25. Pataille

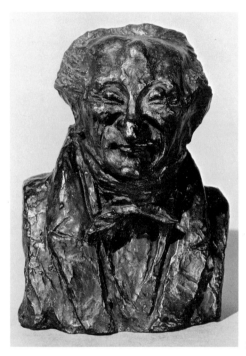

25b.

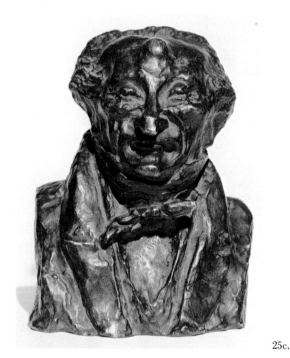

25c.

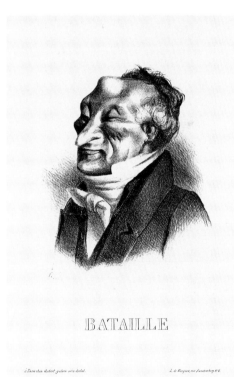

25d.

25b. PATAILLE
Cast bronze; h. 6-9/16″ (167 mm.)
Markings: lower right rear: MLG, BRONZE;
inside: 23/30
National Gallery of Art, Lessing J. Rosenwald
Collection

25c. PATAILLE
Surmoulage (fugitive cast)
Cast bronze (sand cast) ; h. 6-7/16″ (163 mm.)
Markings: lower left side: H-D
Collection Benjamin A. and Julia M. Trustman, Boston

25d. BATAILLE L.D. 151
Lithograph, second state; 140 x 120 mm.
Charivari, June 11, 1833
Benjamin A. and Julia M. Trustman Collection,
Brandeis University

26. Persil

Jean-Charles 1785-1870

Gobin No. 15

Daumier did not make Persil into a sympathetic figure. Nor is it any wonder, for Persil, who was then Attorney General, was violently opposed to the freedom of the press (Bibliothèque Nationale, 1958, no. 32). Saint-Beuve wrote that he gave up a brilliant career as a lawyer to enter politics (he became a Deputy in 1830, and Attorney General under Louis Philippe). Durbé said that Philipon's newspapers used yards and yards of type in violent invective against him, considering him a "cruel enemy of liberty and of the press." Champfleury called Persil dry, cold, pale, with sunken eyes (in Poldi Pezzoli, 1961, no. 21). His profile was likened to a sawblade and his nickname, "Père-Scie," suggested the sound of the guillotine.

This bust has suffered greatly from the ravages of time, as may clearly be seen from Geffroy's 1905 photograph (see cat. no. 26b). At that time the head had cracked from crown to chin, which created a deep gouge in the left cheek and destroyed the left half of the mouth. The nose seems to have been broken away, and the right cheek was apparently crumbling. The clay head in Gobin's photograph (no. 15) though apparently in good condition, seems dead, dull, lackluster, almost like a plaster copy of an original. Clearly, this is the result of the extreme restoration that was necessary to prepare this sadly damaged clay for casting. However, the sunken eyes still attest to Daumier's handiwork, as do the shape of the head, the joining of head and neck, and the base of the figure in general. A lithograph signed by L. P. Fromant, of Persil at about the age of twenty suggests that, as with Dupin, we may never be sure what Persil looked like, for although the sideburns and hair are similar and the face has a long nose in both works, Fromant's Persil has widely-spaced melting eyes, very different from the close-set sunken eyesockets Daumier gave him. The bust has a high forehead like that of Viennet, a large chin very like Ganneron's and sunken eyes suggesting both Ganneron and Delessert. Persil is especially close to Lefebvre in his total lack of animation or expression of any kind (noticeable even in the 1905 photograph).

Daumier drew numerous lithographs of Persil, mostly, however, in 1834, the year the latter became Minister of Justice. One of these is the frighteningly evil face of the magistrate in "Modern Galilee" (cat. no. 26f) of 1834 based only indirectly on the bust. Persil was included in "Charenton Ministériel" (cat. no. B). His profile there is not much like the bust. In the "Ventre législatif" (cat. no. C) Persil is half-hidden behind Guizot. The bust-length lithograph of Persil was the last portrait to appear in the *Célébrités de la Caricature*, in April, 1833 (cat. no. 26e). Here is a drawing from the clay in its original form, for as in all the portraits in this series, Daumier seems to have copied the clay carefully, and in the case of Persil a certain stiffness of handling was suitable.

This clay was first mentioned in the catalogue of the Champfleury sale as one of the busts appearing in Philipon's 1865 photograph (1891, no. 72). The first mention of a bronze was in 1947 (Musée Cantini, no. 30). Gobin called the bust "Le Scrupuleux" (The Scrupulous One) in 1952 (no. 15). In 1967 Alva Museum Replicas began issuing an edition of reproductions of Persil (see cat. no. 26d), based on the Rosenwald bronze (cat. no. 26c).

Interestingly, this enemy of the press was the grandfather of the painter-engraver Dunoyer de Segonzac. In 1968 the artist wrote that "Daumier's caricatures had the gift of exasperating my maternal grandfather. . . ." (in Château de Blois, p. 17), a note which breathes life into the rigid personality depicted by Daumier.

Persil also appears in: L.D. 39, 49, 91, 95, 127, 133, 175, 182, 205, 210, 228, 241, 242, 244, 249.

HISTORY

1891 Champfleury sale, No. 72 (referring to clay)
1905 Geffroy, 105: "Attorney, with perpendicular profile, sharp and voluntary" (clay, ILLUSTRATED)
1932 Bouvy, No. 15 (clay, ILLUSTRATED)
1947 Musée Cantini, Marseilles, No. 30 (bronze)
1948 Mourre, 99: "Lawyer, deputy, minister whose imperfections entertained the satiric papers"

26. Persil

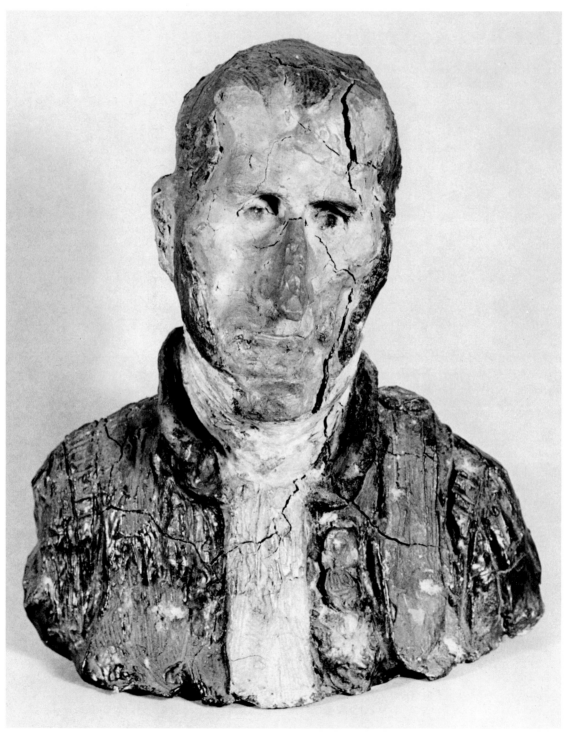

26a.

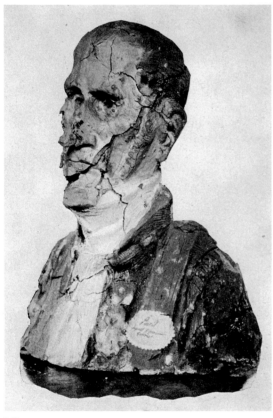

26b.

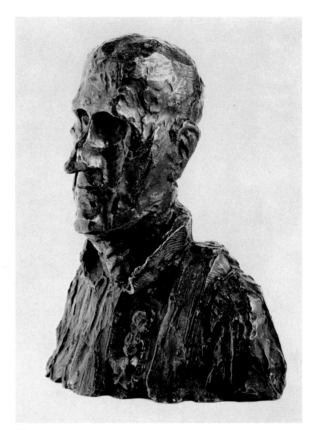

26c.

26a. PERSIL
 Unbaked clay, painted; h. 7¾″ (197 mm.)
 Bronze edition of 25
 Collection Madame Berthe Le Garrec, Paris
 (not in exhibition)

26b. Early photograph of unbaked clay no. 26a from Geffroy,
 1905, p. 105

26c. PERSIL
 Cast bronze; h. 7⅜″ (187 mm.)
 Markings: lower left rear: MLG; bottom rim: 2194-1;
 inside: 3/25
 National Gallery of Art, Lessing J. Rosenwald
 Collection

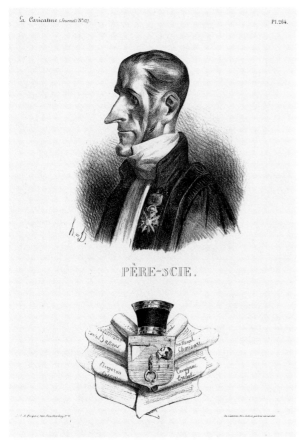

26e.

1952 Gobin, No. 15 (clay, ILLUSTRATED)
Deutsche Akademie der Künste, Berlin, No. 15
(bronze, ILLUSTRATED)
1957 Galerie Sagot-Le Garrec, Paris, No. 15
(bronze)
1958 Bibliothèque Nationale, Paris, No. 32 (bronze,
ILLUSTRATED)
1961 Museo Poldi Pezzoli, Milan, No. 21 (bronze,
ILLUSTRATED)
Musée Cognacq-Jay, Paris, No. 321 (bronze,
ILLUSTRATED)
1966 Larkin, 23
Palais Galliera, Paris, No. 20 (bronze, ILLUS-
TRATED)
1968 Château de Blois, No. 454 (bronze, ILLUS-
TRATED)

17, Letter from Dunoyer de Segonzac: "Dau-
mier's caricatures had the gift of exasperating
my maternal grandfather . . . Minister of Jus-
tice who had Daumier imprisoned in Sainte-
Pelagie. The great artist never pardoned him,
avenged himself in numerous caricatures, de-
formed his name into Père-Scie with a profile
like a saw-blade, to cut off the head of a man
of the people"

26d. PERSIL
Alva reproduction made from Rosenwald bronze no. 26c
Synthetic material; h. 7-19/32″ (193 mm.)
Markings: bottom rear: © 1967 ALVA MUSEUM
REPLICAS INC., MLG
Fogg Art Museum, Harvard University
(not illustrated)

26e. PERE SCIE L.D. 51
Lithograph; 252 x 130 mm.
La Caricature, April 11, 1833
Benjamin A. and Julia M. Trustman Collection,
Brandeis University

26f. MODERNE GALILEE L.D. 93
Lithograph, second state; 240 x 275 mm.
La Caricature, November 6, 1834
Fogg Art Museum, Harvard University
(not illustrated)

26g. MINISTRE DE LA NATION LA PLUS CIVILISEE
DE LA TERRE (Minister of the most civilized
nation in the world) L.D. 200
Lithograph; 160 x 245 mm.
Charivari, August 15, 1834
Museum of Fine Arts, Boston
(not illustrated)

27. Podenas

Joseph, Baron de 1782-c. 1838

Gobin No. 1

Though no more than 8⅜ inches high, massive Podenas is the mightiest of Daumier's sculptures. Oddly enough, the man who served as model was not a major figure of his day, as might be supposed. He was an obscure politician whose only claim to notoriety was that he began on the left, then converted to the right in early 1833 (Bibliothèque Nationale, 1958, no. 33; Poldi Pezzoli, 1961, no. 22).

The clay was illustrated (see cat. no. 27b) and identified by Geffroy in 1905: "Podenas, Deputy, with his pointed forehead and his lip" (pp. 105-06). Pach and Fuchs repeated the same illustration, although Pach called the sculpture wax and Fuchs called it terra cotta. This clay was one of the first to be cast in bronze. A cast was included in the Museum of Modern Art exhibition (1930, no. 140). Gobin called the bust "L'Important malicieux" (The Malicious Man of Importance) in 1952 (no. 1). Daumier and Philipon had previously converted his name into "Pot-de-naz" (Pot-nose).

Since 1905 the cracks in this clay have been progressively widening. A particularly serious area is that at the left side of the mouth, which has caused Daumier's original chasm to stretch too far to the side of the head (see cat. no. 27a). Since our photograph was taken, in early 1968, the bust has been restored. A terra-cotta reproduction (cat. no. 27e) of Daumier's Podenas accompanies the original clay for this exhibition. The terra cotta is noticeably smaller than the clay. This is due to shrinkage caused by firing.

Two bronzes of Podenas have also been included here. The one from the Rosenwald collection is number three of the first edition of bronzes, the edition that was made by Barbedienne for Maurice Le Garrec (cat. no. 27c). The second, from a Boston collection, was cast more recently — from the same molds — by the Valsuani foundry for Berthe Le Garrec, in an edition of three. This bronze, stamped "Mme H," is from the set of thirty-six made for one of the Le Garrec daughters (cat. no. 27d).

Though an ugly brute, Podenas is a truly handsome sculpture. It is similar to several others, like Pataille, Baillot, Lecomte, and Gaudry, in which Daumier combined a sure sense of structure and a subtle skill at surface detail with a geometrical approach to the head. Podenas' pointed head is a massive pyramid, with the heavy jaws secured by the collar at the base. The wide, unsmiling mouth emphasizes this horizontal base. Curiously, grim Podenas, like equally grim Dubois, has the most fluid, curvaceous contour along the base. The lapels and collar of this coat unfold around him in a manner as elegant as any courtier's of Louis XIV. This detail makes Podenas the most finished of all the busts.

When Daumier translated this bust into prints he lessened the pyramidal effect and emphasized Podenas' rotundity by means of a series of slightly curved horizontals (neckerchief, wrinkled vest). The bust-length lithograph, like others of this genre, shows the figure before an oval, cross-hatched shadow (see cat. no. 27f). Although Daumier widened the top of the head, the rest of the features — eyes, upper lip, chin, collar — were derived directly from the clay. Both lithographs appeared in 1833, which led Durbé to suggest that the bust was made then as well. However, it seems equally possible that Daumier made all the clays and bust-length lithographs at once, for the *Celebrity* series that ended in April, 1833, then began the new series, *Chambre non prostituée*, with the full-length portrait of Podenas (cat. no. 27g) when that worthy changed his affiliation to the right. The eyes, mouth, forehead, etc. are only indirectly based on the clay in this lithograph of "Pot-nose." He also appeared in the "Ventre législatif."

27. Podenas

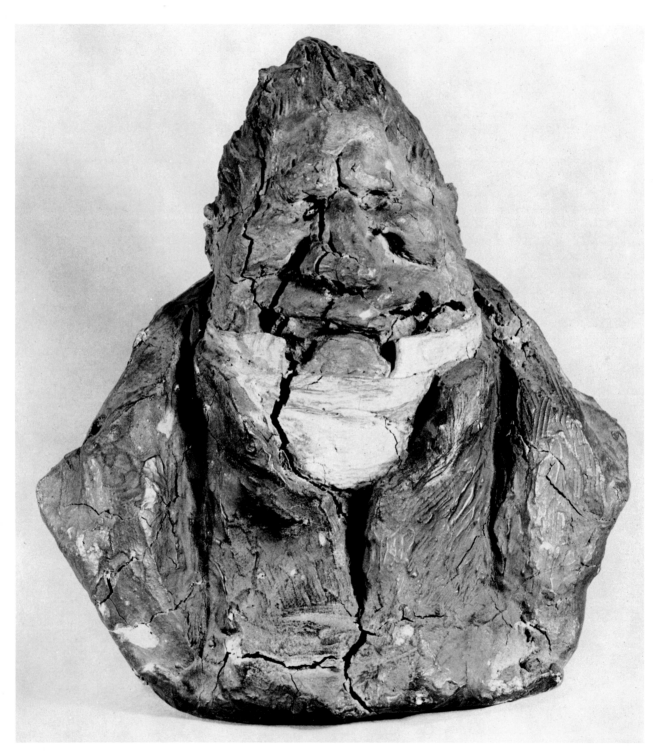

27a.

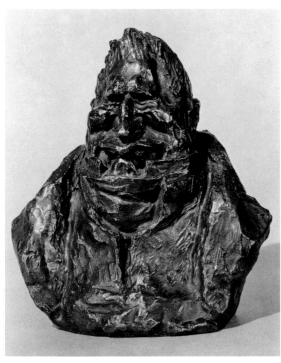

27c.

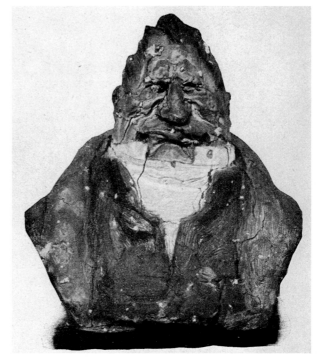

27b.

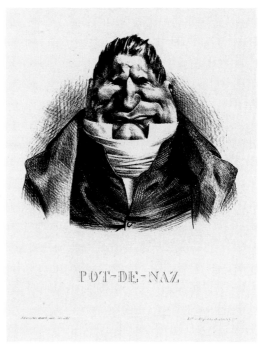

27a. PODENAS
Unbaked clay, painted; h. 8⅜″ (213 mm.)
Bronze edition of 25 made beginning 1929
Collection Madame Berthe Le Garrec, Paris

27b. Early photograph of unbaked clay no. 27a from Geffroy,
1905, p. 106

27c. PODENAS
Cast bronze; h. 8″ (203 mm.)
Markings: lower left side: MLG; bottom rim: 3/25 A¹;
inside: 3/25
National Gallery of Art, Lessing J. Rosenwald
Collection

27f. POT-DE-NAZ L.D. 152
Lithograph; 150 x 170 mm.
Charivari, June 14, 1833
Boston Public Library

27f.

POT-DE-NAZ

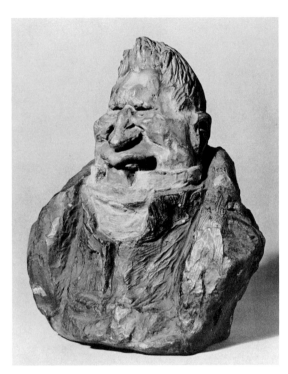

27e.

1905 Geffroy, 105; 106 (clay, ILLUSTRATED)
1924 Pach, Pl. 5: "Unidentified wax head" (actually clay, ILLUSTRATED)
1927 Fuchs, No. 167b: "de Podenas, terra cotta" (actually clay, ILLUSTRATED)
1929 Focillon, 101, Fig. 14: Unidentified (clay, ILLUSTRATED)
1930 MOMA, New York, No. 140: "De Podenas" (bronze)
1932 Bouvy, No. 1 (bronze, ILLUSTRATED)
1934 Bibliothèque Nationale, Paris, No. 389 (bronze)
1937 Pennsylvania Museum of Art, Philadelphia, No. 1 (bronze)
1947 Musée Cantini, Marseilles, No. 29 (bronze)
1948 Mourre, 98: "politician without a history"
1952 Gobin, No. 1 (clay, ILLUSTRATED)
 Deutsche Akademie der Künste, Berlin, No. 1 (bronze, ILLUSTRATED)
1958 Bibliothèque Nationale, Paris, No. 33 (bronze)
 Museum of Fine Arts, Boston, No. 6 (bronze)
1961 Museo Poldi Pezzoli, Milan, No. 22 (bronze, ILLUSTRATED)
1968 Château de Blois, No. 440 (bronze)

27d. PODENAS
 Cast bronze; h. 8⅛″ (267 mm.)
 Markings: lower right rear: MLG; lower left rear:
 Valsuani stamp, Mᵐᵉ H
 Private Collection, Boston
 (not illustrated)

27e. PODENAS
 Terra-cotta reproduction, painted to resemble original
 clay; h. 7⅞″ (200 mm.)
 Galerie Sagot-Le Garrec, Paris

27g. DE PODENAS L.D. 52
 Lithograph, second state; 249 x 183 mm.
 La Caricature, May 2, 1833
 Private Collection, Boston
 (not illustrated)

132

28. Prunelle

Dr. Clement-François-Victor-Gabriel
1774-1853

Gobin No. 8

In his own day Dr. Prunelle was nicknamed "The Bison." He was a professor, a doctor, the mayor of Lyons, and a Deputy, an "excellent administrator, but posterity forgot his merits seeing him only as a weeping willow" (Mourre, 1948, p. 99) and "a man with generous ideas but ill-served by his facial characteristics" (Bibliothèque Nationale, 1958, no. 34). While practicing medicine in Lyons he had become important in the democratic party there and was elected mayor. He accepted the July Monarchy with the idea that a constitutional monarchy recognized Republican ideas and had inherent unity (Poldi Pezzoli, 1961, no. 13).

Geffroy was first to illustrate this bust (1905, p. 102). His photograph shows a large, shiny repair at the center of the head and numerous chips, including one at the left corner of the mouth (see cat. no. 28b). Fuchs repeated this photograph. The bust of Prunelle was one of the first to be cast in bronze; a cast was included in the exhibition at the Museum of Modern Art in 1930 (no. 135).

The bust of Prunelle (see cat. no. 28a) is one of the most active of Daumier's series of grimaces. It stands between the shouting bald man (cat. no. 36a) and the enraged man with curly hair (cat. no. 33a). The large head with its shaggy hair is twisted sharply to one side. The eyes peer out like an angry bird's. A beak-like nose is drawn up over the double arch of a spiteful mouth. Prunelle's mouth is one of Daumier's most effective, and it is fortunate that the bronze was cast before his incisive lines were softened and smoothed away by age and restoration. Gobin called the bust "Le Dédaigneux" (The Scornful). Durbé dated the bust among the early ones, done in 1832, because of its small size and the fact that Prunelle was most often mentioned in 1831 (Poldi Pezzoli, no. 13).

Although the sculpture seems to be one of the earlier ones Daumier made, there is no recorded bust-length lithograph of Prunelle. He appears in only two lithographs, a full-length portrait of 1833 (cat. no. 28d) and the "Ventre législatif." The inspiration for the former print seems quite similar to that for the standing portrait of Podenas (cat. no. 27g) especially the sharp horizontal folds of the coat. The face is not exactly like the bust, for the features are relaxed, the mouth and chin are no longer drawn up, nor does the nose resemble a beak. It is, in fact, a sympathetic portrait. Once again, Daumier seems to have recalled rather than copied his sculpture. In the "Ventre" (cat. no. C) Prunelle has a position of importance, and his pose is one that surely was derived from the figure of a man standing in just that position, and not from a small clay head. Daumier found the shaggy doctor's physiognomy a natural one to include in his series, but probably did not have too great a quarrel with his political views.

HISTORY

1905 Geffroy: 105: "Doctor, Deputy, mayor of Lyon, his scornful face partly hidden by his hair"; 102 (clay, ILLUSTRATED)
1927 Fuchs, No. 167a (clay, ILLUSTRATED)
1930 MOMA, New York, No. 135 (bronze)
1932 Bouvy, No. 8 (bronze, ILLUSTRATED)
1934 Bibliothèque Nationale, Paris, No. 390 (bronze)
1947 Musée Cantini, Marseilles, No. 31 (bronze)
1948 Mourre, 99
1952 Gobin, No. 8 (clay and bronze, ILLUSTRATED)
 Deutsche Akademie der Künste, Berlin, No. 8 (bronze, ILLUSTRATED)
1957 Galerie Sagot Le-Garrec, Paris, No. 8 (bronze)
1958 Bibliothèque Nationale, Paris, No. 34 (bronze, ILLUSTRATED)
 Museum of Fine Arts, Boston, No. 8 (bronze, ILLUSTRATED)
 Los Angeles County Museum, No. 227 (bronze)
1961 Museo Poldi Pezzoli, Milan, No. 13 (bronze, ILLUSTRATED)
1964 Rostrup, No. 615b (bronze)
1966 Larkin, 23; 5 (bronze, ILLUSTRATED)
1967 Licht, No. 83 (bronze, ILLUSTRATED)
1968 Château de Blois, No. 447 (bronze)

28. Prunelle

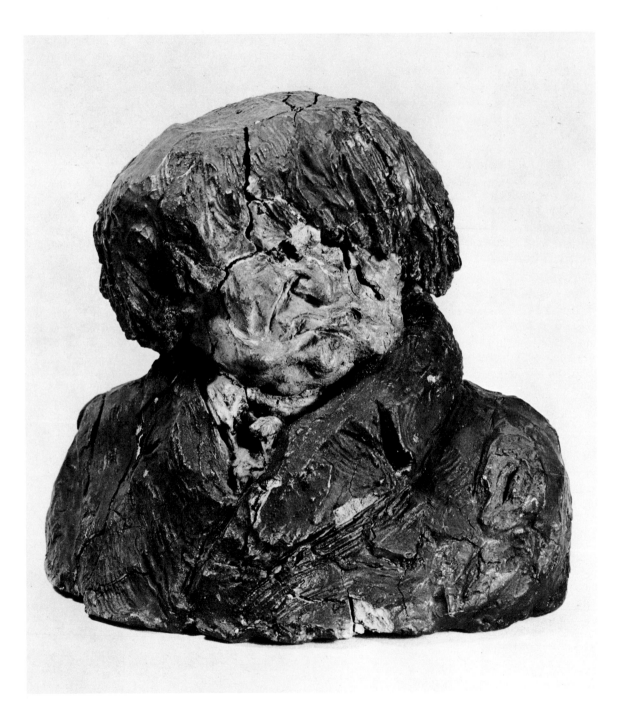

28a.

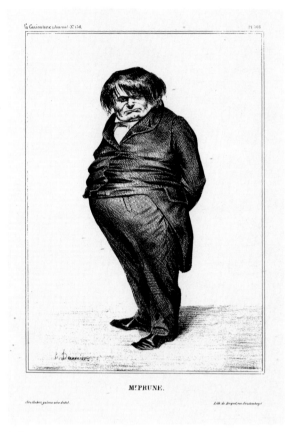

28d.

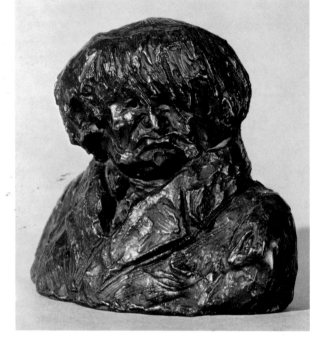

28c.

28a. PRUNELLE
 Unbaked clay, painted; h. 5-9/32″ (134 mm.)
 Bronze edition of 30 made beginning 1929
 Collection Madame Berthe Le Garrec, Paris
 (not in exhibition)

28b. Early photograph of unbaked clay no. 28a from Geffroy,
 1905, p. 103

28c. PRUNELLE
 Cast bronze; h. 5-1/16″ (128 mm.)
 Markings: lower left side: MLG; bottom rim: 3/30 D2;
 inside: 3/30
 National Gallery of Art, Lessing J. Rosenwald
 Collection

28d. MR. PRUNE. . . . L.D. 60
 Lithograph; 259 x 185 mm.
 La Caricature, June 27, 1833
 Fogg Art Museum, Harvard University

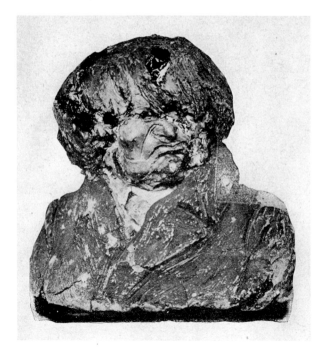

28b.

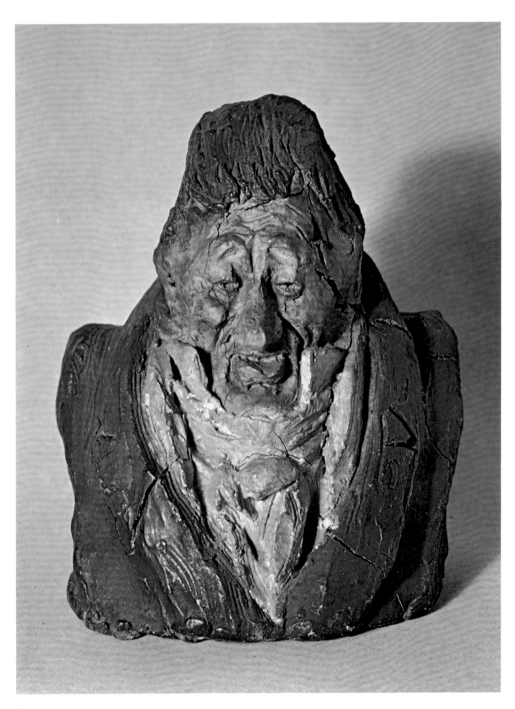

29a.

29. Royer-Collard

Pierre-Paul 1763-1845

Gobin No. 6

The bust of Royer-Collard is something of an enigma. The bust today appears heavily restored, and in Gobin's photograph, published in 1952, damage is visible, notably a corner broken off his right side. Yet the bronze seems to reflect little damage. Perhaps this is one of the clays damaged in casting referred to by Escholier (see Introduction to the Busts). The earliest reference to this bust was in the catalogue of the Champfleury sale which listed group photographs of the clays taken in 1865, and mentioned Royer-Collard by name (Champfleury sale, 1891, no. 72). The bust was not mentioned again until 1930 when the Museum of Modern Art exhibited one of the new bronze casts (no. 145). Finally, in 1932, Bouvy illustrated the clay (no. 6).

Royer-Collard was a very prominent man in his day, a political philosopher who along with Guizot had helped to formulate the constitutional government of France. During the Revolution he had been a member of the Paris city council and Secretary of the Commune. He and Napoleon mistrusted each other; the Emperor named him professor of the history of philosophy in 1811 to keep him out of trouble. Nevertheless, he assisted in the return of Louis XVIII, and attained high prominence under that monarch. In 1819 he upheld the freedom of the press, in vain. A Deputy since 1814, he was elected President of the Chamber in 1828. Then the Revolution of 1830 seems to have shocked him. First he refused to take his seat in the Chamber, and then did not speak there for four years. After 1838 he retired from active political life.

Royer-Collard is said to have had a long, triangular nose and thick lips, the lower one of which projected well ahead of the other. His hair fell out during his forties and after that he wore a wig, which moved back and forth when he raised his eyebrows. Daumier capitalized upon this wig (see cat. no. 29a), making a string mop of it, and emphasizing the raised eyebrows which made it wiggle. The nose of his sculpture is certainly triangular. The projecting lower lip now looks more like his tongue, but this is probably due to the restoration of the bust. The bust, a small one, has one of the milder grimaces invented by Daumier, and is perhaps one of the earliest well-developed clays, for Daumier's hand shows more subtlety here than in Dupin or Kératry. The handling is not far from Harle *père*.

Daumier's lithographs of Royer-Collard include the "Ventre législatif" (where he seems to have recovered his speech, and is chatting animatedly with Harle) and two others. In one, Royer is shown as an aging Marquise, from the old court (cat. no. 29d), an allusion to his belief in monarchy. In the other, Daumier drew him as a sort of scarecrow stupidly shuffling along, empty now of ideas (cat. no. 29c). The relation of the drawings to the clay is like that of Gaudry, more linear than sculptural. The large lower lip is quite clear in the drawing.

Royer-Collard also appears in L.D. 233.

HISTORY

1891 Champfleury sale, No. 72 (refers to clay)
1930 MOMA, New York, No. 145 (bronze)
1932 Bouvy, No. 6 (clay, ILLUSTRATED)
1934 Bibliothèque National, Paris, No. 390 *bis* (bronze)
1936 Albertina, Vienna, No. 77 (bronze)
1948 Mourre, 98: "Not too badly treated, his liberal eloquence must have protected him"
1952 Gobin, No. 6 (clay, ILLUSTRATED)
 Deutsche Akademie der Künste, Berlin, No. 6 (bronze, ILLUSTRATED)
1957 Galerie Sagot-Le Garrec, Paris, No. 6 (bronze)
1958 Bibliothèque Nationale, Paris, No. 35 (bronze)
1961 Museo Poldi Pezzoli, Milan, No. 14 (bronze, ILLUSTRATED)
1968 Château de Blois, No. 445 (bronze)

29a. ROYER-COLLARD
 Unbaked clay, painted; h. 5-11/32" (136 mm.)
 Bronze edition of 25 beginning 1929
 Collection Madame Berthe Le Garrec, Paris
 (not in exhibition)

29b. ROYER-COLLARD
 Cast bronze; h. 5″ (127 mm.)
 Markings: lower left side: MLG; bottom rim: 3/25 C²;
 inside: 3/25
 National Gallery of Art, Lessing J. Rosenwald
 Collection

29c. MR. ROYER-COL. . . . L.D. 68
 Lithograph; 286 x 213 mm.
 La Caricature, August 22, 1833
 Benjamin A. and Julia M. Trustman Collection,
 Brandeis University

29d. MR. ROYER COLAS L.D. 136
 Lithograph, second state; 242 x 189 mm.
 Charivari, January 24, 1833
 Boston Public Library
 (not illustrated)

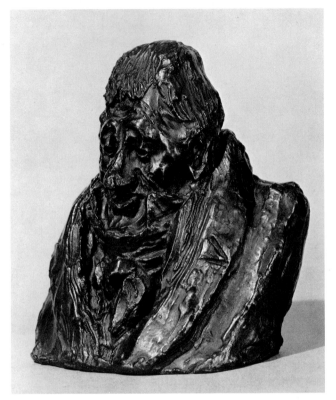

29b.

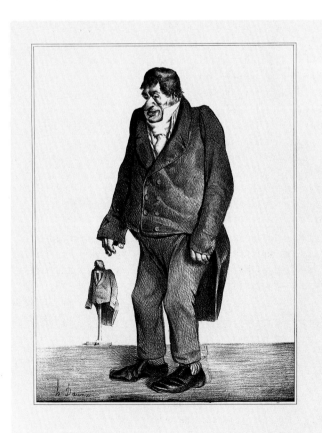

29c.

30. Sébastiani

Le Comte Horace-François 1775-1851

Gobin No. 19

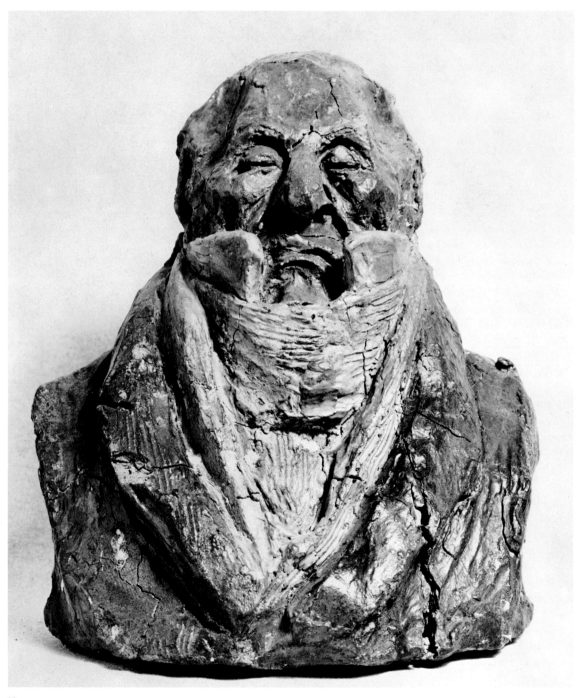

30a.

The son of a cooper, Sébastiani came from Corsica. He rose to great glory serving as a General under his fellow-islander. He was known as much for his elegance as for his audacity, and came to be called the "Cupid of the Empire." Gobin was right to call the bust "Le Fat" (The Fop), for one legend has it that when the Cossacks captured his luggage they thought they had found that of a clothing salesman. Louis Philippe made him Minister of the Navy, then of Foreign Affairs. In the latter capacity, as a believer in peace at any price he aided in blocking popular revolutions in Poland, Italy, and Belgium. He was replaced in October, 1832, by de Broglie. Durbé wrote that in the minds of the young Republicans this old soldier who had attained glory in his youth, and then had enlisted in the abject politics of businessmen, seemed to incarnate the type of illusions lost (Poldi Pezzoli, 1961, no. 11). Philipon attacked him for his pride and arrogance.

The bust of this former Cupid, the most delicate of the thirty-six, was first published by Bouvy in 1932 (no. 19). The first bronze was mentioned in 1952 (Deutsche Akademie, no. 19). However, in 1934 a terra-cotta reproduction of the clay, cast under the direction of Maurice Le Garrec, was exhibited at the Bibliothèque Nationale. It was listed as one entry with three other terra-cotta reproductions (no. 393; also in Berthe Le Garrec, *Arts et Livres*, 1948, p. 102).

This tiny bust, just over five inches high, wears a disdainful expression similar to that of Etienne, although the fine features are closer in handling to those of Cunin and Royer-Collard (see cat. no. 30a).

Daumier drew Sébastiani in two portrait lithographs, both in profile. In the bust-length print, probably drawn first (cat. no. 30c), Daumier lengthened the nose and emphasized the wrinkles above the eye, while copying the eye itself fairly closely. The features of Sébastiani, the juggler, in the "Charenton Ministeriel" (cat. no. B) are quite different from either the sculpture or the portrait lithographs.

Sébastiani also appears in the following lithographs: L.D. 44, 49, 110.

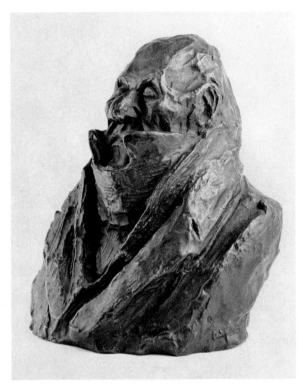

30b.

30a. SEBASTIANI
Unbaked clay, painted; h. 5-5/16″ (135 mm.)
Bronze edition of 25
Collection Madame Berthe Le Garrec, Paris
(not in exhibition)

30b. SEBASTIANI
Cast bronze; h. 5-1/16″ (128.5 mm.)
Markings: right side: MLG; bottom rim: 2201-1;
 inside: 3/25
National Gallery of Art, Lessing J. Rosenwald
 Collection

30c. MR. SEBAST. . . . L.D. 156
Lithograph; 187 x 128 mm.
Charivari, July 10, 1833
Boston Public Library

30d. MR. SEBAST. . . . L.D. 56
Lithograph, second state; 235 x 140 mm.
La Caricature, June 13, 1833
Fogg Art Museum, Harvard University
(not illustrated)

HISTORY

1932 Bouvy, No. 19 (clay, ILLUSTRATED)
1934 Bibliothèque Nationale, Paris, No. 393 (terra-
 cotta reproduction)
1948 Mourre, 98: "General of the Empire, magnifi-
 cent in his vain rigidity — Daumier portrayed
 with ferocity"
 Le Garrec, Berthe, *Arts et Livres*, 102 (terra-
 cotta reproduction)
1952 Gobin, No. 19 (clay, ILLUSTRATED)
 Deutsche Akademie der Künste, Berlin, No.
 19 (bronze, ILLUSTRATED)
1957 Galerie Sagot-Le Garrec, Paris, No. 19
 (bronze)
1958 Bibliothèque Nationale, Paris, No. 36 (bronze)
 Los Angeles County Museum, No. 231
 (bronze)
1961 Museo Poldi Pezzoli, Milan, No. 11 (bronze,
 ILLUSTRATED)
 Museum für Kunst und Gewerbe, Hamburg,
 No. 105 (bronze, ILLUSTRATED)
1966 Larkin, 23
1968 Château de Blois, No. 458 (bronze)

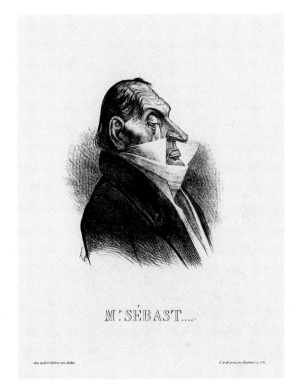

M. SÉBAST....

30c.

31. Vatout

Jean 1792-1848

Gobin No. 24

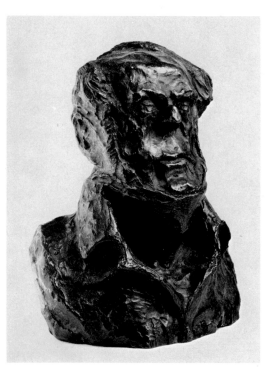

31b.

31a. VATOUT
 Unbaked clay, painted; h. 7⅞" (200 mm.)
 Bronze edition of 25
 Collection Madame Berthe Le Garrec, Paris
 (not in exhibition)

31b. VATOUT
 Cast bronze; h. 7⅝" (194 mm.)
 Markings: rear: MLG; bottom rim: 2203-1;
 inside: 3/25
 National Gallery of Art, Lessing J. Rosenwald
 Collection

It is to be hoped that Vatout was not so strange in countenance as Daumier made him appear. Vatout was a minor political figure, a sub-Prefect. However, he was also a writer who had served first as Secretary to Boissy d'Anglas, and then as Secretary and Historian for the Duke of Orléans. Soon after the latter became King Louis Philippe, in 1831, Vatout was elected Deputy with the King's aid. He was also Librarian to the King, President of the Council on Civil Buildings, and Director of Public and Historic Monuments. Mourre tells that he also composed two comic songs in the style of the day (1948, p. 99), a note which adds a bit of needed humor to this unsmiling portrait. Like Guizot, Vatout went into exile with Louis Philippe (Bibliothèque Nationale, 1958, no. 38).

The clay is mentioned in two early references. Geffroy described it: "Alarming, pretentious, a nose that seems to be a false nose, a bitter mouth" (1905, p. 105). The clay was also mentioned by name as one that was included in Philipon's 1865 photographs (Champfleury sale, 1891, no. 72). Bouvy was the first to illustrate the bust. He included a photograph of the clay in his 1932 book, *Trente-six bustes de H. Daumier* (no. 24). The first bronze was published in 1952, although one must have existed by 1948 to enter the Marseilles collection with the rest that year.

This warped countenance seems to be one of the group with irregular skulls that includes Guizot, Delessert, Fulchiron, Viennet, and Ganneron. Vatout is especially close to Ganneron except for the eyes, which are open and staring. Gobin called the bust "L'Entêté" (The Stubborn), perhaps because of the set of his mouth (in Gobin, 1952, no. 24).

Daumier made one portrait lithograph of Vatout, a bust modelled with strong light-and-dark contrasts (cat. no. 31c), very like most of the other bust-length portraits that appeared in 1832 and 1833. The wide, staring eyes with the large white areas rivet the attention, while the vacuous expression of the clay as it appears today (see cat. no. 31a) suggests that Daumier had originally painted eyes on the clay like those in the print. Vatout also appears in the "Ventre législatif," in profile.

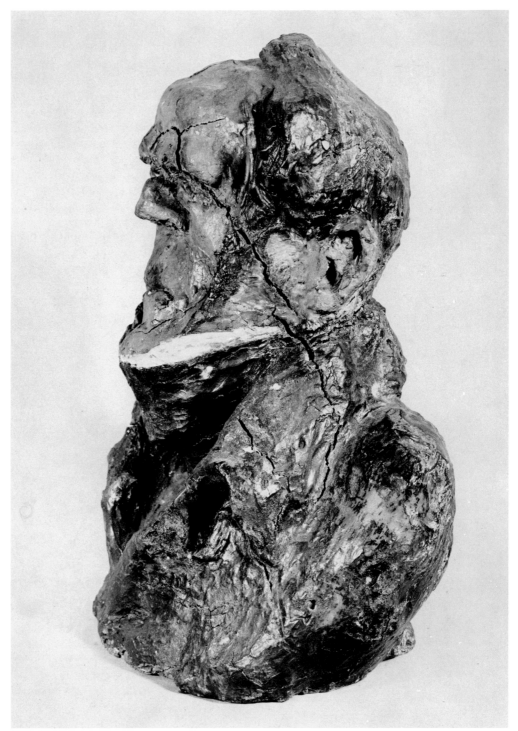

31a.

31. Vatout

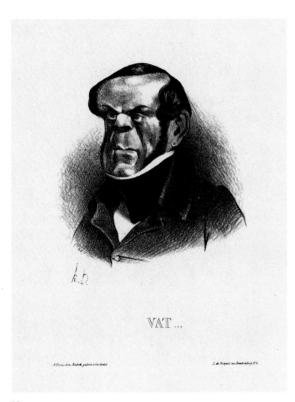

31c.

HISTORY

1891 Champfleury sale, No. 72 (refers to clay)
1905 Geffroy, 105 (referring to clay)
1932 Bouvy, No. 24 (clay, ILLUSTRATED)
1948 Mourre, 99: "Under-Prefect, left two songs, 'The Shield of France,' and 'The Mayor of Eu'"
1952 Gobin, No. 24 (clay, ILLUSTRATED)
 Deutsche Akademie der Künste, Berlin, No. 24: "Vatout (1762-1848)" (bronze, ILLUSTRATED)
1957 Galerie Sagot-Le Garrec, Paris, No. 24 (bronze)
1958 Bibliothèque Nationale, Paris, No. 38 (bronze)
1961 Museo Poldi Pezzoli, Milan, No. 36 (bronze, ILLUSTRATED)
1968 Hôtel Drouot, Paris, No. 4 (bronze, ILLUSTRATED)
 Château de Blois, Paris, No. 463 (bronze)

31c. VAT. . . . L.D. 175
 Lithograph, second state; 135 x 130 mm.
 Charivari, November 16, 1833
 Boston Public Library

32. Viennet

Jean-Pons-Guillaume 1777-1868

Gobin No. 9

Viennet was with d'Argout one of the most often-caricatured men of his day. But unlike d'Argout, who suffered patiently, Viennet seemed to enjoy notoriety, or so Durbé tells us (Poldi Pezzoli, 1961, no. 20). Geffroy identified him as a "Deputy, Academician, and story-teller, lurking in his false collar with bumps on his forehead as if he had been jostled in a romantic tussle" (1905, p. 105). Mourre added that Viennet was a "soldier, journalist, Master Mason of the Scottish Rite, a fine career, who detested young bearded romantics" (1948, p. 99). Durbé elaborated that Viennet was successful in his various careers but unpopular. In 1830 with Guizot he kept Benjamin Constant from the Academy. He enjoyed scandal, and changed sides easily. In 1827 he wrote against censure of the press, then lamented the freedom of the same in 1832 when attacked by the *Tribune*. He was also a satiric poet (Poldi Pezzeli, no. 20).

The bust of this volatile character was first mentioned in the sale of Champfleury's effects, as one of the clays illustrated in the groups of photographs of 1865 (Champfleury sale, 1891, no. 72). Both Dayot in 1897 and Geffroy in 1905 (see cat. no. 32b) illustrated and identified the bust. Fuchs repeated Geffroy's photograph. Bronzes of Viennet were among the first cast. In 1930 one was included in the exhibition at the Museum of Modern Art (no. 141). Then in 1948, Berthe Le Garrec announced that bronzes of Viennet falsely copied from the numbered Barbedienne bronzes had begun to appear in 1943 (*Arts et Livres*, p. 102). These bronzes lack edition numbers and are stamped "H.D." (see Pataille, cat. no. 25, for details). Gobin called the bust "Le Rusé" (The Artful One).

The head is another variant on the Guizot-Ganneron-Vatout type, with its enormous, bony brow, narrow eyes, and long upper lip. Daumier's sculpture has cracked and worn away in many areas since Dayot's photograph (1897, II, 19), though it is now being restored. The surface of the sculpture in Dayot's photograph is worked to a high degree of sensitivity, with warts, wrinkles and other little details that today are greatly smoothed away. The open eyes, which now seem hardly visible, were once more sharply defined. Daumier's original Viennet was a tough-looking character. Today, age has made him appear quite meek.

Daumier made three portrait lithographs of Viennet, the last-published of which is the bust-length portrait, which was perhaps drawn first (see cat. no. 32e). The drawing, with its velvety shading, is quite like the sculpture in proportions and expression— note the smooth curve of the upper lip. Though this lithograph appeared after the *Celebrity* series had ended (in April, 1833) it is much like the lithographs of that series and was very likely drawn when the others were. Daumier and Philipon called Viennet, rather uncharitably, "Un Vieux-Niais" (Old Ninny). In the two other lithographs, both full-length portraits, Daumier appeared to mimic Viennet, catching him in a typical stance with his hands stuffed in his pockets and his head hanging down (cat. nos. 32f and 32g). Only the bulging brow and hidden chin seem to be derived from the clay, and these features have been exaggerated even more than in the sculpture. Viennet appeared in a number of other lithographs, including the "Ventre législatif" (cat. no. C), where he was made to appear small and fat, and is recognizable only by means of the huge forehead and hidden chin.

Viennet also appears in the following lithographs: L.D. 92, 229, 233.

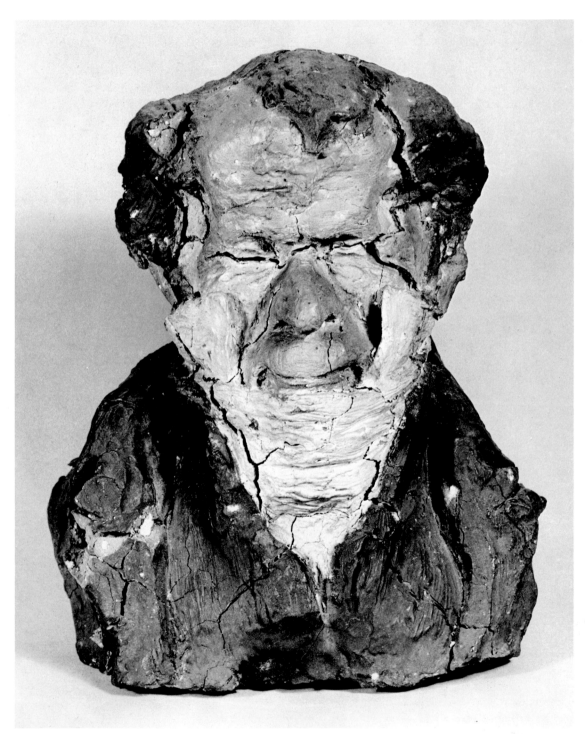

32a.

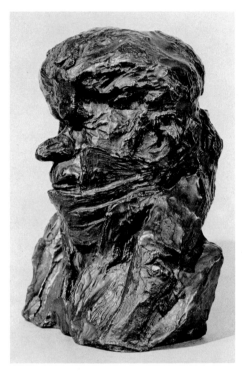

32c.

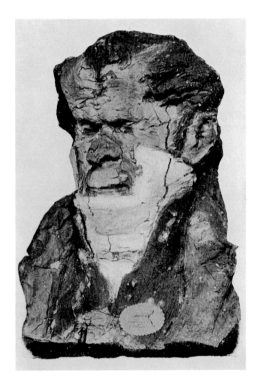

32b.

32a. VIENNET
 Unbaked clay, painted; h. 8-1/32″ (204 mm.)
 Bronze edition of 30 made beginning 1929
 Collection Madame Berthe Le Garrec, Paris
 (not in exhibition)

32b. Early photograph of unbaked clay no. 32a from Geffroy,
 1905, p. 104

32c. VIENNET
 Cast bronze; h. 7⅞″ (200 mm.)
 Markings: lower left side: MLG; bottom rim: 3/30 B1;
 inside: 3/30
 National Gallery of Art, Lessing J. Rosenwald
 Collection

32d. VIENNET
 Cast bronze; h. 8″ (230 mm.)
 Markings: left side: MLG; bottom rim: 4/30 E^1;
 inside: 4/30
 Collection Mr. and Mrs. Thomas H. Lee, Boston
 (not illustrated)

32f. MR. VIEUX-NIAIS. . . . L.D. 54
 Lithograph; 236 x 161 mm.
 La Caricature, May 30, 1833
 Private Collection, Boston
 (not illustrated)

32g. MR. VIENNET A LA TRIBUNE L.D. 145
 Lithograph, second state, hand-colored; 200 x 185 mm.
 Charivari, March 29, 1833
 Boston Public Library
 (not illustrated)

HISTORY

1891 Champfleury sale, No. 72 (refers to clay)
1897 Dayot, II, 19: "Viennet" (clay, ILLUSTRATED)
1905 Geffroy, 105; 104 (clay, ILLUSTRATED)
1927 Fuchs, No. 167d: "terra cotta" (actually clay, ILLUSTRATED)
1930 MOMA, New York, No. 141 (bronze)
1932 Bouvy, No. 9 (bronze, ILLUSTRATED)
1934 Bibliothèque Nationale, Paris, No. 391 (bronze)
1937 Pennsylvania Museum of Art, Philadelphia, No. 6 (bronze)
1947 Musée Cantini, Marseilles, No. 32 (bronze)
1948 Le Garrec, Berthe, *Arts et Livres*, 102 (bronze, surmoulage, see "Pataille")
 Mourre, 99
1952 Gobin, No. 9 (clay and bronze, ILLUSTRATED)
 Deutsche Akademie der Künste, Berlin, No. 9 (bronze, ILLUSTRATED)
1957 Galerie Sagot-Le Garrec, Paris, No. 9 (bronze)
1958 Bibliothèque Nationale, Paris, No. 40: "Jean-Ponce-Guillaume Viennet (1777-1866)" (bronze)
 Museum of Fine Arts, Boston, No. 11 (bronze)
 Los Angeles County Museum, No. 228 (bronze)
1961 Museo Poldi Pezzoli, Milan, No. 20 (bronze, ILLUSTRATED)
1964 Rostrup, No. 615c (bronze)
1968 Château de Blois, No. 448 (bronze)

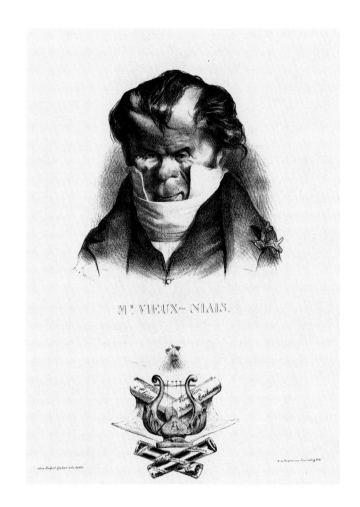

32e. MR. VIEUX-NIAIS. . . . L.D. 150
Lithograph, second state, white paper; 283 x 150 mm.
Charivari, June 5, 1833
Boston Public Library

33. Unknown ("Girod de l'Ain")

Gobin No. 20

The last four busts have not been successfully identified. They are all small (about five inches high) and seem to be among Daumier's early sculptures. This curly-haired fellow with the bad temper was first published by Bouvy in 1932, as an unknown subject (no. 20). Mourre wrote that Bouvy's number twenty was "certainly not Girod de l'Ain, as some have thought" (1948, p. 98). Gobin mentioned this attribution but also suggested the subject might be Admiral Verhuel (1952, no. 20). He called the clay "Le Niais" (The Simpleton). All who have studied the busts carefully agree that there is no resemblance between this bust and Daumier's drawing of Girod de l'Ain, the fat, bald man on the left in a triple portrait (see cat. no. 33c). This name should be dropped once and for all.

There is a resemblance between the sculpture and Admiral Verhuel, on the right in the same print (cat. no. 33c), and Adhémar firmly accepts this, identifying him further as Charles Henry Verhuel, Count of Sevehar, 1759-1845, Admiral and politician (Bibliothèque Nationale, 1958, no. 39). The man in Daumier's drawing wears a weird hair style with a pointed topknot, and his eyes and mouth are stretched into an evil grimace not unlike the clay (see cat. no. 33a).

The sculpture is one of Daumier's finest facial studies, following along with Royer-Collard, Harle, the bald unknown (cat. no. 36a), and Prunelle, as the features grow ever more contorted. This enraged face seems to climax the group, with its eyes and mouth clenched, and the lips stretched open at the corners as if the man were about to roar. The tightly-curled hair, made with short, curving jabs drawn on the clay, heightens the tension. Daumier's conception of this head was completely three-dimensional and full of movement, with the head turning easily on the neck.

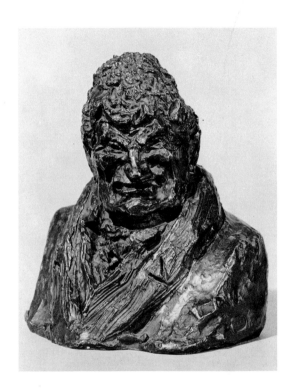

33b. UNKNOWN ("GIROD DE L'AIN")
Cast bronze; h. 5" (127 mm.)
Markings: lower left rear: MLG; bottom rim: 2186-1; inside: 3/30
National Gallery of Art, Lessing J. Rosenwald Collection

33. Unknown ("Girod De L'Ain")

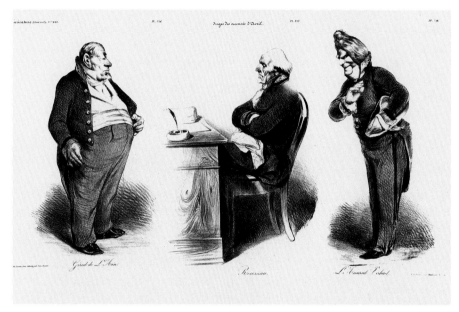

33c.

HISTORY

1932 Bouvy, No. 20: "Unknown" (clay, ILLUS-
TRATED)

1948 Mourre, 98: "not Girod de l'Ain"

1952 Gobin, No. 20: "Admiral Verhuel or Girod
de l'Ain?" (clay and bronze, ILLUSTRATED)
Deutsche Akademie der Künste, Berlin, No.
20: "Unknown. Not Girod de l'Ain" (bronze,
ILLUSTRATED)

1957 Galerie Sagot-Le Garrec, Paris, No. 20:
"Girod de l'Ain?" (bronze)

1958 Bibliothèque Nationale, Paris, No. 39:
"Charles Henry Verhuel, Count de Sevehar,
1759-1845. Admiral and politician" (bronze)
Los Angeles County Museum, No. 232:
"Le Niais" (bronze)

1961 Museo Poldi Pezzoli, Milan, No. 4: "Unknown.
Identifications of Girod or Verhuel are purely
hypothetical" (bronze, ILLUSTRATED)

1968 Château de Blois, No. 459: "Admiral Verhuel
or Girod" (bronze)

33a. UNKNOWN ("GIROD DE L'AIN")
Unbaked clay, painted; h. 5-3/16″ (132 mm.)
Bronze edition of 30
Collection Madame Berthe Le Garrec, Paris
(not in exhibition)

33c. GIROD DE L'AIN — J.-JOSEPH ROUSSEAU —
AMIRAL VERHUEL L.D. 125
Lithograph, second state; 290.5 x 491 mm.
La Caricature, August 6, 1835
Private Collection, Boston

150

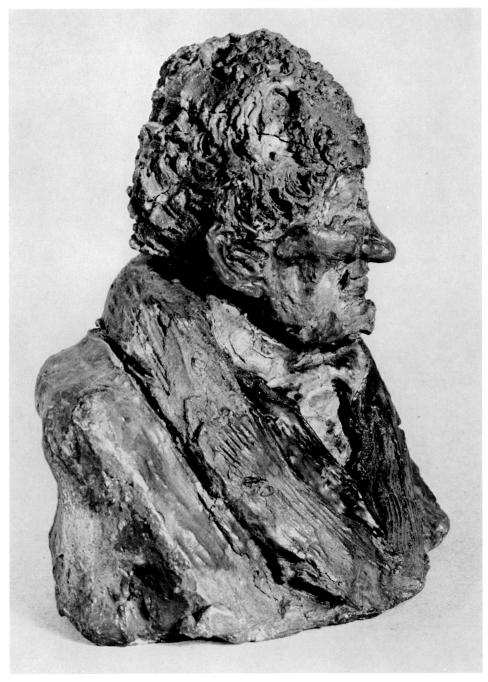

33a.

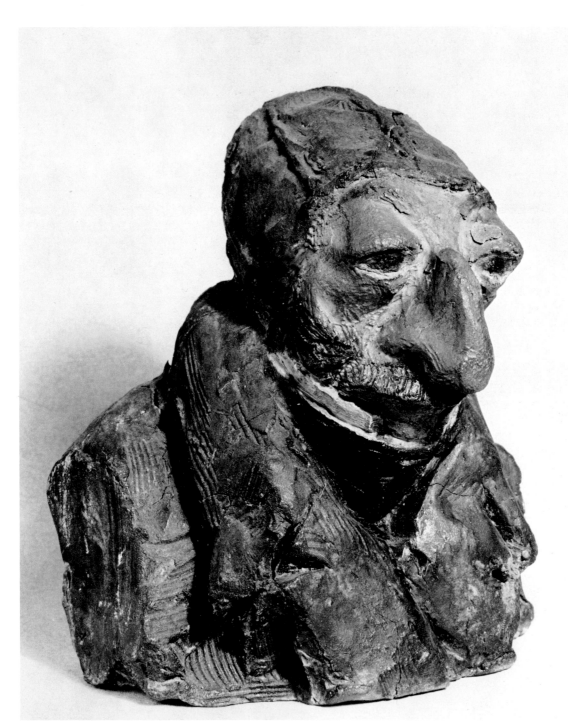

34a.

34. Unknown
("Pelet de la Lozère")

Gobin No. 13

This bust, which was first published in 1897, has never been identified satisfactorily. Dayot in 1897 and Geffroy in 1905 illustrated it without naming it (Dayot, II, p. 41; Geffroy, p. 107). Both photographs show the clay to have been in excellent condition in those years (see cat. no. 34b). Fuchs repeated Geffroy's photograph. Bouvy illustrated a bronze cast (1932, no. 13). Mourre asked if Bouvy's number thirteen was Tachereau, adding that he would respond in the negative without hesitation (1948, p. 98). Gobin called the sculpture "L'Homme à Tête plate" (Man with a Flat Head), and also "Pelet de la Lozère" (1952, no. 13). That same year Kaiser said the subject of this bust was unknown (Deutsche Akademie, 1952, no. 13). In 1958 Adhémar once again identified it as "Pelet de la Lozère" (Bibliothèque Nationale, no. 31). Durbé rejected this identification (Poldi Pezzoli, 1961, no. 3). He thought the figure identified as Pelet in the "Ventre législatif" and the clay did not resemble each other, nor do they, for the man in the print lacks a mustache.

The head seems to be one of Daumier's very first, along with d'Argout, Dupin, and Kératry. The bust is modelled with simple forms: bullet-shaped head, bug eyes, large nose — without the worked surface of the angry bust just described (cat. no. 33a), for example. As in d'Argout, Daumier greatly exaggerated certain features (the nose and eyes). One can almost see Daumier at work here, pinching ridges into the strange cap, smoothing two balls of clay onto the head to form the bulging eyelids, and drawing a ridge of clay over his thumb for the mustache, then adding the lines of the hair with a comb tool. Perhaps this comic face pleased the sculptor well enough to keep it, but did not resemble any of his political enemies sufficiently for him to utilize it for a lithograph.

HISTORY

1897 Dayot, II, 41: "Unknown" (clay, ILLUSTRATED)
1905 Geffroy, 107: "Unknown" (clay, ILLUSTRATED)
1927 Fuchs, No. 168a: "Unknown, terra cotta" (actually clay, ILLUSTRATED)
1932 Bouvy, No. 13: "Unknown" (bronze, ILLUSTRATED)
1948 Mourre, 98
Emporium, 185 (clay, ILLUSTRATED)
1952 Gobin, No. 13: "Pelet de la Lozère" (clay and bronze, ILLUSTRATED)
Deutsche Akademie der Künste, Berlin, No. 13 (bronze, ILLUSTRATED)
1957 Galerie Sagot-Le Garrec, Paris, No. 13: "Pelet de la Lozère (bronze)
1958 Bibliothèque Nationale, Paris, No. 31 (bronze)
1961 Museo Poldi Pezzoli, Milan, No. 3: "Unknown" (bronze, ILLUSTRATED)
1968 Château de Blois, No. 452 (bronze)

34a. UNKNOWN ("PELET DE LA LOZERE")
Unbaked clay, painted; h. 5-13/16″ (132 mm.)
Bronze edition of 25 begun by 1932
Collection Madame Berthe Le Garrec, Paris
(not in exhibition)

153

34b. Early photograph of unbaked clay no. 34a from Geffroy,
 1905, p. 107

34c. UNKNOWN ("PELET DE LA LOZERE")
 Cast bronze; h. 5-5/16″ (135 mm.)
 Markings: lower left shoulder: MLG; bottom rim:
 3192-1; inside: 3/25
 National Gallery of Art, Lessing J. Rosenwald
 Collection

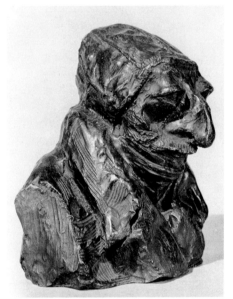

34c.

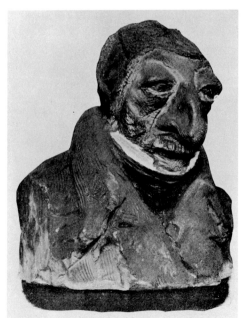

34b.

154

35. Unknown "Le Rieur Edenté" (Toothless Laughter)

Gobin No. 12

In this head Daumier personified the laugh. Long popular, the bust has never been identified, although Adhémar thinks it might be Charles Philipon himself (Bibliothèque Nationale, 1958, no. 43). Dayot's and Geffroy's photographs (1897 and 1905) show the head in two views, appearing in excellent condition in both. There is a tag on the bust in Geffroy's photograph (see cat. no. 35b), but this seems to show only a number, rather than a name. Fuchs repeated Geffroy's photograph (1927, no. 168b). In 1930 the Museum of Modern Art published one of the first bronzes, cast by Maurice Le Garrec (no. 139). Then in 1948 (*Arts et Livres*, p. 102) Berthe Le Garrec reported that unauthorized bronzes had been made, copied from three of the Barbedienne bronzes, which lacked the edition number and the stamp "MLG" (see Pataille, cat. no. 25, for details). She said one of the three was an unknown, "probably Violette." She was probably referring to the suggestion made by Mourre that the bust might represent Baron Vialettes de Mortarieu (1948, p. 97). Durbé felt the bust was one of the very first made by Daumier, and was not a portrait at all (Poldi Pezzoli, 1961, no. 2).

Though small, this clay has more breadth, more expansiveness, than some, such as d'Argout, Lameth, or the bullet-headed unknown (cat. no. 34a). It seems to join with Dupin and Kératry. In all three, the surfaces are simple while the expressions are big and broad enough to be instantly understood, with Dupin haranguing, Kératry grinning, and this one laughing aloud. All three engaged in a momentary activity. Daumier's humor is slapstick here, while with Sébastiani or Fulchiron or Chevandier it is more refined. The instantaneity of this bust is quite remarkable for a sculpture made in 1832. There is no reason why this could not have been a caricature of Philipon, certainly, though one hopes he was not toothless at thirty. Daumier drew similar laughing men occasionally in his later genre lithographs. Gobin's name, "Le Rieur Edenté," (Toothless Laughter) surely captured Daumier's intention.

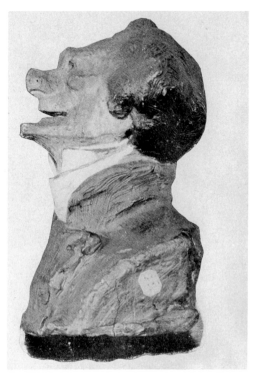

35b.

35b. Early photograph of unbaked clay no. 35a from Geffroy, 1905, p. 102

35. Unknown "Le Rieur Edente"
(Toothless Laughter)

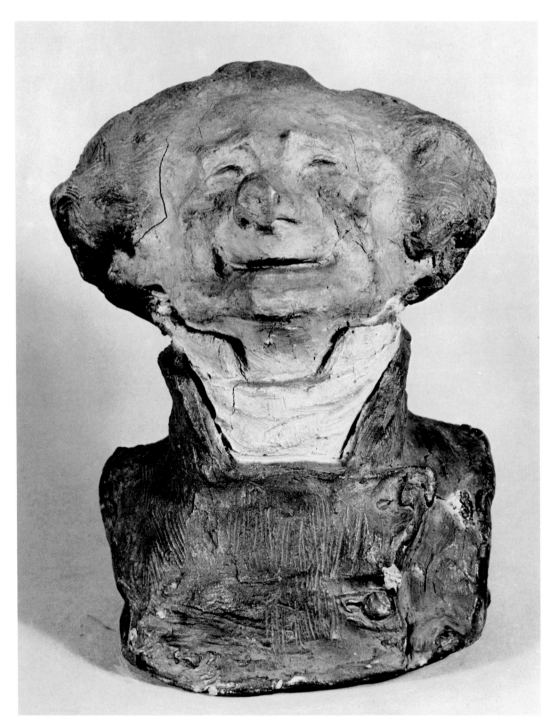

35a.

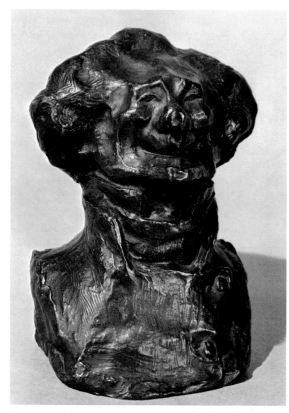

35c.

HISTORY

1897 Dayot, II, 41: "Unknown" (clay, ILLUS-
 TRATED)

1905 Geffroy, 102: "Unknown" (clay, ILLUSTRATED)

1927 Fuchs, No. 168b: "Unknown, colored terra
 cotta" (actually clay, ILLUSTRATED)

1930 MOMA, New York, No. 139: "Unknown"
 (bronze, ILLUSTRATED)

1932 Bouvy, No. 12: "Unknown" (bronze, ILLUS-
 TRATED)

1948 Mourre, 97: "Unknown — Baron Vialettes de
 Mortarieu?"
 Le Garrec, Berthe, *Arts et Livres*, 102 (bronze,
 surmoulage; see "Pataille")
 Emporium, 185 (clay, ILLUSTRATED)

1952 Gobin, No. 12: "Le Rieur Edenté" (clay and
 bronze, ILLUSTRATED)
 Deutsche Akademie der Künste, Berlin, No.
 12: "Unknown" (bronze, ILLUSTRATED)

1957 Galerie Sagot-Le Garrec, Paris, No. 12: "Un-
 known" (bronze)

1958 Bibliothèque Nationale, Paris, No. 43: "pre-
 sumably Charles Philipon 1802-1862"
 (bronze)

1961 Museo Poldi Pezzoli, Milan, No. 2: "Un-
 known" (bronze, ILLUSTRATED)

1967 Licht, No. 82: "Toothless Laughter" (bronze,
 ILLUSTRATED)

1968 Château de Blois, No. 451: "presumably
 Charles Philipon" (bronze)

35a. UNKNOWN ("LE RIEUR EDENTE")
 Unbaked clay, painted; h. 6⅜" (162 mm.)
 Bronze edition of 25 made beginning 1929
 Collection Madame Berthe Le Garrec, Paris
 (not in exhibition)

35c. UNKNOWN ("LE RIEUR EDENTE")
 Cast bronze; h. 6-3/16" (157 mm.)
 Markings: left side: MLG; bottom rim: 3/25 F2;
 inside: 3/25
 National Gallery of Art, Lessing J. Rosenwald
 Collection

36. Unknown ("Soult")

Gobin No. 30

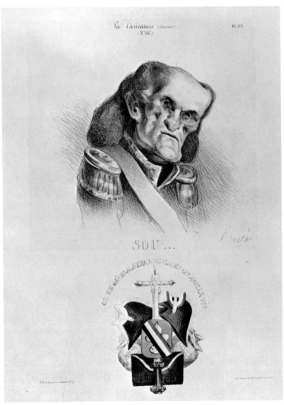

36d.

36d. SOU. . . . L.D. 46
 Lithograph; 275 x 160 mm.
 La Caricature, June 28, 1832
 Fogg Art Museum, Harvard University

36a. UNKNOWN ("SOULT")
 Unbaked clay, painted; h. 6⅛″ (155 mm.)
 Bronze edition of 25 made beginning 1934
 Collection Madame Berthe Le Garrec, Paris
 (not in exhibition)

Scholarly argument rages over whether or not this bust represents Soult, a Marshal of France under Napoleon, whom Daumier portrayed in one of the lithographs of the *Célébrités de la Caricature*, in June, 1832. The head in the print (see cat. no. 36d) does indeed look as if it were drawn directly from a sculpture, but not this sculpture. Daumier often made changes from bust to print, as has been shown, but never to the extent of closing an open mouth, dropping the head to a different angle, and changing the shape of the skull. In fact, Daumier copied the busts carefully only in the *Celebrity* series lithographs. The head is nothing like Soult of the "Masks of 1831" either (see cat. no. A), nor in the "Charenton Ministériel" (cat. no. B). Let it be said, then, that Daumier did not mean this clay to represent Soult.

The clay was illustrated first in 1897 (Dayot, II, p. 41). Bouvy, the next to publish it, did not identify it (1932, no. 30). The first bronze was published in 1934 (Bibliothèque Nationale, no. 392), when it was identified as "Marshal Soult." Mourre said it was certainly not Soult, but might be de Broglie (1948, p. 98). Gobin and Adhémar (Bibliothèque Nationale, 1958, no. 37) called it Soult, while Kaiser (Deutsche Akademie, 1952, no. 30) and Durbé (Poldi Pezzoli, 1961, no. 5) said it is not. The clay has apparently remained in excellent condition.

The head is one of the most skillful, and most exaggerated, of Daumier's studies of physiognomy, and one that might be related to Boilly's *Grimaces*. The surface is much more detailed than that of Dupin or "Toothless Laughter." The anatomy is handled with ease as Daumier twisted the head on the shoulders in an effort to make the pose more dynamic. The eyes and nose do not have quite the authority of say, Prunelle or Royer-Collard, however. Gobin's epithet, "Le Hargneux" (The Surly One) is much too mild to express the shouting anger of this head. Perhaps, like his curly-haired counterpart (cat. no. 33a), this one did not resemble any of Louis Philippe's supporters enough to be translated into one of the lithographs.

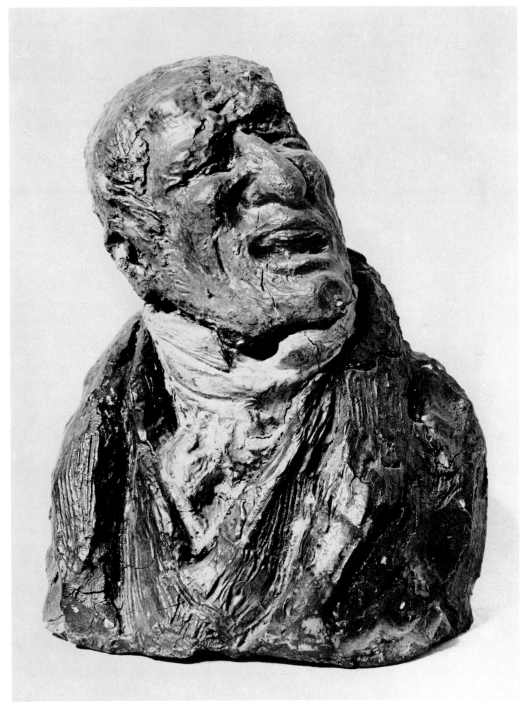

36a.

36. Unknown ("Soult")

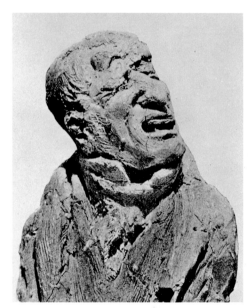

36b.

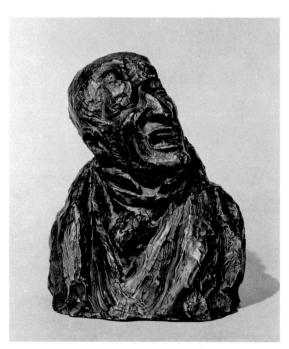

36c.

HISTORY

1897 Dayot, II, 41: "Unknown" (clay, ILLUS-
 TRATED)
1932 Bouvy, No. 30: "Unknown" (clay, ILLUS-
 TRATED)
1934 Bibliothèque Nationale, Paris, No. 392:
 "Soult" (bronze)
1948 Mourre, 98
1952 Gobin, No. 30: "Soult" (clay and bronze, IL-
 LUSTRATED)
 Deutsche Akademie der Künste, Berlin, No.
 30: "Unknown, not Soult" (bronze, ILLUS-
 TRATED)
1957 Galerie Sagot-Le Garrec, Paris, No. 30:
 "Soult" (bronze)
1958 Bibliothèque Nationale, Paris, No. 37: "Le
 Maréchal Soult" (bronze)
1961 Museo Poldi Pezzoli, Milan, No. 5: "Un-
 known. Not Soult" (bronze, ILLUSTRATED)
 Museum für Kunst und Gewerbe, Hamburg,
 No. 107: "Unknown" (bronze)
 Musée Cognacq-Jay, Paris, No. 325: "Soult"
 (bronze, ILLUSTRATED)
1966 Palais Galliera, Paris, No. 25: "Soult" (bronze,
 ILLUSTRATED)
1968 Château de Blois, No. 469: "De Broglie? Not
 Soult" (bronze)

36b. Early photograph of unbaked clay no. 36a from Dayot,
 1897, II, p. 41

36c. UNKNOWN ("SOULT")
 Cast bronze; h. 5⅞″ (149 mm.)
 Markings: rear: MLG, BRONZE; inside: 23/25
 National Gallery of Art, Lessing J. Rosenwald
 Collection

37. Ratapoil

Gobin No. 61

For most people, "Ratapoil" embodies Daumier's sculptural art. It is his only full-length, free-standing single figurine. Though monumental in appearance, "Ratapoil" stands only seventeen inches high. Table sculptures were popular in the early 19th century, but "Ratapoil" is most unlike the usual graceful, vaguely Classicized nymphs and fauns. So full of movement is the figurine that "Ratapoil" has no simple front and back angles, but swings around in a corkscrew movement, which is emphasized by the twisted head and the curved folds of the coat (see cat. nos. 37a, b, c). Daumier left no angle of the figurine unworked, from the battered hat, to the ropy neck, the coat buttons, gloves, baggy trousers, club, to the turned-up toes of his torn boots. "Ratapoil" typifies the growing trend, under the impetus of Realist thinking, to dress figures in contemporary clothing. But, ever the satirist, Daumier avoided portraying the heroism of a Marshal Ney to personify instead the scamp and the scoundrel.

This sculpture, so often included in surveys of modern art, should have an old, reliable history. But such is not the case. The work is most often discussed as a bronze sculpture, which is hardly surprising as there are at least fifty-five bronzes of "Ratapoil" in existence. Daumier himself, however, probably never conceived of "Ratapoil" as a bronze sculpture. He originally modelled his figurine in clay, then had the clay cast in plaster. "Ratapoil" exists today in the form of at least three nearly-identical plaster casts (see cat. nos. 37a and 37d), and three separate bronze editions (cat. nos. 37b, 37c, and 37e). In the early literature, only a single plaster figurine is mentioned (unlike the "Emigrants," two plasters of which were exhibited in 1878). It has not been at all clear just why there should now be more than one plaster in existence, nor how the bronzes and plasters are related to each other and to Daumier's original figurine. In this past century some sculpture has had a tendency to proliferate by itself, as it were, independently of the artist who originally conceived it. It has been our purpose to attempt to discover how these plasters and bronzes of "Ratapoil" are related to one another, and to Daumier.

Like the busts of Louis Philippe's supporters, this sculpture can be traced to Daumier by means of contemporary references, and like them also it is a piece of political satire, although "Ratapoil" belongs to the era of Louis Napoleon (who became Napoleon III), rather than that of Louis Philippe. "Ratapoil" was not a person, but a political concept. Gustave Geffroy called him "the résumé of an epoch, the agitator who prepared the coup d'état" (1905, p. 108). For Daumier, "Ratapoil" exemplified the agent-provocateur, the hired bully who, by means of threats and bribes, rounded up the votes which gave Louis Napoleon power. Earlier, in 1835, Daumier had invented a shabby personage with a club, in one of his *Robert Macaire* lithographs (see cat. no. 37g). In 1848, Louis Philippe's government fell and he went into exile. During the next few years, Louis Napoleon's forces began to fill the air with propaganda, in preparation for his take-over. Republican Daumier was once again in strong opposition to the idea of a new monarch, and began to attack once again with his crayon.

At the same time, apparently, in 1850-51, he began modelling the figurine. Alexandre wrote that the historian Jules Michelet (1798-1874), also an avid anti-Bonapartist, found Daumier working in his studio one day, "modelling in clay a statuette the idea of which haunted him." Michelet's eye fell upon the interrupted work; he exclaimed: " 'You have struck the enemy full force! Here is the Bonapartist idea pilloried by you forever!' On the sculptor's stand a figure stands and braces himself. It is a man with a hip-swaying gait, and a sinister aspect; an old floppy frock coat crosses his convex torso . . . One hand is thrust in the pocket of a tumultuous pair of Hussar's trousers; the other brandishes a knotted cudgel; the feet wear worn-down boots. The head of this person, a little, bony, featherless vulture's skull, is covered with a dented top hat falling over the projecting, blinking eyes; the crooked neck overhung by a thick mustache that hides his mouth and a goatee that terminates the line of the chin with an aggressive point. It is the synthesis of the clandestine agent, the indefatigable auxiliary of Napoleonic propaganda, 'Decembrist' provocateur and assassin. In a

161

37. Ratapoil

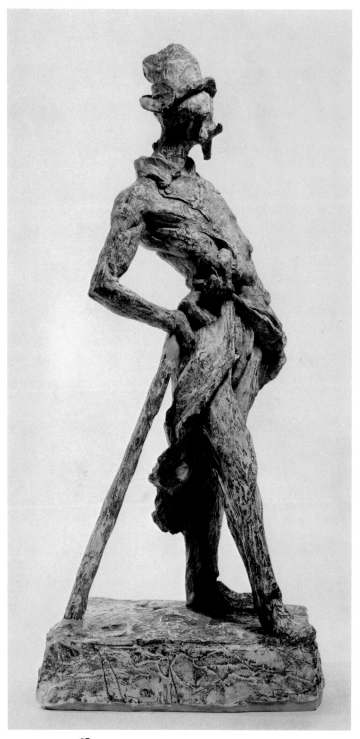 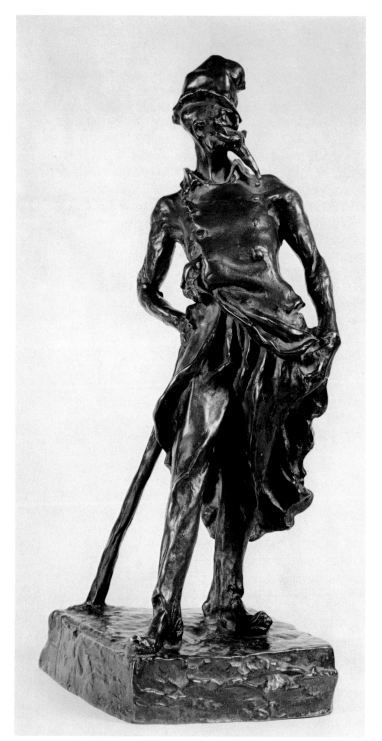

37a. 37b.

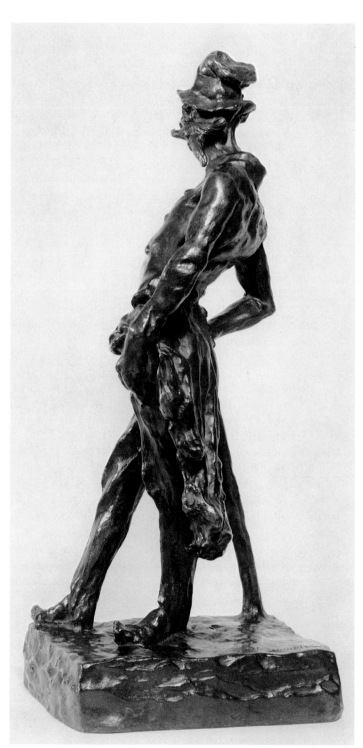

37c.

37a. RATAPOIL
Plaster, toned; h. 17″ (432 mm.)
Bronze edition of about 20 cast by Siot-Decauville
c. 1890
Bronze edition of about 20 cast by Alexis Rudier
c. 1925
Provenance: Madame Daumier 1890's?
 Geoffroy-Dechaume ? 1890's?
 Armand Dayot 1890's?
 Arsène Alexandre 1890's?
 L. Roger-Milès ?-c. 1924
 Henry Bing c. 1925
 Emile Laffon
 Galerie Weil ?-1954
Albright-Knox Art Gallery, Buffalo, New York,
 acquired 1954

37b. RATAPOIL
Cast bronze; h. 17-3/16″ (436.5 mm.)
Markings: top of base, left rear: DAUMIER 17; side of
 base, left rear: Siot-Decauville stamp
National Gallery of Art, Lessing J. Rosenwald
 Collection

37c. RATAPOIL
Cast bronze; h. 17⅛″ (435 mm.)
Markings: top of base, left edge: h Daumier No. 0;
 side of base, right rear: Alexis Rudier Fondeur, Paris
Collection Mr. and Mrs. Harry Remis, Boston

word, it is *Ratapoil!*" (1888, p. 295-96). A letter from Michelet to Daumier, dated November 28, 1851, and referring to his conviction that in 1852 Daumier's "engravings" in *Charivari*, such as "Ratapoil," would be put on in the theater (Alexandre, p. 300) provides an approximate date for the sculpture.

A lithograph dated October, 1850, portrays two Bonapartist agents, Ratapoil and Casmajou (see cat. no. 37h). Interestingly, Ratapoil, on the left, has the general pose and dress of the figurine, including the knee-length coat lifted at one side and falling in a ruffle, while Casmajou, on the right, peers with one eye from under his lifted hat brim, in a fashion similar to the figurine. Both men in the lithograph are closer in their portliness to Macaire (see cat. no. 37g, center figure) than to the skeletal "Ratapoil" of the figurine and later lithographs. Perhaps this print was done before Michelet's visit. By the Summer of 1851, "Ratapoil" of the prints had taken on his typical aspect: wraithlike, angular, hat battered down on one side and resting on a broken nose (see cat. nos. 37i and 37j). A lithograph of September, 1851, is perhaps the closest Daumier came to copying his statuette outright (see cat. no. 37k), with "Ratapoil" leaning his hip on his club and thrusting his other foot forward (though off the ground). During the reign of Napoleon III, Daumier generally found it expedient not to refer to "Ratapoil." But in 1871, at the end of the Franco-Prussian war, after Napoleon III had lost his throne "Ratapoil" reappeared, his coattails torn off, unsuccessfully trying to rouse the peasants to the deposed king's cause (see cat. no. 37m). Though still recognizable, with his club in his hand, the figure is heftier and has lost its torque. As with the thirty-six busts, though Daumier might have derived ideas from his statuette, he never copied it entirely. He probably hardly looked at it after the Fall of 1851, for the statuette was generally kept hidden (see below), perhaps throughout the Third Empire.

The first tangible mention of the statuette is in Alexandre's biography of Daumier, written in 1888 with assistance from Daumier's widow and Geoffroy-Dechaume. Champfleury did not mention the figu-

rine, nor was it included in Daumier's exhibition in 1878 at the Durand-Ruel galleries. The explanation generally given for this is that "Ratapoil" was still considered too politically aggravating. To be sure, the critic Duranty had written that same year, in an article on Daumier, that "when Daumier wished to make some of his most characteristic types, like the Deputies of 1834, or the Pear, or Ratapoil, he began by modelling them in clay. . . ." (1878, II, p. 532). Duranty may have been speaking broadly, however, for Daumier is not known to have modelled "the Pear," that caricature of Louis Philippe. Alexandre, however, was certainly discussing an actual object, for he included an illustration of a plaster of "Ratapoil" in his book (1888, opp. p. 296). Alexandre had said that Michelet had seen Daumier modelling "Ratapoil" in clay. He is also the first to state that the clay modelled by Daumier was soon cast in plaster: "Then began *chez* Daumier the peregrinations of the historic maquette — it is a marvel that it has been conserved intact. The artist had it cast in plaster and that fragile statuette was hidden with a jealous care . . . Wrapped in linens, or straw, Ratapoil was unceasingly moved by Madame Daumier who could never find a safe enough hiding place . . ." (p. 301).

Maurice Gobin (d. 1963) is the first published source for much of the "Ratapoil" documentation, not all of it verifiable, so it is just as well to turn now to him. He wrote that the "Ratapoil" was modelled in unbaked clay and probably destroyed in the casting of the plaster. Daumier, Gobin said, "had had made, by his friend the sculptor Victor Geoffroy-Dechaume, a casting from which are known *two original plasters*." He quotes Armand Dayot as saying that "Daumier utilized Ratapoil on numerous occasions until, fearing an accident to his fragile clay mannequin, he resolved to make a plaster casting." Gobin gives no source for this quote. Of the two plasters, Gobin wrote, that "after Daumier's death the first served to make a very small edition of numbered bronzes at the Siot-Decauville foundry. The plaster offered by Madame Daumier to Armand Dayot then passed to Arsène Alexandre, then to Roger Milès. It served Henry Bing to make in 1925

another edition of twenty bronzes: Rudier foundry. A bronze, cast at government expense, has entered the Louvre. Another is in the Musée de Marseilles. This plaster is part of the Lafont collection."

"The other plaster," added Gobin, "remained in the Geoffroy-Dechaume family until 1916. In January of that year it was ceded to M. Bowasse-Lebel. It belongs today to M.M.L." (1952, p. 294). Gobin had three illustrations of plasters, one of which belonged to M. Loncle, coming from Geoffroy-Dechaume (no. 61). The other two photographs are not identified, and may or may not be the same plaster (no. 61 *bis*).

Since Gobin wrote, the two plasters he described have changed hands. The first plaster that he mentioned, at that time in the "Lafont" collection, is now in the Albright-Knox Art Gallery in Buffalo, New York (see cat. no. 37a). It is included in this exhibition. The second plaster, which was in the collection of Maurice Loncle, is now in a private Milanese collection, and could not leave Italy for the exhibition (see cat. no. 37d). Neither owner has a complete provenance for his sculpture; those provided here are only tentative. The Albright-Knox museum purchased their plaster in 1954 from the Galerie André Weil in Paris; it had formerly been in the collections of Henry Bing and Emile Laffon. The museum has in its files copies of two letters addressed only to "Monsieur," one signed by L. Roger-Milès in 1924 and the other signed by Armand Dayot in 1929. They were acquired with the sculpture from the Galerie Weil. Both letters state that they had formerly owned the "Ratapoil" plaster, the "only original plaster." Roger-Milès said that after Daumier's death this statuette passed to Geoffroy-Dechaume, who left it to Arsène Alexandre, from whom he had acquired it. Dayot wrote regarding the unknown addressee's "original plaster, Daumier's *Ratapoil*," that "I had it from Geoffroy-Dechaume, who had received it from Daumier's widow." This is substantially the same history that Gobin gave for the first plaster he mentioned, the one that he said had served for the Siot-Decauville and Rudier bronze editions (1952, no. 61, 1). The Albright-Knox museum's plaster had been in the collection of Emile

Laffon; Gobin apparently misspelled the name.

The Milanese plaster (cat. no. 37d) passed from Maurice Loncle to René Gaston-Dreyfus. It was purchased at auction by the late Count Borletti di Arosio from the Gaston-Dreyfus sale in 1966. Gobin wrote that this plaster had passed from Geoffroy-Dechaume to a Bowasse-Lebel in 1916 (Gobin, 1952, no. 61, 2). Whether or not Loncle received it directly from Bowasse-Lebel has not been determined. The third bronze edition was cast from this plaster at the Valsuani foundry.

These two plasters are quite different in appearance, the Buffalo plaster being a light tan, heavily mottled throughout with deep brown stains, even after thorough cleaning. The plaster in Milan is a uniform chalky white, and is apparently covered with a transparent protective coating.

A troublesome question which now arises is why there should be more than one "original" plaster of Daumier's "Ratapoil." Alexandre clearly stated that "the artist had *it* cast in plaster, and *that* fragile statuette was hidden with care" (1888, p. 301), speaking in the singular. Indeed, if the statuette caused Daumier's wife to hide it in fear of a raid by Napoleon III's police, would Daumier have wanted two plasters of it?

The first source we have been able to locate, published or unpublished, that mentions the existence of two plasters of "Ratapoil," is Gobin, in 1952 (p. 294). As far as can be determined, Gobin is also the source for the categorical statement that the plaster of "Ratapoil" was made for Daumier by Victor Geoffroy-Dechaume. Gobin does not give *his* source for these statements and, as he was writing a century after the fact, one would like to know where he got this information.

Before going further into the question of the plasters, it is convenient to discuss the bronze editions here. "Ratapoil" was the first of Daumier's sculptures to be cast in bronze. The circumstances of this casting are not entirely clear, however. For one thing, we do not know who owned the original "Ratapoil" from which the bronzes were made. Presumably this was the same plaster illustrated by Alexandre in 1888. It may have belonged to Dau-

37. Ratapoil

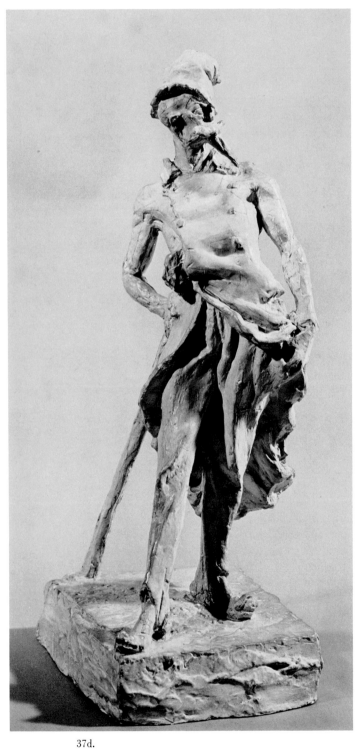

37d.

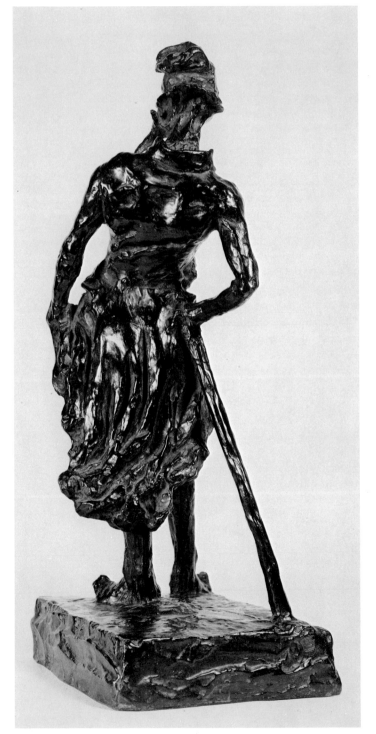

37e.

37d. RATAPOIL
 Plaster; h. 18⅛″ (460 mm.)
 Bronze edition of 12 plus 3 proofs cast by Valsuani
 c. 1960
 Provenance: Geoffroy-Dechaume family ?
 Bowasse-Lebel 1916-?
 Maurice Loncle c. 1952-c. 1960
 René Gaston-Dreyfus c. 1960-1966
 Count Aldo Borletti di Arosio 1966-1967
 Private Collection, Milan
 (not in exhibition)

37e. RATAPOIL
 Cast bronze; h. 17-5/16″ (440 mm.)
 Markings: side of base, right rear: Valsuani stamp;
 top of base, left side: 1/12
 Collection Benjamin A. and Julia M. Trustman, Boston

37f. RATAPOIL
 Alva reproduction made from Rosenwald bronze no. 37b
 Synthetic material; h. 17⅝″ (448 mm.)
 Markings: top of base, rear: DAUMIER; side of base,
 rear: Siot-Decauville stamp, © 1961, AMR
 Fogg Art Museum, Harvard University
 (not illustrated)

mier's widow, for Alexandrine Daumier did not die until 1895. The casting was made at the Siot-Decauville foundry. The date of this casting is generally given as about 1890 (1926, Galerie Charpentier, no. 610; Fuchs, 1927, no. 171; MOMA, 1930, no. 147; Marceau-Rosen, 1948, p. 82; Adhémar, 1954, pl. 36; Bibliothèque Nationale, 1958, no. 135; Museo Poldi Pezzoli, 1961, p. 27; and Rostrup, 1964, no. 615g). Armand Dayot wrote in 1897 that "the bronze statuette of the famous *Ratapoil* is today the property of the state" (I, p. 2). Gustave Geffroy wrote in 1905 that this bronze casting was done with the aid of the government (p. 102). According to the catalogue of the Daumier exhibition at the Bibliothèque Nationale in 1958, one of the Siot-Decauville bronzes entered the Musée du Luxembourg in 1892; this one is now in the Louvre (no. 135). Therefore, a bronze of "Ratapoil" must have been made by Siot-Decauville at government expense, between 1888 and 1892.

The exact number of bronzes in the Siot-Decauville edition is not clear, though it is generally assumed to have been about twenty. However, the catalogue of the Daumier exhibition at the Pennsylvania Museum in 1937 included a bronze, "the first cast of an original series of six castings made on the initiative of the French government. . . ." (no. 7). And Gobin wrote that after Daumier's death Siot-Decauville made "a small edition of numbered bronzes." But he went on to say that the second casting was "another edition of twenty bronzes. . . ." (no. 61, 1). Twenty bronzes obviously exist, for the Siot-Decauville bronze lent to this exhibition by the National Gallery of Art, Rosenwald Collection, is stamped "17" (see cat. no. 37b), and the Ny Carlsberg Glyptotek owns number twenty of that edition (Rostrup, 1964, no. 615g). A copy of a letter now in the files of the Albright-Knox Art Museum, dated March 15, 1924, from L. Roger-Milès to "Monsieur," said that "Thirty-some years ago Geoffroy-Dechaume had Siot-Decauville make a bronze edition of 'Ratapoil' in an edition of twenty." It is possible, then, that there were two castings made of "Ratapoil" at Siot-Decauville in the 1890's, the first an edition of about six, made before 1892 and paid for by the state, and the second, an edition of about twenty,

made for Geoffroy-Dechaume after Madame Daumier's death. This, of course, is simply speculation.

A second edition of "Ratapoil" bronzes was cast in 1925 by the Rudier foundry. According to Fuchs, who in 1927 was the first to mention this new edition, twenty bronze casts were made in Paris for Henry Bing, who owned "the original model" (p. 24; no. 171). Fuchs illustrated a bronze and a plaster (nos. 171 and 172a). Gobin repeated the information about the Rudier casting (1952, no. 61, 1), as did Durbé (Poldi Pezzoli, p. 27). The Rudier bronze in our exhibition was lent by Mr. and Mrs. Harry Remis (see cat. no. 37c).

Probably in 1959-60, a third bronze edition of "Ratapoil" was made, cast this time by the Valsuani foundry, for Maurice Loncle (Loncle owned the only known plaster that was not in a museum by that time). This is an edition of fifteen bronzes, numbered 1-12 and E1, E2 and E3. Durbé wrote in 1961 that the Valsuani edition was "recently cast" (Museo Poldi Pezzoli, p. 27). His exhibition included cast number "E 3." (no. 38). In our exhibition the "Ratapoil" lent by Benjamin A. and Julia M. Trustman (see cat. no. 37e) bears the Valsuani stamp and is numbered "1/12." For a fuller discussion of the bronze editions see "Materials and Techniques."

Recently, the firm of Alva Museum Replicas began production of an unlimited edition of reproductions cast from the Rosenwald bronze (cat. no. 37b), in a synthetic material. An Alva replica is included in this exhibition for purposes of comparison (see cat. no. 37f).

Gobin had written that the Siot-Decauville and Rudier bronze editions had been made from the Dayot/Roger-Milès/Bing/Lafont (that is, Laffon) plaster, now in the Albright-Knox Art Gallery, and Durbé added that the Valsuani bronzes were made from the Loncle plaster, now in a Milanese collection. Laboratory studies have verified that this is indeed the case. The Albright-Knox museum allowed the Fogg to borrow their plaster six months before the exhibition in order that extensive technical studies could be made of it, both alone and in actual comparison with bronzes from all three editions. The owners of the plaster in Milan kindly allowed

it to be viewed in some detail, although there was not time to remove it from a vitrine. From these studies, it seems certain that the Siot-Decauville and Rudier bronzes were made from the Buffalo plaster, and that this plaster was made in the 19th century. It also seems certain that Daumier's original clay would have been destroyed in the casting of a plaster, as Gobin and others had surmised. Therefore, it would hardly have been possible to cast more than one plaster from Daumier's original clay. The plaster "Ratapoil" now in Italy was most probably made from the Buffalo plaster. For a full discussion of these points, see "Materials and Techniques."

As noted above, Gobin in 1952 was the first to mention the existence of two "original" plasters of "Ratapoil." But the insistence of several writers in the 1920's that they were discussing *the* "original" plaster leads to the supposition that two (or more) plasters existed by about 1925. Prior to that date the plaster of "Ratapoil" is always noted in the singular.

The third plaster of "Ratapoil," in the Musée des Beaux-Arts in Marseilles came to our attention almost at press time, and the authors have not seen it. However, because a founder's stamp (Siot-Decauville) was cast right in the plaster (on a statuette supposedly made about 1850, long before bronze casting was considered for it), it seems reasonable to assume that this plaster was made from a Siot-Decauville bronze. It is therefore only distantly related to Daumier's original clay sculpture.

Gobin made a statement regarding "Ratapoil" which should be questioned, if not denied. He wrote that Madame Daumier kept the statuette hidden, and that Daumier himself "attached no importance to it" (p. 28). Gobin also suggested that Daumier tossed the thirty-six busts around as he changed addresses, even though Daumier had not been the possessor of the busts since the 1830's. By implying that Daumier was heedless of the sculpture he is known to have made, Gobin appears to be making a case for Daumier having also carelessly "lost" the other sculpture he was attributing to him. But in the case of "Ratapoil," Daumier seems instead to have attached a great deal of importance to his figurine and to have

kept it carefully. Why have it cast in plaster if it were politically troublesome? Why not simply destroy the clay? Instead it seems that Daumier had the plaster made soon after he finished the clay, perhaps while the clay was still moist, and then carefully hid that statuette.

It is with some excitement then, and some humility, that we present to the American public in its first real introduction, the Buffalo "Ratapoil," the "fragile mannequin" that Daumier had so carefully preserved.

J. M. L.

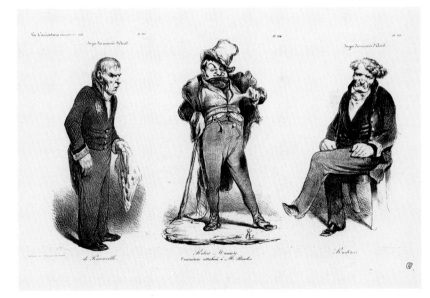

37g.

37g. HUGUET DE SEMONVILLE — ROBERT MACAIRE
(THIERS) — COMTE ROEDERER L.D. 124
Lithograph, first state; 280 x 470 mm.
La Caricature, July 30, 1835
Collection Benjamin A. and Julia M. Trustman, Boston

Ce bon Mr Ratapoil leur a promis qu'après qu'ils auraient signé sa pétition les alouettes leur tomberaient toutes rôties.

37i.

Le Sire de Berryer se fesant recevoir Chevalier dans l'ordre philantropico-militaire du Dix-Décembre

37j.

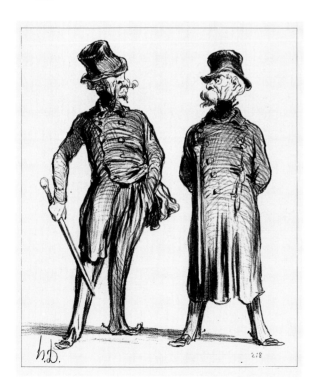

37h.

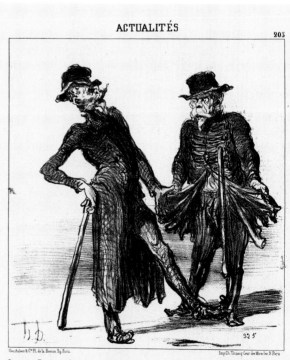

Casmajou —Je crois que le moment est venu de réclamer pour prix de mon dévouement une redingote en gratification
Ratapoil —Eh! bien, crois-tu donc que mes bottes ne laissent rien à désirer sous le rapport de la semelle!
(Tous deux en chœur) —O ingratitude des Gouvernements!

37k.

170

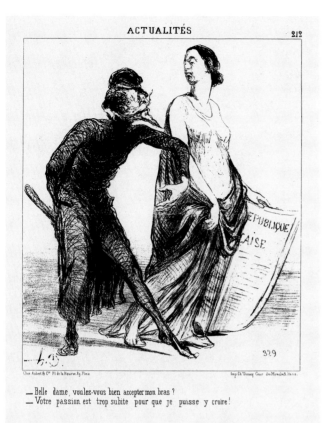

329

— Belle dame, voulez-vous bien accepter mon bras ?
— Votre passion est trop subite pour que je puisse y croire!

37l.

37h. RATAPOIL ET CASMAJOU L.D. 2035
Lithograph, first state; 247 x 210 mm.
Charivari, October 11, 1850
Collection Benjamin A. and Julia M. Trustman, Boston

37i. CE BON M. RATAPOIL LEUR A PROMIS . . .
(This fine Mr. Ratapoil has promised them . . .)
L.D. 2118
Lithograph, second state, white paper; 264 x 214 mm.
Charivari, June 20, 1851
Boston Public Library

37j. LE SIRE DE BERRYER . . . CHEVALIER . . .
DU DIX-DECEMBRE . . . (The Lord of Berryer
. . . Knight . . . of the 10th of December) L.D. 2138
Lithograph, second state, white paper; 267 x 234 mm.
Charivari, August 19, 1851
Boston Public Library

37k. CASMAJOU-RATAPOIL (TOUS DEUX EN
CHOEUR) (Casmajou and Ratapoil . . . speaking in
chorus) L.D. 2146
Lithograph, second state, white paper; 250 x 230 mm.
Charivari, September 11, 1851
Boston Public Library

37l. BELLE DAME VOULEZ-VOUS . . . ACCEPTER
MON BRAS? (Lovely lady, will you . . . accept my
arm?) L.D. 2153
Lithograph, second state; 256 x 220 mm.
Charivari, September 25, 1851
Boston Public Library

37n. LA SOUSCRIPTION NAPOLEONIENNE (The
Subscription for Napoleon) L.D. 2085
Lithograph, second state; 255 x 203 mm.
Charivari, February 26, 1851
Museum of Fine Arts, Boston
(not illustrated)

37o. RATAPOIL FESANT DE LA PROPAGANDE
(Ratapoil making propaganda) L.D. 2117
Lithograph, second state; 260 x 199 mm.
Charivari, June 19, 1851
Boston Public Library
(not illustrated)

37p. UN JOUR DE REVUE (A Day of Review) L.D. 2123
Lithograph, white paper; 253 x 224 mm.
Charivari, July 1, 1851
Collection Mr. and Mrs. Arthur E. Vershbow,
Newton, Massachusetts
(not illustrated)

37q. PROJET D'UNE NOUVELLE PIECE DE CINQ
FRANCS . . . (Project for a new five franc piece . . .)
L.D. 2147
Lithograph, second state; diameter 220 mm.
Charivari, September 12, 1851
Museum of Fine Arts, Boston
(not illustrated)

37r. ET CES LAIDS DEBRIS SE DESOLAIENT
ENTRE EUX (And these ugly wrecks console each
other) L.D. 3935
Lithograph, second state; 239 x 210 mm.
Charivari, July 3, 1872
Boston Public Library
(not illustrated)

1878 Duranty, II, 532 — see text

1888 Alexandre, pp. 295, 300, 301, 336, 379, opp. p. 296 (plaster, ILLUSTRATED) see text

1901 Palais de l'Ecole des Beaux-Arts, Paris, No. 307 (bronze)
Geffroy, 21 (bronze, ILLUSTRATED)

1905 Geffroy, *L'Art et Les Artistes*, 101, 102, 108 (bronze, ILLUSTRATED)

1907 Marcel, 117 (plaster, ILLUSTRATED)

1908 Bertels, 109; fig. 53 (bronze, ILLUSTRATED)
Auquier, Musée de Marseille, No. 1.044: Bronze, cast in ten examples by Siot-Decauville, acquired 1896 (bronze)

1922 Phillips, 57

1923 Klossowski, 36; Pls. 10-11, no. 459 (bronze, ILLUSTRATED)
Escholier, 156

1926 Hôtel Jean Charpentier, Paris, No. 610 (bronze)
Galerie Matthiessen, Berlin, No. 146 (bronze, ILLUSTRATED)

1927 Fuchs, 24; Pl. 171 (plaster, ILLUSTRATED); Pl. 172a (bronze, ILLUSTRATED)
Galerie Georges Petit, Paul Bureau sale, Paris, No. 125: Siot-Decauville cast no. 1 (bronze, ILLUSTRATED)

1929 "Une Exposition Daumier à Marseille," 210 (Ratapoil was exhibited)

1930 V.N., *International Studio*, 76
MOMA, New York, 18; No. 147: says the original "terra cotta" is in the possession of Mr. Henry Bing, Paris (bronze, ILLUSTRATED)

1931 Escholier, 60-61; 128
Grass-Mick, 20-21: "thanks to Armand Dayot this famous maquette of cracked clay was saved and reconsolidated for a bronze casting (that in Musée du Luxembourg). Dayot, great friend of Geoffroy-Dechaume, tells this story in his writings, and told me in may, 1926." 52: "a bronze of this was the only sculpture exhibited at Durand-Ruel, 1910, at the Exposition Société des Artistes Lithographs Français . . ."

1934 Bibliothèque Nationale, Paris, xv-xvi; No. 394 (bronze)

1936 Albertina, Vienna, No. 84 (bronze)

1937 Pennsylvania Museum of Art, Philadelphia, No. 7 (bronze)

1945 Courthion, ed., opp. p. 161 (bronze, ILL.)

1947 Musée Cantini, Marseilles, No. 34 (bronze, ILLUSTRATED)

1948 Marceau-Rosen, 82 (bronze, ILLUSTRATED)

1952 Gobin, 28, 30; No. 61 (plaster and bronze, ILLUSTRATED)

1954 Adhémar, Pl. 36 (bronze, ILLUSTRATED)

1955 Albright Art Gallery, 71: Gallery announces acquisition of plaster figurine, "Ratapoil"; 57 (plaster, ILLUSTRATED) *same as cat. no. 37a*

1957 Galerie Sagot-Le Garrec, Paris, No. 61 (bronze, ILLUSTRATED)

1958 Bibliothèque Nationale, Paris, No.135 (bronze)
Museum of Fine Arts, Boston, No. 22 (bronze, ILLUSTRATED)
Los Angeles County Museum, No. 239 (bronze, ILLUSTRATED)

1959 Rey (bronze, ILLUSTRATED)

1961 Museo Poldi Pezzoli, Milan, 3, 26, 27; No. 38 (bronze, ILLUSTRATED)
Musée Cognacq-Jay, Paris, No. 344 (bronze); No. 346 (plaster, ILLUSTRATED) *same as cat. no. 37d*

1962 Museum für Kunst und Gewerbe, Hamburg, No. 116 (bronze, ILLUSTRATED)

1963 Brandeis University, Waltham, Mass., No. 127 (bronze, ILLUSTRATED)
Smith College Museum of Art, Northampton, Mass., No. 35 (bronze)

1964 Rostrup, No. 615g (bronze, ILLUSTRATED)

1965 Escholier, 85, 188; 87 (bronze, ILLUSTRATED)

1966 Hôtel Drouot, Paris, No. 19 (bronze, ILLUSTRATED)
Palais Galliera, Paris, No. 16 (plaster) *same as cat. no. 37d*; No. 48 (bronze, ILLUSTRATED)
Larkin, 103; 45 (plaster, ILLUSTRATED) *same as cat. no. 37a*

1967 Licht, 85 (bronze, ILLUSTRATED)

1968 Château de Blois, No. 498 (bronze, ILLUSTRATED)

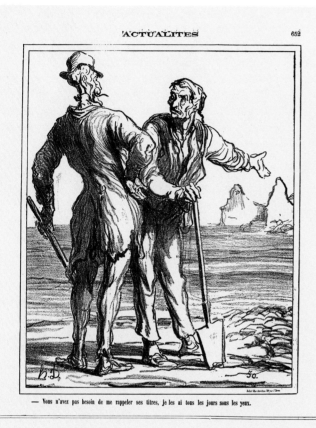

38. Les Emigrants
(The Refugees) "First Version"

Gobin No. 64

39. Les Emigrants
(The Refugees) "Second Version"

Gobin No. 65

Perhaps Daumier's greatest achievement in sculpture is the heroic and monumental concept known as "Les Emigrants." A frieze of nude figures — men, women and children — modelled in low and high relief, it presents a seemingly endless line of human misery on the march. Daumier repeatedly treated the theme of refugees; in at least four paintings which, according to Maison, cover a span of twenty years, and in several drawings. The composition of the sculpture appears, however, in only one drawing — the crayon, pen and wash from the Roger-Marx collection (see cat. no. 38c), which seems closely related. Nevertheless, nowhere has Daumier expressed the stark tragedy of his theme more eloquently than in the sculpture. Stripped of all the exterior factors shown in the paintings — the barren landscapes, blowing draperies, horses and barking dogs — the tragic, unclothed figures in the sculpture move slowly and silently toward the unknown, carrying only their bundles, their children and their dead.

Although "Les Emigrants" is considered to be one of the documented Daumier sculptures, it poses many problems. There is, in the first place, the usual disagreement among Daumier specialists about the date. In his note for the Roger-Marx drawing, K. E. Maison writes (vol. II, no. 819): "The drawing is without doubt relatively early, i.e., before 1850. Adhémar's suggested date of the relief is equally early (1848/49), while Fuchs dates it c. 1855 and Gobin even 1870/71." The turbulent history of Daumier's time, with its recurrent phenomenon of uprooted people, could justify any of these dates. For example, the Polish revolution of the 1830's drove many families from Poland to France; in 1848 thousands who had supported the insurrections of May and June were deported to the French colonies; and 1871 marked France's bitter defeat in the Franco-Prussian war.

A more difficult problem than the dating, however, is the existence of two plasters, both treating the same subject with subtle differences, and both apparently documented from Daumier's lifetime. In the description of a visit to Daumier's studio under date of January 14, 1852, in which he also described a study of the "Washerwoman" (see cat. no. 40), Poulet-Malassis mentioned: "He is also doing some sculpture; I see a kind of bacchanal in wax on the wall of the studio." Oliver Larkin in his book on Daumier asks (p. 134): "Was this a lost relief by Daumier or a work of Préault? Gobin's speculations seem rather tenuous. If Poulet-Malassis mistook clay for wax, a medium never used by Daumier, is it not possible that he saw too hastily the two bas-reliefs of the Emigrants or Fugitives, either in the original clay or in the tinted plaster casts which were made from them?" In a letter of December 29, 1966 to the Fogg, Mr. Larkin wrote, "Philippe Burty describes a visit to the studio of Geoffroy-Dechaume about 1862, and says he then saw the two reliefs, one in terra cotta, the other wax. Gobin is probably right in saying that Burty was mistaken about the medium."

Gobin's catalogue raisonné of 1952 mentions that the two bas-reliefs modelled in unbaked clay were so fragile that Daumier had his friend, the sculptor Victor Geoffroy-Dechaume, make a plaster cast of each. Adhémar also states (p. 39) that "according to a family tradition, the bas-reliefs, in order to conserve them better, seem to have been cast in tinted plaster by a friend and neighbor of Daumier's, Geoffroy-Dechaume, and the latter's family still preserves them, since the clays have disappeared." There is documentary evidence that the Geoffroy-Dechaume family did, in fact, own two plasters of "Les Emigrants" from at least the time Burty saw them in Victor's studio in 1862, until almost a hundred years later. On March 29, 1960 the plaster designated by Gobin as the "first" version was auctioned at the Galerie Charpentier and acquired by the Louvre. The "second" version, generously loaned to this exhibition by Monsieur D. Geoffroy-Dechaume, great-grandson of Victor, still belongs to the family. (It also appeared in the Charpentier catalogue, but was withdrawn from the sale.)

The written history of the two versions is as confusing as that of the caricature busts. There are inconsistencies and omissions that make an accurate picture difficult to reassemble. For example, the catalogue of the exhibition at Durand-Ruel organized

by Daumier's friends in 1878 lists two studies in plaster (nos. 235 and 236) called "Fugitifs," belonging to Monsieur Geoffroy-Dechaume. Nevertheless, that same year, Duranty, in an article on Daumier in the *Gazette des Beaux-Arts* (II, p. 535) mentions that "M. Geoffroy-Dechaume possesses by him a little bas-relief representing 'Fugitifs.'" Then in 1888 Alexandre's book on Daumier lists in its "Catalogue Sommaire," under sculpture (p. 379), busts, Ratapoil and "*two bas-reliefs in plaster representing lines of émigrants*." The plaster of the "second" version is illustrated. In 1897 Dayot, in, *Journées Révolutionnaires* (I, p. 2) mentions only one relief, and the catalogue of the 1901 Daumier exhibition at the Palais de l'Ecole des Beaux-Arts lists only one plaster study (no. 308). In his article "Daumier sculpteur" which appeared in *L'Art et Les Artistes* in 1905 (p. 102), Geffroy mentions only one clay bas-relief of "Emigrants" belonging to Geoffroy-Dechaume, son of Daumier's friend, and expresses the hope that bronze will save this fragile work of great beauty. The plaster of the "second" version is illustrated.

Illustrations of bronze casts of the "second" version do, in fact, appear shortly thereafter. In 1907 Marcel illustrates a bronze cast of "Version II" from the Philipon collection. Bronze casts of the "second" version are illustrated also in Phillips' book in 1922 (p. 57), and Klossowski's in 1923. Fuchs, however, in *Der Maler Daumier*, published in 1927, writes of a bronze edition of 20 casts of the "second" version which he dates as early as 1890.

Gobin, always conscientious, tried to clarify the history of the two "Emigrants" and the various editions. He wrote that the original tinted plasters of each version remained with the Geoffroy-Dechaume family from the time Victor cast them from Daumier's original clays. In 1939, Victor's grandson, Charles, formally declared to Gobin that these were the only ones made by his grandfather. Gobin believed, although he could not definitely confirm the information, that four additional tinted plaster casts had been made after Daumier's death from "Version II," probably by Adolphe Geoffroy-Dechaume, son of Victor, and himself a sculptor. In 1893 Adolphe

offered one of these to Roger-Marx, another to Armand Dayot, and a third to the sculptor Desbois, from whom Gobin acquired it. The fourth remained with the Geoffroy-Dechaume family. (It should be noted here that one of these copy plasters of "Version II" was acquired by the Ny Carlsberg Glyptotek in Copenhagen in 1947, the gift of Georges and Roby Grappe, who, in turn, had acquired it from the Geoffroy-Dechaume family.)

According to Gobin, a bronze edition of "Version II" was made from the Armand Dayot plaster consisting of five numbered casts bearing the mark of the Siot-Decauville foundry. Although he gives no date for this bronze edition, it was presumably after 1893 and therefore not in agreement with Fuchs who mentions an edition of 20 cast in 1890.

In order to be as complete as possible, Gobin mentions (p. 309) the existence of an edition of "Version II" made by surmoulage and a German edition in *galvanoplastie*, as well as a mediocre reduction. He adds that the Geoffroy-Dechaume family has a plaster fragment of the left side of the relief (he does not give the version), which appears to be from the original mold, but is an incomplete cast. He does not, however, mention a second bronze edition of "Version II" made by the Rudier foundry when the Alexis Rudier stamp was still being used. (According to Larkin in a summary of the editions prepared for the Fogg Museum in September 1966, the Rudier edition of "Version II" was made for members of the Geoffroy-Dechaume family and consisted of ten numbered casts.) It is not clear, however, when the edition was made, although presumably it was after publication of Gobin's book in 1952.

The history of the "first" version of "Les Emigrants" is far less complicated than that of the "second." The original, and evidently unique plaster remained with the Geoffroy-Dechaume family until it was acquired by the Louvre at the Charpentier sale of 1960. Just before this, Georges Rudier made an edition of ten numbered bronze casts from it. According to Pierre Pradel, Chief Curator of Sculpture at the Louvre, the mold was broken in the presence of a government official, after the Rudier

edition was finished. It is presumably the only edition of the "first" version. (However, it should be mentioned here that two years ago the French sculptor Jean Osouf indicated the existence of two bronzes cast by the Goddard foundry, although he did not specify when they were made, by what method, nor their present whereabouts.)

Puzzling as the history of the editions may be, Daumier's reasons for making two almost identical versions of the relief are even more puzzling. This evidently troubled Gobin, for he speculates that Daumier might have tried the same subject twice since it was his first attempt at modelling in relief, as well as his first attempt to create multiple figures in a sculpture. Besides, Gobin adds, his failing eyesight might have made his hand less sure. The failing eyesight theory is not relevant if one accepts the earlier dates suggested by Adhémar or Fuchs. As to Daumier's unfamiliarity with the sculptured form of the relief, one could agree with Gobin that this is a possible motive for making two attempts. It would be logical to expect, then, that the second attempt would present a fuller development of the theme or at least a further stylistic development. However, a comparison of the two versions only serves to raise baffling questions.

Unfortunately it was not possible to make a side-by-side comparison of each version, since the Louvre plaster cannot travel. However, the Geoffroy-Dechaume plaster did arrive just before the publication of this catalogue. In addition, photographs of the Louvre plaster and the bronze casts on exhibition were available for study, and a careful comparison of these revealed the differences described below.

The plaster of the so-called "second" version appears to be slightly larger than the other version — by about 1¾″ in height and 3″ in length. The apparent inconsistencies in the measurements of the bronze editions of "Version II" can most likely be explained by the border on the Siot-Decauville bronze, comparable in size to the copy-plaster in the Glyptotek which also has a border. The Rudier bronze, without a border, is about the same size as the Geoffroy-Dechaume plaster. A comparison of individual figures in the two versions reveals inconsistent differences in height ranging from ¾″ to 1½″ higher in the "second" version than the "first." It is apparent then, that the "second" version is not a point-by-point enlargement of the "first," but rather a free-hand adaptation.

The composition is identical in both versions. The same figures in the same pose appear in both, although the manner in which they are modelled is different. Most striking is the difference in proportion between the figures in the two versions. Some figures in the "first" version are designed more compactly than those in the "second," which, although just as muscular as the "first" version figures, appear more attenuated. Comparing the procession of figures as they move across the relief from right to left, other differences become apparent. The first discernible man is roughly sketched in the "first" version, whereas in the other, although he remains a background figure, his facial features are given in more detail than those of any other figure in the relief. The man carrying a litter appears stronger and more muscular in the "first" version, his neck thickened by the strain of his load, his chest expanded, and the muscles of his arm straining as his hand grasps the handle of the litter. His counterpart in "Version II," however, is much narrower of chest, and the figure is slightly turned from profile to a more frontal view so that the neck is not as apparent. The arm and hand holding the litter are not clearly articulated but seem formless and vague. The handle of the litter does not continue beyond his hand, as it does in the other version, but either was broken off before the plaster was cast, or was cut off intentionally by the sculptor.

The greatest compositional difference between the two versions is found in the treatment of three of the figures in the center of the relief — a group formed by the man carrying the litter and the two figures preceding him. In the "first" version the spatial relationship between the three figures is clearly defined by the modelling of the closest figure — the man carrying the litter — in high relief, the short figure just behind him in low relief, and the man farthest away almost flat, a mere shadow, silhouetted against the background. In the "second" version, the spatial relationship of the three figures is confused by similar handling of the two figures preceding the man with the litter. Both are modelled in low relief, with the shorter figure indicated by vertical grooves that cause him to advance rather than recede, while the taller man appears on the same plane rather than as a shadow in the background.

And finally, the last child on the left of the relief

is treated differently in the two versions. In the "first" version, he is shown in full back view, legs astride, turning backward toward the moving procession, while his left arm is extended toward the figures in front of him. The small figure thus stops the eye in preparation for the end of the composition, where additional shadowy figures seem to disappear into the distance. In the "second" version, the child does not function in the same way, for he looks up rather than back, and his left leg is lifted, carrying him into the background of disappearing figures. The left arm has been broken away so the artist's intention for it can no longer be read.

The endless procession of the theme is more successfully expressed in the "first" version through the use of depth in the modelling. The background plane is higher at the ends of the relief than at the center. This allows for the modelling in high relief of the central figures without losing the illusion of immense space and distance. In the "second" version, the figures move across a flat background which forms a single plane. The endless procession is further emphasized in the "first" version by the rhythmic repetition of the figures' legs, but in the "second" version the legs are not as parallel and the rhythm is broken.

Perhaps the most significant difference between the two versions is seen in the modelling techniques. The so-called "first" version reveals the same techniques associated with such Daumier sculptures as the caricature busts and the "Ratapoil." Like these, the entire surface is worked over, giving a uniform roughness of texture: Texture is further emphasized by frequent use of a comb tool that serves to draw parallel lines on the clay much like the use of pen and ink to make shading in a drawing. Comb tool marks are noticeable everywhere in the "first" version — on the figures in high and low relief and in the background. Few such marks are visible in the "second" version. Here the modelling was achieved with the aid of a blunt tool which was used to delineate muscles in arms and legs, to make the spine of the man carrying the bundle, and to indicate the body of the short figure in front of the man with the stretcher. In fact, the grooves made with this blunt tool bring to mind the treatment of the neck in the plaster "Portrait of Daumier" (see cat. no. 42a) and the delineation of the breast of the washerwoman in "Le Fardeau" (see cat. no. 40a). Similar to these also is the evidence of the rapid working of the clay in rather broad strokes, which makes the "second" version of "Les Emigrants" appear so different from the tightly worked surfaces of the "first" version.

These observations seem to indicate two possible theories to explain the existence of the two versions of "Les Emigrants." In lieu of documentary evidence, however, they must be considered mere speculations based on the physical evidence alone.

The first possibility is that Daumier made both versions and did them in the order suggested by Gobin. Thus the "first" version, tighter and more worked over, was followed by a second attempt that became looser, freer and more abstract. The fragmented condition of the later version could be explained by the supposition that it had dried too much before it was cast in plaster, and pieces are therefore missing where the clay had broken off. This would explain the smooth area between the legs of the woman just left of the center, which could have been filled in at the time of the casting. It could also explain the abrupt termination of the legs of the sobbing woman, the missing piece of stretcher handle and the separated chunks representing the ground.

A second possibility is that Daumier made both versions, but in the reverse of the order suggested by Gobin. In fact, M. D. Geoffroy-Dechaume, in a letter of September 25, 1968, writing to the Fogg Museum of the plaster he has loaned, referred to it as "the one currently called the second version, but several experts, in particular M. Lecomte, think that it is, on the contrary, the first. This is really of little importance, the one being the replica of the other, and my Great-Grandfather, sculptor and friend of Daumier, having molded them in plaster probably at the same time." If this version were actually made by Daumier first, perhaps he had abandoned it before completion, and wishing to complete it later found it too dried out to continue working on it. He could then have made a completely new one (the so-called "first" version) which does appear to be more fully conceived as a sculpture, even to the continuity of the bottom edge which shows a repetition of thumb prints below the continuous line of the ground. A decision could have been made later to cast both versions in plaster.

At the eleventh hour of the writing of this catalogue, through the generosity of M. D. Geoffroy-Dechaume, the original plaster cast of the "second" version of "Les Emigrants" arrived on loan at the Fogg Museum. Arthur Beale of the museum's Conservation Department was able to make a brief visual examination of the work in the laboratory. His report is quoted below:

This plaster cast of "Les Emigrants" exhibits two distinct types of losses. The first type appears to have been caused by the work having received a severe shock sometime after manufacture. This

blow broke the cast into four or more pieces. Large losses occurred in the relief border below the weeping woman and through the chest area of the figure to her right. Smaller losses occurred along the edge of the broken sections. A photograph of this work published in 1888 (Alexandre, p. 337) shows the work intact as far as these particular losses are concerned. A photograph published in 1928 (Luc-Benoist, pl. XVIII) shows these losses present and the work repaired as it appears today. I feel it is safe to assume that the cast was damaged sometime during the forty years between publications. The copy plasters or plaster foundry models that were made for the production of the two bronze editions, Siot-Decauville and Rudier, must have been made before the original cast was damaged. This conclusion is based on the fact that I have not found these particular losses to be present in any other cast, bronze or plaster, of the "second" version.

The second types of losses exhibited by the original plaster have even greater implication for dating. These losses have been cast through from the original clay. The clay model itself must have been dry and damaged before the plaster was made from it. Reading from right to left, the losses which appear to have occurred in the clay original are as follows: the feet of the weeping woman, the crack in the left knee of the stretcher bearer, the flat space between the legs of the woman carrying the child, the raised border between her feet, the border between the feet of the child on the far left of the relief, and finally the missing left arm of this child figure.

Losses of this type are generally not found in the original plaster cast of the "first" version of "Les Emigrants" (now in the Louvre). I believe the model for this plaster must still have been soft when the original mold was made. Why this version, being more complete, was not used earlier to make copy plasters and bronze casts in the way "version two" was used is a mystery. There are three technical considerations which might suggest an answer. First, some of the undercuts in the "first" version are deeper than those in the "second," making the former more difficult to cast. Second, the plaster of the "first" version has a fine pitted or eroded surface quality that does not read as well in bronze as the smoother surface produced by casts made from the plaster of the "second" version. Third, the probable early existence of copy plasters of the "second" version may have provided a convenient source for foundry models without again risking either original plaster in the mold-making process.

A close examination of the handling and tool working as seen in a comparative study of the plaster originals of both versions is extremely significant. I have previously observed the similarity of the fine comb tool marks in the original plasters of the "first" version of "Les Emigrants" and "Ratapoil." This similarity in both size and use has suggested that these are contemporary works modelled by Daumier in the 1850's. I have not found this type of comb tool mark cast through into the original plaster of the "second" version of "Les Emigrants." However, I have found faint indications that a coarse-toothed comb tool was sparingly used on the clay model of the "second" version. These marks are quite similar to the ones found on Daumier's caricature busts of the 1830's. I wonder if it is not possible that the "second" version is instead the first, an early work of Daumier abandoned and allowed to dry out. Although individual passages in the two works are identical, the modelling, proportions and gestures of the figure appear more resolved in the "first" version than in the "second." Finally, taken as a whole, the maturity of concept inherent in the "first" version is sought but not yet felt in the "second" version.

In addition to the technical information and opinions that are outlined in this report, the conclusion of the early dating of the "second" version of "Les Emigrants" is given indirect support by lithographs by Daumier in 1848 (L.D. 1726) and in 1850 (see cat. no. 39e). In this latter drawing he depicts an artist posing his model. On the wall of the artist's studio Daumier has illustrated a sculptured relief that strongly resembles "Les Emigrants" in size and composition. Is it possible, then, that he could have been using a familiar work on the wall of his own studio as a model?

J.L.W.

HISTORY

1878 Galeries Durand-Ruel, Paris: "Fugitifs," plaster, Collection Geoffroy-Dechaume; "Fugitifs," plaster, Collection Geoffroy-Dechaume"
Duranty, II, 535

1888 Alexandre, 339, 359, 379: refers to two bas reliefs in plaster; 337 ("Version II," plaster, ILLUSTRATED)

1893 Burty (see text)

1897 Dayot, I, 2

1901 Palais de l'Ecole des Beaux-Arts, Paris, No. 308 (plaster)

1905 Geffroy, 102; 108; 101 ("Version II," plaster, ILLUSTRATED)

1907 Marcel, 121 ("Version II," bronze, ILLUSTRATED)

1922 Phillips, 57 ("Version II," bronze, ILLUSTRATED)

1923 Escholier, 154: "terre cuite" ("Version I," ILLUSTRATED, actually plaster)
Klossowski, Pl. 36, No. 460 ("Version II," bronze, ILLUSTRATED)
Ivins, 89

1926 Galerie Matthiesen, Berlin, No. 143 ("Version II," bronze)

1927 Fuchs, 24; No. 172b ("Version II," plaster, ILLUSTRATED); No. 173 ("Version I," detail of plaster, ILLUSTRATED)
Galerie Georges Petit, Paris, Bureau Collection, No. 127 ("Version II," bronze, ILLUSTRATED)

1928 Luc-Benoist, Pl. XVIII ("Version II," plaster, ILLUSTRATED)

1929 Focillon, 94
Anon., *L'Art et Les Artistes, Art Ancien, Art Moderne, Art Décoratif*, 210 (bronze)

1930 MOMA, New York, No. 148 ("Version II", bronze)
Escholier, Pl. 99: "terre cuite" ("Version I," ILLUSTRATED, actually plaster)

1934 Escholier, 189 ("Version I," plaster, ILLUSTRATED)
Bibliothèque Nationale, Paris, XVI; No. 395 (plaster)

1939 Buchholz Gallery, New York, No. 1 (bronze)

1952 Gobin, 309 ("Version II," bronze, ILLUSTRATED); No. 64 ("Version I," plaster, ILLUSTRATED); No. 65 ("Version II," plaster, ILLUSTRATED)

1954 Adhémar, Pl. 47 ("Version I," plaster, ILLUSTRATED)

1957 Galerie Sagot-Le Garrec, Paris, No. 64 ("Version I," plaster)
Rueppel, 10 ("Version II," bronze, ILLUSTRATED)

1958 Bibliothèque Nationale, Paris, No. 100 ("Version I," plaster); No. 101 ("Version II," plaster)
Museum of Fine Arts, Boston, No. 23 ("Version II," bronze, ILLUSTRATED)
Los Angeles County Museum, No. 240 ("Version II," bronze, ILLUSTRATED)

1959 Rey, Pl. 37 ("Version I," plaster, ILLUSTRATED)

1960 Galerie Charpentier, Paris, No. 86 ("Version I," plaster, ILLUSTRATED); ("Version II," plaster, ILLUSTRATED)

1961 Musée Cognacq-Jay, Paris, No. 344 bis ("Version I," bronze)
Museo Poldi Pezzoli, Milan, 3
Smith College Museum of Art, Northampton, No. 24 ("Version II," bronze)

1962 Museum für Kunst und Gewerbe, Hamburg, No. 117 ("Version II," bronze, ILLUSTRATED)

1964 Rostrup, No. 615 h ("Version II," plaster)

1965 Escholier, 181; 183 ("Version I," bronze, ILLUSTRATED)
Klipstein and Kornfeld, Bern, No. 187 ("Version II," bronze)

1966 Palais Galliera, Paris, Pl. XXII, No. 50 ("Version I," bronze, ILLUSTRATED)
Larkin, 91; 134; 40 ("Version I," bronze, ILLUSTRATED)

1968 Château de Blois, No. 500 ("Version I," bronze)

38. Les Emigrants
"First Version"

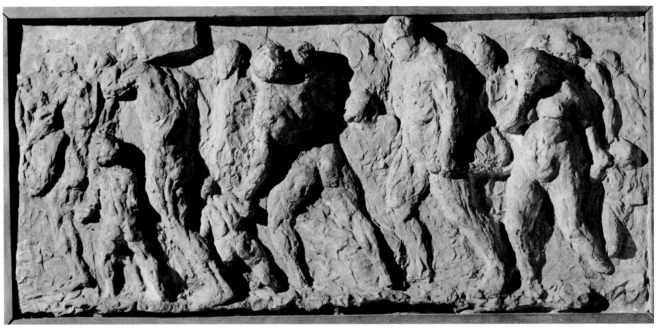

38a.

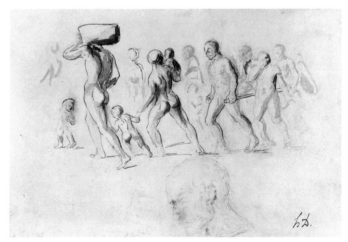

38c.

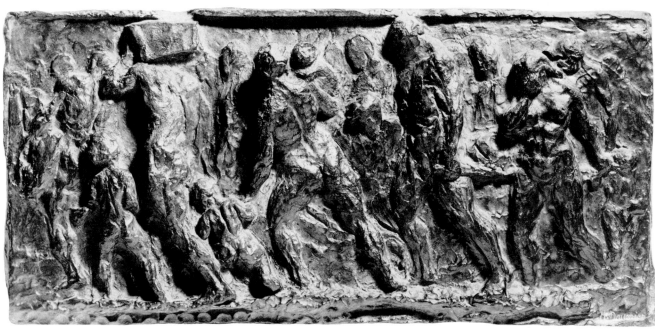

38b.

38a. LES EMIGRANTS
 Plaster, toned; 11 x 26″ (280 x 660 mm.)
 Bronze edition of 10 cast by Georges Rudier c. 1960;
 mold then broken at the Louvre
 Provenance: Adolphe-Victor Geoffroy-Dechaume
 Geoffroy-Dechaume family
 Musée du Louvre, Paris, acquired 1960
 (not in exhibition)

38b. LES EMIGRANTS
 Cast bronze; 12⅛ x 26″ (308 x 660 mm.)
 Markings: lower right: H. Daumier; right edge:
 10/10, Georges Rudier Fondeur Paris
 Fogg Art Museum, Harvard University

38c. Study for "Les Emigrants" (Maison No. 819)
 Drawing, crayon, pen and wash, sanguine; 235 x
 365 mm.
 Signed bottom right: h.D.
 Provenance: Roger-Marx, acquired on the Paris
 art market, 1920
 Collection Claude Roger-Marx, Paris

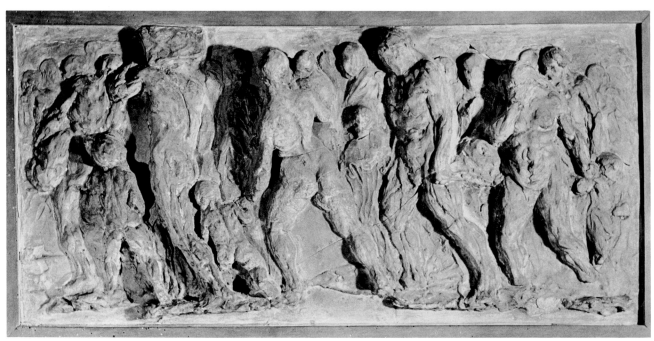

39a.

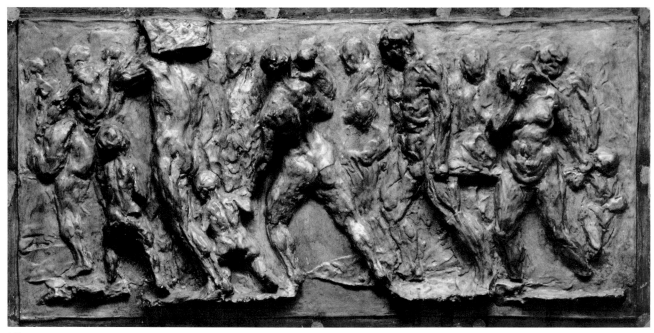

39b.

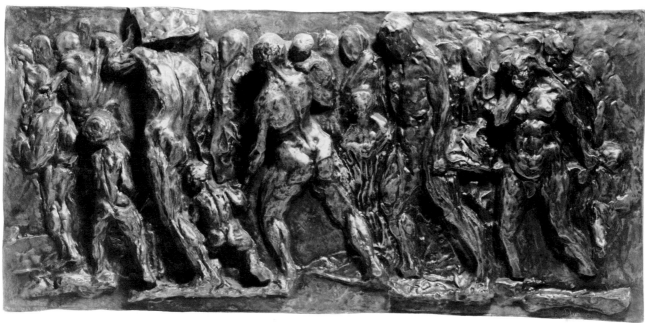

39c.

39e. COMMENT, ST. GERVAIS A PRIS CETTE
POSITION LA . . . (What, St. Gervais took that
position . . .) L.D. 1724
Lithograph, second state, white paper; 249 x 212 mm.
Charivari, 1850
Museum of Fine Arts, Boston

39a. LES EMIGRANTS
Plaster, toned; 13⅝ x 29⅛″ (346 x 740 mm.)
Provenance: Adolphe-Victor Geoffroy-Dechaume
Geoffroy-Dechaume family
Collection D. Geoffroy-Dechaume, Paris

39b. LES EMIGRANTS
Cast bronze; 14⅝ x 30⅛″ (372 x 765 mm.)
Markings: lower right: h. Daumier, 2, Siot-Decauville
stamp (effaced)
National Gallery of Art, Lessing J. Rosenwald
Collection

39c. LES EMIGRANTS
Cast bronze; 13 x 28-5/16″ (330 x 720 mm.)
Markings: lower right: h. Daumier; lower left:
Alexis Rudier 0
Collection Mr. and Mrs. Harry Remis, Boston

39d. LES EMIGRANTS
Surmoulage
Cast bronze (sand cast); h. 28⅜ x 13¾″
(720 x 350 mm.)
Markings: lower right corner: SIOT-PARIS h Daumier
Private Collection, Paris
(not illustrated)

183

40. Le Fardeau
(The Heavy Burden)

Gobin No. 62

In 1948 the Walters Art Gallery in Baltimore acquired a terra-cotta statuette, a little less than fourteen inches high, of a woman carrying a heavy bundle with a child clutching her skirt. Called "Le Fardeau," the terra cotta was first described by Fuchs in 1927 in *Der Maler Daumier* (no. 174a) in which he mentions that during recent studies of Daumier sculpture he had discovered it as well as another terra cotta, "Le Pitre Aboyeur" (cat. no. 41). It has been treated subsequently by such Daumier specialists as Gobin, Adhémar, Escholier and Larkin, and reproduced in Robert Rey's Daumier picture book, published by Harry N. Abrams in 1965 and in Fred Licht's book on 19th and 20th century sculpture, published by the New York Graphic Society in 1967.

Henry Marceau and David Rosen, in an article on the terra cotta in *The Journal of the Walters Art Gallery* (vol. XI, 1948, pp. 76-82) refer to a memorandum of January 14, 1852, now in the Archives du Louvre, by Baudelaire's friend Poulet-Malassis, in which he mentions a visit to Daumier's studio on the Quai d'Anjou. Poulet-Malassis wrote, "He also makes sculpture . . . I see a kind of large bacchanal in wax on the wall of the studio. Several unfinished studies, a Magdalen, a washerwoman pulling a small girl along the quay in a high wind." Marceau and Rosen, assuming that the description referred to the statuette, find in it proof that the sculpture was already in existence in 1852. Larkin, however, in his book *Daumier, Man of his Time*, believes that "a careful reading of the visitor's description with its reference to the quay would rather suggest one of the painted versions of this theme . . ."

Certainly the theme was of great significance to Daumier, who returned to it many times. Maison reproduces six paintings all with the same composition, and writes (I, p. 72) that "Few single themes so consistently occupied Daumier in his painting as that of a woman burdened with a heavy bundle of laundry, dragging her child along the walls of the Quais. . . . Over a period of more than ten years he repeated the theme, varying it fundamentally three times." Maison agrees with Larkin that Poulet-Malassis referred to a painted version of "Le Far-

deau" rather than the terra cotta.

Marceau and Rosen (and later Gobin) believe the terra cotta corresponds most closely to the painting in the Burrell collection which was loaned for several years to the Tate Gallery (see cat. no. 40b). It is similar to the five other paintings reproduced in Maison in which the woman and child rush along the quay, struggling against a strong wind that presses their clothing against their bodies and sends the child's hair flying. In all the paintings the woman's body is bent forward, contorted by the heavy bundle of wet laundry that hangs over her left arm; her hands are tightly clasped at her waist in order to support the enormous weight. The pose is awkward and tormented, and in two of the versions (Maison nos. I-42 and I-43) Daumier shows some difficulty in articulating the areas of the neck, shoulder and breast as the body twists away from the bundle. But in all the versions Daumier succeeds in expressing the inherent monumentality of his theme.

In comparing the terra cotta to the Burrell painting, Marceau and Rosen state: "it is quite obvious that the painted version and the terra cotta belong to the same creative impulse. Knowing Daumier's method of forming figures plastically to serve as models for his painting, we may assume that the picture followed the clay study immediately, or, at least, within a short space of time." Gobin and Larkin also believe that the terra cotta preceded the painting. Fuchs, on the other hand, refers to the statuette as a "sculptural repetition" of a painted version of the subject (Maison no. I-42), although it is difficult to determine whether or not he meant literally that the sculpture came after the painting. Actually, the terra-cotta washerwoman appears to be based directly on the largest painting of "Le Fardeau," a canvas measuring $57\frac{7}{8}''$ x $37\frac{3}{8}''$ (see cat. no. 40c) in a private collection in Paris. The details of both mother and child in this version are the very ones that find a "sculptural repetition" in the terra cotta.

The matter of sequence however is not of great moment here. With the exception of the small caricature busts, which appear to have been studies for subsequent lithographs, Daumier's modelling seems to be an expression in yet another medium of subjects with which he was preoccupied and which he also treated in paintings, drawings or graphic works. Thus, the character of "Ratapoil" appeared in his lithographs over a period of almost twenty years, and Maison reproduces four paintings, each different, called "Les Emigrants" or "Fugitifs" that span a twenty-year period as well. These subjects deeply absorbed Daumier who seems to have been able to capture them in paint, ink or clay at will. It would therefore seem entirely logical that Daumier should have made a sculpture of the washerwoman that he painted so obsessively.

Careful examination of the Walters statuette, however, raises some questions concerning Daumier's authorship. In comparing the sculpture to the paintings, striking differences become apparent. All the painted versions of the washerwoman are made with conscious distortion which emphasizes the thrust of the body leaning into the wind. In the terra cotta, the axis of the lower part of the body is shifted, so that the woman appears to be toppling forward rather than battling the wind. In all the paintings the woman's arms are twined about her body with the hands meeting in a tight grasp at the hip, dramatizing the weight of the bundle of laundry. The arms and hands are fully expressed and modelled in the round. In the sculpture the elbow and forearm are hardly formed; the hands are ambiguous and lifeless. The very proportions of the woman's figure in the terra cotta vary significantly from the paintings. The sculptured figure is much taller. The distance from her head to that of the child is far greater than it is in the paintings, and her thigh is much longer.

Above all, there is a definite articulation of the woman's body in the paintings; bone and flesh exist beneath the drapery. Daumier was also capable of conveying this vitality in his sculpture. In the "Ratapoil," for instance, every part of the body throbs with life under the tattered clothing, and all is eloquently expressed from the pointed beard and bony fingers to the feet with their upturned, pointed shoes. The woman's body in the sculpture of "Le Fardeau," on the other hand, is poorly articulated. There is no

40. Le Fardeau (The Heavy Burden)

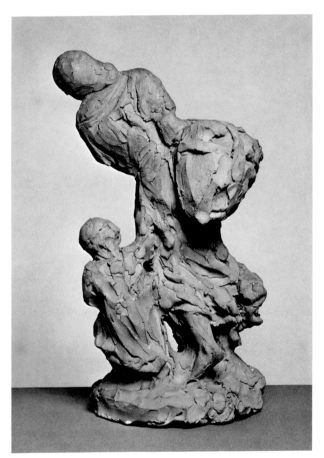

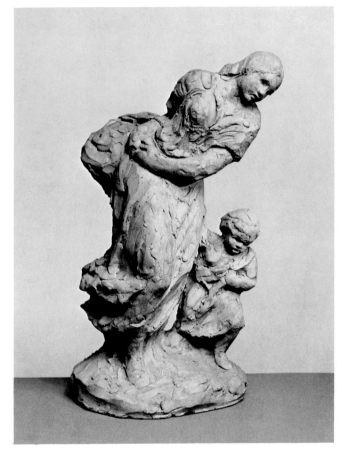

40a.

40b. LE FARDEAU (Maison no. I-85)
 Painting, oil on panel; 400 x 300 mm.
 Signed lower left corner: h. Daumier
 Provenance: Camentron
 Sir William Burrell
 Glasgow Art Gallery and Museum, Burrell Collection,
 acquired 1944
 (not in exhibition)

40c. LE FARDEAU (Maison no. I-121)
 Painting on canvas; 1470 x 950 mm.
 Signed lower right corner: h. D.
 Provenance: Alexandre
 Hertz
 Madame Boulanger
 Benatov
 Private Collection, Paris
 (not in exhibition)

40a. LE FARDEAU
 Terra cotta, unpainted; h. 13⅜″ (340 mm.)
 No casts
 Markings: rear of base: h.D.
 Provenance: Pierre Cloix, Paris
 Paul Rosenberg, Paris, 1911-1948
 Walters Art Gallery, Baltimore, acquired 1948

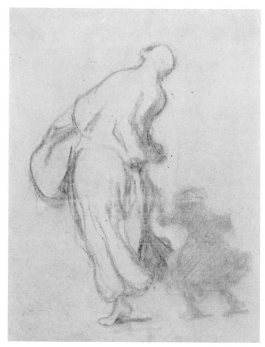

40d.

40d. FEMME ET ENFANT (Woman and Child) Maison
no. 236
Drawing, charcoal; 292 x 229 mm.
Unsigned
Provenance: Egisto Fabbri, Florence
Carstairs Gallery, New York
R. S. Davies
Collection Mr. and Mrs. Lester Francis Avnet,
New York

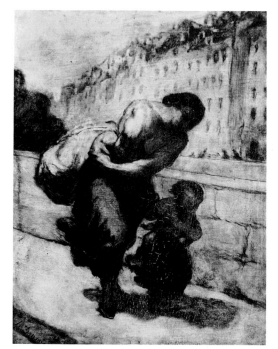

40b.

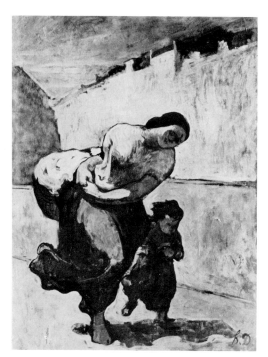

40c.

hip bone, no sense of leg beneath the skirt. The breast is drawn with lines rather than modelled, the pelvic region is amorphous and the right foot, seen from the front, barely exists, while the left foot, lifted behind, is unaccountably twisted. Most curious of all, the right leg, below the knee, is foreshortened just as it appears in the paintings, as though the artist, copying a painting in order to conceive the sculpture, transferred this two-dimensional device to his three-dimensional interpretation.

In describing the Walters terra cotta, Marceau and Rosen write that the "clay has been manipulated quickly to establish the main forms and movements of the figures, and then left without any attempt at smoothing or finishing the surface. The figure must have been fired immediately, for the edges are sharp and crisp and there are no damages. The initials H.D. were incised on the base, toward the back, before firing." To this very accurate description one can add that much of the rough surface treatment is meaningless — it has no organic relation to the main composition — particularly in the back where the figures of both the woman and the child are scarcely defined. It is almost as if the backs of the figures, which are not shown in the paintings, were left unfinished.

In addition, the modelling of the "Fardeau" is quick, sketchy and loose; it is very different from the tight modelling technique evident in Daumier's documented sculpture. The surfaces of the busts, the "Ratapoil" and the "first" version of the "Emigrants" are heavily textured. This is accomplished largely by means of the frequent use of a combing tool, as if the tool were replacing a pen or crayon to indicate shading by means of parallel lines. "Le Fardeau," on the other hand, is mostly formed by quick finger manipulation, with occasional use of a blunt tool for outlining such areas as the woman's breast and the back of her arm, where it touches her body. In this respect the modelling of "Le Fardeau" anticipates the group of smaller terra-cotta figurines that were discovered and attributed to Daumier several years later (see cat. nos. 44-64). Also to be compared with the figurines are the faces of the terra-cotta washerwoman and her child. They

are soft, round, and much too pretty. Nowhere in Daumier's pictorial oeuvre — paintings, drawings or prints — are faces to be found so stereotyped and sweet. Certainly such faces do not appear in any of the paintings of "Le Fardeau."

In the volume of his catalogue raisonné devoted to Daumier's drawings, Maison includes five sketches related to the paintings of "Le Fardeau" (Maison II, nos. 228, 229, 234, 235, 236). The charcoal drawing illustrated here (cat. no. 40d), shows the laundress and her child from the back. With great economy, the principal elements of the paintings are suggested. Here is the same figure of a robust woman — the same child clutching at her skirt and struggling to keep up with her mother's long strides. As in the paintings, there is a massing of the forms of the hip and the bundle to balance the twist of the torso. There is a strong feeling of the body beneath the clothing. The fluttering folds of the woman's blouse and skirt, pushed behind her by the wind, recall the scalloped outline of "Ratapoil's" coat. Rapid sketch that it is, the drawing suggests two-dimensionally the power and monumentality of the paintings in economical terms. Although the sculpture also is meant to function as a rapid study, its forms are ambiguous, lacking both power and a sense of anatomical structure. Seen from the back, the sculpture is busy rather than economical, but there is nothing there. And Daumier's theme, the unseen hostile wind, against which the figures struggle and with which he was so preoccupied in the paintings, comes through in the drawing but is entirely missing from the sculpture. In the paintings, the woman rushes against the wind; in the drawing she hurries; but in the sculpture she hardly moves at all.

J.L.W.

HISTORY

1927 Fuchs, No. 174a: "Frau mit Kind" (ILLUSTRATED)
1948 Marceau and Rosen, 76-82 (ILLUSTRATED)
1949 Seymour, 43 (ILLUSTRATED)
1952 Gobin, No. 62 (ILLUSTRATED)
1954 Adhémar, Pl. 53 (ILLUSTRATED)
1965 Escholier, 197 (ILLUSTRATED)
 Rey, Pl. 54 (ILLUSTRATED)
1966 Larkin, 61 (ILLUSTRATED)
1967 Licht, Pl. 78 (ILLUSTRATED)

41. Le Pitre Aboyeur
(The Barker)

Gobin No. 60

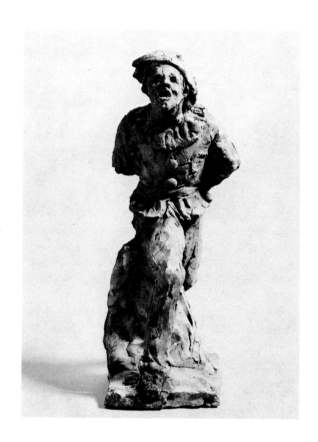

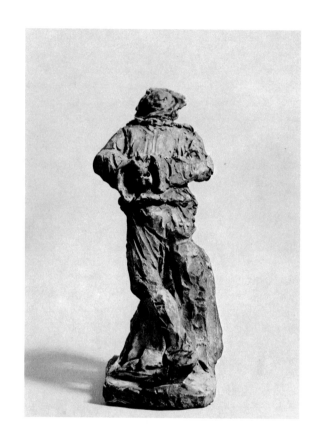

41a.

41a. LE PITRE ABOYEUR
Terra cotta; h. 10-7/32″ (260 mm.)
No casts
Musée Magnin, Dijon
(not in exhibition)

In the Musée Magnin in Dijon, there is a terra-cotta statuette about ten inches high, called "Le Pitre Aboyeur" and attributed to Daumier. The sculpture itself bears no signature or identification mark of any kind, but a piece of paper is pasted underneath on which the following is hand-written: "At the Fair — The Buffoon Barking — a study by Daumier — 1850 — Given by him." There is, in addition, a tag reading "E. C. Caze, Paris." Like all the sculptures attributed posthumously to Daumier, the origin of this terra cotta remains a mystery, but unlike many of them, the "Pitre" has a fairly early history.

It was already part of the Magnin collection in 1922, for it is illustrated and described (no. 683) in the catalogue of the collection prepared by Jeanne Magnin and entitled *Un Cabinet d'Amateur Parisien en 1922.* Unfortunately Mlle. Magnin revealed nothing of its provenance, but merely quoted the label pasted on the bottom. The question of to whom the sculpture was given by Daumier remains unanswered. We know that Maurice Magnin and his sister Jeanne were avid collectors at the turn of the century and that theirs is an intimate collection reflecting their personal taste. In his article on the Magnin Museum in Dijon that appeared in *L'Oeil* in March 1966 (p. 18), Jacques Thuillier writes: "The almost 2000 paintings and drawings that they assembled were almost all found in Paris, by chance, at small sales without catalogues, more by means of science and flair than by money. They even limited themselves not to exceed the sum of 300 francs . . ."

Anxious to keep their collection intact, the Magnins installed it in the charming 17th century town house they owned in Dijon, which was inaugurated as the Musée Magnin on January 16, 1938. The "Pitre Aboyeur" has been there ever since, and no bronze edition of it has ever been made. It has been exhibited elsewhere only once, at the *Exposition Louis-Philippe* held at the Hôtel Jean Charpentier in Paris in 1926 where it appeared as no. 609 of the catalogue with the title "Le Pitre à la Parade." Under the terms of the Magnin bequest, the objects in the Musée Magnin cannot be loaned.

In 1927 Eduard Fuchs included the terra cotta (pl. 174b) in *Der Maler Daumier* and wrote (p. 24)

that, in searching for unknown sculpture by Daumier, he had recently succeeded in finding two more — "Le Pitre Aboyeur" and "Le Fardeau." Fuchs dated the sculpture 1850 based on the paper pasted on the bottom, as did Gobin in his catalogue raisonné of 1952. Gobin comments on Daumier's habit of giving his sculptures away as gifts to his friends, a fortunate occurrence which, Gobin believes, in many cases saved them from ruin. Gobin has difficulty fitting the "Pitre" into his theory that Daumier's sculpture always preceded and inspired later lithographs, drawings or paintings. Unable to find the specific subject in the graphic work, Gobin resorts to several unconvincing comparisons based on lithographic figures that have movements or gestures vaguely similar to the "Pitre" but are completely different in character and subject.

Although Gobin does not mention it, there is a drawing reproduced by Escholier in 1934 as "L'Alarme" (cat. no. 41b) that somewhat suggests the "Pitre" in attitude, facial expression and perhaps costume. The drawing is reproduced also by Maison (II, no. 709, pl. 278) with the title "Cri d'alarme sur la Grève" and the comment that its present location is unknown and that the subject is unexplained, although there is some validity to Adhémar's suggestion that it represents a Scapin imploring his master not to beat him. Certainly Daumier made many drawings and paintings of clowns, buffoons and street performers, but except for the tenuous resemblance to the figure in "L'Alarme," the sculpture shows no relationship to any of these.

It has not been possible to study "Le Pitre Aboyeur" under laboratory conditions, and therefore it is difficult to evaluate the attribution to Daumier. The terra cotta is for the most part a dark reddish brown in color with mottled areas that have a creamy white appearance. Except for a mend where the head, having broken off a few years ago, has been re-attached, the condition is good, indicating that the clay was baked shortly after it was modelled. In lieu of an armature for support, the sculptor resorted to a lump of clay placed between the widespread legs. In spite of this rather awkward device, and poor articulation where the legs join the body,

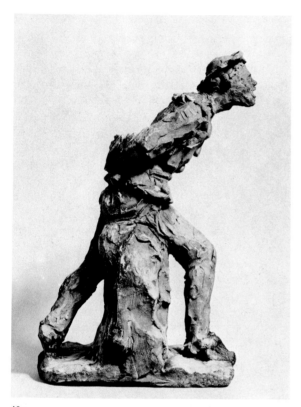

40a.

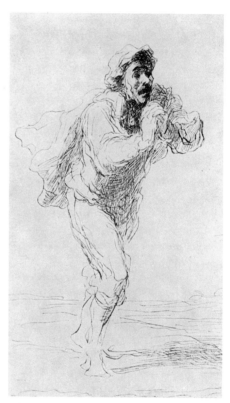

40b.

41b. L'ALARME (Maison no. 709)
Drawing, pen and ink; 190 x 120 mm.
Initialed
Provenance: Vial
 Bernheim Jeune
Present location unknown
(Photograph from Escholier, 1934, p. 93)

41. Le Pitre Aboyeur (The Barker)

the figure conveys movement and action and is modelled in a compact and consistent manner. The torso is rather flat compared to the striding legs; the hands behind the back and the feet are scarcely expressed, whereas the buttons and the ruffled collar of the buffoon's costume are carefully detailed. In this respect "Le Pitre" brings to mind several of the smaller terra-cotta figurines (see cat. nos. 44-64) that were discovered and attributed to Daumier somewhat later and published by Gobin. Many of these are also modelled with attention to details of clothing and sketchy treatment of hands and feet, as well as the use of a columnar lump of clay for support.

In scale, the "Pitre" can be compared to "Le Fardeau" (cat. no. 40); they both fall between the busts and the "Ratapoil" in size. The modelling, however, is quite different. The "Pitre" was modelled with frequent use of a tool — not the raking tool that Daumier used in modelling the busts and the "Ratapoil" — but a blunt tool that dented the clay with parallel marks to indicate fabric folds in the trouser legs and the ruffles of the collar. "Le Fardeau," on the other hand, was built up by hand with pellets of clay, with tool marks showing only on the upper part of the body.

"Le Pitre" was not at once accepted by the experts as the work of Daumier, according to Raymond Escholier who wrote in 1965 (p. 192), "I remember the time when M. Magnin, Referendary to the Audit Bureau, and his sister, Mlle. Magnin, submitted to the judgement of several museum curators, among whom were Paul Vitry, Gaston Brière, Jean Guiffrey, Paul Jamot . . . and Raymond Escholier, this 'Pitre Aboyeur' attributed to Daumier. Everyone seemed surprised and kept silent." Mr. Escholier for one appears to have changed his opinion, perhaps since the publication of Gobin's book, for he adds, "About his work as a sculptor, one knew so little at that time."

Unfortunately our knowledge of Daumier sculpture is still so limited that conclusions cannot yet be drawn about the authorship of "Le Pitre Aboyeur." It does not appear to relate very strongly to Daumier's graphic work, drawings or paintings, nor does it resemble to any marked degree other sculptures attributed to Daumier, whether documented or not. One might well ask then, as in the case of the two little clay busts in the Glyptotek (see cat. nos. 65 and 66), whether this could not be a legitimate work of another artist working independently, and mistakenly attributed to Daumier.

J.L.W.

HISTORY

1922 Magnin, No. 683 (ILLUSTRATED)
1926 Hôtel Jean Charpentier, Paris, No. 609
1927 Fuchs, 24; No. 174b (ILLUSTRATED)
1952 Gobin, No. 60 (ILLUSTRATED)
1965 Escholier, 192
1966 Thuillier, 18
1968 Kaposy, 256 (ILLUSTRATED)

42. Portrait of Daumier
(so-called "Self Portrait")

Gobin No. 63

This work was first attributed to Daumier by Gobin in 1952. In his catalogue Gobin illustrated the plaster and identified it as a portrait of Daumier by himself. He gave no provenance for the plaster, which was at that time in the collection of Maurice Loncle. To justify his attribution, Gobin compared the plaster to the photograph of Daumier by Laisné, of about 1855, and mentioned the plaster medallion of Daumier by Michel Pascal made about 1830. His other references were a description of Daumier by Théodore de Banville, and two quotations which appear to refer to the plaster portrait, by Robert Nanteuil and Elie Faure (see below).

In 1956 the work was cast in bronze (according to the Bibliothèque Nationale catalogue, 1958, no. 192). This edition was made by Valsuani, and included twelve numbered casts plus five trial proofs. The owner was still Maurice Loncle. One of these bronzes, cast number E3, is included in this exhibition (cat. no. 42b). Subsequently, the plaster was acquired by René Gaston-Dreyfus from whose collection it passed in the 1966 Palais Galliera auction (Palais Galliera, Frontispiece), to Count Borletti di Arosio of Milan. The Count died in 1967; the plaster portrait is now in a private Milanese collection. It could not be included in this exhibition as it cannot leave Italy.

Besides the obvious question of where this large bust had been before 1952, it does not seem out of line to ask if it is indeed a self portrait, and furthermore, how was it made? Certainly, it "looks like" Daumier, that is, like other portraits of Daumier, in

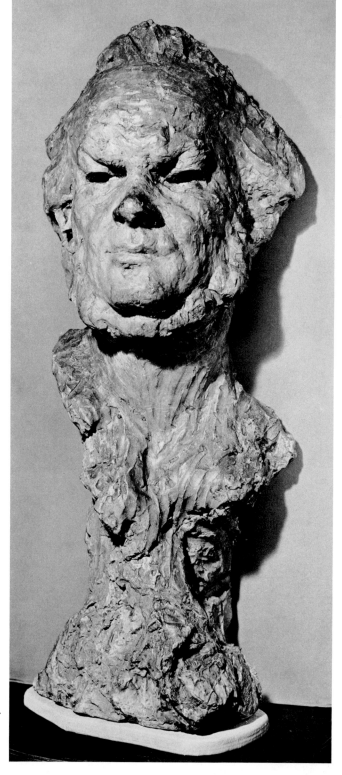

42a. PORTRAIT OF DAUMIER
 Plaster, coated; h. 28⅜" (720 mm.)
 Bronze edition of 12 plus 5 proofs cast by Valsuani
 1956
 Provenance: Maurice Loncle
 René Gaston-Dreyfus, acquired about 1961
 Count Aldo Borletti di Arosio 1966-67
 Private Collection, Milan
 (not in exhibition)

42a.

42. Portrait of Daumier (so-called "Self Portrait")

his middle years. One may compare the Carjat photograph of Daumier taken in 1861 when Daumier was fifty-three (see page 2). But surely this is not a very strong argument for claiming the bust as a self portrait. Gobin's references (p. 63) are not very satisfactory either. He claimed that Nanteuil called it "a veritable resemblance," but gives no source for this remark. He repeated how much it looked like Daumier. Then he wrote: "and the work justifies these lines of Elie Faure: 'When one has that fine forehead, those piercing eyes, that valiant mouth, that large Rabelaisian face, when one models form as one wishes with that good thumb, one is aware that one is king.'" (from Faure, *Histoire de l'Art*, 1924, p. 332). If the reader turns to Faure, however, it becomes quite clear that his remarks, which, taken out of context seem to refer to a self portrait, actually refer to Daumier's appearance, and to his sculpting ability in general.

The authors of this catalogue have combed the sources on Daumier before Gobin for a reference to a sculpted self portrait, and found nothing. (There appear to be one or two self portraits among the lithographs.) If Champfleury, Duranty, Claretie, Baudelaire, etc. knew of such a work, they avoided mentioning it. If for some reason Daumier hid it in his lifetime, his widow, who survived him for sixteen years (to 1895), did not make it known to Alexandre, Dayot, Geffroy, and so on. In fact, Champfleury in 1865 and Alexandre in 1888 drew up lists of portraits of Daumier, and neglected to mention a sculpted self portrait (Champfleury, *Histoire Caricature*, pp. 62-66; Alexandre, p. 380. Champfleury's sale in 1891 included eleven portraits of Daumier, none by himself, no. 111).

Concerning medium, the bust appears to be plaster, cast from a previous medium, perhaps clay. The plaster is of only the front half of the head, concave at the back (the heads of the bronzes have been rounded out somewhat so that they are convex behind). At the base and along the edges of the plaster may be seen burlap rags, which were worked into the wet plaster shell, probably over an armature, to add strength. The plaster is a uniform grayish color, covered with a transparent protective coating.

Stylistically, also, it is possible to question if the work is from Daumier's hand. One aspect of the bust alone makes it seem greatly different from other sculpture associated with Daumier, and that is its size. Not only is it larger by half than any of the other sculptures, it seems actually conceived as a large-scale object. The features are just over life-size, and are startlingly bold, almost gigantic. This is difficult to reconcile with the many descriptions of the modest Daumier. The artist of this portrait used large physical scale to add to the impressiveness of the personality represented. Conversely, in his thirty-six busts, or "Ratapoil," or the "Refugees," Daumier was able to derive an amazing expressive power from very small objects. Each parliamentarian fits into a man's hand. "Ratapoil," a full-length figure, is less than half the size of this portrait. The portrait, when seen with other Daumier sculpture, seems stretched a little beyond its proper dimensions. There are no signs of use of the comb-tool (found on the busts, "Ratapoil," and the smaller "Refugees"); even the hair and fringe of beard are treated as broad, flat planes. Below the neck there is no clothing, nor is the neck made with Daumier's characteristic fondness for and skill in surface details. The joinings of head to neck and neck to base are unclear, hastily rubbed over with long, meaningless finger-marks. Had the artist stopped at the base of the V below the throat, about one-quarter of the way from the bottom, the portrait might have better proportions. As it is, this bottom quarter is merely a pile of meaningless plaster. At the age that he appears in this bust Daumier had made "Ratapoil," in which no portion of the anatomy was ignored or blurred over, in which even small details such as the mustache, nape of neck, or toes of boots are salient, and in which the back of the figure is as fully mastered as the front.

There is a certain similarity between this portrait and Daumier's "Delort" (cat. no. 7). But this is not much more than a similarity of facial types, of broad-faced men with tufts of hair and beard framing the entire face, rather than in handling of the medium. On the other hand, there is in the eyes an important difference between the portrait and Dau-

mier's busts or "Ratapoil." The eyes in the portrait of Daumier are empty sockets, deeply hollowed out behind the thick (⅛") projecting lids. Within this hollow there is simply smooth plaster. Daumier rarely hollowed out eyes to such an extent, preferring either to twist the eye socket itself to some amusing shape or position (Delessert, cat. no. 6 or Lecomte, cat. no. 21), or to place a small, flat, irregular button there for a pupil (Guizot, cat. no. 17 or Vatout, cat. no. 31), or to hood the eyes with baggy eyelids from under which peep small holes for pupils (Royer-Collard, cat. no. 29). In many photographs Dupin appears to have empty hollows in those deep eye sockets, but actually the clay shows small squinting eyelids with small holes for pupils (cat. no. 9).

One possibility is that the portrait of Daumier was made with the aid of a lifemask. Both the empty eye sockets and the fact that this is a plaster shell of the front half of the head prompt this consideration. Lifemasks were certainly common enough in Daumier's lifetime. In fact, Philippe Burty wrote in 1863 that "casting faces (*moulé le visage*) was at that time the fad of Meissonier, Steinheil, and Geoffroy [Dechaume]" (in *Croquis d'Après Nature*, 1892, p. 22. See p. 16 for reference to Geoffroy-Dechaume). The two latter were of course two of Daumier's sculptor friends from the 1850's and after; Geoffroy-Dechaume is supposed to have made the plasters of "Ratapoil" and the "Refugees." Daumier himself commented upon the process of casting lifemasks in a lithograph of 1852 (see cat. no. 42d).

Now, if this bust is based upon a lifemask of Daumier (and only laboratory study could answer this question), did Daumier then add the hair and beard and set the face upon the base? Possibly. But the working of the plaster still seems to suggest otherwise. The pushings and slappings of the plaster seem to come from the shoulder and palm rather than from the artist's wrist and thumb, as in "Ratapoil," for example. This sense of exhuberant motion is more suggestive of sculpture of a later era, that of Rodin and Bourdelle. The latter, in fact, did a posthumous bust of Daumier not unlike this one (in Musée du Vieux-Marseille; see *Arts et Livres de Provence*, 1948, Frontispiece).

Perhaps strong consideration should be given to the words of Champfleury as he listed portraits of Daumier. He mentioned that Daumier appealed to sculptors because of the sculptural quality of his work, then listed: the medallion of Daumier by Michel Pascal, made when Daumier was clearly a young man (illustrated Gobin, *Appendice* B); he quoted Baudelaire's four-stanza poem "Honoré Daumier"; mentioned Banville's description in an *"ode funambulesque"*; listed two caricature portraits, a lithograph by Benjamin Roubaud and a photograph by Carjat made in 1861 (cat. no. 42c); and most interesting, described "a bust of Daumier by Mr. Carrier-Belleuse which unfortunately with his qualities also bears his faults of 'fa presto' [working quickly, or too quickly]" (*Histoire Caricature*, pp. 60-66).

Albert Ernest Carrier-Belleuse (1824-87) was a sculptor of enormous output who made figural groups, busts of living persons (Delacroix, Gautier, Thiers, etc.), historical portraits, and the like. He is said to have worked in Daumier's studio as a young man; later on he was Rodin's instructor. Daumier drew his portrait in 1863, showing the busy sculptor at work on two busts at once (cat. no. 42e). In this century Carrier-Belleuse's work has suffered such an eclipse that it is almost impossible to locate, and must exist unlabelled on basement shelves. Could not his bust of Daumier have also lost its identity, until someone noticed the resemblance to Daumier (the features are very like those in Adolphe Geoffroy-Dechaume's more idealized memorial bust at Valmondois; see Gobin, *Appendice fin*), and in trying to discover the author, decided on Daumier himself?

In any case, a much more thorough study of this piece should be made before it can simply be accepted as a portrait of Daumier by his own hand.

J.M.L.

42. Portrait of Daumier (so-called "Self Portrait")

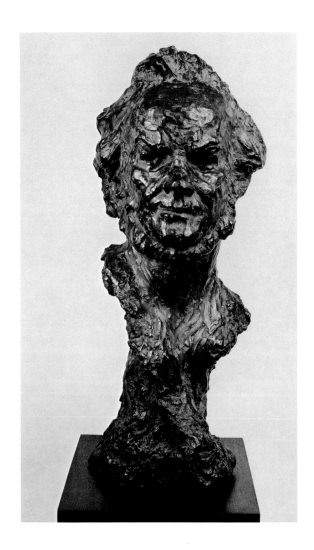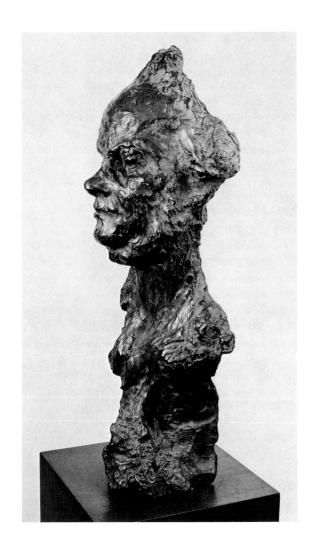

42b. PORTRAIT OF DAUMIER
Cast bronze; h. 28⅜″ (720 mm.)
Markings: lower right rear: Valsuani stamp, E3
Private Collection

1952 Gobin, 62-64; No. 63 (plaster, ILLUSTRATED)

1954 Adhémar, Pl. 84: says it is contemporary with Nadar's photo (plaster, ILLUSTRATED)

1957 Galerie Sagot-Le Garrec, Paris, No. 63a (plaster, ILLUSTRATED) ; No. 63b (bronze)

1958 Bibliothèque Nationale, Paris, XXVII; No. 192 (bronze, ILLUSTRATED)
Museo de Bellas Artes, Buenos Aires, No. 281 (bronze)

1959 Rey, Pl. I: "plaster" (actually bronze, ILLUSTRATED)

1961 Museo Poldi Pezzoli, Milan, 1; No. 1 (bronze, ILLUSTRATED)
Musée Cognacq-Jay, Paris, No. 345 (bronze) ; No. 347 (plaster)

1965 Escholier, 197 (wrote that a Museums of France meeting accepted it); 187 (plaster, ILLUSTRATED)

1966 Palais Galliera, Paris, Frontispiece (plaster, ILLUSTRATED) ; No. 49 (bronze)

1967 Licht, 84 (bronze, ILLUSTRATED)

1968 Château de Blois, No. 499 (bronze)

42d.

42c. (see p. 2)

42d. L'ARTISTE — VOILA QUI EST TERMINE! . . .
(Artist — "It is finished! . . .") L.D. 2290
Lithograph, second state, white paper; 237 x 213 mm.
Charivari, April 20, 1852
Boston Public Library

42e. A. CARRIER-BELLEUSE L.D. 3254
Lithograph, second state; 367 x 282 mm.
Le Boulevard, May 24, 1863
Museum of Fine Arts, Boston

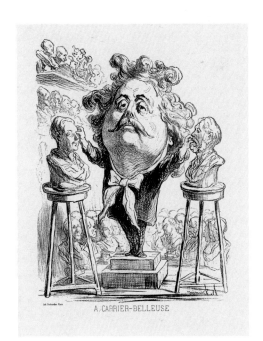

42e.

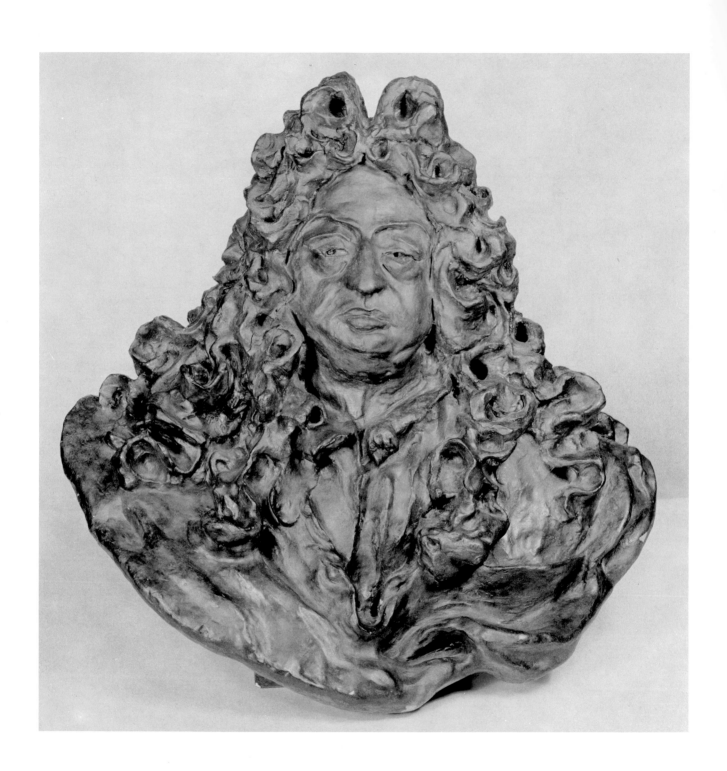

43a. LOUIS XIV
 Unbaked clay with colored coating; h. 18″ (457 mm.)
 Markings: left shoulder, rear: N, Daumier
 Provenance: Alexis Rudier, Paris
 Wildenstein & Co., Inc., New York
 (not in exhibition)

43. Louis XIV or "L'Homme à Large Perruque"
(Man in a Large Wig)

Gobin No. 59

The many problems associated with the portrait bust known as "Louis XIV" could not be solved before publication of this catalogue. Time has not permitted us to find the information necessary to fill the gaps in its history nor to shed further light on the sculpture itself through laboratory study and visual comparisons. We know "Louis XIV" only from an apparent clay original belonging to Wildenstein & Co., Inc., and the bronze edition cast by the Valsuani Foundry within the past ten years. Although the clay is too fragile to travel, a bronze Valsuani cast is included in this exhibition (cat. no. 43c). Missing links between these objects include a plaster, which we have been unable to locate, and at least two earlier bronzes.

In the catalogue prepared by Alfred Barr for the *Corot-Daumier* exhibition at the Museum of Modern Art in 1930, a bronze bust (no. 149; p. 18) loaned by the Balzac Galleries is listed with the comment: "The problematical bust of Louis XIV is exhibited here for the first time in America because its attribution to Daumier seems sound and because it is a work of extraordinary pungency." A note adds that "the original terra cotta of this bronze bust was recently discovered in a Jesuit church in Paris. It is attributed to Daumier entirely upon stylistic grounds." We are indebted to Mrs. Elizabeth Shaw, Director of Public Information at the Museum of Modern Art, for searching the Museum's files where she found the hand-written note: "Passy Ecole des Frères, near Balzac's house, a Jesuit school, demolished about 1905. Discovered by _____. Sold to Rudier." This reference presumably indicates the Wildenstein clay bust, for it was acquired from Rudier around 1959.

Gobin never saw the clay, but wrote that he had heard of the existence of a "clay or wax" from reliable sources, and knew the work only by several casts, one in plaster and two in bronze (p. 288). However, he illustrated both a clay and a plaster, but evidently confused the two. His photograph with the caption "modelled in clay" (p. 289) is identical to the one reproduced here (cat. no. 43b), which was given to the Museum of Modern Art by Curt Valentin and confusingly labeled "Louis XIV,

bronze and marble, attributed to Daumier, Chez. M. Krueman, New York." The air pockets along the edges of the wig curls, clearly shown in the photograph, are characteristic of a poured plaster cast. We have been unable to locate M. Krueman and consequently have not been able to trace the plaster. We know only that a plaster was exhibited by the Galerie Sagot-Le Garrec in Paris in 1957 (*Daumier Sculpteur*, no. 59) and that, according to Marcel Lecomte, a plaster owned by Maurice Loncle served for the Valsuani bronze edition made in the late 1950's or early 1960's. (Casts of this edition of eight bronzes plus two trial proofs have appeared in the Gaston-Dreyfus sale at Palais Galliera, June 1966, the Hôtel Drouot sale of December 1966, and the Daumier exhibition at the Château de Blois, 1968.) We cannot determine, however, whether the Krueman-Gobin plaster is the same as the one exhibited in 1957, nor do we know what plaster was used for the Valsuani edition. Furthermore, we have no way of knowing whether the Wildenstein clay was used to make one or more plasters.

A comparison of the photographs of the Wildenstein clay, the early plaster and the Valsuani bronze reveals interesting differences, notably in the area of the right side of Louis' garments. Folds of his robe below the collar are missing in the clay, but exist in both the plaster and the bronze. If the plaster were made from this clay, the clay has since been considerably restored. The bronze, on the other hand, was probably made from this plaster or one also made before restoration of the clay.

Since it was not possible to transport the Wildenstein bust to a laboratory at this time, we had to limit our observations to a simple visual inspection in New York. It appears to be made of an unfired, light-gray clay and coated with a shellac-like substance containing brown pigmentation. The pedestal appears to be plaster, and there are evidences of repairs, perhaps also made of plaster. Unfortunately the thick coating makes it difficult to determine the exact location and extent of these repairs, but it is probable that they were necessary along the front bottom edge where handling would have caused the clay to crumble. This would explain the differences

43. Louis XIV or "L'Homme a Large Perruque"
(Man in a Large Wig)

in treatment of this area between the clay on the one hand, and the plaster and bronze. The clay has a curious signature on the lower part of the left shoulder which reads "Daumier" with the letter "N" above it. The thick coating, however, again makes it difficult to determine if the signature was applied at the time the bust was made.

In spite of these restorations and changes, the Wildenstein clay is an impressive object, a portrait of imposing presence, handled with great skill. The haughty yet disillusioned expression on the face of the subject is achieved with great economy — by means of such touches as the supercilious lift of the right eyebrow, the pouches beneath the eyes, the downward curve of the upper lip. The smooth modelling of the face is contrasted with the deep convolutions of the curled wig and the exuberant swirls of the drapery. The control and mastery of the sculptured medium denote the hand of a master, but is it the hand of Daumier? Certainly the deep undercutting in the curls and the drapery, like the "Ratapoil," imply a lack of concern with the problems involved in casting. The difficulty of making a mold from this sculpture is seen in the loss of subtle details of expression in the bronze cast. However, the textured surfaces achieved with a comb tool, which are so typical of Daumier's caricature busts, "Ratapoil" and the "Emigrants" are entirely missing. Although the brown coating could conceivably obscure some of the surface detail, it should be pointed out that comb marks are clearly evident on the caricature busts, which also have been heavily restored and repainted.

The subject of Louis XIV is not without precedent in Daumier's work. His interest in the theater, particularly that of Molière, may have been part of a wider interest in the 17th century. In 1839, he made at least two illustrations for the Comte de Laborde's book, *Versailles ancien et moderne* (Bouvy nos. 312 and 313), and therefore his familiarity with the 17th century works of the château is highly probable. Furthermore, representations of figures in 17th century dress were not uncommon in his graphic work. Two drawings (Maison nos. 445 and 479) show his interest in the treatment of the late 17th century wig

(see cat. no. 43e). Daumier portrayed Louis XIV himself in two lithographs (L.D. 3875 and 3897), one of which shows the old king in profile (see cat. no. 43f).

Unidealized portraits of Louis XIV are extremely rare, especially in sculpture. In marble, only the bust by Girardon in the Musée de Troyes shows the fleshy neck and slightly protruding lower jaw portrayed in the Wildenstein clay. Gobin has suggested (p. 59) that Daumier may have seen a wax relief of the aged Louis XIV by Antoine Benoist which had been exhibited in the King's bedchamber at Versailles since about 1856. Its profile view comes closest of all to the sculpture known as "Louis XIV" or "L'Homme à Large Perruque" (see cat. no. 43d).

Although the attribution of this bust to Daumier cannot be rejected on the basis of subject matter, the modelling technique appears quite different from that of the caricature busts, the "Ratapoil" and "Les Emigrants." It is more carefully modelled, and the facial features are more subtly expressed. It is a more finished and sophisticated piece of sculpture. These differences could be accounted for by the larger scale of "Louis XIV" — more than twice the height of the largest caricature bust — and almost monumental in scale compared to "Ratapoil" and "Emigrants." A final judgement on the attribution cannot be made, however, until further study is possible, both of the history and of the clay and plaster versions of the sculpture itself.

J.L.W.

HISTORY

1930 MOMA, New York, No. 149 (bronze)
1952 Gobin, 288; 289 (plaster, ILLUSTRATED); 291 (unbaked clay, ILLUSTRATED)
1957 Galerie Sagot-Le Garrec, Paris, No. 59 (plaster)
1965 Escholier, 196
1966 Palais Galliera, Paris, No. 47 (bronze, ILLUSTRATED)
 Hôtel Drouot, Paris, No. 18 (bronze, ILLUSTRATED)
1968 Château de Blois, No. 497 (bronze)

Introduction to the Figurines

The group known as the "figurines" presents one of the most difficult problems associated with Daumier's sculpture. First published in 1952 in Maurice Gobin's catalogue raisonné of Daumier sculpture, the origin of these small terra-cotta figures remains a mystery to this day. Although opinion among the experts is divided, few have committed to paper their doubts about this attribution to Daumier. However, in 1968, in the introduction to Volume I of his *Catalogue Raisonné of the Paintings, Watercolors and Drawings* (note 40, p. 36), K. E. Maison wrote: "In spite of the good quality of some of the Gobin figurines, I cannot believe that the sculptor of the ingenious and powerful little 'Deputés' busts could, between 1840 and 1862, have been responsible for these figurines which at best are no more than superior bric-à-brac. It seems impossible to accept that the 'Ratapoil' and especially the 'Emigrants' are by the same hand and stem from the same mind as the figurines from the Gobin Collection."

It is interesting to note that the figurines were not included in the 1961 exhibition, *Daumier Scultore*, held at the Museo Poldi Pezzoli in Milan, although they were then part of the collection of Daumier bronzes owned by Count Aldo Borletti di Arosio, which was shown. Dario Durbé, who wrote the catalogue of the exhibition, comments that he and other members of the Exhibition Committee, particularly Franco Russoli, Lamberto Vitali and Count Borletti, studied the figurines intensively and decided to omit them from the exhibition. Lacking positive documentation, they concluded from stylistic evidence that the figurines could not be by an artist of Daumier's level.

Although not published until 1952, there is evidence that at least several of the figurines were known in the 1930's. The two terra cottas in the David-Weill collection were acquired in 1933, and in 1936 two bronzes, which Gobin identifies as trial proofs of "L'Homme d'Affaires" (cat. no. 53) and "Le Dandy" (cat. no. 52), were exhibited at the Albertina in Vienna. Gobin also indicates that E. Fuchs was studying a bronze cast of "L'Avocat Saluant" (cat. no. 46) around 1932, or twenty years before the publication of his book. Claude Roger-Marx in an introduction to the catalogue of the Daumier exhibition held in 1934 at the Musée de L'Orangerie, refers to "some recent discoveries that will perhaps permit the enrichment of this sculptured work."

There is no mystery about the history of the bronze editions of the figurines. Cast by the lost-wax method, in editions of thirty plus three or four justified trial proofs, the bronzes are all numbered and stamped with the seal of the Valsuani foundry in Paris. According to Mr. Tamburro, director of the foundry, the figurine editions have been in process since the 1930's, and the most recent, three figurines discovered since Gobin's catalogue appeared, were cast in 1965.

It is the provenance of the terra cottas from which the bronze editions were made, however, that remains in question. In his book *Daumier et Son Monde* published in 1965, Raymond Escholier states that to Maurice Gobin "will go the honor of having rediscovered a large number of figurines modelled in clay by the son of the glazier poet." Gobin himself probably owned twelve of the nineteen terra-cotta figurines he presents in his book. They are now in a private collection in Paris. Two, already mentioned, have remained in the David-Weill collection and have never been cast. Another, "The Valet de Chambre" (Gobin no. 43) is described by Gobin, who had no photograph of it and assumed that the terra cotta had been lost in the exodus of 1940. No trace of it has been found. Of the remaining four, "Le Lecteur" (cat. no. 54a) and "Le Monsieur Qui Ricane" (cat. no. 55a) belong to Marcel Lecomte, "L'Avocat Saluant" (cat. no. 46a) has been broken and lost, and the whereabouts of "Le Dandy" is unknown.

Gobin argues that the figurines were modelled by Daumier as reminders of people and scenes he had observed and then used by him as "modèles évocateurs," inspiring later a lithograph, wood engraving, watercolor or painting. He envisions Daumier, in need of a subject for a lithograph, allowing his eye to range over the host of little statuettes he has created. Seizing an expression or gesture from one or another, he is thus inspired by it to create a whole new situation in which the sculptured image is transformed by the imagination of the lithographer. In every instance, however, Gobin finds the sculpture superior, "more sincere and spontaneous, stronger, and at the same time finer and more penetrating" than the lithograph.

If one accepts Gobin's theory that the figurines were created by Daumier to be used as models for drawings and graphics, one could logically expect

to find them portrayed in the two-dimensional works in a variety of contexts. This is so in the case of the political caricature busts, and of Ratapoil. Similarly, one would be justified in expecting to find that the personality captured within the sculptured figure is carried over into the graphics. Again, in the case of the busts and Ratapoil the individual eccentricities and the particular personality of each are preserved in their essentials regardless of the context in which they appear in the various lithographs. D'Argout with his huge nose remains d'Argout; Guizot, sad and resigned remains Guizot, although the politics in which he plays a rôle change over a period of almost twenty years. So, too, "Ratapoil" remains "Ratapoil" whether he is begging contributions door to door for the cause of Napoleon III in 1850 or twenty years later, older, but devious as ever, he is found offering his services to a disdainful lady representing the Republic.

There is no such consistency when the figurines appear on paper. Not only do their rôles change but their very personalities are transformed as they appear in one medium or the other. Thus the terra cotta "Business Man" is seen as the "Officious Public Defender" in the wood engraving (see cat. nos. 53a and 53c), and the dreamy figurine called "The Lover" is recognized in a lithograph prosaically discussing politics with a friend (cat. nos. 45a and 45c).

There are other troublesome aspects in Gobin's comparisons of figurines and graphic subjects. When he identifies a particular figure as appearing in more than one lithograph, the sculpture is actually more like a pastiche than a source for the various persons represented on paper. It clearly appears to be a synthesis of the drawn characters rather than a model for them. For example, the terra cotta "Le Rodeur" combines the posture found in one lithograph with the subject matter of another (see cat. nos. 60a, 60c and 60d). For some figurines, such as "Le Bourgeois en Attente" (cat. no. 48), Gobin can find no counterpart in the graphics. As additional evidence against the "model" theory, when a sculptured figurine is identical in pose with a figure in the graphics, the side not revealed in the lithograph tends to be sketchy and ill conceived in the statuette. It is as though the principal view in the print served as the prototype for the three-dimensional object, with the consequent limitation on the self-sufficiency of the figure in the round. This is clearly demonstrated in such figurines as "Le Bon Vivant" (cat. no. 47) and "Le Représentant" (cat. no. 59) which are similar in frontal aspect to the lithograph but poorly articulated in the rear. Another example is "Le Visiteur" (cat. no. 61), where the left side of the

sculpture, the side drawn in the lithograph (cat. no. 61c) is more fully developed than the right side.

And finally, if the statuettes had served as models for the lithographs, one might logically expect, as a result of the printing process, that the pose in the lithograph would appear in reverse. This reversal does, in fact, take place with many of the busts. For example, Gaudry's head is tilted to the right in the sculpture and to the left in the lithograph (see cat. nos. 16b and 16c), whereas Guizot's head tilts toward his left shoulder in the sculpture and towards the right in the lithograph (see cat. nos. 17c and 17e). Here Daumier appears to have drawn the portrait directly on the lithographic stone, following the sculptured model, and the lithograph, therefore, shows the portrait in reverse. If, on the other hand, the terra-cotta figurines were copied from the lithographs, one would expect them to appear in the same direction, rather than reversed. This does appear to be the case wherever the same figure is evident in both a sculpture and a print. Thus we find the statuette of "L'Amateur d'Art" carrying a vase in his right hand and a picture in his left, exactly like the figure in the lithograph (see cat. nos. 44a and 44b). Again, the terra cotta "L'Amoureux" and his lithographic counterpart both carry their hats in their left hands (see cat. nos. 45a and 45c), while both versions of "Le Dandy" carry *their* hats in their *right* hands (cat. nos. 52a and 52c), indicating that the sculptures followed the prints.

Contemporary accounts stress Daumier's extraordinary visual memory and his skill in drawing on the lithographic stone. It is thus improbable that he needed to make little clay models from which to copy a face, costume or gesture. We can imagine him working in a tactile three-dimensional medium in order to conceive fully the personality and inherent qualities of the subjects he wished to create. This seems to be the case with the busts and "Ratapoil." A careful study of Daumier's large and varied graphic oeuvre does not support Gobin's theory that the figurines preceded and inspired the prints; nor can we accept his conclusion that they are superior as works of art. Quite the contrary, the strength, the power, the conviction are manifest in the lithographs. The terra-cotta and bronze figurines emerge as weak echoes, sweet and mannered. The powerful satire present in the prints has become quaintness, perceived through a veil of sentimentality and nostalgia. The figures are no longer of Daumier; they have become little characters from Daumier.

Gobin groups the figurines in three periods, based in part on the dates when the corresponding lithographs appeared and partly on a theory of stylistic

development. He places seven figurines (Gobin nos. 40-46) in the period from 1832-1845, the time of the lithographic series *Moeurs Conjugales, Emotions Parisiennes* and the *portraits charges*. He describes this group as modelled in a dark red terra cotta in a fine and incisive manner with youthful verve. He dates six statuettes (Gobin nos. 47-52) from 1845-52, describing them as light tile in color and modelled with greater freedom and more powerful movement, with the maturity evident in the "Ratapoil." He dates the final group of six (Gobin nos. 53-58) after 1852, finding in them a more sober and dense form, the apotheosis of Daumier's style, the period of the allegories.

Careful examination of the figurines undermines Gobin's theory of the three periods. They appear to be too stylistically similar to allow for development over a period of time. With the exception of the crudely executed "Le Monsieur Qui Ricane," and possibly the three figurines discovered after Gobin which, though similar in scale and spirit, seem to be made with greater concern for detail, they appear to be by a single hand. All of the figurines range in size from 5¾" to 7⅞". They are solidly built, made to stand without the use of an armature for support. Such handling implies an intent on the part of the sculptor to fire the clay almost immediately. The absence of cracks and general excellence of condition also indicate that the clay was fired soon after it was modelled. This was not the case with the caricature busts which were never fired at all, and which have greatly deteriorated over the years. The modelling technique, easy and assured, suggests the professional sculptor, one who is familiar with the techniques of casting in bronze, who therefore avoids deep undercuts and complicated surfaces, which are difficult to reproduce in molds. This is certainly not the case with the busts and the "Ratapoil" where the worried surfaces and deep undercutting imply an ignorance of or at least unconcern with the problem of casting in bronze. As a matter of fact, the clay "Ratapoil" was probably turned over by Daumier to his friend, the sculptor Victor Geoffroy-Dechaume, who made a plaster cast of it with such difficulty that the clay undoubtedly was destroyed in the process. This also was the fate of Daumier's two clay reliefs of "Les Emigrants" which exist now only in the plaster casts made in the 19th century and the bronze editions subsequently cast from the plasters.

Although some of the figurines are more successful than others, they have characteristics of style in common. Except for only a few, notably "Le Portier Parisien" (cat. no. 58), "Le Lecteur" (cat. no. 54) and "Le Rodeur" (cat. no. 60), the figurines are rather carefully detailed in front and scarcely articulated in back. In front, details of clothing are modelled — collars, vests, even buttons, whereas the backs are curiously flat, with in most cases, the legs replaced by solid columns of clay. The technique is rather smooth as to surface treatment, particularly in front, with an overlay of rough surface here and there usually in back, as though to call attention to the fact that these are intended as unfinished studies.

The hands, feet and faces of the figurines are treated in the same manner. Even taking into consideration their small scale, the hands when modelled at all, are at best lifeless, the feet hardly indicated. The faces, broad-featured and bland, have a family resemblance that borders on stereotype. Daumier's faces are never stereotyped. Of the thousands of human beings that people his lithographs, every one is an individual; of the thirty-six busts, every one reveals a unique personality. The figurines have a flabbiness, a lack of indication of the bone structure beneath the clothing, that is never the case with Daumier in the paintings, drawings and lithographs, or the sculpture known to be by his hand. Gone are the fat citizens of the lithographs, their clothing pulled taut over their paunches; gone the emaciated ones with their clothes drooping on their gaunt frames. In the figurines the very silhouettes are modified, the proportions changed so that the portly are no longer robust, the thin no longer gaunt. Gone are the strong lines of the lithograph that portray human frailty in a few bold strokes of the crayon. Gone is the turbulent sculptured form of the seedy, rascally "Ratapoil" and the twisted exaggeration of expression of the thirty-six politicians of Louis Philippe's government. In their stead appears a host of characters in miniature, stepping from the pages of *La Caricature* or *Le Boulevard* but in milder form, with gestures softened, expressions turned bland, exuding a quaint and somewhat mannered charm.

Since it has not been possible to study the terra cottas in the laboratory or even to see more than a third, the mystery of their origin remains unsolved. The observations noted here have been made on the basis of comparison of style, with the use of photographs when the objects themselves were not available. Although Gobin notes two colors of terra cotta, dark red and light tile, the figurines actually seen (twelve that formerly belonged to Gobin and now in a private collection in Paris, and one belonging to Marcel Lecomte) were all dark reddish brown in color and appeared to be coated with either shellac or varnish, probably for protection during the casting process. The condition was uniformly good, with

no sign of cracks.

Gobin's descriptive names are used for the figurines in this catalogue as the only possible means of identification. Since we do not agree with Gobin's dating, they are presented alphabetically, with the exception of "L'Amateur en Contemplation" (cat. no. 62), "L'Amateur Surpris" (cat. no. 63) and "Coquetterie" (cat. no. 64), all of which were discovered since Gobin's book, and are therefore presented last. All measurements noted were supplied by the owners with the exception of the terra cotta measurement of "Le Dandy" which comes from Gobin, since the owner is unknown, and of "L'Amateur en Contemplation," "L'Amateur Surpris" and "Coquetterie" which were furnished by Marcel Lecomte.

The bronze editions of the figurines share a similar history. Except for two trial proofs shown in Vienna in 1936, the bronzes were first mentioned in Gobin's book in 1952 with the statement that a bronze edition was in progress, notably of "L'Homme d'Affaires" and of "Le Dandy." They have subsequently appeared largely in exhibition and sales catalogues. The private collection exhibited at the Musée Cognacq-Jay in 1961 belonged to René Gaston-Dreyfus, and included fourteen bronze figurines. When this collection was offered for sale at the Palais Galliera in 1966, it included four additional figurines, "L'Avocat Saluant," "L'Amateur en Contemplation," "L'Amateur Surpris," and "Coquetterie." In the 1968 Daumier exhibition held at the Château de Blois, there were nineteen bronze figurines loaned by Marcel Lecomte including, for the first time, a bronze cast of "Le Monsieur Qui Ricane."

Implicit in our consideration of the figurines is a basic disagreement with Gobin's interpretation of the visual evidence. He believed the sculptures to be of a higher quality than the graphic work. He therefore felt that they must have been the inspiration for the figures in the prints and drawings. Our analysis has led us to the opposite view. In the absence of further documentation we must rely upon weighing the known facts and the evidence of the objects themselves. Only examination and comparison of as many works as possible can inform us more. Finally, it is each individual who must answer for himself the questions raised here.

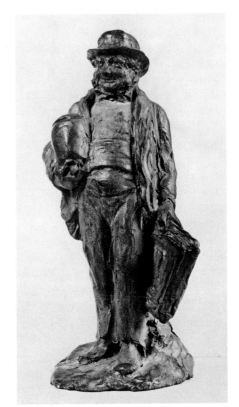

44a.

J.L.W.

44. "L'Amateur d'Art
(The Art Lover)

Gobin No. 58

Acquired on the Paris art market in 1933, this terra-cotta figurine has remained in a private collection in Paris and has never been cast in bronze. Gobin compares the sculpture to the figure on the right in the wood engraving by C. Maurand after Daumier, which appeared on July 11, 1863 in *Le Monde Illustré*. Accompanying an article by Champfleury entitled "L'Hôtel des Commissaires-Priseurs — Les Marchands," the wood engraving, at first glance, appears to portray the same rotund figure as the sculpture. The clothing, even the very objects he carries are the same; yet there is a marked difference in the expression of the face. The benign, smiling face of the statuette is that of the collector who, in the words of Gobin, "is returning home, happy with his acquisitions." The figure in the wood engraving, on the contrary, appears to have the hard mouth and piercing eyes of the crafty dealer. Thus, in translation from one medium to the other, the artist's intent and the figure's personality are changed.

The terra cotta has been exhibited only once, at the Galerie Sagot-Le Garrec, Paris, in 1957. Since it has not been possible to see or study it, no detailed description can be given. However, judging from the only available photograph, it seems related in style to the group of twelve figurines formerly belonging to Maurice Gobin and now in a private collection in Paris.

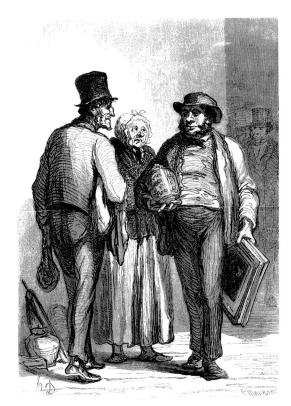

44b.

HISTORY

1952 Gobin, No. 58 (terra cotta, ILLUSTRATED)
1957 Galerie Sagot-Le Garrec, Paris, No. 58 (terra cotta)

44a. "L'AMATEUR D'ART"
 Terra cotta; h. 6½" (165 mm.)
 No casts
 Collection David-Weill, Paris
 (not in exhibition)

44b. L'HOTEL DES COMMISSAIRES-PRISEURS —
 LES MARCHANDS (The Auction House — The Art Dealers) Bouvy 941
 Wood engraving, china paper; 226 x 161 mm.
 Le Monde Illustré, July 11, 1863
 Collection Mr. and Mrs. Arthur E. Vershbow,
 Newton, Massachusetts
 (not in exhibition)

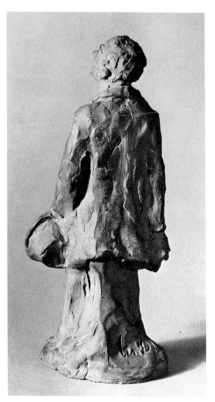 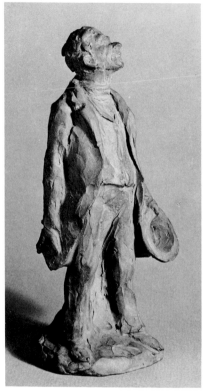 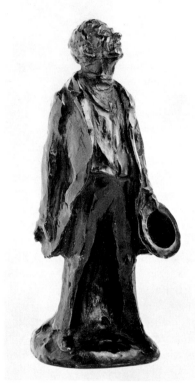

45a. 45b.

45a. "L'AMOUREUX"
 Terra cotta; h. 7-3/16″ (182.5 mm.)
 Private Collection, Paris
 (not in exhibition)

45b. "L'AMOUREUX"
 Cast bronze; h. 7⅛″ (181 mm.)
 Markings: base: h.ᴅ., Valsuani stamp; rim: 20/30
 National Gallery of Art, Lessing J. Rosenwald
 Collection

45c. OUI, MONSIEUR GIMBLET, L'ORDRE NE SERA
 ... RETABLI ... (Yes, Mr. Gimblet, order will not
 be ... re-established ...) L.D. 1713
 Lithograph, second state, white paper; 259 x 214 mm.
 Charivari, 1851, pl. 68 of series *Tout ce qu'on voudra*
 Boston Public Library

45. "L'Amoureux" (The Lover)

Gobin No. 50

The figurine called "L'Amoureux" by Gobin first appears in his catalogue raisonné published in 1952. The terra cotta is compared to three Daumier lithographs (L.D. 1682, 1713, and 1681). Although the figure in the lithograph is bending forward (whereas the statuette is leaning backward) there seems to be a resemblance to L.D. 1713 (see cat. no. 45c). The figurine is clothed similarly to the man in the lithograph even to the top hat he is holding in his left hand, but the clothes on the figure in the lithograph have a loose and droopy look that is entirely absent from the figurine. Gobin's comparisons to the other lithographs are hardly plausible.

Typical of most of the terra-cotta figurines, "L'Amoureux" is a compact sculpture, made to stand solidly without the use of an armature for support. The back is merely presented in rough outline with no attempt to show the legs, which are modelled in front and replaced behind by a pedestal-like support. The hands are barely indicated; the right hand is lifeless and the left hand, holding the top hat, is represented only by the thumb on the brim of the hat. The front is rather smooth in execution with only the outline of the coat, lapels, and vest given in detail. There is a certain roughness of texture indicated on the back and the hair. The face bears some resemblance to that of the figure in the lithograph but in a sweetened version.

HISTORY

1952 Gobin, No. 50 (terra cotta, ILLUSTRATED)

1957 Galerie Sagot-Le Garrec, Paris, No: 50a (terra cotta, ILLUSTRATED) ; No. 50b (bronze)

1958 Museo Nacional de Bellas Artes, Buenos Aires, No. 275 (bronze, ILLUSTRATED)

1961 Musée Cognacq-Jay, Paris, No. 337 (bronze, ILLUSTRATED)

1962 Museum für Kunst und Gewerbe, Hamburg, No. 113 (bronze, ILLUSTRATED)

1966 Palais Galliera, Paris, No. 38 (bronze, ILLUSTRATED)

1968 Château de Blois, No. 488 (bronze, ILLUSTRATED)

45c.

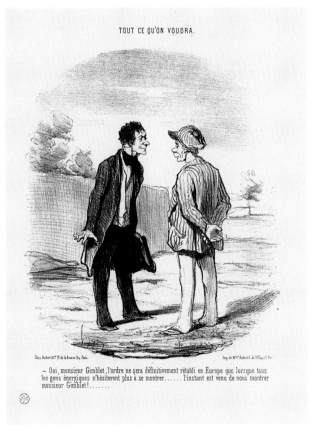

TOUT CE QU'ON VOUDRA.

— Oui, monsieur Gimblet, l'ordre ne sera définitivement rétabli en Europe que lorsque tous les gens énergiques n'hésiteront plus à se montrer...... l'instant est venu de nous montrer monsieur Gimblet!.......

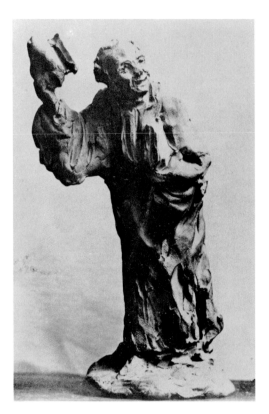

46a.

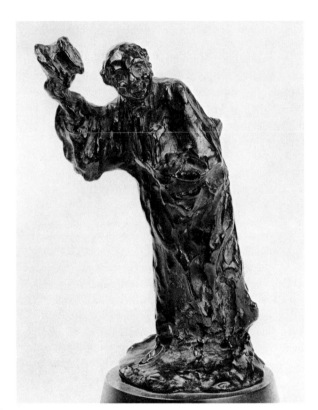

46b.

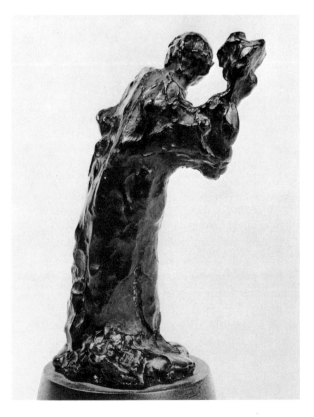

46a. Photograph of terra-cotta original of "L'Avocat saluant" from Gobin 1952, p. 259
Present location unknown

46b. "L'AVOCAT SALUANT"
Cast bronze; h. 6″ (152.5 mm.)
Markings: left of base: h.D.; rear of base: Valsuani stamp, 19/30
Private Collection

46c. MON CHER CONFRERE . . . (My dear colleague . . .)
Maison no. 600
Crayon, pen and wash, watercolor and gouache;
280 x 218 mm.
Signed bottom left: h. Daumier
National Gallery of Victoria, Melbourne

46. "L'Avocat saluant"
(Lawyer Tipping His Hat)

Gobin No. 46

Gobin reproduces a photograph of the terra-cotta original of "L'Avocat Saluant" (p. 259), a photograph which, he writes, had come to him recently from Paraguay with the news that the fragile terra cotta was broken in three pieces. He had known of the figurine through E. Fuchs who seems to have had a bronze cast in the early 1930's. In September 1968, J. C. Romand of Paris wrote (in a letter to the Fogg) that he had shown Mr. Gobin a bronze cast of this statuette which had been brought to him by a Parisian dealer at the time Gobin was preparing his catalogue raisonné. This bronze, presumably the one that Fuchs had indicated to Gobin earlier, was exhibited in 1957 at the Galerie Sagot-Le Garrec, Paris, with a notation in the catalogue that it was the only known bronze cast.

Subsequently, according to Mr. Romand, Maurice Loncle acquired a plaster from which, around 1962-63, a bronze edition was made by the Valsuani foundry. The whereabouts of such a plaster is today unknown, nor is it known whether it was made from the original terra cotta or from the early bronze cast.

In this instance, Gobin compares the figurine to a watercolor entitled "Mon Cher Confrère" (see cat. no. 46c), commenting that "the lawyer who salutes is differently expressed in it; the gesture a little awkward, the figure contracted, the attitude constrained and uncertain." He finds the sculpture more natural and fluent, which implies that it is the more spontaneous expression and therefore preceded the watercolor. Again we disagree with Gobin's interpretation of the visual evidence. The strength and vitality appear to be in the drawn figure. One is fully aware of the lawyer's body beneath his robe. There is action in the hunched shoulder, lifted foot, and raised arm. Far from awkward and constrained, the gesture of the hurrying lawyer, interrupting his conversation with a colleague to greet a passerby, is masterfully expressed. In contrast, the figurine appears weak and ambiguous. There is no feeling of anatomy beneath the surface fussiness of the robe. No individuality is expressed in the round smiling face, and the hat is more clearly stated than the hand tipping it. It would seem that the sculpture has emerged from the drawing as a far weaker interpretation of the theme.

HISTORY

1952 Gobin, No. 46 (terra cotta, ILLUSTRATED)
1957 Galerie Sagot-Le Garrec, Paris, No. 46 (bronze)
1966 Palais Galliera, Paris, No. 34 (bronze, ILLUSTRATED)
Hôtel Drouot, Paris, No. 15 (bronze, ILLUSTRATED)
1968 Château de Blois, No. 483 (bronze)

46c.

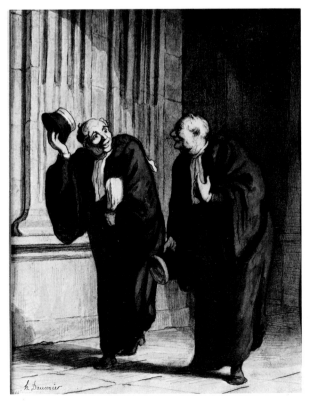

213

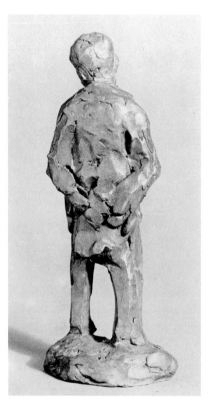 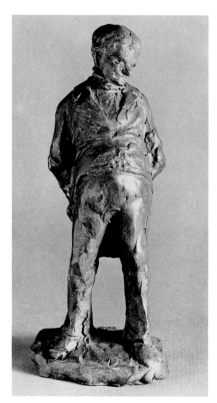 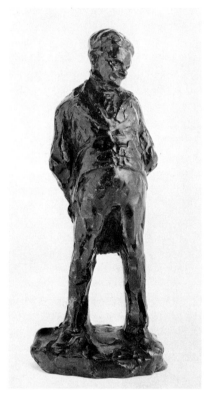

47a. 47b.

47a. "LE BON VIVANT"
 Terra cotta; h. 6-7/16" (162.5 mm.)
 Private Collection, Paris
 (not in exhibition)

47b. "LE BON VIVANT"
 Cast bronze; h. 6¼" (159 mm.)
 Markings: rear of base: h.ᴅ., Valsuani stamp;
 rim: 11/30
 National Gallery of Art, Lessing J. Rosenwald
 Collection

47c. PARDONNEZ-MOI, O MON DIEU! . . . (Pardon me,
 Oh Lord! . . .) L.D. 3031
 Lithograph, second state; 213 x 253 mm.
 Charivari, April 3, 1858
 Boston Public Library

47. "Le Bon Vivant"
(The Man Who Enjoys Life)
Gobin No. 54

The figurine called by Gobin "Le Bon Vivant" makes its first published appearance in 1952 in his catalogue raisonné. The pose of a man standing with legs apart, hands behind his back, is a favorite of Daumier's. Gobin points out that it appears in at least half a dozen of the lithographs. He finds the exact person of the figurine, however, in a lithograph of 1858 (see cat. no. 47c). He believes it was inspired by the terra cotta, and that it has less natural ease than the sculpture, which he considers the real masterpiece.

The front view is indeed similar to the lithograph from *Les Comédiens de Société*, except that the facial expression has become sweeter, in fact almost coy. The back is far less articulated than the front, with the hands barely indicated, although because of the stance with legs apart, the back of the legs is modelled. Here again the strong personality and gesture expressed in Daumier's drawn figure are altered and weakened in the sculpture.

HISTORY

1952 Gobin, No. 54 (terra cotta, ILLUSTRATED)
1957 Galerie Sagot-Le Garrec, Paris, No. 54 (bronze)
1958 Museo Nacional de Bellas Artes, Buenos Aires, No. 277 (bronze)
 Museum of Fine Arts, Boston, No. 17 (bronze)
 Los Angeles County Museum, No. 241 (bronze)
1961 Musée Cognacq-Jay, Paris, No. 340 (bronze, ILLUSTRATED)
1966 Palais Galliera, Paris, No. 41 (bronze, ILLUS-TRATED)
1968 Château de Blois, No. 491 (bronze)

47c.

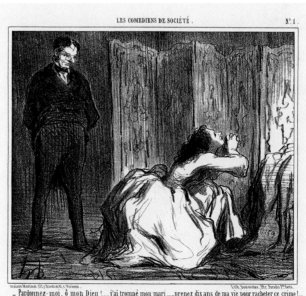

LES COMEDIENS DE SOCIÉTÉ. N°. 1.

– Pardonnez-moi, ô mon Dieu !.....j'ai trompé mon mari.....prenez dix ans de ma vie pour racheter ce crime !....
– Tiens ! ma femme qui répète son rôle....cette pièce est très bien écrite....elle me plaît !

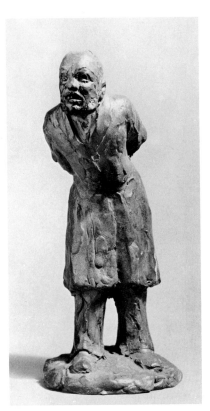
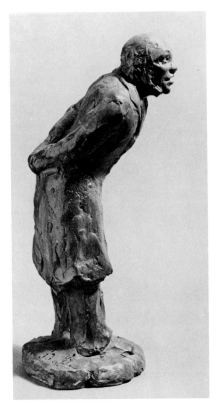
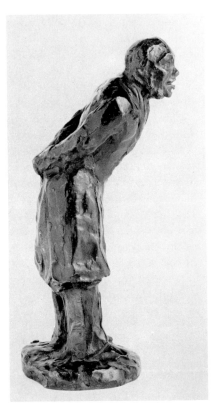

48a. 48b.

48a. "LE BOURGEOIS EN ATTENTE"
 Terra cotta; h. 6-3/16″ (157.5 mm.)
 Private Collection, Paris
 (not in exhibition)

48b. "LE BOURGEOIS EN ATTENTE"
 Cast bronze; h. 6⅛″ (155.5 mm.)
 Markings: front of base: H.D., Valsuani stamp;
 rim: 11/30
 National Gallery of Art, Lessing J. Rosenwald
 Collection

48. "Le Bourgeois en Attente"

(The Listener)

Gobin No. 55

"I have not found this character in the graphic work," Maurice Gobin admits, but he finds the sculpture similar in style to "Le Visiteur" (cat. no. 61), "Le Petit Propriétaire" (cat. no. 56), and "Le Bon Vivant" (cat. no. 47), all of which he dates from the same period, around 1852.

One cannot quarrel with this comparison since the four figurines have many similarities. The stance, with feet apart but firmly planted on the ground, is similar to that of "Le Bon Vivant," as are the hands clasped behind the back but barely defined, merely indicated. But why stop there? The face bears a striking resemblance to that of "Le Rodeur" (cat. no. 60), and, as in so many of the figurines, there is predominantly a softness and roundness in spite of an attempt to indicate action, with a scattering of rough texture over the surface. The figure bending forward forms a smooth and gentle curve.

HISTORY

1952 Gobin, No. 55 (terra cotta, ILLUSTRATED)

1957 Galerie Sagot-Le Garrec, Paris, No. 55 (bronze)

1958 Museo Nacional de Bellas Artes, Buenos Aires, No. 278 (bronze)
Museum of Fine Arts, Boston, No. 18 (bronze)

1961 Musée Cognacq-Jay, Paris, No. 341 (bronze, ILLUSTRATED)

1966 Palais Galliera, Paris, No. 42 (bronze, ILLUSTRATED)

1968 Château de Blois, No. 492 (bronze)

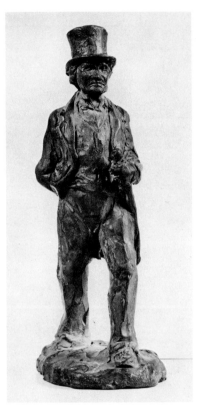

49a.

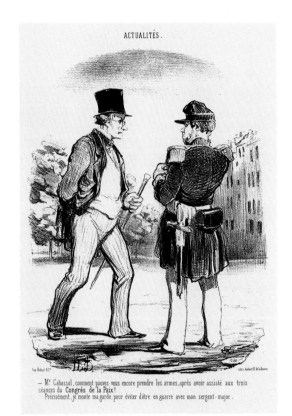

49b.

49a. "LE BOURGEOIS EN PROMENADE"
 Terra cotta; h. 6-11/16" (170 mm.)
 No casts
 Collection David-Weill, Paris
 (not in exhibition)

49b. MR. CABASSOL, COMMENT POUVEZ-VOUS . . .
 PRENDRE LES ARMES . . . (Mr. Cabassol, how
 can you . . . take up arms . . .) L.D. 1906
 Lithograph, second state, white paper; 257 x 198 mm.
 Charivari, September 15, 1849
 Boston Public Library
 (not in exhibition)

49. "Le Bourgeois en Promenade"

(Bourgeois Out for a Walk)

Gobin No. 52

Like "L'Amateur d'Art" (cat. no. 44), this terra cotta was acquired on the Paris art market in 1933, has remained in a private collection in Paris, and has never been cast.

Gobin mentions that similar walking bourgeois appear in at least eight lithographs between 1846 and 1849, but he finds a striking resemblance to L.D. 1906 (see cat. no. 49b) except for certain details such as the cane, the eyeglasses, and a rather scowling expression. The very face, scowl and all, however, overlooked by Gobin, appears in L.D. 582 (see cat. no. 49c) suggesting that the sculpture is, in fact, a pastiche.

Like "L'Amateur d'Art" the terra cotta has been exhibited only once, at the Sagot-Le Garrec gallery, in 1957.

HISTORY

1952 Gobin, No. 52 (terra cotta, ILLUSTRATED)
1957 Galerie Sagot-Le Garrec, Paris, No. 52 (terra cotta)

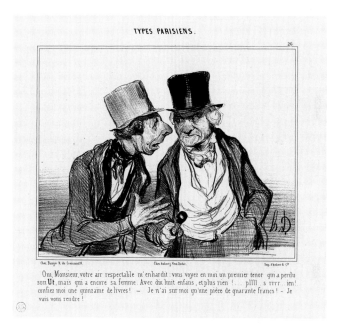

49c.

49c. OUI, MONSIEUR, VOTRE AIR RESPECTABLE
M'ENHARDIT . . . (Yes, sir, your respectable appearance encourages me . . .) L.D. 582
Lithograph, second state, white paper; 175 x 224 mm.
Figaro, May 29, 1840
Collection Mr. and Mrs. Arthur E. Vershbow, Newton, Massachusetts
(not in exhibition)

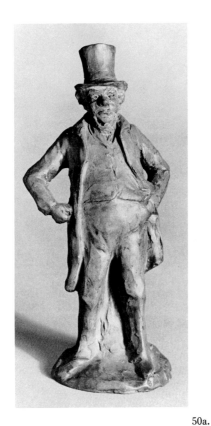 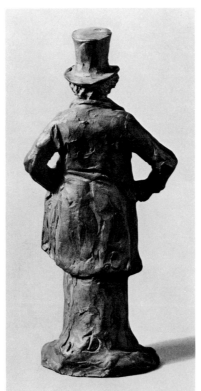 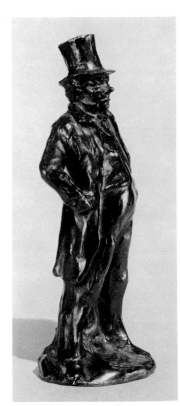

50a. 50b.

50a. "LE BOURGEOIS QUI FLANE"
 Terra cotta; h. 7½" (190 mm.)
 Private Collection, Paris
 (not in exhibition)

50b. "LE BOURGEOIS QUI FLANE"
 Cast bronze; h. 7⅜" (187.5 mm.)
 Markings: front of base: h.d., Valsuani stamp;
 inside: 20/30
 National Gallery of Art, Lessing J. Rosenwald
 Collection

50c. LE BOURGEOIS ET SON TAILLEUR (The
 Bourgeois and His Tailor) L.D. 1560
 Lithograph; 252 x 204 mm.
 Unpublished, c. 1847
 Photograph from Delteil, XXIV
 (not in exhibition)

50. "Le Bourgeois qui flâne
(The Strolling Bourgeois)

Gobin No. 51

The catalogue of the Daumier exhibition held in 1968 at the Château de Blois describes a bronze cast of "Le Bourgeois Qui Flâne" as "one of the most beautiful of the series of figurines." Surely this preference is a personal one, for stylistically the figurine is very similar to most of the others presented by Gobin. The modelling is rather smooth and round with a superficial suggestion of rough surface texture. The stance, with legs apart, is delineated only in the front. The back of the legs becomes a solid column similar to the back treatment of "L'Amoureux" (cat. no. 45) and at least half a dozen others. Again, there is more attention to detail in the front of the figure than in the back. The face, hair, cravat, vest, and coat are all delineated. However, the face has a more individual character than is found in many of the figurines, and more care has been taken with the back above the knees. Two horizontal lines indicate that the fabric of the coat is pulled taut by the hands in the pockets, and the collar and the edge of the coat are carefully modelled.

Gobin relates the statuette to figures in two lithographs, but the resemblance is at best very slight. He admits that the sculpture does not much resemble the individuals of the lithographs, but represents the same class or type. The figurine could be based, however, on the stout gentleman portrayed in the unpublished lithograph "Le Bourgeois et Son Tailleur" (see cat. no. 50c), not mentioned by Gobin. Gobin also speculated that Daumier might have amused himself by making this figurine a kind of self-portrait caricature. He believes it could easily be Daumier himself witnessing the spectacle of life.

HISTORY

1952 Gobin, No. 51 (terra cotta, ILLUSTRATED)
1957 Galerie Sagot-Le Garrec, Paris, No. 51 (bronze)
1958 Museo Nacional de Bellas Artes, Buenos Aires, No. 276 (bronze, ILLUSTRATED)
1961 Musée Cognacq-Jay, Paris, No. 338 (bronze, ILLUSTRATED)
1962 Museum für Kunst und Gewerbe, Hamburg, No. 114 (bronze)
1966 Palais Galliera, Paris, No. 39 (bronze)
1968 Château de Blois, No. 489 (bronze, ILLUSTRATED)

50c.

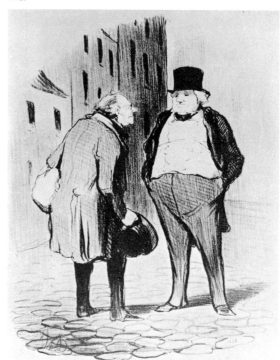

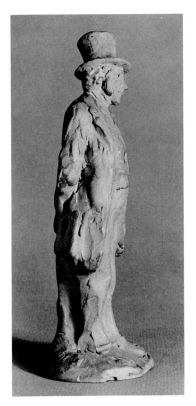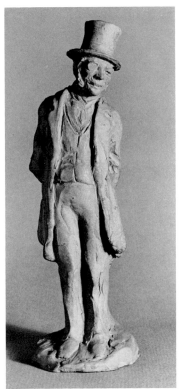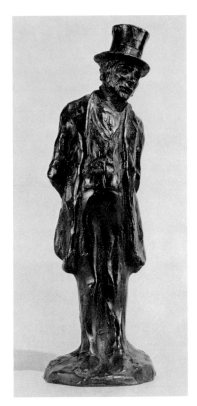

51a. 51b.

51a. "LE CONFIDENT"
 Terra cotta; h. 7-13/32″ (188 mm.)
 Private Collection, Paris
 (not in exhibition)

51b. "LE CONFIDENT"
 Cast bronze; h. 7-5/16″ (185.5 mm.)
 Markings: front of base: h.D., Valsuani stamp;
 rim: 20/30
 National Gallery of Art, Lessing J. Rosenwald
 Collection

51c. COMMENT PEUVENT-ILS TROUVER AMUSANT
 DE RESTER . . . (How can they find it amusing to
 stay . . .) L.D. 1704
 Lithograph, second state, white paper; 242 x 238 mm.
 Published in 1850 as pl. 58 of the series
 Tout ce qu'on voudra
 Boston Public Library

51. "Le Confident"

(The Confidant)

Gobin No. 49

Of the character whom he presents as "Le Confident," Gobin writes that he has not found him in Daumier's lithographs, drawings, or paintings. He notes that Daumier very rarely had his subjects wear monocles; more often he gave them eyeglasses. He finds a family resemblance to the principal figure in an 1850 lithograph (see cat. no. 51c), although like "L'Amoureux" (cat. no. 45), Daumier's drawn figure is concave as it bends forward, whereas the statuette leans slightly backward, with rounded paunch thrust forward, forming a convex line.

This is perhaps the smoothest of the figurines with almost no indication of rough surface treatment. The smooth face with its round monocle recalls the style of Dantan rather than Daumier. In spite of the surface, however, "Le Confident" has many similarities to others in the group of figurines. The back, for instance, is much less detailed than the front. The sketchy indication of the hands clasped behind the back recalls "Le Bon Vivant" (cat. no. 47), and the replacement of the backs of the legs with a clay column is handled like "L'Amoureux," "Le Bourgeois Qui Flâne," and several others.

HISTORY

1952 Gobin, No. 49 (terra cotta, ILLUSTRATED)
1957 Galerie Sagot-Le Garrec, Paris, No. 49 (bronze)
1961 Musée Cognacq-Jay, Paris, No. 336 (bronze)
1963 Brandeis University, Waltham, Mass., No. 125 (bronze)
1966 Palais Galliera, Paris, No. 37 (bronze, ILLUSTRATED)
1968 Château de Blois, No. 487 (bronze)

51c.

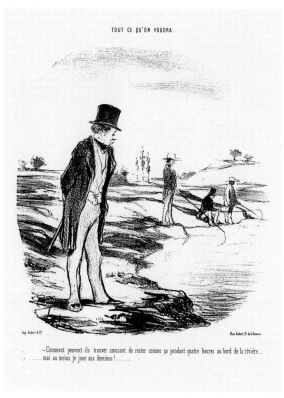

TOUT CE QU'ON VOUDRA.

—Comment peuvent-ils trouver amusant de rester comme ça pendant quatre heures au bord de la rivière...moi au moins je joue aux dominos !......

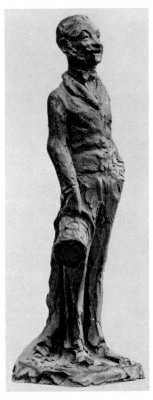
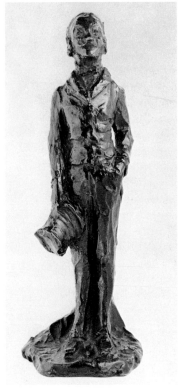
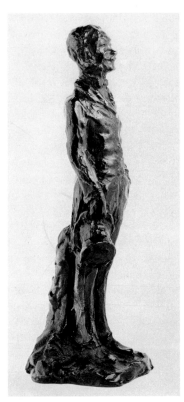

52a. 52b.

52a. Photograph of terra-cotta original of "Le Dandy"
 from Gobin, 1952, p. 249
 Present location unknown

52b. "LE DANDY"
 Cast bronze; h. 7-5/16" (185.5 mm.)
 Markings: base: h.d., Valsuani stamp, BRONZE, 6/30
 National Gallery of Art, Lessing J. Rosenwald
 Collection

52c. MON CHER AMI, TU VOIS . . . , J'ETAIS NE
 POUR . . . (You see, my dear friend . . . , I was born
 for . . .) L.D. 3033
 Lithograph, second state; 211 x 251 mm.
 Charivari, April 9, 1858
 Museum of Fine Arts, Boston

52. "Le Dandy" (The Dandy)

Gobin No. 41

Since the whereabouts of this terra cotta is unknown, the photograph is reproduced from Gobin. Unlike the stocky gentlemen portrayed in many of the figurines, "Le Dandy" is slender and attenuated, a perfect replica of the silhouette shown in profile in the lithograph illustrated (see cat. no. 52c) from the series *Les Comédiens de Société*. The back seems to be more completely modelled than the backs of other figurines, with the column-like support, instead of replacing the backs of the legs, appearing as a separate element behind the legs, like the trunk of a tree.

Gobin wrote that a bronze edition was in progress, a trial proof of which had been exhibited at the Albertina in Vienna in 1936. A bronze statuette called "Man with Hat in Hand" was indeed exhibited in a Daumier exhibition held at the Albertina, November-December 1936 as no. 83 of the catalogue. The bronze was compared to L.D. 3038, presumably a misprint for L.D. 3033 (cat. no. 52c). The bronze could very well have been that which we call "Le Dandy," but we have been unable to locate further reference to clarify this point.

HISTORY

1952 Gobin, No. 41 (terra cotta, ILLUSTRATED)
1957 Galerie Sagot-Le Garrec, Paris, No. 41 (bronze)
1958 Museo Nacional de Bellas Artes, Buenos Aires, No. 274 (bronze)
Museum of Fine Arts, Boston, No. 15 (bronze)
1961 Musée Cognacq-Jay, Paris, No. 331 (bronze, ILLUSTRATED)
1962 Museum für Kunst und Gewerbe, Hamburg, No. 109 (bronze)
1966 Palais Galliera, Paris, No. 30 (bronze, ILLUSTRATED)
1968 Château de Blois, No. 479 (bronze)

52c.

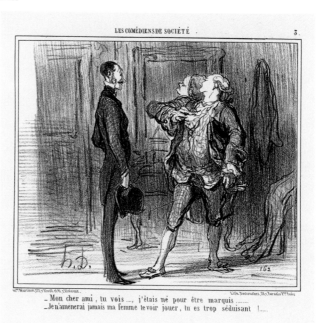

LES COMÉDIENS DE SOCIÉTÉ . 3.

— Mon cher ami , tu vois ..., j'étais né pour être marquis
— Je n'amènerai jamais ma femme te voir jouer , tu es trop séduisant !.....

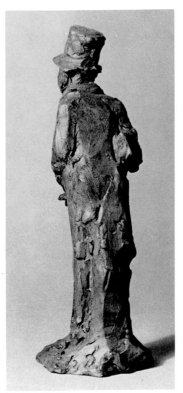
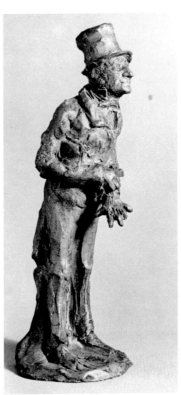

53a.

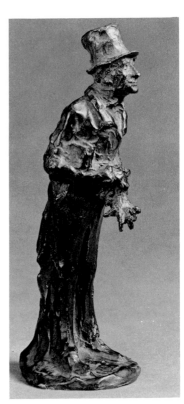

53b.

53a. "L'HOMME D'AFFAIRES"
Terra cotta; h. 7-23/32" (196 mm.)
Private Collection, Paris
(not in exhibition)

53b. "L'HOMME D'AFFAIRES"
Cast bronze; h. 7⅝" (193 mm.)
Markings: front of base: h.D., Valsuani stamp, BRONZE;
inside: 6/30
National Gallery of Art, Lessing J. Rosenwald
Collection

53c. LE DEFENSEUR OFFICIEUX (Officious Public
Defender) Bouvy 366
Wood engraving; 137 x 93 mm.
Les Français peints par eux-mêmes, Paris, 1840-1842,
II, p. 347
Museum of Fine Arts, Boston

53. "L'Homme d'Affaires"
(The Businessman)

Gobin No. 40

Gobin presents this figurine as the inspiration for a wood engraving (see cat. no. 53c) and two later lithographs. He is convinced that the sculpture preceded the graphic works, and that its superiority is self-evident. In comparing the sculpture to the wood engraving he states: "we can appreciate all the distance which separates the statuette, original work, from the wood engraving, interpretive work, of which the heaviness and crudity are explained by the necessary intervention of a professional, more or less faithful and more or less facile." There are indeed striking differences between the graphic and and the sculptured statement. The "Officious Public Defender" of the wood engraving is a caricature in profile with a large ugly head on a small body, tapering down to two small flat feet. The sculpture has more elegant proportions, with the head in proper scale to the body and a pleasant expression on a face with attractive, if rather nondescript, features. Only the gesture, of a man with a packet under his right arm drawing a glove on his left hand, remains the same. It would seem more plausible that the sculpture is a misinterpretation of the wood engraving than that the wood engraving is inspired by the sculpture.

The terra cotta, like many of the figurines, is developed in rather full detail in front and left almost unfinished in back. In fact the back is so flat, it almost gives the impression of a relief that has been cut away from its background. Similar back treatment occurs in "Le Bon Vivant" (cat. no. 47) and "Le Confident" (cat. no. 51).

It should be noted here that a bronze statuette entitled "Offizioser Verteidiger am Friedensgerichtshof" was listed as no. 82 in the Daumier exhibition at the Albertina in Vienna in 1936. As the catalogue compares the statuette to a wood engraving from *Les Français peints par eux-mêmes* of 1840-1842, it could well be identified as "L'Homme d'Affaires." Gobin refers to this entry in the Albertina 1936 exhibition catalogue as one of three trial proofs of the edition of thirty numbered casts that were in progress at the time his book was published (p. 245).

HISTORY

1952 Gobin, No. 40 (terra cotta, ILLUSTRATED)
1957 Galerie Sagot-Le Garrec, Paris, No. 40 (bronze)
1958 Museo Nacional de Bellas Artes, Buenos Aires, No. 273 (bronze)
1961 Musée Cognacq-Jay, Paris, No. 330 (bronze, ILLUSTRATED)
1962 Museum für Kunst und Gewerbe, Hamburg, No. 108 (bronze)
1966 Palais Galliera, Paris, No. 29 (bronze, ILLUSTRATED)
1968 Château de Blois, No. 478 (bronze, ILLUSTRATED)

53c.

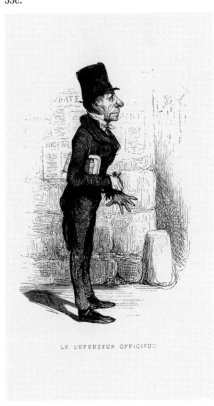

LE DEFENSEUR OFFICIEUX

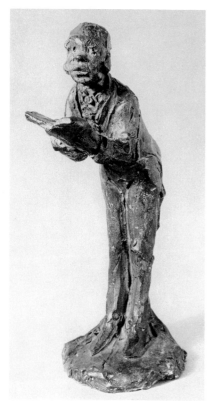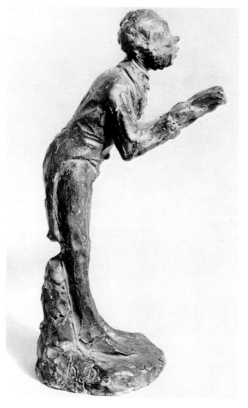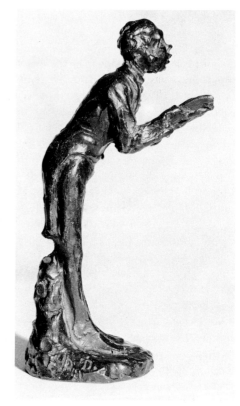

54a. 54b.

54a. "LE LECTEUR"
 Terra cotta; h. 5-29/32" (150 mm.)
 Collection Marcel Lecomte, Paris
 (not in exhibition)

54b. "LE LECTEUR"
 Cast bronze; h. 6⅞" (171.5 mm.)
 Markings: right of base: h.D.; left of base: Valsuani
 stamp; rim: E.E.
 Private Collection

54c. VOYONS MR. LE BARON . . . JE N'ENTENDS
 RIEN . . . (Come now, Baron . . . I can hear
 nothing . . .) L.D. 3032
 Lithograph, second state; 211 x 249 mm.
 Charivari, April 5-6, 1858
 Museum of Fine Arts, Boston

54. "Le Lecteur" (The Reader)

Gobin No. 45

In presenting this figurine in his catalogue raisonné, Gobin somehow overlooked the lithograph illustrated here (cat. no. 54c), even though it is reproduced in Delteil as no. 3032. Instead, he compared the terracotta statuette to a vignette by Daumier, engraved on wood by Verdeil which appeared in *La Physiologie du Poète* in 1841, and named it "The Reader." Only the pose of the poet reading to an audience can be compared to the statuette. The face, the very shape of the figure are entirely different.

It was Marcel Lecomte, expert for the sale of the René Gaston-Dreyfus collection at the Palais Galliera in June 1966, who changed the name of the figurine to "Le Souffleur" (The Prompter) in the sales catalogue, and compared it to the lithograph of 1858 from the series *Les Comédiens de Société* where the exact figure of the sculpture is shown "prompting in the wings." In his catalogue for the Daumier exhibition at the Château de Blois in 1968, Roger Passeron lists the figurine as "Le Souffleur" (no. 482) and compares it to the lithograph (no. 340 in the catalogue), "which represents exactly this personage, who has evaded Maurice Gobin."

One of the few slender figurines in the group, it is one of the most successful in its execution, a figure of considerable charm. Unlike the lumpy bending figure of the "Bourgeois en Attente," the "Lecteur" (or "Souffleur") forms a graceful curve, and is as consistently modelled in the back as in the front. The rough surface treatment also is handled with consistency over the entire surface and is better integrated into the total form than in other examples of the figurines.

The terra cotta belongs to Marcel Lecomte, acquired from Maurice Loncle who had the bronze edition made in the early 1950's, giving Mr. Lecomte the sole distribution rights. The bronze edition of thirty plus three trial proofs was cast by Valsuani.

HISTORY

1952 Gobin, No. 45 (terra cotta, ILLUSTRATED)
1957 Galerie Sagot-Le Garrec, Paris, No. 45 (terracotta original)
1961 Musée Cognacq-Jay, Paris, No. 334 (bronze, ILLUSTRATED)
1962 Museum für Kunst und Gewerbe, Hamburg, No. 112 (bronze)
1963 Brandeis University, Waltham, Mass., No. 123 (bronze)
1966 Hôtel Drouot, Paris, No. 14 (bronze, ILLUSTRATED)
Palais Galliera, Paris, No. 33 (bronze, ILLUSTRATED)
1968 Château de Blois, No. 482 (bronze, ILLUSTRATED)

54c.

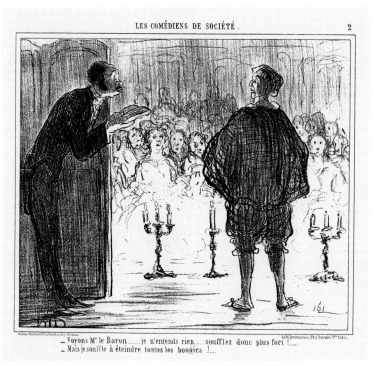

LES COMÉDIENS DE SOCIÉTÉ.

— Voyons M^r le Baron......je n'entends rien..... soufflez donc plus fort !.....
— Mais je souffle à éteindre toutes les bougies !...

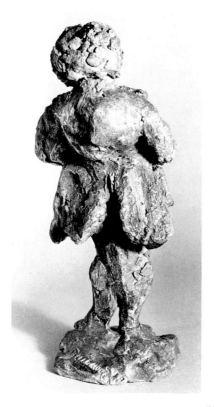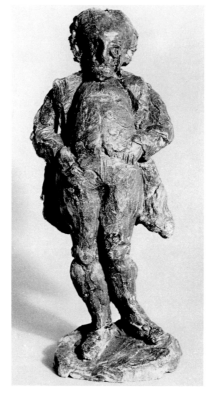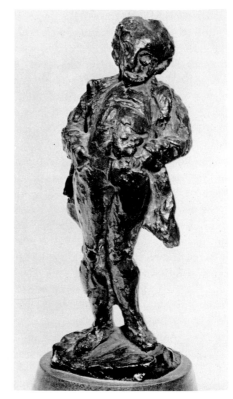

55a. 55b.

55a. "LE MONSIEUR QUI RICANE"
 Terra cotta; h. 7⅞" (200 mm.)
 Collection Marcel Lecomte, Paris
 (not in exhibition)

55b. "LE MONSIEUR QUI RICANE"
 Cast bronze; h. 7-5/16" (186 mm.)
 Markings: rear of base: Valsuani stamp, DAUMIER, E 2
 Private Collection

55c. VOLE! . . . RUE VIDE-GOUSSET (Robbed! . . .
 Pickpocket Avenue) L.D. 697
 Lithograph, second state, white paper; 242 x 190 mm.
 Charivari, November 22, 1839
 Boston Public Library

55. "Le Monsiuer qui Ricane"

(The Scoffer)

Gobin No. 47

Of all the figurines attributed to Daumier, the one named by Gobin "Le Monsieur Qui Ricane" remains the greatest mystery. Gobin himself remarks that this statuette does not appear to have had very marked contact with the graphic work. He sees some resemblance (only in the movement of the coat-tails) to the suit of Thiers, as represented in two caricatures of this durable political figure appearing in *Charivari* in 1849 and 1850. Stylistically, however, there can be no comparison between the sculpture and the two lithographs, which are drawn in the convention of the large head on a small body. There appears to be more of a resemblance (although still slight) to a lithograph published in *Charivari* in 1839 (see cat. no. 55c).

Moreover, the figurine of "Le Monsieur Qui Ricane" does not relate stylistically to any of the other figurines. All of these, no matter how hastily made, or how sketchy in parts, denote the hand of an accomplished sculptor certain of his medium. This figurine is so clumsy in execution it might almost be the work of a child, or at least an unskilled amateur. The face is misshapen as if unfinished, and an attempt to show action results in grotesque lumpy areas such as the clumsy coat-tails and the back that has the deformity of a hunchback. The entire surface is gritty, and the hands thrust in the pockets are indicated by childish parallel incisions made with a sharp tool. It is also interesting to note that, unlike all the other figurines which bear the initials "h.D.," this one is signed "Daumier" across the rear of the base.

Marcel Lecomte owns the terra cotta which he describes as "Goyesque" and which he acquired through an intermediary from an anonymous collector in Marseilles (Letter of September 15, 1968 to the Fogg). A bronze cast no. 485, from the collection of Marcel Lecomte, was exhibited for the first time at the Château de Blois in the Summer of 1968.

HISTORY

1952 Gobin, No. 47 (terra cotta, ILLUSTRATED)
1968 Château de Blois, No. 485 (bronze)

55c.

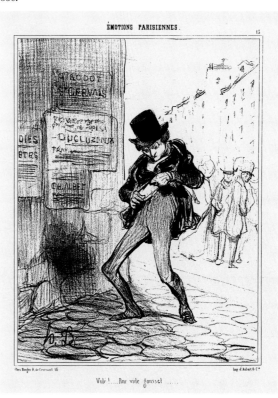

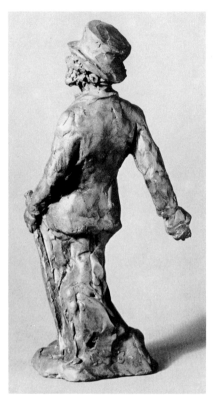
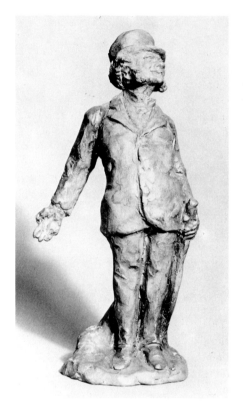
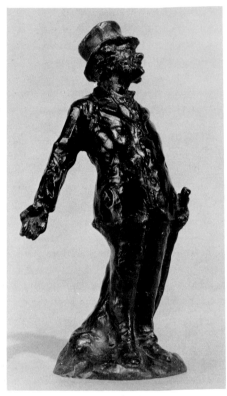

56a. 56b.

56a. "LE PETIT PROPRIETAIRE"
Terra cotta; h. 6¾″ (172 mm.)
Private Collection, Paris
(not in exhibition)

56b. "LE PETIT PROPRIETAIRE"
Cast bronze; h. 6-11/16″ (170 mm.)
Markings: front of base: h.ᴅ., Valsuani stamp;
 right of base: 11/30
National Gallery of Art, Lessing J. Rosenwald
 Collection

56c. A LA VARENNE-SAINT-MAUR, "LA VOILA,
 MA MAISON DE CAMPAGNE!" (At Varenne-
 Saint-Maur, "There it is, my country house!")
 L.D. 3247
Lithograph, second state, china paper; 210 x 275 mm.
Boulevard, May 11, 1862
Boston Public Library

56. "Le Petit Propriétaire"
(The Small Property Owner)
Gobin No. 56

Gobin presents the figurine he calls "Le Petit Propriétaire" along with one he calls "Le Visiteur" (cat. no. 61), since he finds them both in the same lithograph published in *Le Boulevard* in 1862 (see cat. no. 56c). He goes to great pains to establish that the statuettes, which he calls "the two friends," were created first, and that Daumier later developed the lithograph around them, filling in the scene with the house in the country, the barren landscape and even a young female companion. He explains that "the gesture of the proprietor is modified in a way to designate his house, over there . . . that miserable little cube, the object of the action." Gobin's theory that the miniature sculptures preceded the graphic work in an abstract way, is least convincing here when he stretches it to accommodate two figures from the same lithograph. It is hardly credible that "the two friends" were created in a vacuum, and later a scene invented to explain their gestures. How much more logical to assume that the proprietor's gesture was modified when translated from drawn to sculptured figure, since the lowered arm was more easily modelled than one extended at right angles to the figure!

The terra cotta seems to have been modelled by the same sure hand as the majority of the figurines. The figure stands firmly without need for interior support and the surface is handled with ease and assurance. The back, with no indication of legs, recalls "L'Amoureux" (cat. no. 45) and the "Bourgeois Qui Flâne" (cat. no. 50). The face bears at least a family resemblance to the broad and pleasant faces of "L'Amoureux," "Le Bon Vivant" (cat. no. 47), and "L'Homme d'Affaires" (cat. no. 53).

HISTORY

1952 Gobin, No. 56 (terra cotta, ILLUSTRATED)
1957 Galerie Sagot-Le Garrec, Paris, No. 56 (bronze, ILLUSTRATED)
1958 Los Angeles County Museum, No. 242 (bronze) Museo Nacional de Bellas Artes, Buenos Aires, No. 279 (bronze, ILLUSTRATED) Museum of Fine Arts, Boston, No. 19 (bronze)
1961 Musée Cognacq-Jay, Paris, No. 342 (bronze, ILLUSTRATED)
1966 Palais Galliera, Paris, No. 43 (bronze, ILLUSTRATED)
1968 Château de Blois, No. 493 (bronze)

56c.

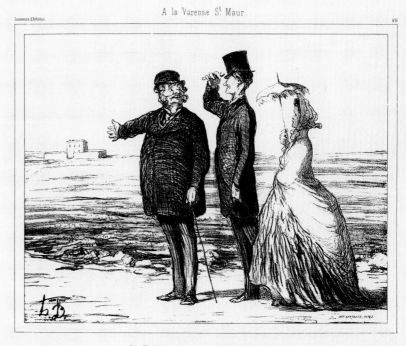

233

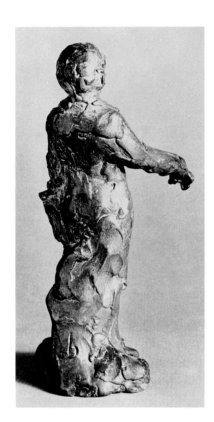 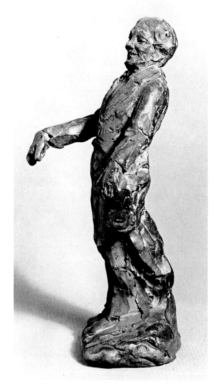

57a. "LE POETE"
 Terra cotta; h. 6⅛″ (156 mm.)
 Private Collection, Paris
 (not in exhibition)

57. "Le Poète" (The Poet)

Gobin No. 42

This compact, smiling figurine looks more like a jolly country gentleman than the poet that Gobin calls him, after the wood engraving "Le Poète Cavalier Régence" from *Physiologies* of 1841, to which it bears no visible resemblance. It is close in style to many of the other figurines, with more development in front than in back, where there is merely a shapeless swirl of textured clay. Since its counterpart has not been found in the graphic work nor the drawings, the meaning of the gesture of the extended right arm is unclear. It is difficult to imagine Daumier creating such an insipid gesture, with fingers daintily spread out beneath a limp wrist.

HISTORY

1952 Gobin, No. 42 (terra cotta, ILLUSTRATED)
1957 Galerie Sagot-Le Garrec, Paris, No. 42 (terra cotta)
1961 Musée Cognacq-Jay, Paris, No. 332 (bronze, ILLUSTRATED)
1962 Museum für Kunst und Gewerbe, Hamburg, No. 110 (bronze)
1963 Brandeis University, Waltham, Mass., No. 121 (bronze)
1966 Palais Galliera, Paris, No. 31 (bronze, ILLUSTRATED)
1968 Château de Blois, No. 480 (bronze)

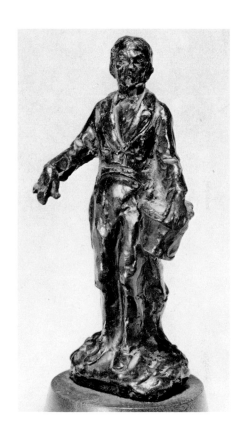

57b. "LE POETE"
Cast bronze; h. 6-1/16″ (153.5 mm.)
Markings: rear of base: h.D., Valsuani stamp; on rim: 18/30
Private Collection

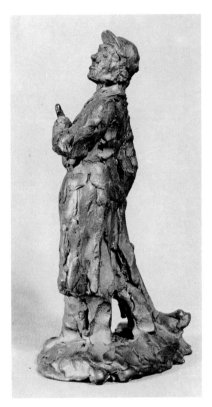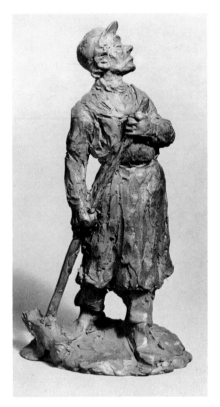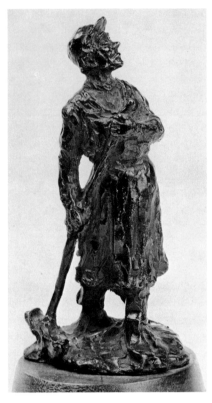

58a. 58b.

58a. "LE PORTIER PARISIEN"
 Terra cotta; h. 6⅜" (162 mm.)
 Private Collection, Paris
 (not in exhibition)

58b. "LE PORTIER PARISIEN"
 Cast bronze; h. 6⅜" (162 mm.)
 Markings: rear of base: h.D., Valsuani stamp;
 rim: 2/E
 Private Collection

58c. C'EST INUTILE QUE JE VOUS FASSE VOIR
 MON APPARTEMENT . . . (It's useless to show
 you my apartment . . .) L.D. 2825
 Lithograph, second state; 204 x 271 mm.
 Charivari, July 30, 1856
 Benjamin A. and Julia M. Trustman Collection,
 Brandeis University

58. "Le Portier parisien"

(The Parisian Janitor)

Gobin No. 44

In describing the terra-cotta figurine he has named "Le Portier Parisien," Gobin, as always, finds it superior to the drawn figure it resembles. "This superiority of the sculpture one observes here again, not only in its spirit but even in its execution. The statuette is upright; the attitude of the individual and his movement agree perfectly with the expression on his face; each of the accents is in its place, incorporated into the work, animating it without breaking the equilibrium. On the other hand, in the lithograph the attraction of the character has something unstable and forced. One could maintain perhaps that this effect is voluntary, that it tends toward caricature and in no way diminishes the merit of the artist. But, even while recognizing all the qualities of the drawing, the question remains who, in sculpture could surpass in this regard the lithographer, if not Daumier himself?"

One could argue that the upright stance of the sculpture represents, on the contrary, a loss of the verve and movement that Daumier has created in the lithograph. It is characteristic of many of the figurines that, although they strike a pose found in a lithograph, the pose has somehow lost its vitality, and has become, instead, static and frozen in space. The "Portier," nevertheless, has not lost as much in translation from lithographic crayon to terra cotta as many of the others. Even without the malicious swing of the hip, the statuette retains some of the air of disdain and insolence that is expressed in every line of the drawn figure. It is surely one of the more successful of the figurines.

HISTORY

1952 Gobin, No. 44 (terra cotta, ILLUSTRATED)
1957 Galerie Sagot-Le Garrec, Paris, No. 44 (bronze)
1958 Museum of Fine Arts, Boston, No. 21 (bronze)
1961 Musée Cognacq-Jay, Paris, No. 333 (bronze, ILLUSTRATED)
1962 Museum für Kunst und Gewerbe, Hamburg, No. 111 (bronze)
1963 Brandeis University, Waltham, Mass., No. 122 (bronze)
1966 Palais Galliera, Paris, No. 32 (bronze, ILLUSTRATED)
1968 Château de Blois, No. 481 (bronze)

58c.

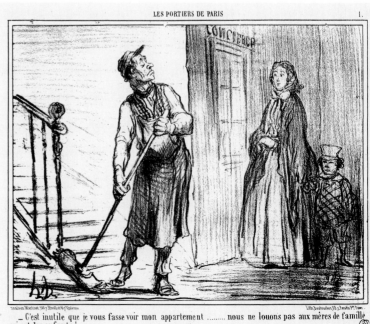

LES PORTIERS DE PARIS

— C'est inutile que je vous fasse voir mon appartement nous ne louons pas aux mères de famille qui ont des enfants !....

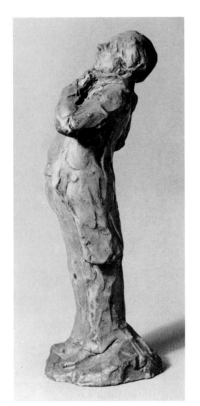

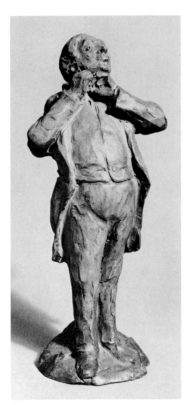

59a.

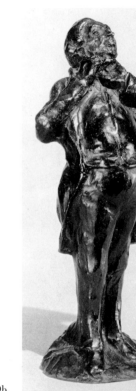

59b.

59c.

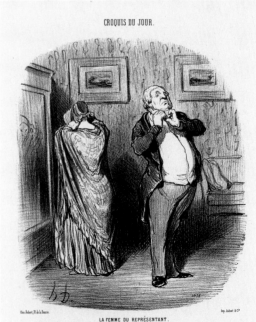

59a. "LE REPRESENTANT NOUE SA CRAVATE"
 Terra cotta; h. 7″ (178 mm.)
 Private Collection, Paris
 (not in exhibition)

59b. "LE REPRESENTANT NOUE SA CRAVATE"
 Cast bronze; h. 7″ (178 mm.)
 Markings: rear of base: H.D., Valsuani stamp;
 inside: 20/30
 National Gallery of Art, Lessing J. Rosenwald
 Collection

59c. LA FEMME DU REPRESENTANT (The
 Representative's Wife) L.D. 1938
 Lithograph, second state, white paper; 240 x 208 mm.
 Charivari, August 9, 1849
 Boston Public Library

238

59. "Le Représentant noue sa cravate"

(Representative Knotting His Tie)

Gobin No. 48

Once again Gobin finds the statuette superior to the lithograph with which he compares it and argues, therefore, that the sculpture preceded the lithograph. He reinforces this judgment by describing another terra cotta of the same subject signed "h.D." with traces of the additional initials "J.D." partially scratched out. Gobin concludes that this second terra cotta, which he illustrates in the appendix of his book, was probably made by Jean-Pierre Dantan in frank imitation of Daumier. Gobin admits that this second terra cotta has a more striking resemblance to the Representative of the lithograph both as to face and figure than the figurine he attributes to Daumier. In fact, he argues, although it resembles the lithograph, it is inferior to it and therefore made *after* the lithograph. He finds, in comparing the two statuettes that the copy-statue is doubly inferior to the "original" sculpture because it is third-hand. It is derived from the lithograph which was in turn inspired by the original sculpture.

The existence of the "h.D.-J.D." terra cottas (Gobin illustrates four in addition to the "Représentant") only adds to the mystery of the authorship of the figurines. They do not in any way resemble the known sculptures by Dantan, and though perhaps slightly more realistic and detailed than the terra cottas Gobin attributed to Daumier, they are actually quite similar in scale and treatment. It is true that the "h.D.-J.D." "Représentant" is much closer to Daumier's lithograph than the one Gobin prefers, yet one can hardly agree with him that it is less skillful.

Gobin mentions that three bronze trial proofs not on the market existed of this figurine and that perhaps a lost-wax casting would be made under the same conditions as those carried out for "L'Homme d'Affaires" (cat. no. 53) and "Le Dandy" (cat. no. 52). The edition had perhaps been realized by 1957 when a Valsuani bronze was exhibited at the Galerie Sagot-Le Garrec.

HISTORY

1952 Gobin, No. 48 (terra cotta, ILLUSTRATED)
1957 Galerie Sagot-Le Garrec, Paris, No. 48a (terra cotta); No. 48b (bronze)
1961 Musée Cognacq-Jay, Paris, No. 335 (bronze, ILLUSTRATED)
1963 Brandeis University, Waltham, Mass., No. 124 (bronze)
1966 Palais Galliera, Paris, No. 36 (bronze, ILLUSTRATED)
1968 Château de Blois, No. 486 (bronze)

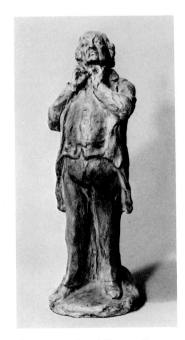 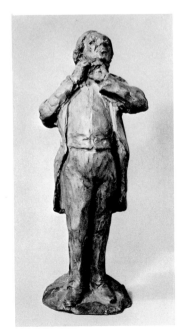

Terra cotta signed "h.D.-J.D." Terra cotta signed "h.D."

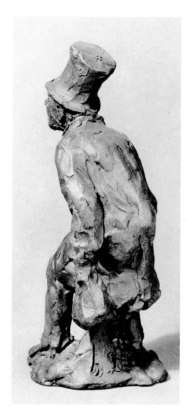
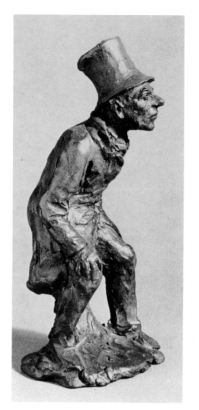
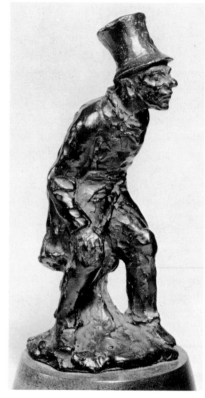

60a. 60b.

60a. "LE RODEUR"
 Terra cotta; h. 5-25/32″ (147 mm.)
 Private Collection, Paris
 (not in exhibition)

60b. "LE RODEUR"
 Cast bronze; h. 5¾″ (146 mm.)
 Markings: rear of base: h.D., Valsuani stamp; rim 2E
 Private Collection

60c. LE RAMASSEUR DE BOUTS DE CIGARES (The
 Scavenger of Cigar Butts) L.D. 825
 Lithograph, second state, white paper; 236 x 193 mm.
 Charivari, December 5, 1841
 Collection Mr. and Mrs. Arthur E. Vershbow,
 Newton, Massachusetts

60d. ROBERT . . . TU NE SOUTIENS PLUS LA
 CONVERSATION . . . (Robert . . . You are not
 keeping up the conversation . . .) L.D. 1529
 Lithograph, third state; 265 x 212 mm.
 Charivari, September 4, 1847
 Museum of Fine Arts, Boston

60. "Le Rôdeur" (The Scavenger)

Gobin No. 53

This figurine is named for one lithograph (see cat. no. 60c) in which his sack of cigars is found. The crouching pose, however, appears to be dependent on another lithograph (see cat. no. 60d). His face recalls that of the "Bourgeois en Attente" (cat. no. 48). The combination of these elements, nevertheless, results in a successful little sculpture, rather more fully conceived than many of the figurines, and like the "Portier Parisien" (cat. no. 58), expressed with considerable vitality. Entirely missing from the statuette, however, is the pathos of Daumier's lithograph "Le Ramasseur de Bouts de Cigares" which, far from being a caricature, expresses the tragedy of failure.

HISTORY

1952 Gobin, No. 53 (terra cotta, ILLUSTRATED)
1957 Galerie Sagot-Le Garrec, Paris, No. 53 (bronze)
1958 Museum of Fine Arts, Boston, No. 16 (bronze)
1961 Musée Cognacq-Jay, Paris, No. 339 (bronze, ILLUSTRATED)
Smith College Museum of Art, Northampton, Mass., No. 22 (bronze)
1962 Museum für Kunst und Gewerbe, Hamburg, No. 115 (bronze)
1963 Brandeis University, Waltham, Mass., No. 126 (bronze)
1966 Palais Galliera, Paris, No. 40 (bronze, ILLUSTRATED)
1968 Château de Blois, No. 490 (bronze)

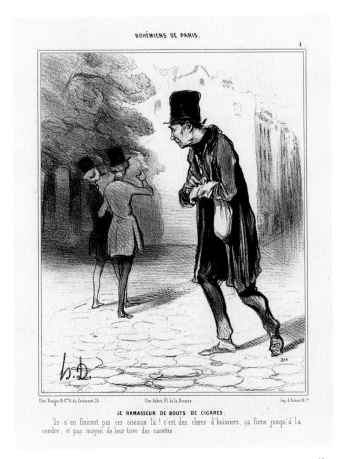

BOHÉMIENS DE PARIS.

LE RAMASSEUR DE BOUTS DE CIGARES.
Ils n'en finiront pas ces oiseaux là ! c'est des clercs d'huissiers, ça fume jusqu'à la cendre, et pas moyen de leur tirer des carottes.

60c.

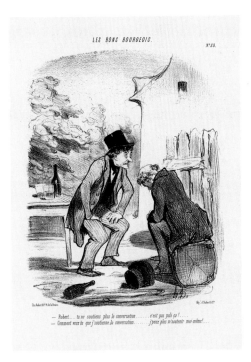

LES BONS BOURGEOIS.

— Robert.... tu ne soutiens plus la conversation...... c'est pas poli ça !....
— Comment veux tu que j'soutienne de conversation...... j'peux plus m'soutenir moi-même!....

60d.

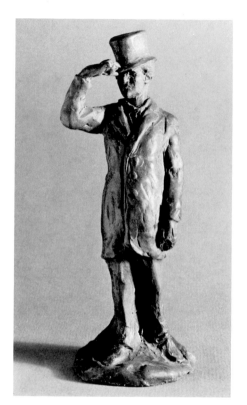
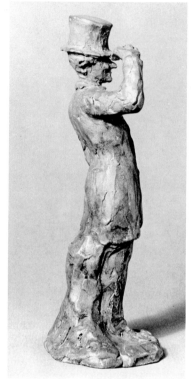

61a.

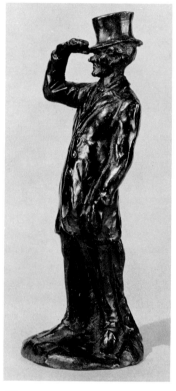

61b.

61a. "LE VISITEUR"
Terra cotta; h. 6¾" (172 mm.)
Private Collection, Paris
(not in exhibition)

61b. "LE VISITEUR"
Cast bronze; h. 6¾" (172 mm.)
Markings: front of base: H.D., Valsuani stamp;
 rear of base: 11/30
National Gallery of Art, Lessing J. Rosenwald
 Collection

61c. A LA VARENNE-SAINT-MAUR, "LA VOILA,
MA MAISON DE CAMPAGNE!" (At Varenne-
Saint-Maur, "There it is, my country house!")
L.D. 3247
(See also no. 56c)

61. "Le Visiteur" (The Visitor)

Gobin No. 57

Companion piece to "Le Petit Propriétaire" (cat. no. 56), "Le Visiteur" is the tall thin friend in the lithograph (see cat. nos. 56c and 61c) who stands with right hand shielding his eyes, as he gazes at the distant house in the country to which its owner points. The left profile of the sculpture is a close copy of the figure in the lithograph, even to the stance with right leg placed in front of the left. The right side of the sculpture, however, is much less developed, with no attempt at modelling the right leg, which becomes part of the unarticulated mass of the back, brought around to the side. Divorced from the action of the lithograph, the statuette could be saluting or even about to remove his top hat. In the lithograph, the action of the raised hand with fingers spread out is perfectly clear. The hand in the sculpture, however, is lifeless, the gesture unconvincing.

The comparison between drawn and modelled figure in the case of "Le Visiteur" leaves little doubt that the inspiration came from the lithograph which has strength and vitality. The weaker statement of the sculpture refutes rather strongly Gobin's theory that it preceded and inspired the lithograph.

HISTORY

1952 Gobin, No. 57 (terra cotta, ILLUSTRATED)
1957 Galerie Sagot-Le Garrec, Paris, No. 57 (bronze, ILLUSTRATED)
1958 Museo Nacional de Bellas Artes, Buenos Aires, No. 280 (bronze, ILLUSTRATED)
 Museum of Fine Arts, Boston, No. 20 (bronze)
1961 Musée Cognacq-Jay, Paris, No. 343 (bronze, ILLUSTRATED)
1966 Palais Galliera, Paris, No. 44 (bronze, ILLUSTRATED)
1968 Château de Blois, No. 494 (bronze)

61c.

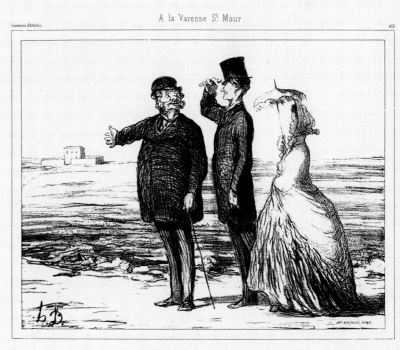

A la Varenne St Maur.

La Voilà!.. ma maison de Campagne!...

62. "L'Amateur en Contemplation"
(The Art Collector in Contemplation)

Not in Gobin

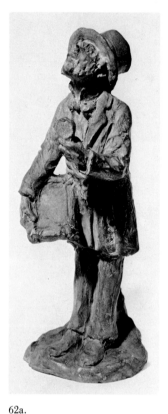

62a.

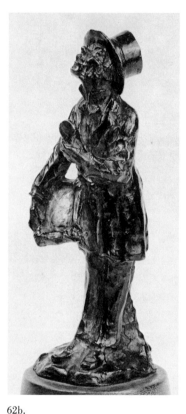

62b.

These two figurines in bronze are listed as "Amateurs de Tableaux en Visite à l'Hôtel Drouot" in the catalogue of the Gaston-Dreyfus sale at the Palais Galliera in June 1966 (nos. 45 and 46), where they made their first published appearance. The catalogue states that they are not described in Gobin, but gives them the Gobin numbers "58 bis" and "58 ter" in an attempt to relate them to "L'Amateur d'Art," the terra cotta presented by Gobin as no. 58. In a retraction published by the *Commissaires-priseurs* at the request of Francis Gobin, Maurice Gobin's heir, the statement is made that these numbers do not appear in the latter's catalogue raisonné, that they do not correspond to any part of his text, and that the numbers were inserted in the sales catalogue for reasons of comparison and in order to place them chronologically.

In the Galliera catalogue, the two figurines are compared to the wood engraving published in 1863 in *Le Monde Illustré* (see cat. no. 62c). The "Amateur en Contemplation" does resemble the figure on the right in the wood engraving, with the magnify-

62c.

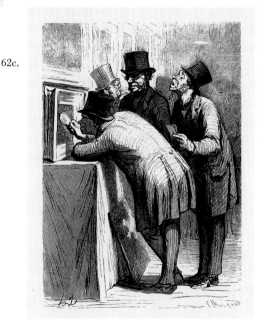

62a. "L'AMATEUR EN CONTEMPLATION"
 Terra cotta; h. 7-9/32" (185 mm.)
 Present location unknown

62b. "L'AMATEUR EN CONTEMPLATION"
 Cast bronze; h. 7-1/16" (179 mm.)
 Markings: rear of base: h.D., Valsuani stamp, EE 3
 Private Collection

62c. L'HOTEL DES VENTES — L'AMATEUR (The
 Auction House — The Collector) Bouvy 940
 Wood engraving, china paper; 225 x 160 mm.
 Le Monde Illustré, April 18, 1863
 Collection Mr. and Mrs. Arthur E. Vershbow,
 Newton, Massachusetts

63. "L'Amateur Surpris"
(Surprised Art Collector)

Not in Gobin

ing glass belonging to the foreground figure transplanted to his left hand. Like "L'Amoureux" (cat. no. 45) and the "Confident" (cat. no. 51), however, the sculpture tilts backward, whereas the corresponding drawn figure leans forward. "L'Amateur Surpris" is not actually found in the wood engraving, although he could easily fit into the group of collectors shown studying a painting.

Since the terra cottas, now in an unknown collection, have not been studied, it is difficult to determine how they compare with others of the terra-cotta figurines. Marcel Lecomte, expert for the Galliera sale, places them with "L'Amateur d'Art" (cat. no. 44), presumably on the basis of subject, since they appear very different from the rotund, smiling gentleman in the bowler hat. Mr. Lecomte finds the back of "L'Amateur Surpris" similar to that of "Le Bourgeois Qui Flâne" (cat. no. 50), and the expression of the face similar to that of "L'Amoureux." Certainly the two "Amateurs" have at least a superficial resemblance to the other figurines, particularly in their scale and surface treatment. However, they appear to be modelled with greater attention to detail, and the hands in particular are far better articulated than those of the other figurines. Mr. Lecomte also points out that the two "Amateurs" can be "married," and indeed they are as obviously characters taken from the same scene, as are "Le Petit Propriétaire" and "Le Visiteur."

Although the history of the terra cottas is unknown, the bronze editions of thirty casts plus four trial proofs was made about 1963-64 by the Valsuani foundry.

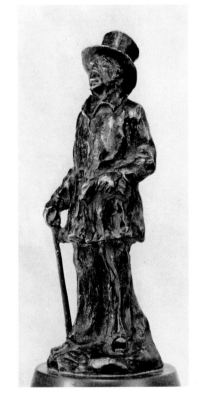

63a. 63b.

HISTORY

1966 Palais Galliera, Paris, Nos. 45 and 46 (bronze, ILLUSTRATED)
Hôtel Drouot, Paris, Nos. 16 and 17 (bronze, ILLUSTRATED)

1968 Château de Blois, Nos. 495 and 496 (bronze)

63a. "L'AMATEUR SURPRIS"
Terra cotta; h. 7-9/32" (185 mm.)
Present location unknown

63b. "L'AMATEUR SURPRIS"
Cast bronze; h. 7-3/16" (183 mm.)
Markings: rear of base: H.D., Valsuani stamp, EE 3
Private Collection

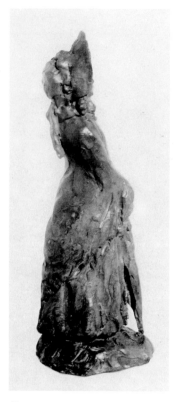

64a.

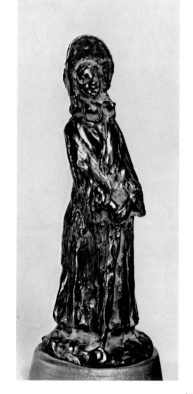

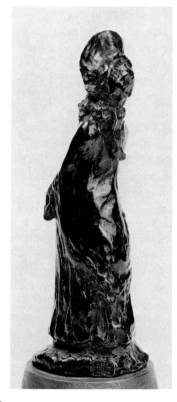

64b.

64a. "COQUETTERIE"
Terra cotta; h. 7-3/16″ (183 mm.)
Present location unknown

64b. "COQUETTERIE"
Cast bronze; h. 6-11/16″ (170 mm.)
Markings: rear of base: H.D., Valsuani stamp, H.C. 2
Private Collection

64c. EH BONJOUR . . . TOUJOURS JOLIE! (Hello there
. . . still pretty!) L.D. 738
Lithograph, second state, white paper; 243 x 189 mm.
Charivari, December 22, 1839
Boston Public Library

64d. JE ME DIS EN MOI-MEME: CROIRAIT ON . . .
(I say to myself: would anyone believe . . .) L.D. 737
Lithograph, second state; 260 x 198 mm.
Charivari, July 17, 1839
Museum of Fine Arts, Boston

64. "Coquetterie" (Flirtation)

Not in Gobin

This is the only female in the group of figurines. The silhouette, in profile, is found in the 1839 lithograph from *Charivari* entitled "Eh Bonjour . . . Toujours Jolie" (see cat. no. 64c), but the insipid and pretty face, not shown in the lithograph, cannot be found in Daumier's oeuvre. Discussing Daumier's treatment of women in his book of 1934 and again in 1965, Raymond Escholier asks if Daumier has ever liked supple and delicate lines, or, in short, the pretty. He answers those who claim to have found charming female figures in some of the lithograph series by demonstrating that these rare characters are always minor figures in the background and lightly sketched. He feels that Daumier never really succeeded in expressing charm and grace in either his children or his young women. Always the good caricaturist, Daumier's women are the ugly and ridiculous creatures of the series of Bathers, Divorcées and Blue-stockings. In another lithograph, also from the *Coquetterie* series (see cat. no. 64d), one sees a young woman with stylish dress and figure, but with a face more typical of Daumier.

The terra cotta of "Coquetterie," in an unknown collection and therefore not studied, appears to be cruder and less developed than most of the other figurines. The ribbon of the bonnet and the curls look as though they had been poured out of a pastry tube, but it is the face, doll-like in its prettiness, that is the least convincing.

Like the two "Amateurs de Tableaux" (cat. nos. 62 and 63), the bronze edition of "Coquetterie" has a recent history. Cast by Valsuani in 1965, a bronze was first published in the Galliera sales catalogue of 1966.

HISTORY

1966 Palais Galliera, Paris, No. 35 (bronze, ILLUS-TRATED)
1968 Château de Blois, No. 485 (bronze)

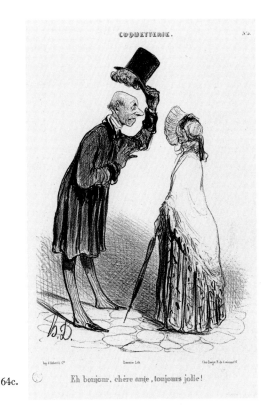

64c.

Eh bonjour, chère amie, toujours jolie!

64d.

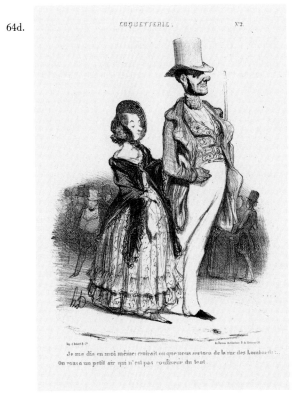

Je me dis en moi même: croirait on que nous sortons de la rue des Lombards?..
On vous a un petit air qui n'est pas confiseur du tout.

65. Tête d'homme souriant
(Head of a Smiling Man)

Gobin No. 38

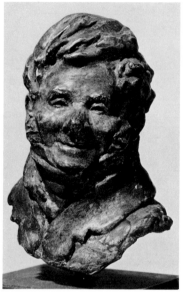

65a.

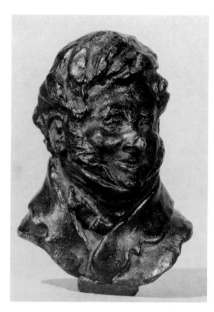

65b.

65a. TETE D'HOMME SOURIANT
Unbaked clay; h. 3-9/16″ (90 mm.)
Markings: center rear of base: h.D.
Ny Carlsberg Glyptotek, Copenhagen, acquired 1950
(not in exhibition)

65b. TETE D'HOMME SOURIANT
Cast bronze; h. 3⅜″ (86 mm.)
Markings: center rear of base: h.D.
National Gallery of Art, Lessing J. Rosenwald
Collection

Two tiny busts of unbaked clay, on an oval red velvet stand typical of the period of Napoleon III, were found by the sculptor Jean Osouf in 1944 at a dealer's in Paris. A hand-written label pasted underneath the stand read: "Souvenir of my step-father, A. Bertrand, master mason; found in the ruins after the fire at the house of Monsieur Daumier."

The smallest of the sculpture thus far attributed to Daumier, the busts are modelled on a simple wood armature. They are made of a yellowish clay which, in drying, has turned almost white, resembling plaster; and they are unevenly coated with a brown shellac-like substance. Each bears the initials "h.D." scratched into the clay in back. Except for an apparent mend on one, along the brim of the hat, they appear to be in good condition.

After a bronze edition of fifteen numbered casts plus two trial proofs had been made of each (presumably under the supervision of Mr. Osouf, since there is no foundry identification on the casts), the unbaked clay originals were acquired in 1950 by the Ny Carlsberg Glyptotek in Copenhagen. In his article "Two Unknown Busts of Daumier" published by the Glyptotek in August 1951, Dr. Haavard Rostrup states that the attribution to Daumier is based upon their high quality. Dr. Rostrup believes that the only clue to the chronology of Daumier's drawings, paintings and sculpture is to be found in the 4000 lithographs he produced between 1830 and 1876, and he relates the little busts to the lithographs of the '40s and '50s when the exaggeration of the early political caricatures had given way to a more broadly based social satire. He considers them closer to the "Ratapoil" of around 1850 than to the busts of the 1830's. He finds the smiling man not unlike Daumier himself, with a round, kind face framed in well cared-for whiskers, but with small, piercing eyes and a sly smile. He believes the man in the top hat, on the other hand, anticipates "Ratapoil," with the shabby elegance of the old military man turned political spy, and a fox-like face that reveals both cunning and brutality. Dr. Rostrup particularly admires the battered top hat, reminiscent of the *Robert Macaire* series, and he points out that with this small bust the hat has entered French sculpture. He finds the prototype of the sculptured bust in a Daumier drawing in profile of a man with a mustache, which was reproduced by Fuchs (p. 11, pl. 7), although its present whereabouts is unknown. This, he believes, is the same man several years earlier when he was not yet so seedy and down-at-the-heel.

Gobin, on the other hand, dates the two little busts

much earlier, based on a slight resemblance between the smiling man and an 1835 lithograph of the President of the Court, Ferey, who is in fact pouting and sneering rather than smiling; and between the man in the top hat and a mustached man in a *Charivari* lithograph of 1838. (The 1842 lithograph from the series *Bohémiens de Paris* [see cat. no. 66c] perhaps comes a little closer to the bust of the top-hatted man than the one chosen by Gobin.) He finds them agreeable portraits rather than caricatures, coming somewhere between the violently satirical busts and the figurines, although he does not consider them as sharp and penetrating as the latter. He believes they belong to a period when Daumier appears slightly weak, and the lithographs tend to be banal and flat. He regrets, however, that they were not brought to his attention by Mr. Osouf before the clay originals went to Copenhagen, and that he knew them only from the bronze casts. He speculates that the bronzes probably lack some of the quality of the originals.

Gobin is quite right in assuming that there is a loss of quality between the original clays and the bronze casts. When the scale is so small, there is an inevitable loss of detail during the complicated process of casting. Considering their size, the original clays have a quite extraordinary liveliness of expression, which is blurred in the bronze version. One can also agree with Gobin that these are portraits, and with Dr. Rostrup that they are objects of quality. Perhaps, however, Dr. Rostrup is reading too much into them when he sees similarities to "Ratapoil." The little heads, lively portraits that they are, are done with understatement, whereas "Ratapoil" is gloriously overstated.

The little heads are modelled in a very different manner from that used by Daumier when he made his political caricature busts. They are handled in a more compact manner, without the deep undercuts typical of Daumier's documented sculpture. Also, unlike Daumier's *portraits-charges* which are squared off somewhere below the shoulder, the two little busts were designed as fragments, and were made to float, suspended on their supports. Daumier's sculpture, as demonstrated in the political busts and the "Ratapoil," has a consistency of handling. Skin, collar, head and hair are all handled in the same manner. There is a greater variety of texture in the two little busts, a contrasting of skin and hair, of face and clothing.

The little busts are skillful portraits, the work of a practiced hand. If, however, they are portraits by Daumier, then the subjects, not clearly found in his drawings or graphic work, remain unknown. Yet they are modelled in a manner so different from the

66. Tête d'homme en chapeau haut de forme
(Head of a Man in a Top Hat)

Gobin No. 39

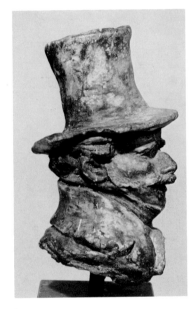 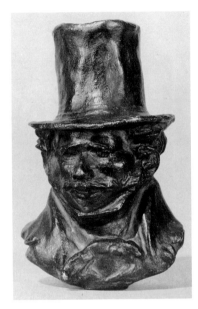

66a. 66b.

66a. TETE D'HOMME EN CHAPEAU HAUT DE FORME
Unbaked clay; h. 4-17/32″ (115 mm.)
Markings: right rear of collar: H.D.
Ny Carlsberg Glyptotek, Copenhagen, acquired 1950
(not in exhibition)

66b. TETE D'HOMME EN CHAPEAU HAUT DE FORME
Cast bronze; h. 3⅞″ (98 mm.)
Markings: right rear of collar: H.D.
National Gallery of Art, Lessing J. Rosenwald Collection

66. Tete d'Homme en chapeau haut de forme
(Head of a Man in a Top Hat)

sculptured style associated with Daumier that one questions how they fit into his oeuvre. It is not impossible that the initials "h.D." were applied independently of their creation, in this instance simply by re-wetting the unbaked clay and scratching them into the moistened surface. Like the "Pitre Aboyeur" (cat. no. 41), these busts suggest the possibility of a 19th century sculptor as yet unidentified.

J.L.W.

HISTORY

1951 Rostrup, 40-48 (unbaked clay, ILLUSTRATED)
1952 Gobin, Nos. 38, 39 (unbaked clay, ILLUS-
TRATED)
1957 Galerie Sagot-Le Garrec, Paris, Nos. 38, 39
(bronze)
1963 Musée Cognacq-Jay, Paris, Nos. 328, 329
(bronze, ILLUSTRATED)
1964 Rostrup, Nos. 615e, 615f (unbaked clay)
1966 Palais Galliera, Paris, Nos. 27, 28; Pl. XV
(bronze, ILLUSTRATED)
1968 Château de Blois, Nos. 476, 477 (bronze)

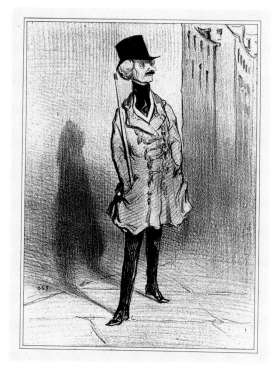

66c.

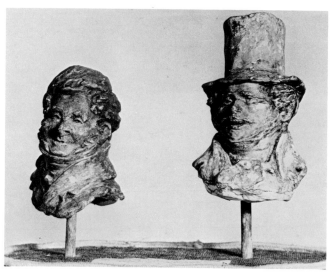

The two little busts on their original mounting.

66c. LE CHEVALIER DE L'EPERON D'OR (The Knight
of the Golden Spur) L.D. 845
Lithograph, first state, white paper; 249 x 183 mm.
Charivari, February 27, 1842
Museum of Fine Arts, Boston

250

Appendix

As this catalogue was being prepared, several sculptures attributed to Daumier, but not mentioned in Gobin, were brought to our attention. Only one of these, the bust of Dupin, was available for study. Although we have not seen the others, and know them only through photographs, we have decided to include them in the catalogue. Their inclusion is important, we believe, since, in two instances, bronze editions have been made. It is our hope, that by illustrating these sculptures, noting their histories, and pointing out certain stylistic elements, we can place them in their proper context and set the stage for future, more conclusive study.

We are indebted to the owners for providing photographs and information and for their generosity in encouraging this objective inquiry.

I. Full-length Figure of d'Argout

Acquired around 1946 from the heirs of Paul Bureau, this clay figurine (cat. no. Ia) is thought by its owner to have been a study for Daumier's full-length lithograph of Comte d'Argout (cat. no. Ib). It is certainly very like the lithograph in pose and costume. The details are so faithful to the lithograph, in fact, that at first glance its use as a model seems logical. But one must remember that a reversal takes place when an image drawn on stone is transferred to the printed page. In this case, such a reversal should have caused the figure's top hat to appear in his left hand and the folded papers in his right. The fact that they appear in the same hands, both in the sculpture and the print, suggests that the sculpture more likely follows after the lithograph.

A comparison between this full-length sculpture of d'Argout and Daumier's bust and two lithographs of the same subject reveals significant differences (see cat. nos. 1a, 1e, and Ib). Most striking is the shape of the head, which is flat-topped and angular in Daumier's clay bust and lithographs, and almost round in the full-length sculpture. In addition, the nose of the figurine is prominent and exaggerated, but lacks the beak-like hook that is so clearly emphasized in Daumier's clay bust and in his lithographs.

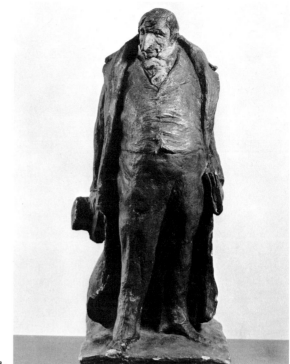

Ia.

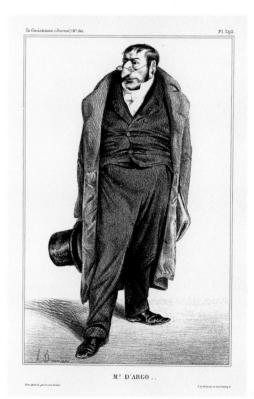

Ib.

Ia. FULL-LENGTH FIGURE OF D'ARGOUT
Clay (?), painted; h. 11-7/16″ (290 mm.)
No casts
Provenance: Paul Bureau
Collection Docteur Christian Tomasini, Paris,
 acquired c. 1946
(not in exhibition)

Ib. Mr. D'ARGO. . . . L.D. 62
Lithograph, second state; 280 x 184 mm.
La Caricature, July 11, 1833
Benjamin A. and Julia M. Trustman Collection,
 Brandeis University

251

The full-length sculpture of d'Argout is modelled in a manner quite different from the d'Argout bust. The handling is much smoother and indications of surface texture appear to be made by brush marks left in the thick coating, rather than by the comb tool marks typical of Daumier's documented sculpture. Identification of the actual material used, can be made only through laboratory analysis.

II. Le Roi Minos (King Minos)

Like the full-length figure of d'Argout (see cat. no. Ia), the statuette of King Minos was acquired from the heirs of Paul Bureau around 1946 and is presumed to be made of unbaked clay that has been painted. Dr. Tomasini, the present owner, is of the opinion that the statuette was modelled by Daumier before he made the drawing for the lithograph "Clémence de Minos," which appeared in the *Charivari* series *Histoire Ancienne* (see cat. no. IIb). He bases this theory on the observation that the right side of the sculpture is superior to the left, indicating that Daumier made his drawing from the more articulated side, which appears reversed in the lithograph.

It is difficult to corroborate this opinion without actually examining the statuette itself. However, both sides, as they appear in the photographs, seem to lack the vitality of the drawn figure. In addition, unlike the lithograph, there is no articulation of the muscles of neck and arm in the sculpture, nor any clear sense of the body beneath the drapery of the garment.

There is little evidence of Daumier's modelling techniques in the statuette of Minos which has largely smooth surfaces, and lines that appear to have been made with a blunt tool, rather than the comb tool more typical of Daumier's documented sculpture.

It appears unlikely that the rather flaccid statuette served as a model for the vigorous drawing.

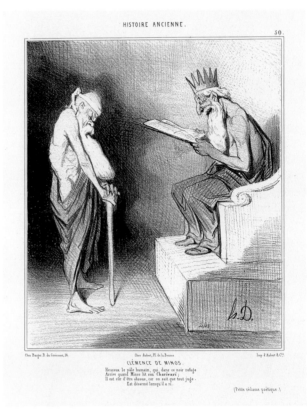

IIb.

IIa. LE ROI MINOS
 Clay (?), painted; h. 7-1/16″ (180 mm.)
 No casts
 Provenance: Paul Bureau
 Collection Docteur Christian Tomasini, Paris,
 acquired c. 1946
 (not in exhibition)

IIb. CLEMENCE DE MINOS (The Clemency of Minos)
 L.D. 974
 Lithograph, second state, white paper; 237 x 202 mm.
 Charivari, January 5, 1843
 Museum of Fine Arts, Boston
 (not in exhibition)

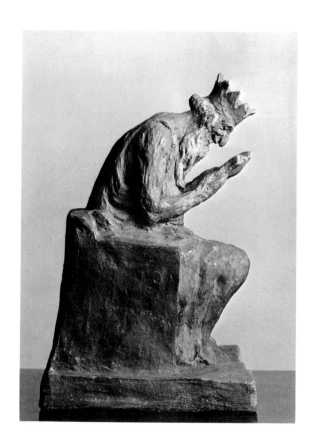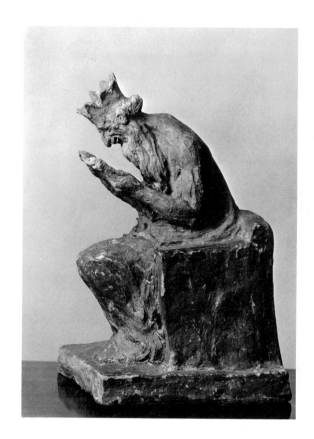

IIa.

Appendix

III. Bust of Dupin

We are very grateful to Dr. Howard P. Vincent for allowing us to borrow his bust of Dupin, in time to study it before the opening of the present exhibition. Visual comparisons suggest a resemblance between this bust (see Appendix IIIa) and the full-length figure of d'Argout (see Appendix Ia) and the seated figure of King Minos (see Appendix IIa), for example, in the modelling, and in the application of a thick, painted coating. All three appear to be in good condition. Although comparative laboratory studies on the Dupin had not been completed at press time, the findings that were available are noted here. Under ultra-violet light, the Vincent bust shows little evidence of having been repaired, except for small areas of repainting, notably around the eyebrows and over the initials "h.D.," which appear on the bottom of the right shoulder. The bust has been hollowed out as if intended for baking. Laboratory analysis by x-ray defraction of a sample taken from this bust indicates the material is unbaked clay of a pinkish-yellow color composed of a high percentage of silica with lower percentages of kaolinite and siderite.

In his recently published book *Daumier and His World*, Dr. Vincent reproduces his bust of Dupin (p. 46, pl. 15) and speculates that it could well be one of the missing Daumier caricature busts, perhaps the thirty-seventh, "in good condition, probably because it was in the hands of a Daumier enthusiast, an admirer like Nadar (or Champfleury), who guarded it with loving care." We have shown (see Introduction to the Busts) that the Le Garrec clay busts were not mistreated, but were kept carefully in glass cases for years by the Philipon family, until they were acquired by Maurice Le Garrec in 1927. Their deterioration, as demonstrated in early photographs and in the photographs recently taken for this catalogue, suggests that they were modelled by an inexperienced sculptor, who left them as solid blocks of clay which shrank and cracked in drying. The Vincent Dupin, on the other hand, has been hollowed out to reduce shrinkage, warpage and subsequent cracking.

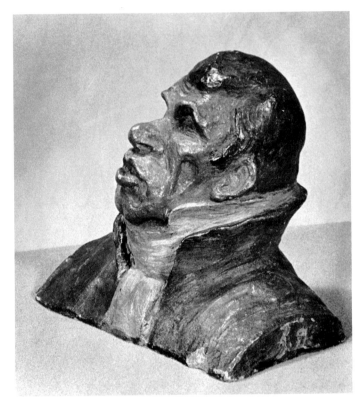

IIIa.

IIIa. BUST OF DUPIN
 Unbaked clay, painted; h. 5½″ (140 mm.)
 No casts
 Markings: lower right shoulder: h.D.
 Provenance: Berberian family, Chicago
 Collection Dr. Howard P. Vincent, Kent, Ohio,
 acquired 1957

In *Daumier and His World*, Dr. Vincent writes (note 9, p. 247): "I bought the bust at the Sheridan Art Galleries in Chicago on 17 September 1957. It was Item 407, listed as an 'Original Sculptured Terra Cotta Bust of a Senator, Circa 1834. Signed H. D. lower right,' and it was but one item in a large four-day sale of the household effects of the Berberian Estate and the Arthur Van Sant collection. Who owned the bust before Berberian or Van Sant is as yet unknown. I suspect it is the bust which Philipon gave to Nadar, because a number of Nadar's effects, especially his enormous collection of photographic plates, have come to America . . ."

If Dr. Vincent's theory were correct, it seems odd that Daumier should have made two clay busts of the same personage. Would not busts of other subjects portrayed in the lithographs, such as Thiers or Jollivet, be more plausible? In addition, this second Dupin (see cat. no. IIIa) is very different from the Dupin portrayed in the Le Garrec bust (see cat. no. 9a) and the lithograph (see cat. no. 9f). It is a shortened version, ending abruptly just below the shoulders, while the shoulders themselves are so abbreviated that they appear sliced off at the ends. It also lacks the narrow, pointed head, high angular cheekbones, and ape-like appearance so strongly depicted in the Le Garrec clay and the lithograph. Only the pursed mouth and protruding lower lip resemble the drawn Dupin. Like the full-length sculpture of d'Argout (see cat. no. Ia), the Vincent Dupin lacks the strength and pungency of Daumier's drawings.

It is possible that Mme. Philippe Garcin's reference to "reproductions of Daumier's busts made around 1850" (see Introduction to the Busts) has some relevancy here. If such copies actually were made long ago, they could provide a possible explanation for these old but well-preserved sculptures, so close to Daumier in subject and yet so far removed in style.

IV. Le Boucher (The Butcher)

Mr. Fersing states (letter to the Fogg Museum, January 7, 1969) that he found the bronze sculpture which he calls "Le Boucher" in an antique shop in Paris about eight years ago. Although it was attributed to Rodin, he recognized the subject as one that appears in several Daumier lithographs and drawings. A pen and ink, wash and watercolor drawing in the Fogg Museum (see cat. no. IVb) comes closest to the sculpture. Convinced that the bronze "Butcher" was an unknown sculpture by Daumier, he sought the opinion of several experts, among them museum curators, professors of art and sculptors. Professor Raymond Martin suggested that a comparison be made with the sculpture of Dalou, and following this advice, Mr. Fersing visited the sculpture reserves at the Petit Palais in Paris. There he discovered that his bronze originated from a wax owned by that museum and attributed to Falguière. Further investigation revealed that the sculptor J. A. Falguière (1831-1900) had willed the contents of his studio to the National Museums of France, and since the wax was found among his effects, it was attributed to him.

Unconvinced by his comparison with the sculpture of Dalou and Falguière, Mr. Fersing studied the plaster of the "first" version of "Les Emigrants" at the Louvre and both a plaster and a Siot-Decauville bronze of the "Ratapoil" at the Musée des Beaux-Arts in Marseilles. He concluded that his bronze was indeed a sculpture by Daumier. Since the wax original in the Petit Palais Museum was in poor condition, he decided to have a bronze edition made by the Valsuani foundry, from his bronze cast. An edition of 30 casts numbered 1/30 – 30/30 plus two *hors commerce* is contemplated. Four casts have been made so far, two of which have been sold.

Mr. Fersing and several of those whom he consulted have found stylistic similarities between Daumier's documented sculpture and "Le Boucher." Our study of Daumier sculpture, however, does not lead us to this conclusion. It is always difficult to resolve problems of attribution by means of stylistic comparisons alone. Until more is learned about the work of some less-known sculptors of the 19th century, similar problems inevitably must remain unsolved.

Appendix

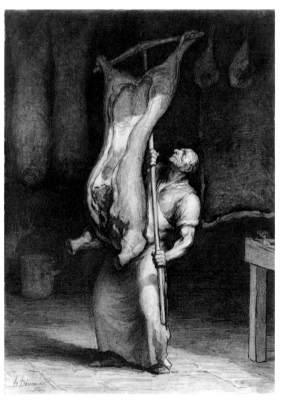

IVb.

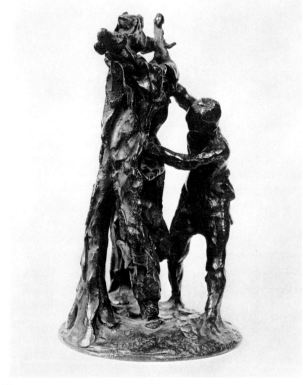

IVa.

IVa. LE BOUCHER
Cast bronze; h. 9″ (228 mm.)
Bronze edition of 30 plus 2 *hors commerce* cast by
Valsuani; now in progress
Collection Aage Fersing, Paris, acquired c. 1961
(not in exhibition)

IVb. LE BOUCHER (Maison no. 264)
Pen and ink, wash and watercolor; 328 x 225 mm.
Signed lower left corner: h. Daumier
Provenance: R. Davis
Bignou
Fogg Art Museum, Harvard University,
Grenville L. Winthrop Bequest
(not in exhibition)

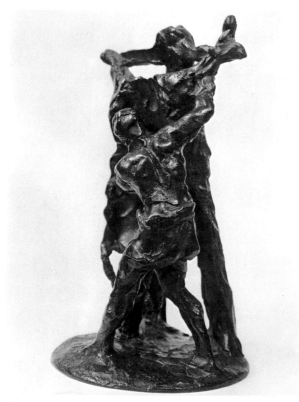

IVa.

V. Head of a Man in a Top Hat
(See Cat. No. Va and Vb)

The painter, Sam Szafran, found this small head of unbaked clay in the Fall of 1963 at the stand of a dealer at the *Foire à la Ferraille*, an antique fair held annually in Paris. The dealer told Mr. Szafran that he had bought the contents of the studio of an old painter who had just died, which contained, among other things, 18th century costumes and antique studio mannequins. Struck by the quality of the small sculpture, Mr. Szafran purchased it and, convinced that it was an unknown sculpture by Daumier, sought confirmation of this opinion from several artists, critics and museum specialists. He had

hoped to show it to Maurice Gobin, but learned by letter that he had died several months before. Although several of the specialists to whom the sculpture was shown appeared to be impressed by it, no one would commit himself to a definite pronouncement on the attribution to Daumier.

Subsequently, the clay head was sold to Joseph H. Hirshhorn, who authorized Pierre Matisse to have a bronze edition of thirty numbered casts made by the Valsuani foundry. It is interesting to note that the clay has no signature (see cat. no. Va), but the initials "h.D." were incised by the foundry in the wax models and then cast in the bronzes (see cat. no. Vb). It is the same procedure as that which was used for the bronze editions of the "Ratapoil" and both versions of "Les Emigrants."

The authorship of this small sculpture is puzzling, for it bears no stylistic resemblance to Daumier's caricature busts. The modelling is smooth, creating an effect of simplification which is entirely different from the bold modelling and consistently textured surfaces of Daumier's documented sculpture. Furthermore, the sculpture is not really a bust in the traditional sense. Unlike Daumier's caricature busts, which include shoulders and the sides of the shoulders, the "Head of a Man in a Top Hat" terminates just below the neck, resembling, in this respect, the two little busts in the Glyptotek (see cat. nos. 65a and 66a). The resemblance to the Glyptotek heads, however, does not appear to go beyond this aspect, although it would be interesting to make a detailed comparison between them under laboratory conditions.

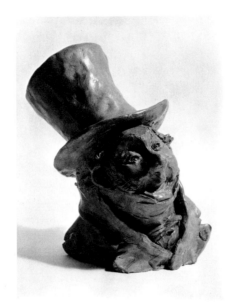

Va.

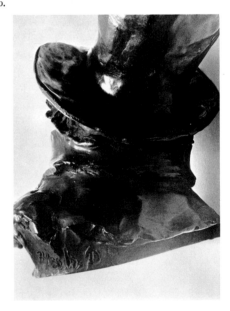

Vb.

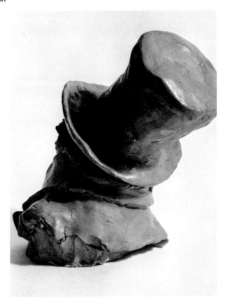

Va. HEAD OF A MAN IN A TOP HAT
 Unbaked clay: 6½″ (165 mm.)
 Bronze edition of 30 cast by Valsuani in 1968
 Provenance: Sam Szafran
 Collection Joseph H. Hirshhorn, New York
 (not in exhibition)

Vb. HEAD OF A MAN IN A TOP HAT
 Cast bronze; h. 6½″ (165 mm.)
 Markings: lower left shoulder: 7/30, h. D.;
 right rear: Valsuani stamp
 Pierre Matisse Gallery, New York
 (not in exhibition)

Bibliography

Books

Adhémar Adhémar, Jean *Honoré Daumier*, Paris: Editions Pierre Tisné, 1954

Alexandre Alexandre, Arsène *Honoré Daumier*, L'Homme et L'Oeuvre, Paris: Librairie Renouard, H. Laurens, Successeur, 1888

Arts et Livres de.Provence *Arts et Livres de Provence*, Daumier issue, Marseilles, 1948

Auquier Auquier, Philippe *Musee des beaux-arts Catalogue des peintures, sculptures, pastels, et dessins*, Marseilles: Barlatier, 1908

Baudelaire Baudelaire, Charles *Les Dessins de Daumier, Ars Graphica*, Paris: Aux Editions G. Crès et Cie., 1924

Bertels Bertels, Kurt *Honoré Daumier als Lithograph*, München und Leipzig: R. Piper & Co., Verlag, 1908

Bouvy 1933 Bouvy, Eugène *Daumier L'Oeuvre Gravé du Maître*, 2 vols., Paris: Maurice Le Garrec, 1933

Bouvy 1932 Bouvy, Eugène *Trente-six Bustes de H. Daumier*, Paris: M. Le Garrec, éditeur, 1932

Burty Burty, Philippe *Croquis d'Après Nature*, Notes sur Quelques Artistes Contemporains (Extrait de la Revue Rétrospective de 1897), Paris: aux Bureaux de la Revue Rétrospective, 1897

Champfleury 1878 Champfleury *Catalogue de l'oeuvre lithographié et gravé de H. Daumier*, Paris: Librairie Parisienne, 1878

Champfleury 1865 Champfleury *Histoire de la Caricature Moderne*, Paris: E. Dentu, Editeur, 1865

Claretie Claretie, Jules *Peintres et Sculpteurs Contemporains*, Première série. Artistes décédés de 1870 à 1880. Paris: Librairie des Bibliophiles, 1882

Cochet Cochet, Gustavo *Honoré Daumier*, Biblioteca Argentina de Arte, Buenos Aires: Editorial Poseidon, 1945

Courthion Courthion, Pierre (dirigée par) *Daumier Raconté par lui-même et par ses amis*, Collection les Grands Artistes vus par eux-mêmes et par leurs amis, Vésenaz-Genève: Pierre Cailler, Editeur, 1945

Dayot Dayot, Armand *Journées Révolutionnaires 1830-1848*, D'Après des Peintures, Sculptures, Dessins, Lithographies, Médailles, Autographes, Objets . . . du Temps. Paris: Ernest Flammarion, Editeur, 1897

Delteil (L.D.) Delteil, Loys *Le Peintre-Graveur Illustré, Honoré Daumier*, 11 vols., Paris: 1925-30

Escholier 1934 Escholier, Raymond *Daumier*, Anciens et Modernes, Paris: Librairie Floury, 1934

Escholier 1913 Escholier, Raymond *Daumier*, Les Ecrits et La Vie Anecdotique et Pittoresque des Grands Artistes, Paris: Louis Michaud 1913

Escholier 1930 Escholier, Raymond *Daumier 1808-1879*, Paris: Librairie Floury, 1930

Escholier 1965 Escholier, Raymond *Daumier et Son Monde*, Nancy: Editions Berger-Levrault, 1965

Escholier 1923 Escholier, Raymond *Daumier Peintre et Lithographe*, La Vie et L'Art Romantiques, Paris: H. Floury, Editeur, 1923

Faure Faure, Elie *Histoire de l'Art*, L'Art Moderne (new edition, revised and enlarged), Paris: Les Editions G. Crès et Cie., 1924

Le Foyer Le Foyer, Jean *Daumier au Palais de Justice*, Paris: Editions du Vieux Colombier, 1958

Fuchs 1927 Fuchs, Eduard (intro.) *Der Maler Daumier*, New York: E. Weyhe, 1927

Fuchs Fuchs, Eduard (intro.) *Honoré Daumier Holzschnitte 1833-1870*, München: Albert Langen, Verlag, n.d.

Geffroy 1901 Geffroy, Gustave "Daumier," ex-

traite de la *Revue de l'Art Ancien et Moderne*, no. 158, Paris: Librairie de L'Art Ancien et Moderne, 1901

Gobin Gobin, Maurice *Daumier Sculpteur 1808-1879*, Genève: Pierre Cailler Editeur, 1952

Grass-Mick Grass-Mick, A. *La Lumière sur Daumier*, Marseilles: A. Tacussel, Editeur, 1931

Klossowski Klossowski, Erich *Honoré Daumier*, München: R. Piper & Co., 1923

Larkin Larkin, Oliver W. *Daumier, Man of His Time*, New York, Toronto, London: McGraw-Hill Book Company, 1966

Lassaigne Lassaigne, Jacques *Daumier*, translation Eveline Byam Shaw, London, Toronto: William Heinemann Ltd., 1939

Lejeune Lejeune, Robert *Honoré Daumier*, Lausanne: Editions Clairefontaine, 1953

Licht Licht, Fred *Sculpture 19th & 20th Centuries*, Greenwich, Conn.: New York Graphic Society, 1967

Luc-Benoist Luc-Benoist *La Sculpture Romantique*, Paris: La Renaissance du Livre, 1928

Magnin Magnin, Jeanne *Un Cabinet d'Amateur Parisien en 1922*, Paris, Dijon: Collection Maurice Magnin, 1922

Maison *Daumier Drawings* Maison, K. E. *Daumier Drawings*, London, New York: Thomas Yoseloff, 1960

Maison *Catalogue Raisonné* Maison, K. E. *Honoré Daumier, Catalogue Raisonné of the Paintings, Watercolours and Drawings*, 2 vols., London: New York Graphic Society, 1968

Marcel Marcel, Henry *Honoré Daumier*, Les Grands Artistes, Leur vie-Leur oeuvre, Paris: Librairie Renouard, Henri Laurens, Editeur, [1907]

Pach Pach, Walter *The Masters of Modern Art*, New York: B. W. Huebsch, Inc., 1924

Phillips Phillips Publications, The *Honoré Daumier, Appreciations of His Life and Works*, New York: E. P. Dutton and Co., 1922

Rey 1965 Rey, Robert *Honoré Daumier*, New York: Harry N. Abrams, 1965

Rey 1959 Rey, Robert *Honoré Daumier 1808-1879*, Livres de Poche, Paris: Flammarion, 1959

Rosenthal Rosenthal, Léon *Daumier*, L'Art de Notre Temps, Paris: Librairie Centrale des Beaux-Arts, 1911

Rostrup 1964 Rostrup, Haavard *Moderne Skulptur*, dansk og udenlandsk, Ny Carlsberg Glyptotek, Kobenhavn: Moderne afdeling, 1964

Rümann Rümann, Arthur *Daumier Der Meister der Karikatur*, München: Delphin-Verlag, 1920

Sadleir Sadleir, Michael *Daumier, The Man and the Artist*, London: Halton & Truscott Smith, Ltd., 1924

Scheiwiller Scheiwiller, Giovanni *Honoré Daumier*, Arte Moderna Straniera, no. 5, Milano: Ulrico Hoepli-Editore, 1936

Vincent Vincent, Howard P. *Daumier and His World*, Evanston: Northwestern University Press, 1968

Articles

Anon. "Une Exposition Daumier à Marseille," *L'Art et Les Artistes, Art Ancien, Art Moderne, Art Décoratif*, no. 95, March 1929, 210

Albright Art Gallery Anon. "Gallery Notes," *Buffalo Fine Arts Academy, Albright Art Gallery*, vol. XIX, nos. 1 and 2, January 1955, pp. 37, 71

Blin Blin, Louis "En Attendant un Musée Daumier. La ville de Marseille achète une série de statuettes de son grand artiste." *Arts*, Beaux-Arts Litterature Spectacles, February 6, 1948, 8

Brookner Brookner, Anita "Current and Forthcoming Exhibitions Paris," *The Burlington Magazine*, May 1958, n. 662, 185

La Caricature	*La Caricature* Journal fondé et dirigé par Ch. Philipon, Paris, 1830-35
Charivari	*Charivari* Journal fondé et dirigé par Ch. Philipon publiant chaque jour un nouveau dessin, Paris, 1832-36
Duranty	Duranty, [Edmond] "Daumier," *Gazette des Beaux-Arts*, v. 17, 1878, I, 428-43; II, 528-44
Feydy	Feydy, Jacques "Plastique et psychologie dans les peintures de Daumier," *Bulletin de la Société de l'Histoire de l'Art Francais*, 1954, 84-91
Focillon	Focillon, Henri "Honoré Daumier (1808-1879)," *Gazette des Beaux-Arts*, August 1929, 79-104
Garcin	Garcin, Madame Philippe "Sur les Bustes modelés par Daumier," *Aesculape*, January 1959, 21-30
Geffroy 1905	Geffroy, Gustave "Daumier Sculpteur," *L'Art et Les Artistes*, April-September 1905, 100-108
Guillet	Guillet, Hubert "Les Bustes de Daumier au Musée des Beaux-Arts — A Marseille," *Arts*, Beaux-Arts-Litterature-Spectacles, February 20, 1948, 8
Ivins	Ivins, W. M., Jr. "Daumier — The Man of His Time," *The Arts*, February 1923, 88-102
Kahn	Kahn, Gustave "Daumier," *Gazette des Beaux-Arts*, vol. 25, 1901, 483-492
Kaposy	Kaposy, Veronika "Remarques Sur Deux Epoques Importantes de l'Art de Daumier Dessinateur," *Acta Historiae Artium*, vol. XIV, 1968, 255-273
Lemann *Daumier and the Republic*	Lemann, Bernard "Daumier and the Republic," *Gazette des Beaux-Arts*, February 1945, 104-20
Lemann *Daumier père et Daumier fils*	Lemann, Bernard "Daumier père et Daumier fils," *Gazette des Beaux-Arts*, May 1945, 297-316
Marceau-Rosen	Marceau, Henri and Rosen, David "A Terracotta by Daumier," *The Journal of the Walters Art Gallery*, vol. XI, 1948, 76-82
Meier-Graefe	Meier-Graefe, Julius "Honoré Daumier — Fifty Years After," *International Studio*, September 1929, 20-25
Mourre	Mourre, Charles "Bustes et Personnages," Daumier issue, *Arts et Livres de Provence*, no. 8, 1948, 97-100
V. N. 1930	V. N. "Exhibitions," *International Studio*, July 1930, 74-76
Osiakouski	Osiakouski, Stanislav "History of Robert Macaire and Daumier's Place in it," *The Burlington Magazine*, November 1958, 388-92
Rostrup 1951	Rostrup, Haavard "To Ukendte Buster af Daumier," *Meddelelser Fra Ny Carlsberg Glyptotek*, 1951, 39-48
Rueppel	Rueppel, Merrill C. "Bas Relief by Daumier," Bulletin I, *The Minneapolis Institute of Arts*, Spring 1957, 9-12
Seymour	Seymour, C., Jr. "Note," *Art News*, September 1949, 43
Thuillier	Thuillier, Jacques "Le Musée Magnin à Dijon," *L'Oeil*, March 1966, 16-23, 68-70
C. V. *Emporium*	C. V. "Marsiglia: I busti di Daumier al Museo di Belle Arti," *Emporium*, April 1948, 184-85

Exhibitions

Durand-Ruel 1878	*Exposition des Peintures et Dessins de H. Daumier* Notice biographique par Champfleury. Paris, Galeries Durand-Ruel, 1878
Champfleury sale 1891	*Catalogue des Eaux-Fortes, Lithographies, Caricatures, Vignettes Romantiques, Dessins et Aquarelles Formant la Collection Champfleury* Pref. Paul Eudel. Paris, Léon Sapin, Lib., January 26, 1891
Palais de l'Ecole des Beaux-Arts 1901	*Exposition Daumier* Paris, Palais de l'Ecole des Beaux-Arts, May 1901
Galerie Georges Petit	*Catalogue des Tableaux Modernes* Composant la Collection de M. Ar-

1903	sène Alexandre Paris, Galerie Georges Petit, May 18-19, 1903	Buenos Aires 1958	*H. Daumier 1808-1958* Buenos Aires, Museo Nacional de Bellas Artes, June-July 1958
Galerie Matthiesen 1926	*Ausstellung Honoré Daumier 1808-1879* Gemälde, Aquarelle, Zeichnungen Plastik Berlin, Galerie Matthiesen, February 21-March 31, 1926	Los Angeles County Museum 1958	*Honoré Daumier*, Exhibition of Prints, Drawings, Watercolors, Paintings, and Sculpture Los Angeles County Museum, November 1958
Hôtel Jean Charpentier 1926	*Exposition "Louis-Philippe"* (l'Art et la Vie sous Louis-Philippe) 1830-1848 Paris, Hôtel Jean Charpentier, June 16-July 10, 1926	Museum of Fine Arts, Boston 1958	*Honoré Daumier Anniversary Exhibition, 1958* Prepared by Peter A. Wick. Boston, Museum of Fine Arts, 1958
Galerie Georges Petit, Bureau Collection 1927	*Catalogue des Tableaux Anciens . . . Oeuvres Importantes de Daumier* Composant la collection de M. Paul Bureau Paris, Galerie Georges Petit, May 20, 1927	Bibliothèque Nationale 1958	*Daumier Le Peintre Graveur* Prepared by Jean Adhémar. Paris, Bibliothèque Nationale, 1958
MOMA 1930	*Corot-Daumier* New York, Museum of Modern Art [MOMA], October 16-November 23, 1930	National Gallery, Cape Town 1958	*Honoré Daumier 1808-1879* Introduction John Paris. Cape Town, National Gallery, 1958
Musée de l'Orangerie 1934	*Daumier Peintures Aquarelles Dessins* Preface Anatole de Monzie. Introduction Claude Roger-Marx. Paris, Musée de l'Orangerie, 1934	Galerie Charpentier 1960	*Tableaux Meubles Objets d'Art* Paris, Galerie Charpentier, March 29, 1960
Bibliothèque Nationale 1934	*Daumier*, Lithographies, Gravures sur Bois, Sculptures Introduction Julien Cain. Paris, Bibliothèque Nationale, 1934	Smith College 1961	*Daumier*, An exhibition of paintings, drawings, sculpture, prints. Northampton, Smith College Museum of Art, October 6-29, 1961
Albertina 1936	*Honoré Daumier, Zeichnungen, Aquarelle, Lithographien, Kleinplastiken* Vienna, Albertina, November-December 1936	Musée Cognacq-Jay 1961	*Daumier dessins lithographies sculptures oeuvre gravé* Prepared by René Héron de Villefosse. Paris, Musée Cognacq-Jay, 1961
Pennsylvania Museum of Art 1937	*Daumier 1808-1879* Introduction Claude Roger-Marx. Philadelphia, Pennsylvania Museum of Art, 1937	Museo Poldi Pezzoli 1961	*Daumier Scultore* Prepared by Dario Durbé. Milan, Museo Poldi Pezzoli, 1961
Buchholz Gallery 1939	*Sculpture by Painters* New York, Buchholz Gallery Curt Valentin, October 31-November 25, 1939	Museum für Kunst und Gewerbe 1962	*Honoré Daumier und Sein Kreis* Karikaturen Bronzen Dokumente Hamburg, Museum für Kunst und Gewerbe, Deutsche-Französische Gesellschaft "Cluny," October 19-November 21, 1962
Musée Cantini 1947	*L'Oeuvre d'Honoré Daumier 1808-1879*, Peintures, Sculptures, Dessins, Lithographies, Livres Illustrés Marseilles, Musée Cantini, June 14-July 6, 1947	Brandeis University 1963	*Honoré Daumier* The Benjamin A. and Julia M. Trustman Collection of Prints, Sculpture and Drawings. Prepared by Alain de Leiris and Thomas H. Garver. Waltham, The Poses Institute of Fine Arts, Brandeis University, 1963
Deutsche Akademie der Künste 1952	*Honoré Daumier Die Parlamentarier Die Büsten der Deputierten der Juli-Monarchie* Introduction Konrad Kaiser. Berlin, Deutsche Akademie der Künste, 1952	Smith College 1963	*A Sculpture Collection for Smith College* Northampton, The Smith College Museum of Art, May 15-June 5, 1963
Galerie Sagot-Le Garrec 1957	*Daumier Sculpteur Lithographe et Dessinateur* Preface M. Georges Duhamel. Introduction Maurice Gobin. Paris, Galerie Sagot-Le Garrec, June 14-July 13, 1957	Klipstein and Kornfeld 1965	*Daumier* Bern, Klipstein and Kornfeld, June 17, 1965
		Palais	*Collection René G.-D.* [Gaston-

Index of Titles